NATIVE AMERICANS

NATIVE AMERICANS

Five Centuries of Changing Images

———■———

Patricia Trenton and Patrick T. Houlihan

Harry N. Abrams, Inc., Publishers, New York

TO OUR SPOUSES, BETSY AND NORMAN

Editor: Phyllis Freeman

Designer: Doris Leath Strugatz

Photo Editor: Neil Ryder Hoos

Photo Research: Pam Bass

Library of Congress Cataloging-in-Publication Data

Trenton, Patricia.
 Native Americans: five centuries of changing images/Patricia
Trenton, Patrick T. Houlihan.
 pp. 304 28×21 cm.
 Bibliography: p. 290
 Includes index.
 ISBN 0–8109–1384–4
 1. Indians—Public opinion—History. 2. Indians in art—History.
 I. Houlihan, Patrick T. II. Title.
 E59.P89T74 1989
 306′.08997—dc19 89–398

A Times Mirror Company

Printed and bound in Japan

TO OUR SPOUSES, BETSY AND NORMAN

Contents

Introduction

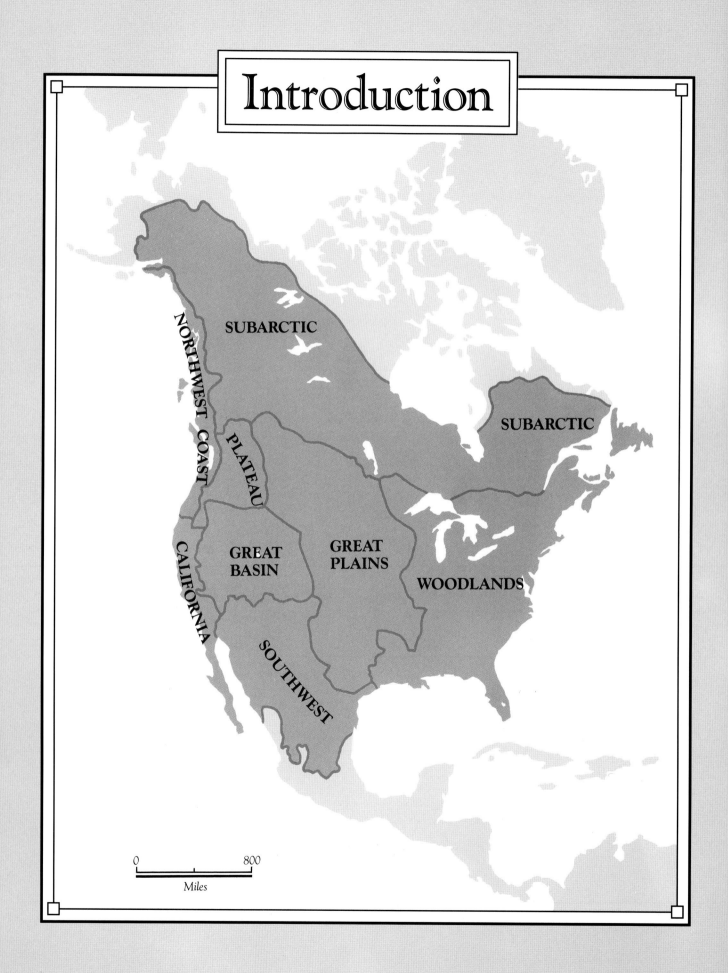

SUBARCTIC

SUBARCTIC

NORTHWEST COAST

PLATEAU

CALIFORNIA

GREAT
BASIN

GREAT
PLAINS

WOODLANDS

SOUTHWEST

0 800

Miles

No image of America has captured the imagination of Americans of European descent more completely than that of the American Indian. Even before the continent was fully explored, the Indian became inextricably fused with the mythology as well as the reality of America. In the course of almost half a millennium, the native American has been considered a noble savage, an innocent primitive, and a living example of natural law. The original American has also been called an impediment to civilization, a barrier to Manifest Destiny, and a radical militant.

Once Europeans began to realize the potential of North America's natural resources, the initial perception of the Indian as an exotic primitive living in a state of nature was replaced by a view more consonant with economic reality. As frontiers were pushed westward, the American Indian became socially, politically, and economically expendable. One historian notes that the Euro-American "developed a series of images of Indians and Indian life useful in justifying wholesale dispossession."[1] These images were often paradoxical stereotypes: bloodthirsty savage and heroic warrior; hopeless drunkard in need of protection; victim of deceit, corruption, and greed, grudgingly but philosophically accepting his fate. In his many guises, the Indian influenced the continent's political and cultural history, as well as its art.

Non-Indians from the time of Columbus to the present have described the native cultures of the Americas in oral and written accounts and in painting and photography. Although many of these descriptions are ethnographically and historically inaccurate, they offer a vivid means for exploring these cultures. At the same time, these accounts and images often offer valuable historical insights into non-Indian beliefs and attitudes toward native Americans.

In this book, images of the American Indian in paintings, drawings, and photographs are seen alongside objects of daily and ceremonial use made by native Americans. Our study of the relationships among these images and artifacts from culturally diverse areas has led to an integrated anthropological and art-historical critique. Some of the best- and least-known European and American artists are included, with work that dates from the sixteenth century to the twentieth. Almost all of the native artists are anonymous, and their work in many mediums spans a multitude of tribal cultures from prehistoric times to the present.

Like many of these pictorial interpretations of the American Indian, our text is sometimes flawed by the intellectual prejudices of our respective disciplines, anthropology and art history. We have tried to overcome this by organizing the book in terms of the culture areas of the original Americans. Within these areas, paintings, photographs, and artifacts were chosen for their appropriateness to a discussion of the history and cultural patterns of each area as well as for their relevance to the history of the American Indian in art. Whenever necessary, we have considered historic changes in Indian cultural patterns, painting styles, and techniques, and the prevailing attitudes toward Indians by non-Indians. Our primary focus, however, has been on the accurate presentation of native American cultural patterns, and thus we have pointed out interpretive exaggerations or inaccuracies where they occur in the paintings we have selected.

For students of the North American Indian, the enormous land mass of this continent is sometimes seen as a kind of regional patchwork quilt, labeled Great Plains, Northwest Coast, Southwest, Woodlands, and so forth. Beneath these geographic names lies the anthropological concept of the *culture area,* a notion of cultural relatedness among different groups of people within defined though often extensive geographical areas.

The concept of the culture area evolved in the late nineteenth century in the work of social scientists whose studies focused at first on a reliance on similar foods among varied Indian groups living in a given region, or "food area." By the middle of the twentieth century, a broader scope of cultural and ecological patterns was identified and the concept of culture areas expanded. According to this broader concept, for any given region of the Americas—like any of the world's other land masses—flora and fauna, climate and physiography, history and culture interact to produce a general, regionalized cultural pattern shared by most of the aboriginal inhabitants of an area at a particular time. Regional cultural patterns were perceived in the distribution of discrete cultural traits, such as social structure, religious beliefs and rituals, and art forms.

As a result of this early scholarly work, many studies of the American Indian continue to be organized by culture areas. North of the present-day border of the United States and Mexico, the continent is usually divided into ten Indian culture areas: the Arctic (whose inhabitants are Eskimo), Subarctic, Northwest Coast, California, Plateau, Great Basin, Southwest, Great Plains, Woodlands, and Caribbean. Within any one of these culture areas there are often significant differences between groups, yet there are also important similarities, such as language. The importance of language in discussions of the American Indian rests, in part, with its usefulness in tracing the movements of people across culture areas, and with these movements the transference of ideas and objects. In another sense, language is a primary means for determining membership in any given culture-bearing group. "English-speakers," for example, immediately identifies a group of people quite distinct from "French-speakers" or "Athabaskan-speakers." Today, many anthropologists, historians, and geographers have concluded that the utility of the culture area concept outweighs the distortions inherent in any broad organizing scheme. It is the primary criterion, for example, that most large museums use in organizing their exhibitions on the American Indian. Perhaps the most telling argument in favor of the attention placed on the environment by the culture-area concept is the emphasis all aboriginal cultures must place on survival, since for small-scale, preindustrial societies the environment and the quest for food underlie most other cultural patterns.

In this survey of the American Indian in art, the treatment of culture areas varies in length, because of the degrees of interest shown by artists in the native inhabitants of different areas. Some native American cultures, namely Eskimo and Aleut from the Arctic, do not appear, nor have we presented any examples of Caribbean, Mexican, or Central American Indians, although a complete presentation would require their inclusion. The maps at the start of each chapter are at best approximations, and no attempt has been made to include every tribe within each culture area or to delineate extensive historical movements by various tribes after the late

nineteenth century. We have sought, however, to present certain cultural phenomena in the major culture areas by a careful choice of paintings, photographs, artifacts, and commentary. These phenomena include language, subsistence patterns, housetypes, dress, and objects of daily and ceremonial use.

In documenting the American Indian, painters, photographers, and engravers have created a universally recognized series of images about America. These images have evolved over time into an evocative iconography—an iconography of shifting emotional content that has given this country a means for expressing some of its most cherished values. As a result, each image has a story that sometimes begins with the artist and his motivation to paint native Americans. At other times, it begins with an action in the history of Indian-white relations. Whatever its origin, our intention has been to document the time and place, the way in which the image came about, and the audience for whom it was intended.

The last chapter of the book presents a selection of ten paintings by modern and contemporary artists whose themes are past and present Indian cultures. Some of these artists break with tradition in approaching their subjects, while others continue to refer to earlier traditions. Unlike the work of artists throughout the rest of the book, these images are not organized by culture areas but rather as approaches to subject matter that illustrate a continuing interest in portraying the American Indian.

Throughout this work the authors have been aware of the constraints of language. The approaching quincentennial of Christopher Columbus reminds us that "Indian" is as inappropriate a label for native Americans in 1992 as it was in 1492, when the great navigator was a continent and an ocean away from India! So too with the word "tribe," which best fits the peoples of the Great Plains—the people whose political organization corresponds most closely to the social scientist's concept of tribe. Yet even for Plains groups, tribe may imply a political structure and stability that are inaccurate. For this reason we have stressed language and linguistic affiliation as an important determinant of group identity and relatedness.

This work is offered with a desire to advance our understanding of the original Americans as well as of non-Indian artists and audiences, whose fascination with Indian cultures seems inexhaustible.

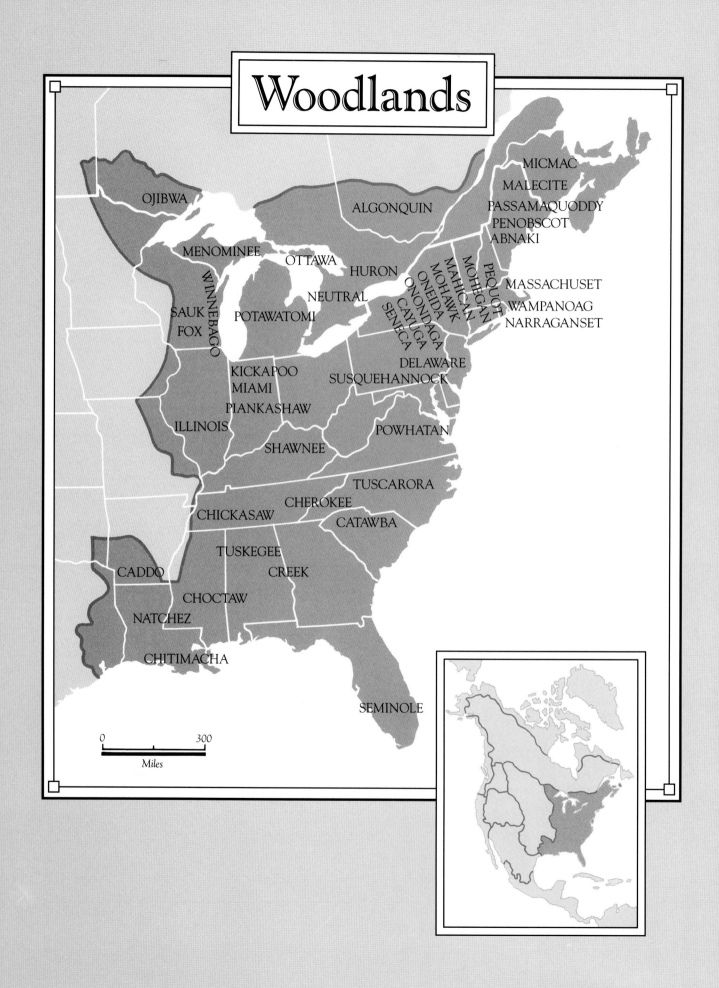

Woodlands

OJIBWA

ALGONQUIN

MICMAC

MALECITE

PASSAMAQUODDY

PENOBSCOT

ABNAKI

MENOMINEE

OTTAWA

HURON

NEUTRAL

WINNEBAGO

SAUK

FOX

POTAWATOMI

PEQUOT

MOHEGAN

MAHICAN

MOHAWK

ONEIDA

ONONDAGA

CAYUGA

SENECA

MASSACHUSET

WAMPANOAG

NARRAGANSET

KICKAPOO

MIAMI

DELAWARE

SUSQUEHANNOCK

PIANKASHAW

ILLINOIS

SHAWNEE

POWHATAN

TUSCARORA

CHEROKEE

CHICKASAW

CATAWBA

TUSKEGEE

CADDO

CREEK

CHOCTAW

NATCHEZ

CHITIMACHA

SEMINOLE

0 300

Miles

In no region of native North America were the cultures of its aboriginal inhabitants more disrupted by the Europeans than in the Woodlands. Almost from the first contact, Europeans appropriated the resources of native Americans: trees and fur-bearing animals from the forests, fish from the lakes and rivers, and ultimately the land itself. Repeatedly, native cultures were sundered and displaced by European settlement, by alien public policy and religion, and by war.

The Woodlands extend from the Gulf of Mexico to the Great Lakes and from the Atlantic Ocean to the Mississippi River. The area's northern margin is marked by mixed forests of deciduous and coniferous trees, stretching from Lake Superior to northern New England and Maritime Canada. Below this margin the trees are predominantly deciduous. In the north there are hardwoods—birch, beech, maple, oak, and hickory as well as elm, basswood, and ash. From these trees an enormous variety of Woodland artifacts were crafted: canoes, containers, medicines and ritual paraphernalia, and shelters. Some trees provided nuts and fruits, or they protected smaller plants whose berries or roots were essential to the aboriginal diet. These forests were the habitat, too, of much of the game hunted by the Woodland Indians: deer, moose, fox, wolf, and bear, along with smaller animals and game birds. Both men and women fished for food in lakes and streams; hunting and trapping were almost always male activities.

Woodland tribes were also horticulturalists, cultivating corn, beans, squash, and in some areas tobacco. Among the wild foods harvested in a seasonal cycle, the most important were rice, maple sap, berries, nuts, potatoes, onions, milkweed, and the root of the yellow waterlily. To the west, the Prairie-Plains region is penetrated by Woodland vegetation along the eastern tributaries of the Mississippi River, and it was culturally distinguished in historic times by an emphasis on equestrian hunting. To the south, along the Gulf of Mexico and in the Southwest, the influence of Mesoamerica is most strongly seen in a greater dependence on agriculture, higher population density, and more complex social stratification and political organization.

Within the Woodlands culture area the largest geographical divisions are the Coastal, the Saint Lawrence Lowlands and Great Lakes-Riverine, and the Southeast-Gulf of Mexico. Much of the Coastal region is separated from the rest of the Woodlands by the Appalachian Mountains. The historic tribes of the region were generally Algonquian- and Iroquoian-speakers. The best known of the Eastern Algonquian-speaking tribes included the Abenaki, Delaware, Mahican, Malecite, Massachuset, Micmac, Montauk, Narraganset, Pennacook, Pequot, and Wampanoag. The Saint Lawrence Lowlands contain most of the territory drained by the many tributaries of that river, and it includes modern-day southern Ontario, Quebec, and upstate New York. Most of its resident tribes were Iroquoian-speakers in contrast to the Algonquian- and Siouan-speakers of the Great Lakes-Riverine region to the west and south. Among the most commonly known Central Algonquian-speaking tribes are the Chippewa, Ottawa, Potawatomi, and Menominee, termed the forest tribes; and the Sauk, Fox, Kickapoo, Illinois Shawnee, Piankashaw, Prairie Potawatomi, and Winnebago—referred to as the prairie tribes. Best known among the Iroquoian-speaking tribes are the Seneca, Onondaga, Mohawk, Oneida,

Cayuse, Huron, Erie, Susquehannock, and Neutral.

Many anthropologists consider the southeastern portion of the United States a separate culture area. It stretches from the 24th to the 39th parallels of northern latitude and from the 75th to the 96th meridians of western longitude. In more common political terms, it includes both the "gulf" and "southern" states—all of Georgia, Florida, Alabama, Mississippi, and parts of Louisiana, Texas, South Carolina, North Carolina, Tennessee, and Arkansas. Among the better-known tribes of this region are the Cherokee, Creek, Catawba, Seminole, Choctaw, Chickasaw, Quapaw, and Natchez. The principal languages in the Southeast were Algonquian, Muskogian, Iroquoian, Siouan, and Caddoan.

The earliest record of European contact with eastern North America—the Woodlands—is lost in the vagueness of a time scholars refer to as protohistory, a time with limited, poorly documented written records. During this period, from the eleventh through the fourteenth centuries, we know that the northern coast of North America was visited by Norsemen from Greenland and possibly by Basque and Breton fishermen from Spain and France.

By the end of the fifteenth century, French, English, Spanish, and Portuguese fishermen and explorers had made contact with the Woodland Indians, and they were followed later by Dutch and Swedish explorers, traders, and settlers. In addition to taking the Woodland resources—fish, furs, and lumber—the Europeans at times even took Indian slaves. By the seventeenth century, fishing was replaced by fur trading, particularly after the beaverfelt hat became a popular European fashion. In exchange for furs, Woodland Indians received woven cloth, knives, hatchets, beads, brass kettles, and liquor.

Although several European colonies were attempted in the sixteenth century, the first permanent, successful colony was established in 1607 by Captain John Smith on Chesapeake Bay in Virginia. While motives for colonization varied widely, its effect on the Indian was invariably cultural change. On the Atlantic Coast from Labrador to Florida the nature of contact between Indians and Europeans altered through time. After 1607, however, instead of intermittent contact and the taking of fish, furs, lumber, or slaves, the land of the Woodland Indian became the prize for European colonists. A rivalry for both North and South American resources was a dominant factor in the relations among European nations for the next 150 years.

Cartographic evidence is one of the important sources of information about European contact with the Woodland Indians before 1700. Such evidence suggests that with the shift of European interest from fisheries to furs, coastal tribes were soon by-passed in an attempt to establish direct trade links with the interior tribes. It also suggests that coastal fur resources of small game, especially beaver, were exhausted by 1600. By 1609, for example, Dutch exploration and later settlement began—near Albany, New York, and on the Connecticut River—at a time when Europeans were still looking for a northwest passage to Asia.

By the seventeenth century, the small, scattered European colonies entered a new phase of white-Indian relations—warfare. Isolated skirmishes and reprisal raids characterized the first white-Indian encounters,

but in the attempt to settle and hold Indian land, full-fledged warfare erupted between the two groups. This warfare began in New England as early as 1637 with the Pequot Wars, which pitted these Indians and their allies against Massachusetts and Connecticut colonists. Other New England colonist-Indian wars were fought against the Narragansets in 1643 and against the Wampanoags in 1675 (King Philip's War). In New York a struggle against the Dutch began in 1638, and in Virginia Bacon's Rebellion erupted in 1675.

Throughout the seventeenth and eighteenth centuries, European powers utilized Indian allies in the contest for North America's resources. The patterns of hostility that developed from these alliances remained long after American Independence. For example, the Iroquois alliance (except for some of the Oneida and Tuscarora) with the British in America's Revolutionary War fanned anti-Iroquois feeling in the United States long after that struggle ended. So too with the Seminoles in the Southeast, who fought against the United States in the War of 1812.

Certainly, the dominant European colonial policy of Indian removal in order to establish colonies continued long after the founding of the United States. In 1830, for instance, the Removal Bill of President Andrew Jackson provided for the relocation of Iroquois from Ohio to the Indian Territory of present-day Kansas and Oklahoma. A few years before his presidency, General Jackson had sent defeated Seminoles to that same Indian Territory after the First Seminole War of 1817–19. The federal policy of Indian removal resulted in the resettlement of numerous Woodland tribes in the Indian Territory or beyond the Mississippi in Iowa (Sauk and Fox), Wisconsin (Oneida, Stockbridge-Munsee), and Nebraska (Potawatomi).

European attitudes toward the native American evolved from the fascination of early explorers and clergy with an exotic land and its people, to the development of preconceived images of the noble or ignoble savage, to the paternalism of nineteenth-century America. One nineteenth-century observer, the writer-chronicler Francis Parkman, generalized: "Spanish civilization crushed the Indian; English civilization scorned and neglected him; French civilization embraced and cherished him." In actuality, the French cultivated a delicate, often deceptive balance in their treatment of the Indian. Fur trading was the primary motive for a French presence in the United States and Canada, and, far outnumbered by the Indians, the French developed an expedient policy that combined missionary zeal with a posture of cultural superiority. Champlain's dream of assimilation had failed before the end of the seventeenth century, and the imperial policy that followed altered the French view of the Indian. Fur trading and missionary activity continued, but in the minds of the French, the noble savage and the unworthy barbarian was superseded by the Indian warrior, until the French were finally defeated by the British in the Seven Years' War (1756–63).

After the 1763 Treaty of Paris, England became the only European power in official contact with the Indians of the Northeastern Woodlands. To reduce Indian-white conflicts, a British Royal Proclamation of 1763 decreed a policy of minimizing contact with the Indians. The document was the basis of the English government's colonial philosophy for North America, and it provided for a huge tract of land as an Indian reserve. This

protective policy continued until Indian support was needed again to try to suppress the American Revolution. With the withdrawal of their European allies in the early nineteenth century, Indian tribes clearly recognized the dominance of United States power. The United States government, in turn, based its relations with the Indians on the English colonial and imperial patterns. Missionary and military activity, trade and land transactions all had colonial precedents, and when these were not effective, imperial models were available. The official position of the United States toward the Indian was characterized by Chief Justice Marshall as that of a guardian toward its ward. Until the 1880s, Indians (and government officials) often acknowledged this paternalism by referring to the president as the "Great Father." Paternalism has persisted to the present.

Any description of the social structure of the Woodland Indians must distinguish between the hunting, fishing, and gathering people of the northern forests and the more southern tribes that practiced agriculture as well. South and west of Virginia and the Carolinas, cultural patterns were much more Mesoamerican. Agriculture predominated as the subsistence base, and most of the southern groups lived in villages and towns that were usually organized about central squares. Earthen mounds and temples for religious rituals were part of a pattern of rituals and beliefs referred to as the Southern Ceremonial Cult. Social stratification was more developed, with political and religious elites, and matrilineal descent was common. In contrast, the social structure of northern hunters was characterized by patrilineal bands with weaker political leadership that probably did not extend much beyond these bands, while horticultural groups from New England, Virginia, and North Carolina formed confederacies of several different tribes.

In the central Mississippi region, Indian groups, such as the Shawnee, Miami, Sauk, Fox, Kickapoo, Potawatomi, and Illinois, subsisted by a careful mix of horticulture, hunting, and gathering. In centrally located villages patrilineal clan members cohabited in large, rectangular, multi-family dwellings during spring and summer. At other times, small family units dispersed to hunting, fishing, or gathering locations. Important social distinctions were made between civil and religious authorities. In the western Great Lakes and northern Mississippi areas of the Woodlands, among such groups as the Ottawa, Ojibwa (Chippewa), and Huron there was much less dependence on corn than elsewhere in the Woodlands. Gathering, especially of wild rice, fishing, and hunting provided a far greater part of the subsistence base, and the dominant social unit was the patrilineal clan.

To the east, among the Iroquois, horticulture provided major food resources, as did hunting, gathering, fishing, and trading. Villages in historic times were large and fortified but without the plazas, mounds, and priestly cult of the Southeast. Descent was bilateral without preference to patrilineal or matrilineal kin. Village government was broadly based and relied on discussion to consensus. As Europeans and, later, Americans and Canadians moved west, these cultures changed. Out of the dislocations came dependence on welfare to supplement traditional subsistence. Changes also occurred in social structure, as intermarriage took place with other tribes.

Very little is known about Woodland Indian religion at the time of first contact. It is generally assumed that all of the tribes subscribed to animism, a generalized belief in spiritual beings. And undoubtedly there was great concern for curing illness through religious beliefs and rituals, especially shamanism. Some scholars assert, however, that the European introduction of measles, smallpox, typhus, and venereal diseases may have heightened the importance of ritual practitioners in the Woodland tribes. By the same token, these European diseases and the need for cures may have made Christianity and some of its ritual practices, such as baptism, more compelling to Woodland Indians. By the eighteenth and nineteenth centuries, some aspects of Christianity had become vital parts of native religions. Some of the best-known features of this fusion can be seen in the Indian revival movements and the appearance of Indian prophets or messiahs, such as the Seneca Handsome Lake.

With time, European perceptions of the Woodland Indians changed. Before the seventeenth century and the advent of permanent colonies, the aboriginal inhabitants were important providers of the most sought-after resource—furs. In the East, Indian trappers harvested the pelts for sale or trade to Europeans; in the West, during the eighteenth and nineteenth centuries, white trappers took pelts directly from the land. After the start of the seventeenth century the colonists shifted from needing Indian labor to wanting to move the Indians off the land. The justification—putting the land to better use—reflects the cultural bias that agrarian use is superior to hunting and gathering. Beaver trapping had long ago exhausted the animal supply in the Eastern Woodlands, and English, French, and some American traders were working the Western Great Lakes and the Trans-Appalachian regions.

The uncaring attitude of European, and later American, traders toward the Woodland Indians, as well as other Indian groups, can be seen in the use of liquor as a major trade commodity. Trade in wine and brandy at first and later in whiskey was a measure of the white man's callousness toward the Indians. Acquiring Indian resources justified any behavior, a cultural arrogance that extended even to the work of Christian missionaries—who believed that Indian "souls" should be Christian and therefore "our" souls.

The many fears and superstitions held by Europeans about the forests of Europe were transferred to the forests of North America. Although the destruction of the forests was required for agriculture, the decision was reinforced by the feeling that danger lurked everywhere within them. By the eighteenth century in the western Great Lakes, lumber from the virgin-pine forests of Michigan, Wisconsin, and Minnesota was the most coveted resource. By this time, however, Indians had been guaranteed land in the form of large reservations, held communally by tribes or subunits of tribes. To acquire title to these lands, Congress passed the Dawes Severalty Act, giving individual Indians and their families ownership rights to varying portions of their reservations. This allowed unscrupulous land agents, lumbermen, and others to buy portions of Indian reservations from individual families. Thus reservation lands were logged, mined, and farmed by white men, and the Indians were deprived of their essential resource, the land itself.

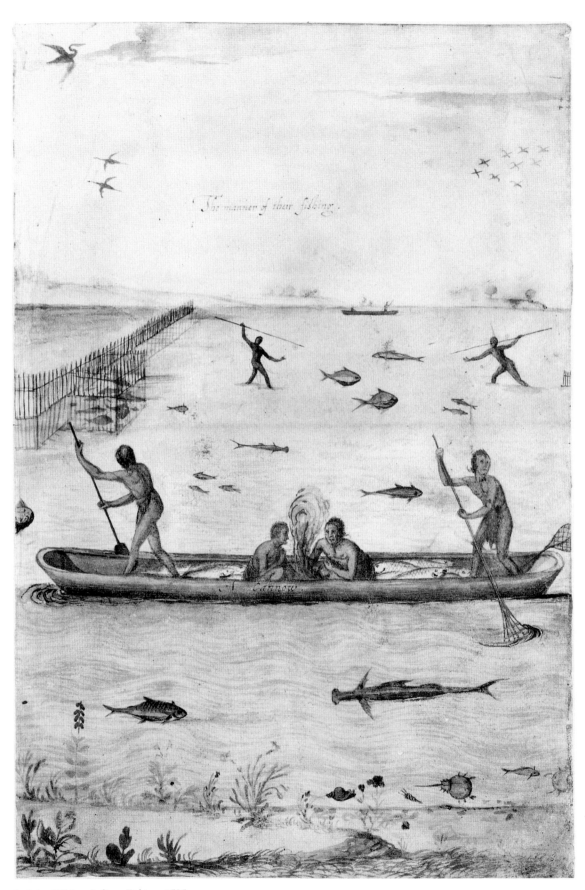

1. John White, *Indians Fishing.* 1585

One of the earliest contacts between Europeans and Woodland Indians occurred between English explorers and the North Carolina Algonquians—in historic times the southernmost Algonquian-speakers on the Atlantic seaboard. This contact came as a result of English efforts, in the 1580s, to establish a colony at Roanoke Island, off the coast of present-day North Carolina. The English intended to exploit the vast resources of the New World, gain a Protestant foothold to offset the Catholic empire of the Spaniards in North America, and convert the native population to the "true religion."

Among the colonists on the 1585 voyage to Roanoke was John White (c. 1540/50–1593), and his drawings of the short-lived colony are some of the earliest and best pictorial records of native North Americans.[1] White's drawings, along with the writings of naturalist Thomas Harriot who made the same voyage, were published as *A briefe and true report of the new found land of Virginia* (1590).[2] The report offers an accurate, sympathetic portrait of Indian life in "Virginia" (present-day North Carolina), seemingly still untouched by European influences. Much of the ethnographic record of this group is supported today by archaeological findings and contributes greatly to our knowledge of the North Carolina Algonquians' urban planning, house types, ritual and mortuary practices, subsistence activities, and clothing. Ample records left by early Spanish, French, and other English explorers of North America confirm that these Indians subsisted by gathering, fishing, and farming. Unfortunately, there is no accurate data on the relative importance of these activities. Nor are there data on trade between coastal and interior groups or between the Algonquian-speakers and early European colonists.

The North Carolina Algonquians who came into contact with the Roanoke colonists were well adapted to the coastal environment. Navigating the extensive systems of rivers and estuaries in the region was essential to their lives. Daily movement between settlements and fishing and hunting locales was relatively easy in dugout canoes that were well-designed to navigate the shallow inland sounds and rivers of the North Carolina coast.[3] In several drawings, John White carefully delineated the manufacture and use of these canoes; and in a complementary text, Harriot detailed the technique of their manufacture, from felling trees to shaping them into canoe shells.[4] Harriot tells us that the English were impressed with every stage of this task, since all the woodworking was accomplished without benefit of "instruments of yron."

White's composite watercolor drawing of *Indians Fishing* (plate 1) provides numerous details on the use of dugout canoes. The drawing is an aerial view of the native manner of fishing by day with dipnet and spear, supplemented by elaborate fish traps, and of fishing by night with a fire in the canoe. Impressive to the English, too, was the efficiency of fishing with traps, weirs, spears, and dipnets. Harriot noted that "ther was never seene amonge us soe cunninge a way to take fish." In the absence of iron and steel, he continued, they "faste unto their Reedes or longe Rodds, the hollowe tayle of a certain fishe like to a sea crabbe," in order to fashion a spearpoint.[5] In night fishing the light of the fire in the canoe attracts the fish and possibly illuminates the shallow bottom or the shore of a river, enabling the fishermen to spear their catch from the canoe.[6]

2. Prehistoric Indian Dugout Canoe. c. 2700–800 B.C.

For many years archaeologists and historians have assumed that the dugout canoe had prehistoric antecedents, and this has been confirmed recently by the recovery of a number of these canoes in the Southeast, including North Carolina. More than twenty prehistoric dugout canoes have been found in Phelps Lake, a large, natural body of water in northeastern North Carolina, testifying to their widespread use (see plate 2). Although the canoe shown here is a North Carolina lacustrine (lake) canoe, it is almost identical to the maritime canoes of the Coastal Algonquians depicted by White and described by Harriot.

The discovery of these canoes together with pottery and stone artifacts substantiates the construction methods detailed in the Roanoke accounts. Large bald cypress or pine trees found along the lake shore were felled with fire and stone tools and then laboriously hollowed out, using small, controlled fires to char interior portions of the logs. Unwanted, burned material was then removed by scraping and chopping with stone or shell adzes, scrapers, and axes. By such methods, the Phelps Lake Indians fabricated canoes as long as 37 feet and with carefully smoothed hulls only ½ inch thick. Another drawing by White details the construction sequence.

Ongoing studies at Phelps Lake reveal other features of these canoes. Some have "rounded or pointed ends," while others have internal structures like "thwarts or seats." Because the Phelps Lake boats look so much like the sixteenth-century canoes White and Harriot described, archaeologists did not expect them to be earlier than late prehistoric. But C-14 dating has revealed that these canoes were made as early as 2,500 to 3,000 years ago. Helping to confirm the C-14 dates for the canoes are very old varieties of pottery as well as stone tool types collected from the lake. This evidence has amplified and clarified our understanding of the way prehistoric Indians lived in the Coastal Plain region of North Carolina, where the wooden canoe was undoubtedly of vital importance to early Indian lifeways.

Although Harriot and White were impressed by the clever fishing practices of the Algonquians, they still saw these people as "savages deprived of the true knowledge of God." Like other Europeans of the sixteenth century, they came to the New World greatly influenced by preconceptions and prejudices inherited from the Middle Ages and modified by ideas from classical literature. "In medieval theory the savage was a naked man covered with hair who lived a solitary life in a forest, . . . subsisted by hunting and gathering, and had no religion and no social and political organizations. . . . In the logic of the Europeans it followed that, if the natives of the New World were savages, they must be men without law or government, and probably also without religion."[7]

White's identity is charged with mystery. There are no extant records on his early career or his family background before the Roanoke voyages (1585–90), sponsored by Sir Walter Raleigh. White's biographer, Paul Hulton, conjectures that the artist was chosen for the 1585 Roanoke voyage because of his previous experiences as an artist-explorer on Martin Frobisher's second voyage to the Arctic in 1577 (watercolor portraits by White of three Baffin Island Eskimos and an Arctic scene are found in his "1585 Album," a bound collection of White's drawings from several parts of the world, deposited in the British Museum). The fine detailing of Eskimo clothing, tents, and kayaks evident in these drawings would be almost

impossible to replicate from secondary sources, written records, or the artist's imagination. Evidence indicates that White took part in all five Roanoke voyages and almost certainly led the second one, which attempted to establish a permanent English colony on Roanoke Island in 1587. At that time White also served as governor of the ill-fated "Lost Colony" in what is now North Carolina.

Although all of White's drawings are unsigned, his authorship is certain. His watercolors drawn from life are more spontaneous and naturalistic than similar work by English artists of this period. Although his images are not completely free of European Mannerist traits—evident in the slightly Europeanized faces and classical poses—he was able to free himself from fashionable artistic conventions of the time. Despite his incomplete knowledge of perspective and anatomy, White saw the New World and its inhabitants with unusually fresh eyes.

His authorship of the engravings is indisputable. Printed on the title page that introduces the section of engravings in *A briefe and true report* are these words: "Diligentlye collected and draowne by Ihon White who was sent thither speciallye and for the same purpose by the said Walter Ralegh the year abouesaid 1585." The engravings closely follow the design of the originals, but they are more elaborate in detail (see plate 3). This leads some scholars to speculate that the engraver may have worked from another set of White's field drawings, or that he may have taken some artistic license. Engravers and lithographers of the time often embellished artists' designs with picturesque details or heightened the drama of everyday scenes, and the public learned about these exotic places from the reproductions rather than from the original sketches.

Thomas Harriot was the scientist and mathematician for the 1584 and 1585 voyages, and he and White worked as a team. White recorded every detail in pictures, while Harriot identified, described, and classified what both men saw. A large collection of field sketches by White now is presumed lost, but according to Harriot, the artist made drawings of almost every aspect of Indian life as well as studies of animals and plants. Like most topographical artists of the period, White made his drawings in pencil and then developed them with watercolor washes, heightening them in some cases with opaque colors. Occasionally, White was inspired by other artistic sources. His drawings of a Floridian woman and man in the "1585 Album" were copied from the watercolor drawings by the artist-explorer Jacques le Moyne de Morgues, who was part of the expeditionary party of René de Laudonnière to Florida in 1564.

To the north of the ill-fated Roanoke Colony, which had mysteriously disappeared by the time of White's second journey there, in 1591, was an Algonquian-speaking confederacy of tribes ruled by the patriarchal leader Powhatan (Wahunsonacock). Chief Powhatan's subjects numbered about 9,000, one-third of them warriors; and his territory of about 8,500 square miles extended from present-day Washington, D.C., to northern North Carolina. Powhatan was almost sixty years old when a small group of English colonists arrived in the tidewater area of eastern Virginia, in April and May 1607, to found Jamestown, the first permanent English colony in the New World. Without the diplomatic ingenuity of Powhatan's favorite daughter, the young princess Pocahontas (born 1596 or 1597), who pro-

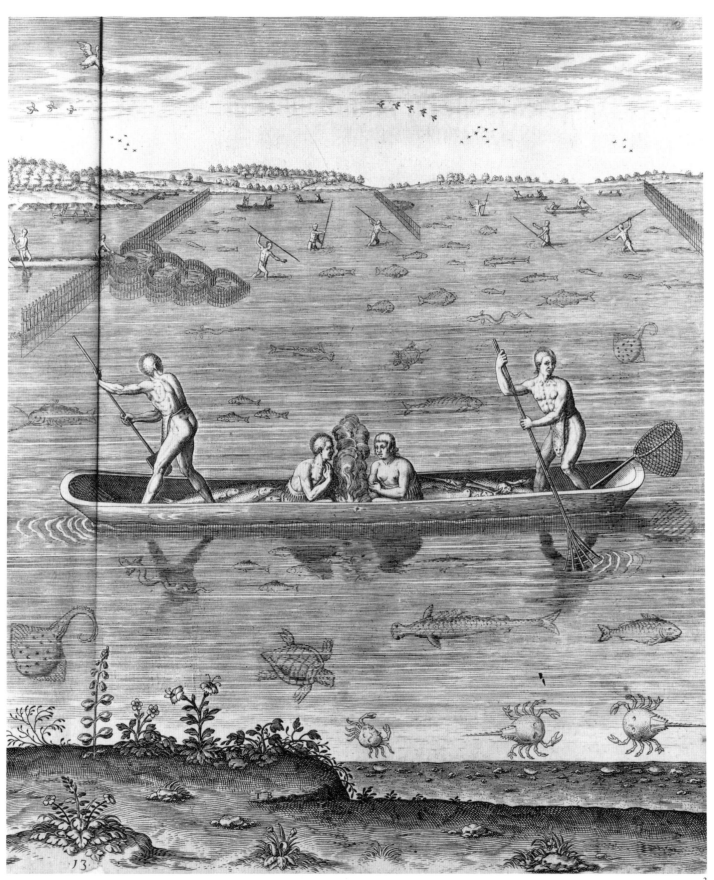

vided food and protection for the settlers, the Virginia colony probably would not have survived.

Long associated with the wealthy chief is an elaborately decorated deerskin known as "Powhatan's" Mantle (plate 4). Made from the tanned hides of four white-tailed deer, the mantle is covered with *Marginella* shell beadwork that represents a standing human figure of unspecified sex flanked by two upright quadrupeds in a field of disks. C. F. Feest, in a study of the mantle, assumes that if the animal forms are of real rather than supernatural beings, the one on the right with a cloven hoof represents a white-tailed deer, "the only member of the order of *Artiodactyla* to occur in tidewater Virginia."[8] The animal on the left, with a long, smooth tail and round paws, presumably is a mountain lion of the type that inhabited eastern Virginia. From 1638 until its acquisition by the Ashmolean Museum in 1683, the mantle was in the Tradescant Collection, where it was catalogued in 1656 as a possession of King Powhatan and a part of his "habit." The same entry of 1656 referred to "the *Marginella* shells as 'roanoke' [of the 'Virginia purse'], a usage not supported by other evidence."

Unsolved questions remain about the provenance as well as the use of "Powhatan's" Mantle. Over the years speculation has centered on whether it actually is a garment and how it became associated with Powhatan. Feest also states that

> it seems quite likely that the skin came from one of the native temples which were closely associated with the treasure-houses of the ruling families among the Virginia Algonquians. "All kinds of Treasure, as skinnes, copper, pearle, and beades" were stored there, as well as the "winter count" [Plains Indian term that means calendar] painted on skins. . . . These temples were occasionally destroyed or looted as part of the strategy of cultural and even physical genocide which was put into effect after the Indian uprising of 1622. The temple/treasure-house theory also supplies the only hint regarding the object's iconography. At the four corners of Powhatan's treasure-house in Orapakes, says John Smith, "stands [sic] 4 Images as Sentinels, one of a Dragon, another of a Beare, the 3 like a leopard, and the fourth like a giantlike man." Even though the images at Orapakes were probably carved, two of them, the "leopard"/puma and the anthropoid seem to duplicate figures represented on the skin.

3. Engraving after John White. *"Their manner of fishynge in Virginia"*

By the time the Jamestown settlers had arrived in eastern Virginia, Powhatan's confederacy already had experienced almost a century of contact with slave traders, Jesuit missionaries, and other European voyagers. Contact had provoked mutual distrust between Europeans and Indians, and the apprehensions of Powhatan's tribe toward the Europeans had ripened into open hostility by the beginning of the seventeenth century. Within two months after the colonists had established their fortified community at Jamestown, they dispatched two of their three ships to England for additional manpower and supplies. By August, shortages, illness, internal dissension, and increasing hostility from the natives had left the English colonists in desperate straits. At that time, Pocahontas, who often visited the Jamestown settlement, began to assist the colonists with gifts of corn, fish, and wild game, even though her royal heritage required her to share her people's distrust of the white man. According to

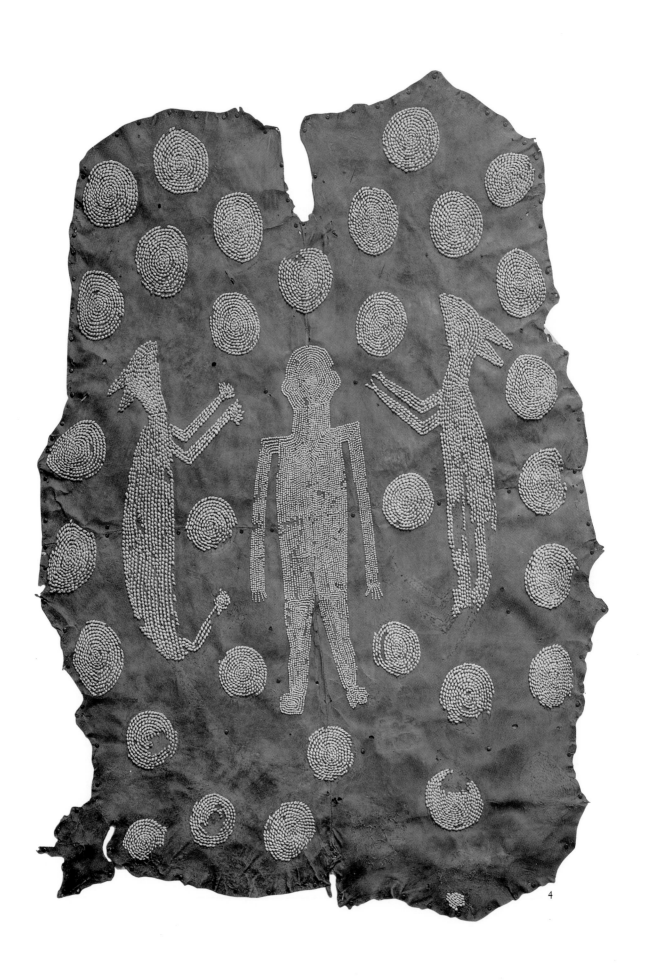

4

the colonists, Pocahontas, like all Powhatans, had two names. Her real name, Matoax, has been translated by scholars as "Little Snow Feather" or "She Amuses Herself"; and her nickname, Pocahontas, meant "playful" or possibly "wanton."

Years later, in 1616, in a letter to Queen Anne (reigned 1605–23), Captain John Smith declared that Pocahontas "under God was the instrument to preserve this colony from death, famine, and utter confusion."[9] He was probably acknowledging his own debt to her, too, for she performed another act that helped immortalize her. Her rescue of Captain Smith from execution left hope for cooperation between the Powhatans and the English and served to boost the morale of the colony. In commuting Smith's sentence, Powhatan made him a ward of Pocahontas.

In January 1608, one of the English ships returned to Jamestown with personnel and supplies to relieve the plight of the colonists. But within a week a fire destroyed most of the food stores as well as portions of buildings and the fort. Once again, Pocahontas is said to have responded by bringing the colonists corn. Later that spring, as a gesture of thanks, Indian prisoners held by the English at Jamestown were released to Pocahontas's custody. Yet her acts of assistance and those of other friendly Indians probably were insufficient to satisfy the needs of the colonists, and, with starvation imminent, the Jamestown militia resorted to food forays against neighboring Indian villages. In the course of these raids lives were lost on both sides and captives taken. At one point, Pocahontas herself was held captive and offered for ransom. In exchange for her release the colonists demanded that Powhatan return English prisoners along with stolen firearms and tools and that he provide Indian food stores as reparation.

Amid this turmoil, on April 5, 1614, Pocahontas converted to Christianity and married the widowed colonist John Rolfe. Although Powhatan did not attend the wedding, two of Pocahontas's brothers, an uncle, and several other Indian representatives were present, and the marriage marked a cessation of conflict between Powhatan and the settlers. Within a year, Pocahontas, now called by her Christian name, Rebecca, gave birth to a son who was named Thomas, probably after the leader of the Virginia Company, Sir Thomas Dale.

In 1616, to elicit political and economic support from England for their colony, the Virginia Company invited Rebecca, her son and husband, and a small retinue of her tribesmen to come to England. By presenting a Powhatan princess to English royalty, clergy, and merchantmen, the Virginia Company hoped to attract more money and colonists to Virginia. After seven months of touring in England, Rebecca became ill. Waiting at Gravesend at the mouth of the Thames to return home, she died, on March 1, 1616, and was buried immediately in the parish cemetery of Saint George's Church. The story of Pocahontas grew after her death and was enshrined on both sides of the Atlantic. Her best-known memorial is probably the large mural *The Baptism of Pocahontas* (plate 5) painted by John Gadsby Chapman (1808–1889). It now hangs in the rotunda of the Capitol, in Washington, D.C., one of the few pictures that honors a national heroine, and, even more remarkable, a native American woman.

Four American painters were commissioned by Congress, in 1836, to create murals for the Capitol rotunda. Chapman's commission was secured

4. "Powhatan's" Mantle. Before 1656

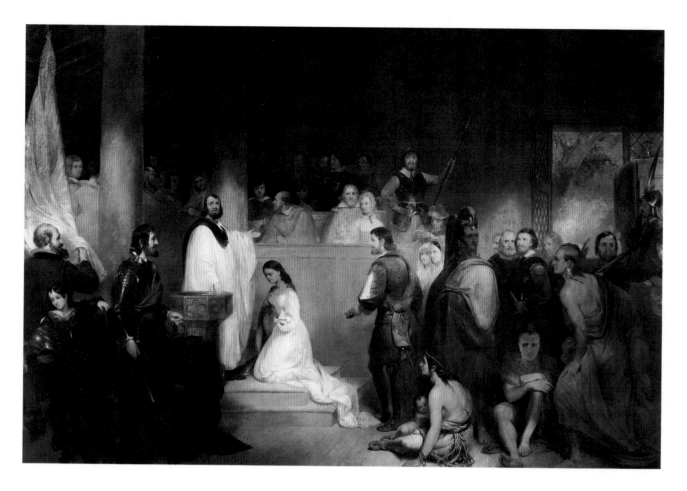

5. John Gadsby Chapman, *The Baptism of Pocahontas.* 1837–40

for him by his lifelong friend, Henry Alexander Wise, a congressman from Virginia and later governor of Virginia and a Confederate Army general. The paintings were to illustrate the discovery of America, the settlement of the United States, the history of the Revolution, and the adoption of the Constitution.[10] Chapman had already employed Indian subjects for book illustrations on the colonization of Virginia. The high moral overtones of this theme—propagating the blessings of Christianity among the so-called heathen savages—undoubtedly pleased his sponsor and Congress as well. A pamphlet published by Peter Force in 1840 justifies Chapman's selection: "Though a simple Indian maid, her life and actions are closely associated with events, which, in their consequences, have assumed a magnitude that fully entitles her to be placed among those who exercised an extensive influence in the destinies of states and the course of human events. She was, therefore, deemed a fit subject for a National Picture, painted by the order of Congress, to commemorate the history and actions of our ancestors."[11]

Although Chapman had never observed an Indian firsthand, a few years earlier he had made illustrations of idealized Indian subjects for magazines and giftbooks. The colossal Capitol mural, however, required a more authentic approach to his subject, so he turned to two portraits that he owned by his former teacher Charles Bird King. In King's portrait of the young wife of an Oto chief, *Hayne Hudjihini (Eagle of Delight)* (plate 6), and his *Young Omawhaw . . . and Pawnees* (see plate 52), Chapman found models for some of the figures in his mural. Authenticity, however, had its

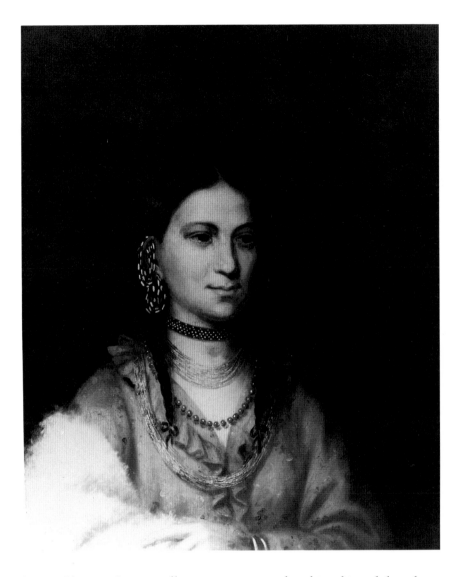

6. Charles Bird King, *Hayne Hudjihini (Eagle of Delight)*. c. 1822

limits. Chapman's essentially romantic approach to his subject did not keep him from borrowing King's models, who were not Powhatans of Virginia or Coastal Indians but instead Indians from a quite different culture—the Great Plains.

In *The Baptism of Pocahontas*, the Indian princess in European dress kneels for the ritual. Her smooth, high forehead, slanted eyes, and rounded chin closely recall King's portrait *Eagle of Delight*. Pocahontas's brother Nantequaus, to her right, turns his head away, quite like King's "War Eagle" in the group portrait *Young Omawhaw*. Also to the right of Pocahontas is her plotting uncle, Opechancanough, seated in the foreground with arms folded, recalling "Little Missouri" from the same King portrait. The standing Indian in profile and the seated Indian woman and child are adopted from two other portraits by King, the *Pawnee ["Petalesharro"]* and *Mohongo and Child*, respectively.[12] And since the mural was painted in Washington, D.C., the young artist probably consulted both King and the celebrated portraitist Thomas Sully.

More cognizant of the historical accuracy of his English figures and their setting, Chapman traveled to England to sketch the period armor and

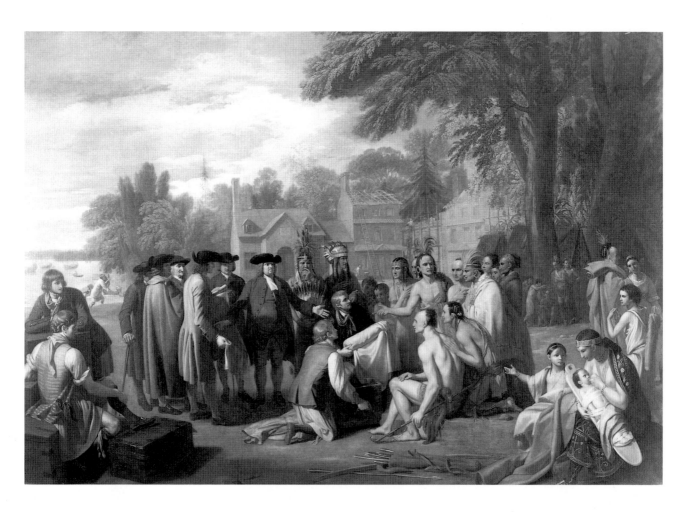

7. Benjamin West, *William Penn's Treaty with the Indians When He Founded the Province of Pennsylvania in North America.* 1771

costumes of James I (reigned 1603–25). There, he made sketches of a seventeenth-century "chair of raised velvet" in the "cartoon Gallery at Knole," a great Tudor palace at Sevenoaks, Kent, England. The chair can be seen in the left foreground of the mural. An 1840 pamphlet describing the picture states that he based his interior on a seventeenth-century Jamestown church. Chapman also turned to seventeenth-century writers and chroniclers for firsthand accounts of the baptism. His interpretation later became the model for a stained-glass window design in the present Saint George's Church, which replaced the earlier building in Gravesend, England.

Pressure on Woodland Indian groups to supply land for new settlements continued throughout the seventeenth century. Almost a century later, the expatriate American artist Benjamin West (1738–1820) commemorated an agreement between William Penn and the Delaware Indians in *William Penn's Treaty with the Indians When He Founded the Province of Pennsylvania in North America* (plate 7).[13] In 1681, to repay a debt to Penn's father, Charles II made William Penn "the true and absolute proprietary" of a large colonial territory, which the king named Pennsylvania. This land would be used for Penn's "holy experiment," a Quaker colony that promised unconditional political and religious freedom. Before coming to America in 1682, Penn added present-day Delaware to his territory, leasing it from the Duke of York for ten thousand years. Penn's land now placed most of the Delaware

Indians under his almost unlimited power—a power that he never invoked.

Penn's philosophy of Indian relations differed substantially from that of his predecessors. Economic benefit was not the principal concern, as it was for the earlier Dutch and Swedish colonists. Before leaving England, Penn wrote a letter to his commissioners in America, to be translated into Algonquian and read to the Indians. Penn wished to enjoy the "great Province" given him by the king with their "love and consent, [so] that we may always live together as Neighbors and friends."[14] For the Delaware, land tenure meant the right to use land—for hunting, fishing, trapping, and building shelters—rather than to possess it permanently. For the English Stuarts, territories not yet discovered or not owned by any "Christian Prince, County, or State" belonged to their discoverers. Penn compromised by attempting to reconcile his legal rights under British law with the moral principles of equity and fairness. Recognizing their prior right, he required the Indians to give "consent" to his occupation of the land they had lived on for centuries.

In the seventeenth century, culturally and linguistically similar Eastern Algonquian-speakers lived in the Delaware River valley in small, dispersed, politically independent bands. The river's interior fresh-water tributaries offered them protection in inclement weather and greater proximity to spawning grounds, animals, and birds. Before the English arrived on the Atlantic Seaboard, these Indians called themselves Lenni Lenâpé, "Original People," "Men Among Men," "Men of Our Kind" (*len*, "common," in both words, and *âpé*, "people," become "common people"; *lenni* reinforces this meaning). Much later, the English gave them another name, derived from that of the third Lord de la Warr, Sir Thomas West, who became governor of Jamestown in 1610. Thus the Lenape living on the shores of "de la Warr Bay" and along the banks of the river that flowed into it became known as the Delaware Indians. Modern ethnologists use both names interchangeably, and they define the traditional homeland of these Indians as the states of New Jersey and Delaware, southeastern Pennsylvania between the Susquehanna and the Delaware rivers, and southeastern New York west of the Hudson.

Scholars today generally consider Benjamin West's biography by John Galt, *The Life, Studies, and Works of Benjamin West, Esquire* (1816), a tangle of myth and reality, since West himself played an active role in writing it, filling its pages with apocryphal stories. Nonetheless, a considerable amount is known about West's life and work. Although he studied in Europe and settled in England, the Pennsylvania-born West may have learned to model his Indians after classical sculpture at the suggestion of John Haidt, a Moravian minister who taught him how to envision an integrated narrative. West's most original, ambitious, and influential pictures were heroic treatments of more recent historical events, such as *The Death of General Wolfe*, commemorating the English general's victory over the French at Quebec, in 1759, and *William Penn's Treaty with the Indians*. Deviating from Neoclassicism, West put his "actors" in contemporary dress, but at the same time he invested both scenes with the classical virtues of nobility, stoicism, and grandeur. Indeed, West's art is revolutionary in this merging of classical moral concepts with elements from contemporary life.

8. Wampum Belt

West wrote that "by possessing the real dresses of the Indians, I was able to give that truth in representing their costumes which is so evident in the picture."[15] Yet despite the artist's claims to authenticity, West's biographers point out a number of inaccuracies in the picture: Penn is made to look too old; his Quaker dress is from the eighteenth rather than the seventeenth century; and, in 1682, there were fewer buildings at Shackamaxon (an Indian community near present-day Philadelphia).[16] For Penn's portrait, West had turned to a likeness carved on an ivory medallion by Silvinius Bevan, made when Penn was an old man. He has even included a vestige from his earlier composition *The Death of General Wolfe,* the seated "Mohawk" warrior posed in reverse.

While the Indian clothing in West's picture seems authentic, it combines the styles of several tribes—Delaware, Iroquois, and northern Algonquian. From the Penn family and Matthew Clarkson of Philadelphia, West borrowed an assortment of Eastern Woodland and Eastern Plains costumes and artifacts that included headgear, weapons, pipes and pipe stems, skin pouches, and possibly an embroidered trade-cloth robe, shown here on the nursing mother.[17] Several of the Indian men wear classical attire, but more appropriate male dress in warm weather would have been a simple breechcloth about the waist; and although dyed feathers in a headband approximate Woodlands head adornment, the horned bonnet on the Indian man in the background is more characteristic of the Eastern Great Plains than of the Woodlands. Atypical, too, is the small amount of decoration on the Indian costumes, since dyed porcupine quills and glass beads usually adorned clothing and other paraphernalia. One important artifact that West did not include in his painting is a wampum belt, customarily offered at the ratification of a treaty. Indeed, Granville Penn gave the Historical Society of Pennsylvania such a belt in 1857—The Great Treaty Wampum Belt—and Pennsylvania Quaker tradition associates it with the 1682 treaty at Shackamaxon (plate 8).

Wampum, an abbreviated form of *wampumpeage,* a New England Algonquian word for a string of white shell beads, gained popular usage in colonial America during the seventeenth century. The word wampum came to include dark purple or "black" shell beads, which the Indians once distinguished from the white beads. White shell beads have been used in the Northeastern Woodlands for over fifteen hundred years, but the purple beads came into use at the time of European contact. Fashioned in the traditional bead-weaving pattern, the Great Treaty Wampum Belt is composed of white and purple clamshell broken into rough triangular beads and attached to leather thongs with linen thread. White wampum beads were made from the central column of the whelk (*Buccinum undatum*) and the

purple beads from the quahog clam (*Mercenaria mercenaria*). Among the Northeastern Woodland Indians white shell was a metaphor for light and life, and in social rituals, such as treaties, for consensus, harmony, and peace. Purple bead strings and belts connoted death and mourning, and by the mid-eighteenth century other matters of grave importance as well. The arrangement of the beads in a wampum belt guaranteed the authority and validity of its message. The white field denotes a social context and connotes a peaceful message, while the figurative pictographs of purple beads carry the specific meaning. Indian and Euroamerican meet hand in hand—a convention for friendship, agreement, and covenant. More variable in meaning, the purple obliques in this context probably are mnemonic devices for the specific terms or articles of agreement. As ritual covenants, wampum belts required periodic "repolishing."

The meeting between Penn and the Delaware tribes, under a great elm at Shackamaxon, to sign a treaty of mutual consideration and peace, probably did not happen as West pictured it, and most scholars today view this work as an allegory of colonial America. West's picture has a fascinating history but problematic historical accuracy. In late 1770 or early 1771, when Thomas Penn (1703–1775) commissioned this work to memorialize his father's peace treaty with the Delaware Indians (1682), the French and Indian War had recently been terminated with a somewhat parallel treaty. Certainly, the picture's real meaning lies beyond any legend. Multilayered, the painting suggests the succession of Indian treaties and the nature of Thomas Penn's political leadership during the eighteenth century, when he was the leading property owner in the colony and its liaison with the home government in England. Friction over elections, Indian raids, land transactions, and even the campaign against the proprietary government seemed to have subsided. Thomas Penn was proclaiming that merchants, Quakers, and Indians now could live in harmony. Thus West's painting celebrates the return of peace and the authority of the Penn family.

Although William Penn had negotiated various agreements with the Indians, primarily for land purchases, documentation is lacking for the treaty depicted by West.[18] The first account of the event was published in Thomas Clarke's *Memoirs of the Private and Public Life of William Penn* (1813), and this closely follows West's narrative, suggesting that West's painting was Clarke's precedent. Several leading historians, however, view Penn's treaty as a probable historical fact. Francis Jennings, for example, states that "although the 1701 document is Penn's only political treaty to have survived, it is apparent that he had negotiated an earlier one with the Delawares, having much the same terms."[19] Similarly, C. A. Weslager states that "after reviewing the evidence I see no reason to doubt that Penn held such a treaty, either in 1682 or early in 1683, to establish a league of peace with the Delawares not necessarily connected to any land purchases. . . . If as tradition has it, the chief Tamany was one of the spokesmen on this occasion, it can be assumed that among those attending were members of the Delaware band with whom Tamany was affiliated."[20]

West himself strongly believed that the event took place, probably because of family accounts and local tradition: "The leading characters which make that composition are Friends and Indians—the characteristicks of both have been known to me from my early life—but to give

that Identity which was necessary in such a novel subject, I had recourse to many persons then living for that Identity—and among that number was my honoured Father and his eldest son, my half Brother, Thos. West."[21] Whether the agreement is fact or legend, *Penn's Treaty* alludes to peace and colonial harmony under the judicious protection of William Penn and his heirs, symbolized by kneeling merchants offering their wares to the Indians in an idyllic setting. Trade as well as friendship flourish as Quakers, merchants, and Indians gather. West links the two opposing groups with Penn's outstretched arms.

Like West, John Vanderlyn (see plate 9) and Charles Wimar (see plate 11) also painted subjects deeply rooted in the collision of two very different cultures, the native American and the dominant European. As a result of this collision, heavily dramatized, often lurid, tales of hardship and death at the hands of Indians became increasingly popular in the early nineteenth century, stories in which the Indian was the implacable enemy of the white man. The captivity narrative, relating the capture of white men, women, or children by Indians, often followed by torture, enslavement, death, or escape, has been part of our heritage in literature and art, even into recent times. Ultimately, these stories were used to help justify the destruction of native cultures and the expropriation of Indian lands, and from the seventeenth century as moralizing tales in children's readers.

One cannot view *The Death of Jane McCrea* (1804) by John Vanderlyn (1775–1852) without considering these attitudes. Feeding this body of fiction were actual events, and among the events of the Revolutionary War few proved more poignant and adaptable to popular modes of expression than the attack on Jane McCrea, a young New England woman who was killed by Mohawk warriors when she ventured beyond the safe confines of Fort Edwards, near Albany, New York, on July 27, 1777. At one level, the picture is a propaganda statement, at once anti-British and anti-Indian. It is anti-British because most Mohawk sided with England during the Revolutionary War, although at least two Mohawk communities, at Canajoharie and at Fort Hunter, New York, remained in the Mohawk Valley after the war began, forsaking their fellow tribesmen who fled to Canada and served under the British general Burgoyne. Ironically, after Burgoyne's victory at Oriskany, American troops with their Oneida Indian allies plundered the neutral towns of Canajoharie and Fort Hunter. Indeed, American attitudes at the time were extremely harsh toward most Iroquois-speakers, including the Mohawk, as a result of the war and almost a hundred years of intermittent competition for the resources of upstate New York.

The Mohawk, along with the Oneida, Onondaga, Cayuga, and Seneca, are Iroquois-speakers who once comprised the Five Nations of New York. After 1722 or 1723, the Tuscarora formally joined the confederacy, enlarging it to Six Nations. The Iroquois compared their confederacy, extending from the Hudson River to Lake Erie, to a "longhouse compartmented by tribes," tribes that once warred among themselves, until the Great Peace, or the Confederacy of the Iroquois, in the late sixteenth century.

Like other Woodland tribes, the Iroquois governed by a council of tribal chiefs. Throughout the Northeast, civil chiefs, or sachems, were assigned to the council by clan, while other council chiefs derived their standing from achievement in war or in council oratory (see Red Jacket, pp. 38–

9. John Vanderlyn, *The Death of Jane McCrea.* 1804

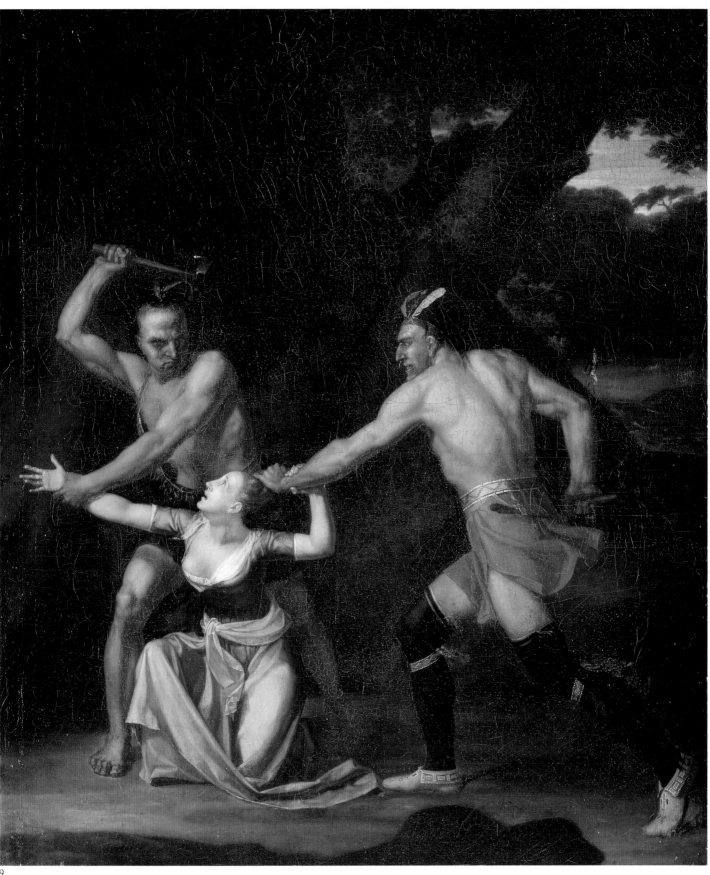

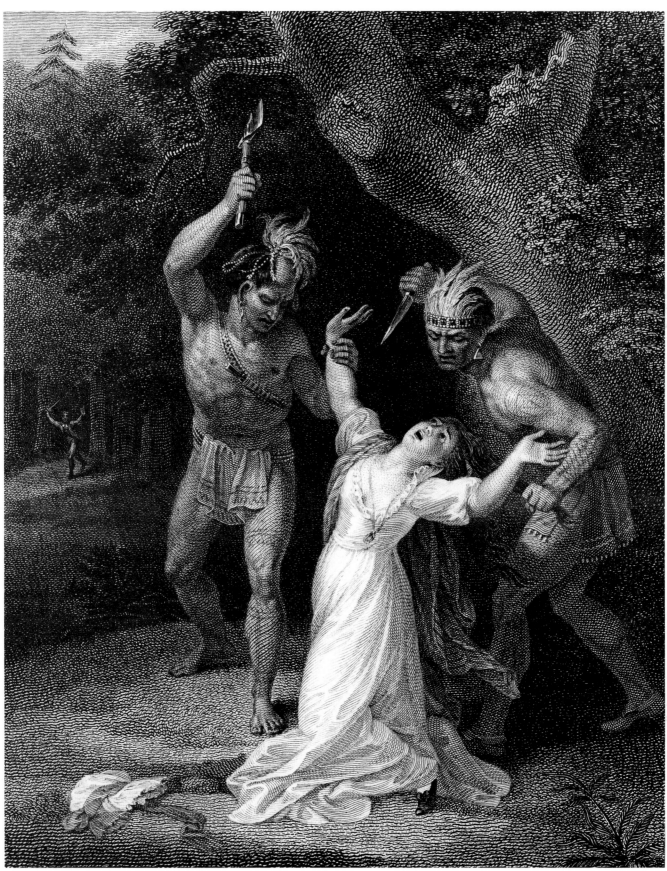

42). Traditionally, the Iroquois were village-dwelling agriculturalists who lived in multifamily longhouses. Each gable-roofed dwelling was from fifty to seventy-five feet long and was built of elm bark sheets lashed to stout poles. Each housed fifty or sixty people in partitioned nuclear-family apartments, and each of several fires placed within the structure was shared by two families. Iroquois women practiced slash-and-burn agriculture near the villages, and the primary crop was corn. Seasonally, the men fished and hunted deer, bear, and smaller mammals for food and pelts. As the easternmost Iroquois tribe, the Mohawk made good use of the strategic Iroquois position in the fur trade, becoming middlemen between Iroquois tribes to the west and European competitors for the furs.

John Vanderlyn's *Death of Jane McCrea* began as an unfulfilled commission to illustrate an episode in the *Columbiad* (1807), an epic poem by the Connecticut patriot and satirist Joel Barlow. In the final version of his book, Barlow disguised Jane's story with a more romantic title, *The Murder of Lucinda,* choosing the English painter-engraver Robert Smirke (plate 10) to illustrate his text. Smirke's maudlin image became the principal source for later representations of the event.

Smirke was the third artist commissioned by Barlow to illustrate his poem. Even before Barlow approached Vanderlyn, in 1802, he had asked the artist-inventor Robert Fulton to do the illustrations, but unfortunately Fulton's drawings are missing today. Barlow's epic probably inspired Vanderlyn's interpretation of the event, which in turn may have been the source for Smirke's imagery. Both show an Indian wielding an ax on the victim's right; a second, menacing Indian on her left; and a large, leafy, background tree. The precedence of Vanderlyn's treatment is further supported by the fact that he came from upstate New York and was the only one of the three artists who had actually seen a Mohawk Indian.

10. Robert Smirke, *The Murder of Lucinda.* 1807

The story of Jane McCrea was compelling not only to Americans but to the French and English as well, and it was recounted in poetry, engraving, lithography, and painting for more than a century after the Revolution. Despite the well-published fact that several Indians participated in the grisly murder, numerous later representations usually follow Barlow's popular storyline and include only two Indians. And the three figures usually are arranged in the grand style, like a classical frieze, as they are in Vanderlyn's *Death of Jane McCrea.* In the distance, Jane's fiancé is coming to her rescue, wearing the blue jacket of the American army, even though he served as one of Burgoyne's soldiers. Vanderlyn has combined moral propaganda—virtue crushed by evil—with Neoclassical drawing, smooth textures, and dramatic lighting. More appreciated today than it was in its own time, the painting is considered the best of the many representations of this incident.

As America's frontiers expanded westward during the eighteenth century, the warfare and killings that resulted from the encounters of whites and Indians continued unabated. Another of these encounters occurred in the Cumberland Valley of Kentucky, where, in 1775, the pioneer and culture hero Daniel Boone, with a company of men, wrested lands from the native Cherokee and Shawnee Indians to found the settlement of Boonesborough for themselves and their families. Within a year, another violent incident took place, the abduction of Boone's daughter by Indians.[22] On Sunday, July 14, 1776, three teen-age girls, Betsey Callaway,

her sister Frances, and Jemima Boone were kidnapped by five Indians near Boonesborough.

Although there is disagreement about the exact circumstances surrounding their capture, the girls seem to have been on an outing in the settlement's dugout or on a raft, about a quarter mile below the fort, and were swept by the current to the opposite shore, out of sight of Boonesborough. A young Virginian, Nathan Reid, was to have accompanied the girls, but at the time of their departure he was not with them. Boonesborough had reported no trouble with Indians since the beginning of the year, despite its forward position west of the Appalachians. Thus the abduction came as a surprise. The abductors were two Cherokee and three Shawnee warriors, one of whom—the Cherokee Hanging Maw—was known to Jemima. The Indians set off to the north with their captives, who at every opportunity tried to leave signs of their trail, while the captors cleverly covered the evidence of theirs. Two days later, on the afternoon of July 16, the girls' fathers and their party caught up with the group and after a brief skirmish drove off the Indians.

Whatever the motive—a desire to regain lost land, or prevent further incursions on their land, or to hold hostages for ransom—word of the abduction and rescue spread far beyond Boonesborough, helping to advance Daniel Boone's reputation as a woodsman and Indian fighter. The celebrated American writer James Fenimore Cooper later modeled his story of Alice and Cora Munro in *The Last of the Mohicans* (1826) after this abduction episode, and the main character in Cooper's *Leather-Stocking Tales* bears a strong resemblance to Boone.

Hanging Maw, known to his fellow Cherokee as "the Beloved Man of the Northern Division," became one of several chiefs who cooperated with the whites but who nonetheless were little respected by the war-weary or land-hungry frontiersmen. In June 1793, a group of settlers raided Hanging Maw's village, Chota, seeking revenge for the killing of a white friend. Although his wife was killed and his house burned in the raid, Hanging Maw continued to work for peace.

Shawnee language and culture are Central Algonquian. Although the Shawnee are a fragmented people who moved frequently, their homeland was centered in the Cumberland Valley where Boone's party claimed land in 1775. From late prehistory into the twentieth century they have lived in village settlements as agriculturalists and hunters. During summer, from semipermanent villages along rivers, women tended the fields as men hunted nearby. Unlike other Central Algonquians, during winter the Shawnee abandoned their villages to disperse into small family bands; the women made maple sugar and the men hunted extensively for food as well as for skins and furs to use in trade.

Heading a Shawnee pantheon of deities was a supreme being called Our Grandmother, or The Creator, whose companions were her grandson, Cloudy Boy, and a small dog. Annual group ceremonies that invoked agricultural success marked the seasons, but community hunting rituals were not observed because the Shawnee split into family units during the winter hunts. After contact, the Shawnee replaced their bows and arrows with guns, clay pottery with metal pots, and native costume with Europeanized clothing and ornament. Their traditional housing, however,

persisted in the rectangular, single-family wigwam or *wegim*.

From the time of the American Revolution, the Shawnee often joined forces with neighboring tribes, such as the Cherokee, to terrorize white settlers in the Cumberland Valley. The Cherokee were a powerful, detached tribe of the Iroquois-language family who belonged to a centuries-old confederacy, dating at least to their first European contact—with Hernando de Soto in 1540. Cherokee is a corruption of Tsálăgı, or Tsárăgı, which may derive from the Choctaw *chiluk-ki,* "cave people," a reference to the caves prevalent in their Southern Allegheny homeland. The decentralized town government of the Cherokee in the eighteenth century reflected the social organization of the Cherokee Nation, with "Kings" and "Great War Chiefs" representing the White (Peace) and Red (War) groups. Continuous warfare with the colonizers during this period led to a great loss of lives and the ravage of Cherokee villages, until the Treaty of Holston in 1791.

Precisely why the German-American artist Charles Wimar (1828–1862) chose to depict the abduction story of Daniel Boone's daughter (plate 11) is a matter of speculation. Certainly, he meant to comment on the conflict between white civilization and a primitive society. As a child, in the 1840s, Wimar may well have observed Indians when he lived on the outskirts of Saint Louis or in the city itself, which had been a major center of western fur trade for almost a century. There, he was surely exposed to the blood-and-thunder tales of frontier hardships and death at the hands of Indians, stories that must have colored his attitude toward native Americans. And no doubt the boy's vivid imagination also was stirred by the stories of James Fenimore Cooper.

A pupil and assistant to the fresco painter and decorator Leon Pomarede from 1846 to 1851, Wimar left for Düsseldorf to continue his studies in 1852. There, he painted two versions of *The Abduction of Daniel Boone's Daughter,* the first in 1853. In both versions, the idealized figures are mawkish and stiff, attesting to the Düsseldorf School's deficiencies. As he looked for an appropriate pictorial model for his abduction scene, the artist turned quite naturally to the hand-colored lithograph *Capture of the Daughters of D[aniel] Boone and Callaway by the Indians* (plate 12) by Karl Bodmer and Jean-François Millet, published in 1852.[23] Wimar, however, followed neither the prototype nor the event itself closely. Instead, he chose to focus solely on Boone's daughter Jemima. Surrounded by three captors who have pulled her canoe ashore in the backwaters of a wooded area, Jemima wrings her hands in despair. Her pose almost certainly was borrowed from European religious painting, and the statuesque stances of her captors, the backlighting, and the tipi within sight add to the drama. The standing Shawnee is identified by his distinctive headgear, a bonnet of straight-standing feathers, probably eagle and owl, some of them dyed and clipped (plate 13). The bonnet's leather headband is decorated with natural and orange-dyed porcupine quillwork. The Shawnee holds a Leman musket (c. 1840), manufactured by a prominent gunmaker, Henry Eicholtz Leman (1812–1887), in Lancaster, Pennsylvania (plate 14). The barrel of a Leman musket was about thirty-six inches long and its overall length fifty-one inches. Originally, the gun shown here may have been longer, since most of these rifles were shortened for portability and use on horseback.[24]

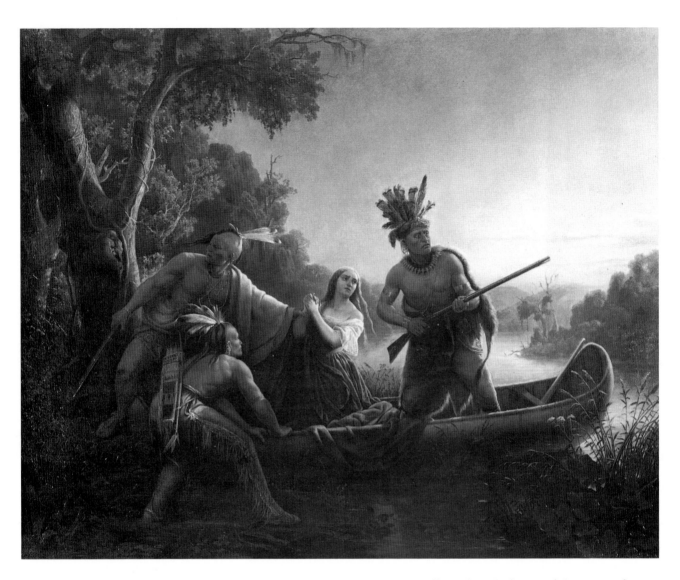

11. Charles Wimar, *The Abduction of Daniel Boone's Daughter by the Indians*. 1853

Typical of many Leman guns as well as other "Indian trade" guns is a dragon ornament that would have been mounted on the stock toward the end of the gun. In the early and mid-nineteenth century, European and North American companies made guns specifically for sale to what was then called "the Indian trade."

Wimar's second version of the abduction of Boone's daughter, painted in 1855, focuses on a raft bearing five Indians and their female captive along the swirling currents of the river, and its implied meaning differs somewhat from that of the 1853 version. The image of a boat, or raft, on water in nineteenth-century Romantic painting can be interpreted metaphorically, although the exact meaning of the motif differs with each context. Traditionally, the boat is identified with man's fate, and the natural universe—water, forest, wilderness—is seen as man's adversary. [25] In Wimar's picture, however, the quiet water and the woods work in concert with the aggressive act of the Indians. The young woman personifies innocence, gentility, and goodness in contrast to the Indians' brutality—the Christian ethos of civilization threatened by savagery. Although both paintings bear the same title, one historian suggests that the later version should be called *Co-*

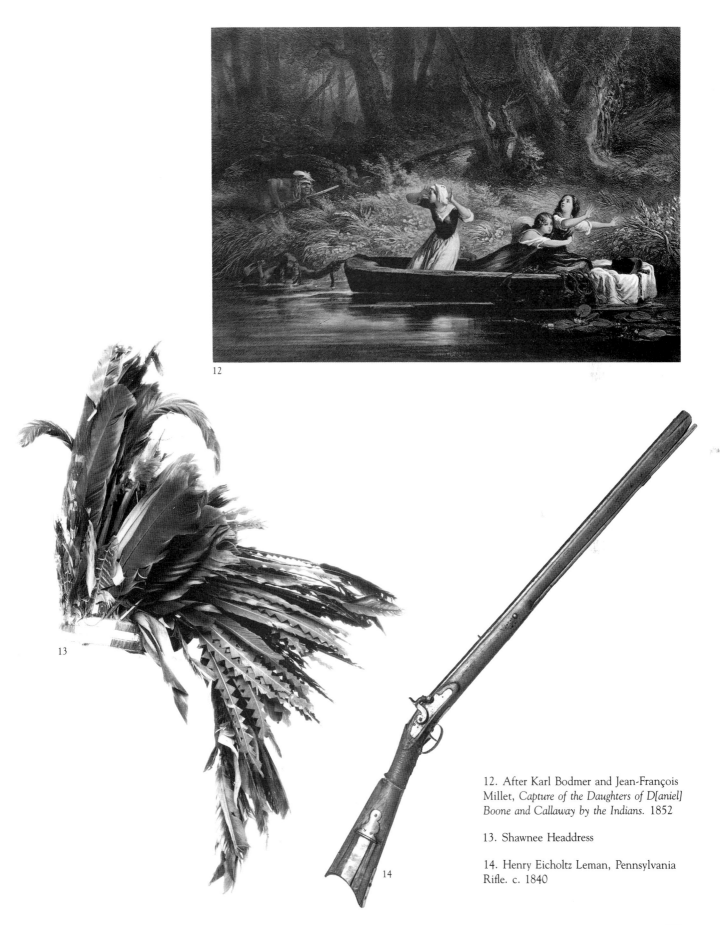

12. After Karl Bodmer and Jean-François Millet, *Capture of the Daughters of D[aniel] Boone and Callaway by the Indians.* 1852

13. Shawnee Headdress

14. Henry Eicholtz Leman, Pennsylvania Rifle. c. 1840

manches carrying off a Captive White Girl from *Ballou's Pictorial Drawing Room Companion.* [26]

Even though Wimar's Düsseldorf paintings betray their studio setting, nine of twelve known canvases are of Indian and western frontier subjects. Impressed by the advice of his former teacher Pomarede, Wimar had launched a career as a painter of the American Indian, with all the storytelling props necessary to appeal to his patrons.

Not all colonists shared the hostile, negative view of the Indian disseminated in American literature and painting. To some writers and artists the Indian's "natural way of life" represented a desirable ideal. This view led to the idealization of the Indian as the noble savage in literature and the visual arts, beginning with the statuesque figures by Theodore de Bry in late-sixteenth-century illustrated books, images repeatedly copied and adapted by other illustrators, both in Europe and in America. In the eighteenth century, full-length portraits of the so-called Four Indian Kings, as English squires *en travestie,* were painted by Anglo-Dutch artist John Verelst. These were Iroquois who visited Queen Anne's court in 1710 to urge England to defend her colonial frontiers. Such grand presentation portraits continued into the nineteenth century. A full-length painting of *Red Jacket,* a widely known Seneca chief, by Robert Weir (1803–1889), is such a portrait.

Red Jacket was one of many chieftains who were portrayed at historic events, such as the signing of a treaty or the creation of an alliance. Two paintings of Red Jacket, one by Weir and the other by John Mix Stanley (plates 15 and 17), exemplify the numerous portrayals of Woodland Indians made in the late eighteenth and early nineteenth century, and these are among the dozen or more known portraits of this Seneca chief. The Seneca were the most populous and powerful of the five tribes that comprised the League of the Iroquois (see p. 30), whose tribal territory stretched from the upper waters of the Allegheny and Susquehanna rivers on the south to Lake Ontario on the north.

In the continuous warfare between the North American Indians and the white man from the time he arrived in America, some tribes aligned themselves with whites against other Indians, even though the political history of America in relation to the native inhabitants has often been interpreted in terms of the clashes between Indians and whites. Recently, however, these conflicts have been interpreted as wars of native resistance, among them King Philip's War (1675–76), Queen Anne's War (1702–13), the French and Indian War (1754–63), the American Revolution (1775–83), and the War of 1812 (1812–14). In each of these conflicts, Indians played substantial roles as allies to non-Indian combatants for reasons quite different from those that caused the whites to take up arms. And from this participation, Indian heroes or antiheroes arose, along with a demand by Europeans and Americans to know more about them. One result of this demand was a spate of biographies, autobiographies, and portraits of American Indians. [27]

Foremost among these Indian heroes was Red Jacket, whose biography by Rev. John Breckenridge is given first place in McKenney and Hall's distinguished three-volume compilation, *History of the Indian Tribes of North America,* first published in 1836. Breckenridge calls Red Jacket "the last of the Senecas," "a perfect Indian in every respect," "the finest specimen of the Indian character." Some of his contemporaries, however, as well as

more recent writers, such as E. L. Hewett and Frederick Dockstader, tempered this uncritical evaluation of Red Jacket by weighing the facts of his life more carefully.

Red Jacket (c. 1756–1830) was born in the village of Canoga in Seneca County, New York. During the first part of his life he was called Otetiani, meaning "prepared" or "ready." With his elevation to chieftain, he became Shagore'watka, now most commonly transliterated Sa-go-ye-wat-ha and translated "He Causes Them to Be Awake." Some biographers suggest that this name refers to his oratorical skills, while others claim that his Wolf Clan affiliation, with its propensity for late-night howling and other wolf-like behavior, prompted him to take this name. His nickname, Red Jacket, resulted from the Iroquois alliance with the British in the Revolutionary War: the chief received his first red coat from a British Army officer. In 1794, at the signing of the Treaty of Canandaigua, an American officer continued the tradition by giving the chief another red jacket. During the American Revolutionary War, Red Jacket apparently did not distinguish himself for bravery. Biographers William L. Stone and Breckenridge agree that Red Jacket, "like his celebrated predecessors in rhetorical fame, Demosthenes and Cicero, better understood how to rouse his countrymen to war than to lead them to victory."[28] Another Seneca leader, Cornplanter, labeled him a coward and nicknamed him "Cow Killer," because Red Jacket was found butchering cattle during a farmhouse raid instead of fighting a war against men. In subsequent warfare, however, Red Jacket redeemed himself by his bravery. Apart from his occasional shortcomings as a warrior, Red Jacket is well known for his efforts to prevent missionaries from working among the Seneca, to retain Indian ownership of land, and to bridge the communication gap between the United States and New York State governments and the Iroquois Nation. In his successes, Red Jacket is thought to have used his oratory (in the Seneca language, not in English) and diplomacy to further Iroquois rights.

Weir received his commission to paint Red Jacket's portrait from a friend, Dr. J. W. Francis, of New York City, whose intent was "to perpetuate the noble character and bearing of the Chief." Writing to the art critic William Dunlap, Dr. Francis described the circumstances:

When he came to New York, in 1828, with his interpreter, . . . he very promptly repaired to the painting-room of Mr. Weir. For this purpose he dressed himself in the costume which he deemed most appropriate to his character, decorated with his brilliant over-covering and belt, his tomahawk and Washington medal. . . . At times he manifested extreme pleasure, as the outlines of the picture were filled up. The drawing of his costume which he seemed to prize, . . . and the distant view of the Falls of Niagara, (scenery nigh his residence at the Reservation) forced him to an indistinct utterance of satisfaction. When his medal appeared complete, he addressed his interpreter, accompanied by striking gestures; and when his noble front was finished, he sprang from his seat with great alacrity, and seizing the artist by the hand, exclaimed, with great energy, "Good! good!"

Red Jacket must have been beyond his seventieth year when the painting was made: he exhibited in his countenance somewhat of the traces of time and trial upon his constitution; he was nevertheless, of a tall and erect form, and walked with a firm gait. . . . His majestic front exhibits an altitude surpassing every other that I have seen of the human skull. As a specimen for

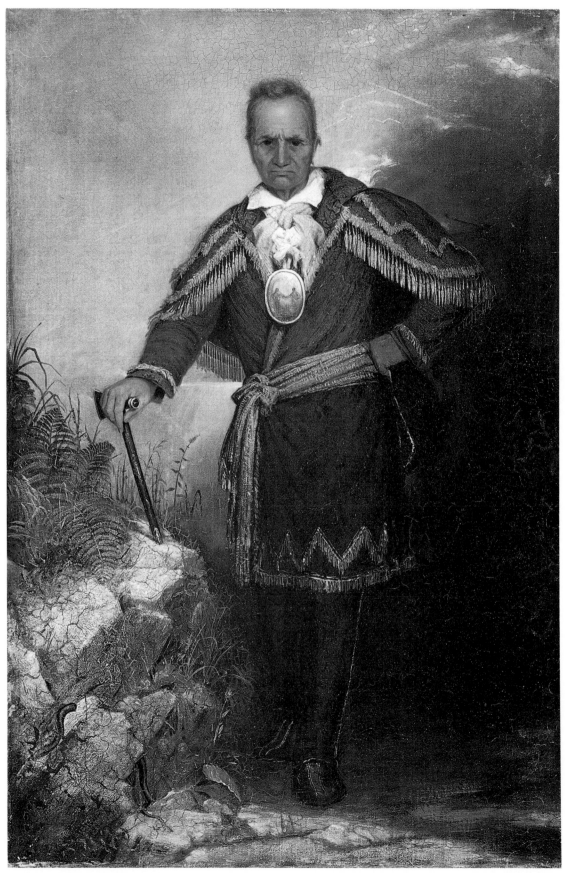

15. Robert Weir, *Red Jacket.* 1828

the craniologist, Red Jacket need not yield his pretensions to those of the most astute philosopher. He affirmed of himself, that he was *born an orator.* [29]

16. Red Jacket's Peace Medal, obverse and reverse. 1792

An engraving after Weir's painting is one of five illustrations for the annual gift book *The Talisman,* and it accompanies Fitz-Greene Halleck's poem "Red Jacket, a Chief of the Tuscaroras [*sic*]; On Looking at his Portrait by Weir in 1830." [30] Red Jacket's prominence and Halleck's tribute gave the illustration a wide audience. The Seneca chief was then being lionized in New York theaters and museums, as he sported the peace medal he had received from President Washington in 1792, when he traveled to the capital (then Philadelphia) with forty-nine other Iroquois chiefs of the Six Nations' delegation. In addition to the engraved silver medal, Washington presented him with a tomahawk and a peace pipe, all symbols of the bond of peace and friendship between the two cultures. From that time on the medal was a conspicuous part of Red Jacket's costume, and it appears in many of his portraits. Red Jacket's medal (see plate 16) differs from the first Washington medal, struck in 1789, which bore the image of a woman. To accommodate the chief's dislike of the earlier image, the medal design of 1792 was changed to show Washington presenting a pipe to an Indian as a symbol of peace and friendship. On the reverse side is the Great Seal of the United States—the eagle with an olive branch in one claw and a bunch of arrows in the other.

In the dozen or more extant portraits of Red Jacket, he most often exhibits a fierce pride and an uncompromising will. The physical frailties of

age often are coupled with a determined expression of intellectual acumen. Represented by these portraitists as a noble, heroic "savage" with all the colorful trappings of that image, he was to be seen as the unyielding spirit of the aged orator, a spokesman for all Indians. Given the classical emphasis of early nineteenth-century American education, comparisons between Red Jacket and orators of ancient Greece or Rome seem quite natural.

After his death, in 1830, interest in Red Jacket continued as a result of the numerous histories and biographies of prominent Indians. More than three decades later, artist John Mix Stanley (1814–1872) dramatized Red Jacket's vivid oratorical skills in his *Trial of Red Jacket* (see plate 17). In about 1801, Red Jacket was tried for witchcraft, a crime punished by death among the Iroquois. His accusers, the Seneca chief Cornplanter and his half-brother Prophet, chose a time when many Iroquois were losing patience with Red Jacket's unwillingness to compromise with the whites, and especially missionaries. Before all the leading Iroquois chiefs, summoned to the banks of Buffalo Creek, Red Jacket's brilliant counterattack on his enemies' faults swayed his jury and gained him acquittal.[31]

Stanley began his painting of Red Jacket in 1863, and completed it five years later. Reportedly, he was inspired by De Witt Clinton's *Discourse Delivered before the New-York Historical Society at their Anniversary meeting, 6th December 1811.* Red Jacket's posture at the center of a group of seventy-two people, his blanket wrapped like a Roman toga, is another allusion to orators from classical antiquity. His face was patterned after the popular portrait (1820–30) of the chief by Charles Bird King, which Stanley most likely knew from C. C. Child's engraving after the original. In Stanley's picture, Red Jacket focuses on his two accusers, pointing toward Cornplanter and turning his face toward the Prophet (Handsome Lake), who stands at the far left. Cornplanter, the son of a Seneca woman and Indian trader John O'Bail, was painted by F. Bartoli (plate 18) shortly after the artist arrived in New York.[32] The white man on the far right of Stanley's painting is identified as Samuel Kirkland, an interpreter and missionary among the Seneca. An area near Buffalo Creek in western New York probably was the source of the landscape background, and the dioramalike setting suggests that engravings were another source. Although the arbitrary spatial relationships among the figures and their incorrect proportions indicate Stanley's difficulty in fitting all the figures into his landscape, the picture toured widely to critical acclaim and was considered the major achievement of his career.

An equally celebrated contemporary of Red Jacket was the Sauk warrior Black Hawk. Born in 1767 at the large village of Saukenuk on the Rock River (now Rock Island, Illinois), Black Hawk (Ma-Ja-Tai-Me-She-Kia-Kick) is said to have taken his first scalp at the age of fifteen in conflicts with Indian tribes to the south. He is best known, however, for his involvement in the so-called Black Hawk War of 1831, which gave him this name and pitted a faction of the Sauk against armed Illinois settlers, militia, and federal troops. Earlier, Black Hawk achieved fame for his alliance with the British against the United States in the War of 1812. Most scholars today refer to the Sauk as the Sauk and Fox (or Sac-and-Fox), but historically the Sauk and the Fox were independent Algonquian-speaking tribes. From 1733 until about 1850, the two tribes were united in an alliance that led the

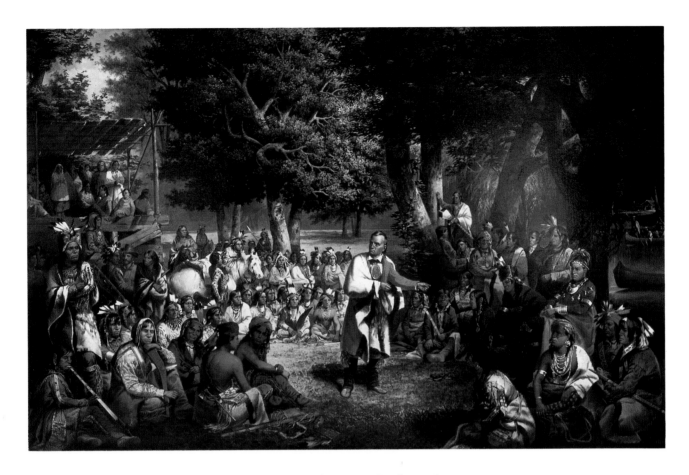

United States government to treat them as a single entity. In the early nineteenth century, the Sauk nation separated into two geographical and political entities. One Sauk group, the Missouri band, led by Keokuk (see p. 52), moved to the west side of the Mississippi River to the present state of Iowa. This group and its Fox allies were designated the Sac-and-Fox of the Missouri, while the Sauk group remaining in Illinois along with its Fox allies, led by Black Hawk, was called the Sac-and-Fox of the Mississippi. In another context, the Missouri groups were known as the American band and those in Illinois the British band. These distinctions refer to the allegiance of Sauk warriors during the War of 1812 but not exactly to the Missouri and Mississippi distinctions. The split was also aggravated by the intertribal dispute over an 1804 treaty in which a group of Sauk and Fox leaders ceded large areas of Wisconsin, Illinois, and Missouri to the United States. Some Sauks claimed that the transaction was invalid, because much smaller territories had been proposed for cession and because the treaty was never ratified by the full tribal council.

Most of the incidents that provoked the Black Hawk War involved white squatters on land traditionally held by the Sauk. In 1828–29, Black Hawk's own village, Saukenuk, was occupied by whites, forcing most of its residents to seek refuge across the Mississippi River in Iowa. In April 1832, Black Hawk led a return to Illinois of the British band then living in Iowa. At first, the battles that ensued with the Illinois militia resulted in Sauk victories and attracted other warriors to join them, but by late July or early August, federal forces joined the fight and Black Hawk was defeated by

17. John Mix Stanley, *The Trial of Red Jacket*. 1863–68

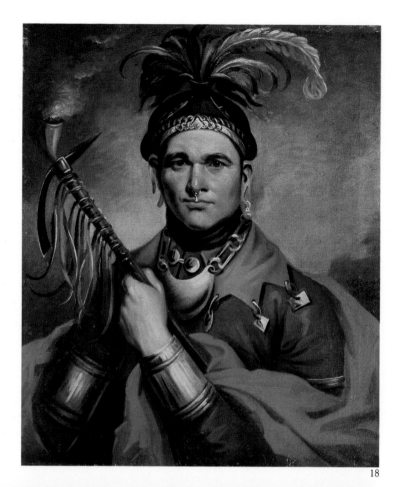

18. F. Bartoli, *Ki-on-twog-ky (Cornplanter)*.
1786 or 1796

19. John Wesley Jarvis (attributed), *Black Hawk and His Son, Whirling Thunder*.
1833

18

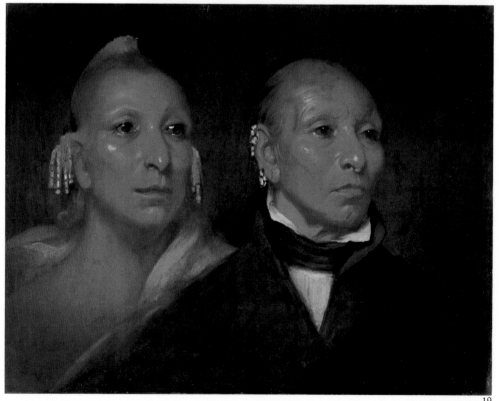

19

Gen. Henry Atkinson. As punishment, all Sauk land in Iowa was confiscated and the British band moved first to Missouri and later to Kansas and Oklahoma reservations. Black Hawk, his two sons, Whirling Thunder and Roaring Thunder, and several of his followers were imprisoned at Jefferson Barracks, south of Saint Louis.

In October 1832, the artist George Catlin portrayed the celebrated chief and his entourage at Jefferson Barracks. Catlin remarked that Black Hawk, whose name "has carried a sort of terror through the country where it has been sounded, has been distinguished as a speaker or councellor [*sic*] rather than as a warrior." A federal official, Thomas Donaldson, also described the prisoners at the time as

> gigantic and symmetrical figures . . . who seemed, as they reclined in native ease and gracefulness, with their half naked bodies exposed to view, rather like statues from some master hand than like beings of a race whom we had heard characterized as degenerate and debased. . . . They were clad in leggings and moccasins of buckskin, and wore blankets, which were thrown around them in the manner of the Roman toga, so as to leave their right arm bare. The youngest among them were painted on their necks with a bright vermilion color, and had their faces transversely streaked with alternate red and black stripes.[33]

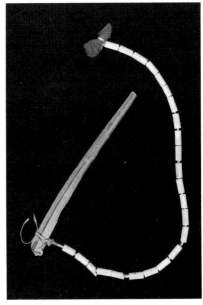

20. Council Invitation Stick. c. 1850

In April 1833, Black Hawk, his son Whirling Thunder, and four followers were moved to another prison in the East. On the way, they stopped in Washington, where they were greeted by President Andrew Jackson. From the White House they were taken to Charles Bird King's studio and picture gallery, where Black Hawk sat for his portrait, clothed in his native costume, which included a deer-crested roach, or headdress, wampum necklaces and ear ornaments (the latter appear in the Jarvis portrait; plate 19), and a peace medal. On April 25, Black Hawk and his party went on to Fort Monroe, Virginia, where they were incarcerated. The Sauk seemed to fare well with minimum restraints at the garrison. Officers' wives gave them presents, and a number of artists sketched and painted their portraits. In addition to the painting attributed to John Wesley Jarvis (1780–1840), portraits of Black Hawk and his son Whirling Thunder were made at Fort Monroe by three other artists: James Weshall Ford and Robert Matthew Sully each painted three, and another was painted by Samuel Brookes.

On President Jackson's order, the group exchanged buckskins for the white man's conventional dress at Fort Monroe. In Jarvis's portrait, Black Hawk wears a white linen shirt, with stock collar tied somewhat lower than usual, and a frock coat of black wool broadcloth, the universal costume for whites during the second half of the nineteenth century.[34] Yet his pierced ears still hold the wampum ear ornaments, depicted in the Catlin and King portraits. For unknown reasons, his son is represented in native costume with elaborate wampum ear ornaments. Shell wampum beads were used in many ways by the Woodland Indians—in addition to their well-known but nontraditional value as "money" (see plate 20). As a metaphor for the continuity of life, ritual strings of wampum beads offered consolation during mourning, wampum belts sealed treaties (see p. 28), and wampum ear ornaments were treasured personal belongings, accumulated and retained throughout a lifetime. Ear decoration began with perforations or

sometimes cuts in the ear to accommodate the ornaments. In the Jarvis portrait, Black Hawk and Whirling Thunder wear ear pendants of white wampum beads suspended from perforations just inside the rim of the ear. The beads usually were strung on vegetal fiber, often the inner bark of softwood trees.

Beginning in 1811, Jarvis, a New York portraitist, spent his winters in the South. In spring 1833, he was working in a studio he had established in Savannah, Georgia, and conceivably he traveled to Fort Monroe to portray Black Hawk and his son. Unfortunately, the portrait is unsigned and the disappearance of Jarvis's late work (1825 to 1840) rules out stylistic confirmation for his authorship of this portrait.[35] Some scholars believe that this finely crafted picture equals in quality some of Jarvis's major early works. His late work is known to us only from William Dunlap's critical biography, which relates their unevenness to Jarvis's personality and penchants. The artist, reputedly, was a raconteur, a man-about-town, and an alcoholic.

Before the Indian prisoners were returned to the Midwest by Secretary of War Lewis Cass, he sent them on a "rehabilitation" tour of military facilities and public buildings along the Eastern Seaboard. Today, Black Hawk is known from biographies and from the portrait images by Ford, Sully, Brookes, and Jarvis. Sometimes he is seen as a sad figure, struggling to repress the emotions of a vanquished chieftain, but in the portrait attributed to Jarvis he exhibits a proud, dignified countenance.

One of the most deleterious effects of colonialism in North America was the displacement and dispossession of Indians from their land through forced concessions and calculated deception. A similar but far less harmful process occurred among the Indians themselves as stronger groups pushed aside weaker ones. These movements of tribal groups are critical to an understanding of their changing lifeways. When the Algonquian-speaking Kickapoo were first encountered by Europeans, in 1600, the tribe resided in lower Michigan between Lake Michigan and Lake Erie. Fifty years later, the French found them on the southern shores of Lake Superior and on the banks of the Fox River, near present-day Green Bay, Wisconsin. This westward movement resulted primarily from conflict with the Iroquois Confederacy, whose power had increased substantially after they acquired firearms from British and Dutch settlers in New York and New England.

In their new location, the Kickapoo came into conflict with Siouan-speakers who caused them to move still farther southward in the eighteenth century, to what is today eastern Iowa and northern Missouri, adjacent to the Mississippi River. Throughout much of that century the Kickapoo were eagerly sought as allies by British and American agents, most notably by George Rogers Clark, who, with Illinois and Wabash Kickapoo assistance, captured Fort Vincennes in December 1778. In all of their European and American alliances the Kickapoo distinguished themselves by the fierceness and independence of their warriors.

Again, during the peace that followed the American Revolutionary War, the Kickapoo along with numerous other tribes (Miami, Potawatomi, Wea, etc.) became obstacles to American settlement of what was then the Northwest Territory. Former soldiers in the Continental Army were now land-seeking settlers, holding warrants that entitled them to land once claimed by the easternmost Kickapoo. The American pressure for land

drove the Kickapoo both to resettlement and to alliances with the British in the western Great Lakes and with the Spanish in the Louisiana Territory.

The United States purchase of the Louisiana Territory in 1803 and the British defeat in the War of 1812, in which the Kickapoo sided with England, brought American military and political power directly against the Kickapoo. And the overall American policy of resettling Indian tribes west of the Mississippi River shifted some Kickapoo groups to western Missouri and eastern Kansas. Still others sought refuge in Mexican territory, in what today is Oklahoma and Texas. Here the struggle for Texan independence (1835) gave the Kickapoo another political entity to battle—the Republic of Texas. Eventually, American pressure to consolidate its Indian population in an Oklahoma Indian Territory and Texas's struggle to prevent an Indian-Mexican alliance aimed at regaining Mexico's lost territory led to the settlement of the Kickapoo in both Oklahoma and Mexico.

This odyssey is reflected in a painting by August Schoefft (1809–1888), *Six Kickapoo Indians, Chief and Family* (plate 21). Schoefft was a Hungarian portrait painter who had traveled widely in Europe and the Middle East before he came to North America for two years, from 1864 to 1866. Few details of his North American visit are known apart from his surviving works and a listing in the New York City Directory in 1864. There are at least two likely places where Schoefft might have encountered the Kickapoo group he portrayed. In 1865, when Schoefft was painting a portrait of the Emperor Maximilian in Mexico City, a delegation of Kickapoo arrived in the capital to present a claim for land in the northern border state of Coahuila. A local reporter for the *Illustrated London News* noted the group's arrival on March 11, 1865:

> The streets of Mexico have been rendered more than ordinarily interesting by the presence of about twenty wild Kickapoos, who inhabit the district of Santa Rosa, sixty leagues to the north of Saltillo, near the Rio Bravo del Norte. . . . Draped in their red or blue blankets, their heads covered with ornaments composed of the feathers of birds of prey, marten fur, ribbon, and glass, they walked hurriedly, without betraying astonishment at what they saw. . . . The total absence of their weapons deprived them of a part of their naturally warlike appearance. The chief who . . . [is] very old . . . wears suspended from his neck, as a sign of superiority, a large silver plate, upon which is engraved the picture of a jaguar, and a medal bearing the effigy of Louis XV.[36]

The Kickapoo embassy portrayed by Schoefft also caught the eye of French artist-illustrator Jean-Adolphe Beaucé (1818–1875), who gave the reporter the description and the engraved illustration for the *News* article (plate 22). Beaucé had come to Mexico with the French army as a military chronicler. Although both Beaucé and Schoefft (in his two known versions of the subject) include similar details of locale and costume, the two men's approaches vary considerably. Schoefft, who left no itinerary of his American journey, may even have encountered this group of Kickapoo Indians in Coahuila, Texas, or Oklahoma, but it seems more likely that both artists observed them in Mexico City. Schoefft's addition of Spanish moss to the oak trees may be a Gulf Coast embellishment.

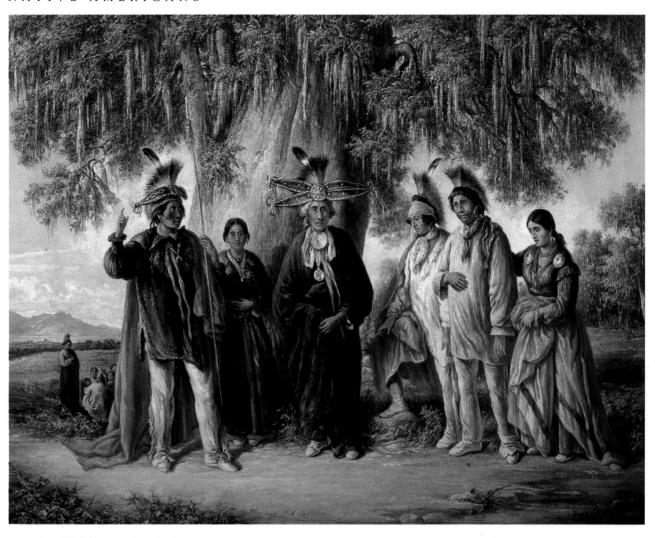

21. August Schoefft, *Six Kickapoo Indians, Chief and Family.* c. 1865

The costumes worn by the Kickapoo seem to represent two or more periods of their history: they wear modified, traditional Indian garb of the Eastern Woodland/Great Lakes region. The roach headgear of the two warriors on the right suggests an earlier Eastern and Northern Woodland style, while the more elaborate headgear of the two on the left suggests a later adaptation to Central Woodland headdress. These soaring caps of otter or marten skins have affixed "wings," or extensions of animal tails (Beaucé described the material), made rigid either by tanning or by inserting sticks as stiffeners. The commercial cloth overshirts worn by the men are like those of frontiersmen, but these are not tucked in as white fashion dictated, and the Kickapoo retain their native buckskin leggings and moccasins. The women wear "Prairie" style dresses, cotton garments like those of pioneer women of the early 1840s. Absent on the woman to the right is the fashionable bertha, worn by white women during the day to conceal a low-cut bodice. Both women are uncorseted, and the older one seems to be wearing a red wool petticoat.[37]

Although the women's costumes are essentially derived from white fashion, an obvious exception is the addition of ornamental German-silver brooches like those worn by the younger woman (see plate 23). As Europeans began to explore and colonize North America, they presented gifts of

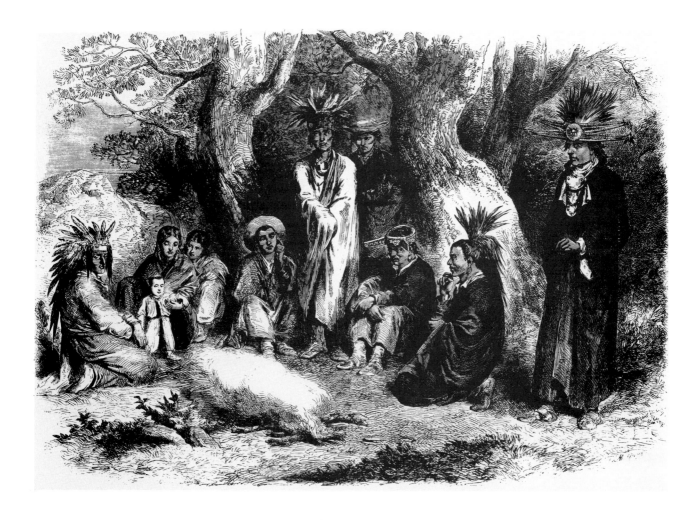

silver to the Indians on special occasions. Medals were among the earliest silver gifts, and silver coins the main source of this metal in eighteenth-century North America. Coin silver is made more durable by adding various alloys, commonly nickel or copper. Often, silver coins were melted down and reshaped into many types of silver objects used in the fur trade. Some of the trade ornaments, however, such as brooches, were produced by hammering coins into wafer-thin disks from which shapes were cut. The old chief in the center of Schoefft's painting wears a small medal, similar to the one worn by the chief on the far right of Beaucé's woodcut. Historic data as well as fieldwork of the 1960s among the Kickapoo suggest that the chief's medal may well be the portrait medal of Maximilian given to the Kickapoo by the Austrian Emperor of Mexico.

With the consolidation of Southeastern Woodlands and Eastern Plains tribes in the Indian Territory of Oklahoma there was considerable cultural exchange, especially of clothing. As tribal styles were exchanged, distinctive native products, such as tanned leather, gave way to commercial trade goods, including broadcloth, buttons, ribbons, and manufactured hats (see plate 24).

Following a precedent of the English colonizers, the United States continued the practice of negotiating treaties with Indian tribes. Touring

22. Jean-Adolphe Beaucé, *Embassy of Kickapoo Indians to the Emperor of Mexico.* 1865

23. Brooch

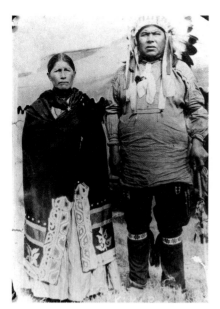

24. *Kickapoo, Oklahoma.* c. 1900

tribal delegations through military installations to impress them with the might and power of the United States military was an educational effort designed to "restrain their warlike propensities" (see Black Hawk, p. 46). The English custom of portraying these chiefly visits in paintings was copied as well, both officially and unofficially. During the rapid expansion of frontiers in the 1820s and 1830s, there were numerous negotiations with Indian delegations in Washington. On one of these visits, in 1824, Washington artist Charles Bird King (1785–1862) first painted the Sauk chief Keokuk (plate 25), who had come with a delegation of Sauk and Fox, Iowa, and Piankashaw leaders.

From 1821 to 1842, King's studio-picture gallery on Twelfth Street (between E and F streets) was the setting for some of the century's most important pictorial documentation of the American Indian. During that time King painted about one hundred Indian visitors to Washington, and for the Department of War he copied a collection of Indian portraits that were painted in the West by James Otto Lewis during treaty councils. Although most of King's sitters posed in his Washington studio, in almost every case they are wearing their tribal costumes and body paint. The artist tended to invest his subjects with a "stoical courage and calm nobility that was part of the nineteenth century's idealization of the vanishing red man."[38]

After King had portrayed Keokuk, the artist followed his custom of giving his sitter a small rendering of his portrait to take home as a souvenir of the visit. Keokuk's portrait, like many painted by King, later was replicated several times by the artist. The image illustrated is a copy, made in 1827, after the commissioned work of 1824. In copying his portraits, King traced their basic outlines from his preliminary charcoal drawings with a stylus and then transferred them to canvas.[39] King's fidelity to his sitter can be seen in the portrait's resemblance to a daguerreotype made twenty years later when Keokuk was an old man (plate 26). One striking difference from the painting is that in the daguerreotype Keokuk wears a grizzly-bear-claw necklace (plate 27), a tribal symbol of manhood and bravery. When his portrait was painted in 1824, Keokuk may have rejected the necklace's symbolism and then espoused it again in his later years.

Like other Indian leaders, Keokuk was portrayed repeatedly during the nineteenth century. George Catlin, Peter Rindisbacher, and James Otto Lewis all did portraits of the Sauk leader. Lewis sketched him at Prairie du Chien, in 1825, when Keokuk met with the explorer William Clark and then Secretary of State Lewis Cass, who were negotiating a treaty for the United States government with the Dakota, Chippewa, and Sauk and Fox. In his *Personal Memoirs,* Henry Rowe Schoolcraft, who had joined the Cass party, shared his impressions of the chief and his warriors:

> Many of the warriors had a long tuft of red-horse hair tied at their elbows, and bore a necklace of grizzly bears' claws. . . . Their leader [Keokuk] stood as a prince, majestic and frowning. The wild, native pride of man, in the savage state, flushed by success in war, and confident in the strength of his arm, was never so fully depicted to my eyes.
>
> Their martial bearing, their high tone, and whole behavior during their stay, in and out of council, was impressive. . . . Keokuk, who led them, stood with his war lance, high crest of feathers, and daring eye, like another

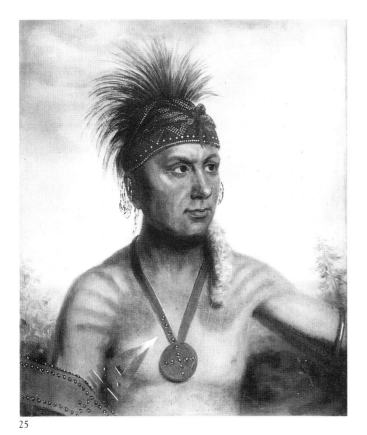

25

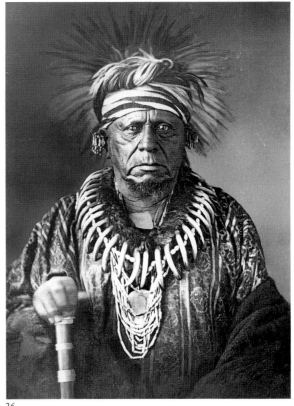

26

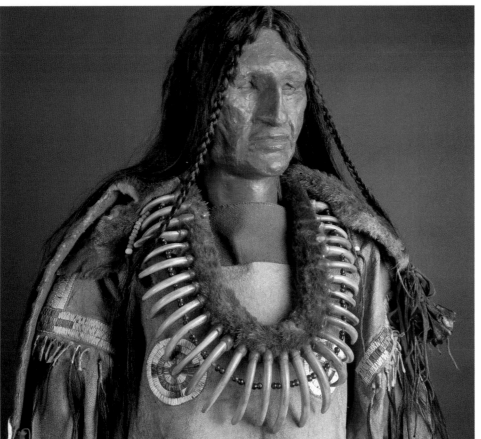

27

25. Charles Bird King, *Keokuk, Sac (Watchful Fox)*. 1827

26. Antonio Zeno Schindler, after Thomas Easterly, *Keokuk, Sac (Watchful Fox)*. 1847

27. Necklace

51

Coriolanus, and when he spoke in council, and at the same time shook his lance at his enemies, the Sioux, it was evident that he wanted but an opportunity to make their blood flow like water.[40]

Some later biographers saw Keokuk in a less favorable light. William Jones of the Field Museum wrote in the *Handbook of American Indians North of Mexico* that "Keokuk was continually involved in intrigue" to advance his political ambitions within the tribe. Keokuk indeed schemed, but primarily to manipulate a rigid social system that restricted political leadership to another Sauk and Fox clan. Ineligible by birth for political office, despite his ability to lead his own tribe, according to some historians Keokuk manipulated tribal factions to break this tradition. His reputation was seriously damaged, too, among those Sauk and Fox tribesmen who participated in the Black Hawk War of 1831–32, in which they tried to overturn the provisions of an 1804 treaty deeding Sauk and Fox land east of the Mississippi River to whites. Keokuk had previously acquiesced to the terms of that treaty, when he and his allies moved their villages to present-day Iowa.

Keokuk's standing within his tribe was redeemed by his eloquent defense of Sauk and Fox land from Sioux claims in Washington on October 5, 1837. At a government-sponsored council to settle land disputes, just after a Sioux leader had placed four sticks on the conference table to demonstrate four recent violations by the Sauk and Fox of Dakota territory, Keokuk is said to have responded: "I have told you that it would be useless to count up all their aggressions; that it would take several days to cut sticks. They boast of having kept quiet because you told them not to strike. Since the treaty [of 1825] was made they have come upon our lands and killed our men. We did not avenge ourselves, because we had given a pledge not to go on their land."[41] Keokuk's diplomacy helped to establish Sauk and Fox claims to land in Iowa, and some of this land continues to be held today by his tribal descendants. By not participating in the Black Hawk War and by moving west of the Mississippi when he did, Keokuk may have strengthened the Sauk and Fox claims to their Iowa land holdings; and on Keokuk's death, in 1848, his son Moses Keokuk, who held the same clan affiliation as his father, was made chief of the tribe.

Today most historians refer to the Great Lakes region west of Pittsburgh and north of the Ohio River as the Old Northwest, an area that was once the northwestern part of a much smaller United States. The region was fiercely contested during the French and Indian War and the American Revolution. After the Revolution it became a melting pot of northern and eastern tribes—remnants of the Iroquois League mingled with Sauk, Fox, and Menominee, along with many others in the area.

Central Algonquian-speakers, the precontact Menominee were hunters and gatherers living seminomadically in a vaguely defined area of northern Michigan and Wisconsin. In dugouts and birchbark canoes, they obtained the region's plentiful sturgeon and wild rice, and they grew squash, beans, and corn in small gardens. Except for occasional large deer or buffalo hunts, hunting was a solitary activity or engaged in by small, congenial parties. Hunting rituals dedicated to guardian spirits and supernatural powers continued well into this century. Menominee women who fished, hunted,

or raced like men were highly respected and actively engaged in these pursuits. Certain animals were revered, such as the bear, who was believed to be man's first ancestor. Tales and myths, formally recounted by a respected male elder, taught Menominee children how to live, and constraint and self-control were consistent themes. From the age of seven or eight, Menominee boys were exposed to physical rigors, such as breaking the ice to bathe in an icy cold lake or river and then rolling in the snow. In addition to their roles as hunters, fishermen, and warriors, Menominee men performed ceremonies that invoked the help of supernatural powers, prepared sacred artifacts, and made canoes, weapons, and tools.

The earliest recorded contact with the Menominee was by the French fur trader Nicolas Perrot around 1667. After the arrival of French fur traders the village pattern of the Menominee disintegrated, and the tribe broke up into roving bands for the express purpose of trapping furs. Encouraged by the French to charge large amounts of supplies at the French trading posts in the summer with the promise of repayment in furs during the winter, the Indians assumed the roles of debtors. Thus their extended family groups split into roving bands of smaller families. As allies of the French, however, the Indians prospered. In 1761 the English arrived and eventually gained the support of the Menominee. In 1815 the tribe came under the control of the Americans. Menominee lands passed continuously into the hands of whites from 1830 to 1852. During this time, the Menominee were transferred from their settlement at Poygan Lake and in the Fox and Wolf river valleys to a reservation on the Upper Wolf River.

In Wisconsin, a contemporary of artist Paul Kane (see pp. 146–47), the portrait and still-life painter Samuel Marsden Brookes (1816–1892) painted the distinguished Menominee chief Oshkosh (see plate 28). Oshkosh was born in 1795 at Old King Village on the Menominee River in north-central Wisconsin. Chieftainship was hereditary, but Oshkosh was also favored as a young man by his grandfather, Chief Tomah, who took him to important council fires as well as to war. It is generally thought that at age seventeen he and other allies participated with the British in the capture of Fort Michilimackinac in Michigan. At that battle in July 1812 and again in 1813 at the unsuccessful attack on Fort Sandusky, Oshkosh achieved warrior status. By 1821 he was a leader of the tribe's Bear Clan and in an 1824 census a chief of a large group of Menominee living along the Wisconsin River. In 1827, Oshkosh and other Menominee warriors served in the United States Army in a campaign against marauding Winnebagos. That same year Lewis Cass, who was then governor of the Territory of Michigan, declared Oshkosh the principal chief of the Menominee at the Treaty of Butte des Morts on the Fox River. According to Paul Kane this position was contested in 1845: "when Oscosh [sic] aspired to the dignity of head chief, his election was opposed in the council by another chief, who insisted on contesting the post of honour with him. Oscosh replied, that as there could only be one head chief, he was quite willing on the instant to settle the dispute with their knives by the destruction of one or the other. This proposal was declined, and his claim has never since been disputed."[42] Other contemporary accounts present a confusing picture of Oshkosh's character, particularly regarding his lack of concern over whiskey traders among the Menominee. It seems that liquor also played a role in his own

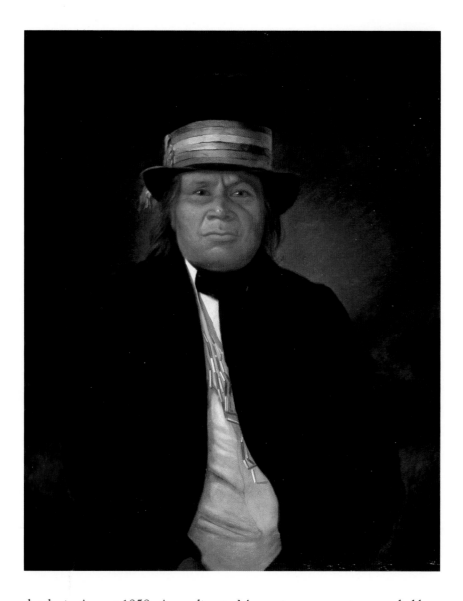

28. Samuel Marsden Brookes, *Chief Oshkosh*. 1858

death, in August 1858. According to Menominee accounts, recorded by a white Indian agent, Oshkosh and his two sons became drunk and an argument ensued that led to the chief's death from a beating inflicted on him by his sons.

Two written accounts from the 1840s supply still other pictures of Oshkosh. The first, by Paul Kane, dated 1845, is laudatory:

I attended a council of the Menominees on the Fox River, at which there were 3,000 Indians invited by head chief, Oscosh [*sic*], Bravest of the Brave. . . . He opened the council by lighting a pipe, and handing it to all present, each person taking a whiff or two, and passing it to the next. . . . After this ceremony the main business of the council began: it almost exclusively consisted of complaints to be forwarded to the Government.

After several of the minor chiefs had delivered their sentiments Oscosh himself rose, and spoke for about an hour, and a finer flow of native eloquence—seasoned with a good sense—I never heard, than proceeded from the lips of this untutored savage. Although a small man, his appearance, while speaking, possessed dignity: his attitude was graceful, and free

from uncouth gesticulation. He complained of numerous acts of injustice which he supposed their father, the President, could not possibly know, and which he desired might be represented to him, through the agent, accompanied with a pipestem of peace richly ornamented.[43]

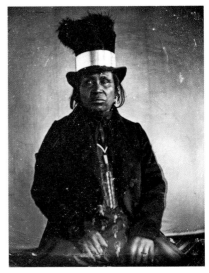

29. *Chief Oshkosh.* 1858

In great contrast is the second account written four years later by a Quaker teacher: "[The] head chief wore no ornament, except the embroidered knee bands. Though his name signifies the Brave, there was nothing in his port or the character of his countenance, to indicate energy of purpose, superiority of intellect, or the dignity of rank. He had a little wrinkled face, proportioned to his stature, and small twinkling eyes, out of which there occasionally shot a ray of shrewdness. He totally lacked that high and noble bearing which we are apt to imagine in these forest kings."[44]

Oshkosh is best known for his defense of Menominee land. With the federal government and later with the State of Wisconsin, he fought a generally losing battle to preserve Menominee land near Green Bay, Wisconsin. In 1852 the tribe was removed to a reservation of almost four hundred acres near the Upper Wolf River. About the time Brookes painted Chief Oshkosh the artist had completed other portrait commissions for the State Historical Society of Wisconsin, such as that of the head Menominee war chief I-om-e-tah and the former Menominee chief Sou-lign-y. A group of Indian studies made by Brookes was described by a historian, in 1898, as "striking in character and truthful and valuable representations of costumes, habits and other peculiarities of the aboriginal race and their life."[45] In the daguerreotype of 1850–55, Chief Oshkosh seems considerably older than the man in Brookes's oil portrait of 1858. Whether Oshkosh actually sat for the artist or whether Brookes referred to the daguerreotype is not known (see plate 29). Because the painting was commissioned the year of the chief's death (August 21, 1858), it may have been intended as a memorial portrait.[46]

In contrast to Indian leaders away at war or negotiating treaties, tribal groups in their homelands performed daily or ceremonial functions. Among these groups were the Dakota, a confederacy of Siouan-speakers—the most populous linguistic family next to the Algonquian. A Woodland people at one time, the Dakota are often grouped with the Plains Indians because of their gradual movement westward from 1700. They were displaced largely by persistent attacks from the Chippewa, who obtained firearms from the French. Despite their widespread reputation for bravery and skill, most of the Dakota had to depend on bows and arrows. (Sioux is an abbreviation of Nadowessioux, a French corruption of Nadowe-is-iw, the Chippewa name for the group, meaning "snake" or "adder" and hence "enemy.")

Early explorers often classified the Dakota into two large divisions, Eastern (Forest) and Western (Prairie). The Santee, or eastern division, speak a single dialect, and their homeland was in Minnesota until the outbreak of 1862. One of the most vivid recorders of the daily lives of the Dakota was the soldier-artist Seth Eastman (1808–1875), whose field sketches were made during his military service at Fort Snelling, Minnesota, from 1841 to 1848. There, according to his artist-friend Charles Lanman, Eastman devoted all his leisure time "to the study of Indian character, and

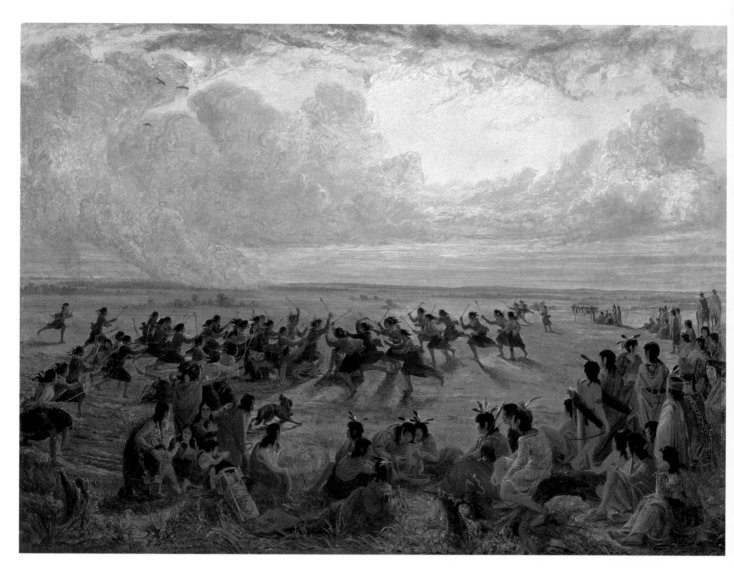

30. Seth Eastman, *Squaws Playing Ball on the Prairie*. 1849

the portraying on canvas of their manners and customs." Lanman's reference was to a collection of "about four hundred pieces" by Eastman, ranging from the *Grand Medicine Dance* "to the singular and affecting *Indian Grave*."[47]

Eastman's knowledge of the Dakota language undoubtedly helped him establish good rapport with the Indians. His wife shared his interest in the Dakota and later wrote a book in which she described the couple's developing relations with them: "Our intercourse with the Sioux [Dakota] was greatly facilitated, and our influence over them much increased, by the success attending my husband's efforts to paint their portraits. They thought it Supernatural (*Wahkun*) to be represented on canvas. Some were prejudiced against sitting, others esteemed it a great compliment to be asked, but all expected to be paid for it. And if anything were wanting . . . for gaining all information that was of interest, we found it in the daguerreotype."[48] Eastman committed all of his means to a pictorial history of the Dakota, investing in a collection of artifacts and a daguerreotype camera and paying his models to pose.

Like other tribal groups, the Dakota participated in Indian games that

were remarkably similar throughout North America as a result of intertribal influences. There are two basic game types: games of chance that involve gambling and games of skill and dexterity, and each type has an important social value. Games of chance, especially dice and cards, are illustrated by John Mix Stanley's *Gambling for the Buck* (see plate 75; p. 176). These games have a purpose both as entertainment and as a means of settling disputes by wagers. Athletic games develop the skills needed for an active outdoor life. Archery, juggling, horsemanship, racing, and spear-throwing, for example, foster stamina, hand-eye-foot coordination, and courage. The rigorous Woodland Indian game played in Eastman's *Squaws Playing Ball on the Prairie* (plate 30) can be identified as lacrosse (*tawinkapsice*), because of the shape of the players' sticks, which resemble a bishop's crozier (plate 31). In all likelihood lacrosse originated with the Woodland Indians and then spread to the eastern Plains. Usually played by men, in some areas of the eastern Plains the game is played by women and at times even by men and women together. A physically demanding game, using a leather ball and a scooplike net on a long stick, traditionally it alternated with games of men's lacrosse (*takapsice*).

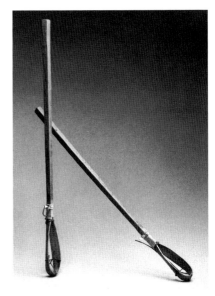

31. Sioux Lacrosse Sticks

Any number of contestants could play, each team requiring an equal number of players, and the object of the game was to pass the ball between the opponent's goal posts. The ball (2½–3 inches in diameter) was usually made of strips of animal skin or commercial cloth wound into a sphere and then covered with buckskin or rawhide. On rare occasions, the ball was made of wood. Several different bands often were pitted against each other, and contestants frequently gathered in one large camp where there was feasting, heavy gambling, and dancing. An English lieutenant, reporting on the character of the eastern Dakota bands near Green Bay, Wisconsin, in 1763, told of their incomparable skills in hunting and in war, adding that "they are remarkable for their dancing; the other nations take the fashion from them."[49]

In a letter to a friend, Eastman's wife elaborated on *Squaws Playing Ball on the Prairie,* which was exhibited at the American Art Union in New York, in 1849: "In their games, the Sioux [Dakota] women get much more excited than the men. . . . Wild as the ball play of the women may appear, it is true to nature, and you may observe that a prairie is burning near them which affects the colouring, making it dark and heavy."[50] For us, it seems curious that a ball game would be played near a prairie fire, with dense billows of smoke moving toward the players. Perhaps Eastman enlivened his background to match the intensity and excitement of the players, just as his somber colors romanticize the event. He probably based the painting on preliminary field sketches or on daguerreotypes made while he was stationed at Fort Snelling. Not only was Eastman the capable topographical draftsman his profession required but a painter of nature as well. Because of his early training with Robert Weir, Eastman was able to make the settings for his Indian subjects seem like real places rather than staged backdrops.

Subsistence was at the core of Indian life, the main theme of Indian religion, legend, and art, and the central focus of Indian technology. With the climatic and physiographic changes of the postglacial age, new subsistence patterns evolved. A shift occurred from collective hunts of predominantly large herds of mammals to individual hunting of smaller animals and

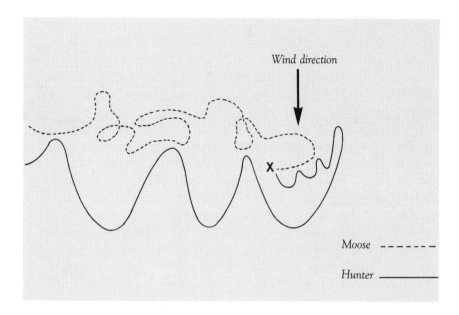

Wind direction

Moose - - - - - -

Hunter _____

32. Moose Hunting: Tracking Technique

birds. The wet marshes and prairies of the northern Woodlands became ranges for three large herbivores hunted by the Indians—moose, bison, and deer. And subsistence patterns of Woodland tribes in the Western Great Lakes and the Eastern Plains culture areas developed accordingly. Deer were an important food resource for Woodland inhabitants, hunted in competition with Eastern Plains tribes, since the marginal region separating the two culture areas was a major habitat for deer. *Gambling for the Buck* by John Mix Stanley shows a hunter's trophy, a deer, as the object of a wager. Similarly, moose found throughout the margins of the Subarctic forests and the northern Woodland areas from eastern Canada to the western Great Lakes, were not only an important food resource for the traditional cultures of both regions but also a source of raw materials for clothing, tools, and utensils.

Moose tend to be solitary animals, unlike caribou, deer, or buffalo, which congregate in large numbers. Particularly in spring and summer, moose generally feed alone or sometimes as mother and calf. In winter, however, a few moose will herd together in sheltered areas called yards to feed on tree bark and low bushes, traveling to and from them along narrow trails in the snow. Moose can be tracked and hunted most easily in winter by running them to exhaustion in the deep snow or on crusted snow too thin to support their weight. A hunter on snowshoes has a distinct advantage over the animals and, after running a moose down, can readily kill it with a spear or other weapon.

Two additional techniques used throughout the Woodlands for taking moose require a knowledge of other behavioral characteristics. One technique involves tracking on land and the other "calling" the male moose during mating season with an imitation of the cow moose's sound. Tracking a moose requires the hunter to avoid trailing the animal directly, because during and after feeding the moose double back on their trail. To stalk them, Indian hunters move in large, semicircular loops downwind of the animal, in the general direction of the moose's movement (see plate 32). After determining that the moose has doubled back, the hunter makes

smaller, downwind loops up the trail until he reaches the moose and then attempts to kill it with a bow and arrow. After firearms were introduced, dispatching a moose was much easier and probably more efficient. Another traditional way to hunt moose involved bringing the prey to the hunter, by attracting the animal with a moose call that imitates the mating sound of a cow moose, made with a birchbark horn, or with a sound made by a moose shoulder bone that mimics the sound of a bull moose's antler scratching a tree in the fall rutting season.

Eastern artist George de Forest Brush (1855–1941) made his first trip to the West in summer 1881. There he sketched the Arapahoe, Shoshone, and Crow tribes in Wyoming and Montana, translating many of these subjects into important studio paintings later. Commenting, in 1885, on the difficulty of breaking away from the simple, primitive life of the Indian, he added that "it is . . . a mistake to suppose that Indians are all homely. A really handsome squaw is rare, but there are more superb and symmetrical men among them than I have ever seen elsewhere, their beardless faces reminding one always of the antique; these are not rare, but are to be seen at every dance, where they are mostly naked, decorated in feathers and light fineries. Their constant light exercise, frequent steam-baths, and freedom from overwork develop the body in a manner only equaled, I must believe, by the Greek."[51]

Brush dramatized and idealized his Indian subjects in the manner of his French mentor Jean-Léon Gérôme, the academician and history painter. The muscular nakedness of the Indian bodies, and the rich color and glazes

34. Gordon R. Sommers, *Gathering Wild Rice by Flailing the Kernels into the Canoe,* c. 1940

he used in *The Moose Chase* (plate 33) certainly recall Gérôme's work. Yet Brush was well aware of the actual state of the Indians, particularly those he had met on his first trip west: "Everyone who goes far West sees about the streets of the little railroad towns a few Indians. The squaws are fat and prematurely wrinkled; the men give the impression of dark-skinned tramps, and we seldom look under their dirty old felt hats to study their features. . . . It is true that from the point of view of the civilized merchant . . . they are a sad sight. . . . But the question of whether they are fit to enter the kingdom of heaven is apart from their artistic interest. Many people fail to see this."[52] Brush was not interested in presenting a historical record of his Indian subjects or the harshness of their forced dislocation by whites. He felt that the artist could reach through their present condition into the past for a clue to their primitive, unfettered lifeways; he could then attempt to recreate them in his paintings, by showing not only the externals but the true spirit of the Indian's natural world—his symbiotic ties with nature. Brush tried to capture the poetry of this relationship through the mannered, statuesque poses of his figures placed against serene backgrounds of water, rock, and sky.

Brush's *Moose Chase,* however, was motivated less by the noble primitive seen as classical sculpture than by the artist's desire to paint a live moose, a difficult objective since the animal still lived in a wild state. In summer 1886, Brush and his bride were living in a remote village, thirty-five miles above Quebec on the Saint Lawrence River, but good fortune led him to a traveling circus where he found a live moose to rent as a model!

Spread across three culture areas—the Subarctic, the Plains, and the Woodlands—a subgroup known as the Southeastern Ojibwa lives on the northern borders of Lakes Ontario, Erie, and Huron as well as on the peninsula of Michigan. In their own language, the Ojibwa refer to themselves as Anishinabe, "first" or "original man." Although the Ojibwa are often referred to as a tribe, the implied political unity is more ideal than real.

At Sault Sainte Marie in 1846, artist Paul Kane (1810–1871) encountered a group identified by today's anthropologists as a band—the Saulteaux or Sault Sainte Marie band of the Southeastern Ojibwa. Traditionally, this Ojibwa band subsisted largely on whitefish, because fishing was excellent almost year-round. They also hunted and gathered wild foods, picking berries during the summer, tapping maple trees for syrup in the spring, and harvesting wild rice from lake marshes in the fall (see plate 34). In addition, they increasingly practiced horticulture as European and American settlers diminished native food resources by occupying or logging aboriginal lands.

Kane's *Sault Sainte Marie—American Side* (plate 35) shows the distinctive dome-shaped housetype of this Southeastern Ojibwa group, a dwelling commonly called a wigwam, consisting of a pole framework covered with birchbark and cattail mats, and later with canvas. Two types of Ojibwa birchbark lodges can be seen in a photograph by T. C. Weston (plate 36). The framing of these circular or elliptical houses was made of sharpened saplings, their ends imbedded in the ground and then bent and tied to other saplings that formed structural ribs. Many smaller poles were then tied perpendicular to the main saplings with basswood cordage to strengthen the larger framing poles. A smoke hole was left open in the center of the

35

36

35. Paul Kane, *Sault Sainte Marie—
American Side*. c. 1846

36. T. C. Weston, *Two Types of Ojibwa
Birchbark Lodges*

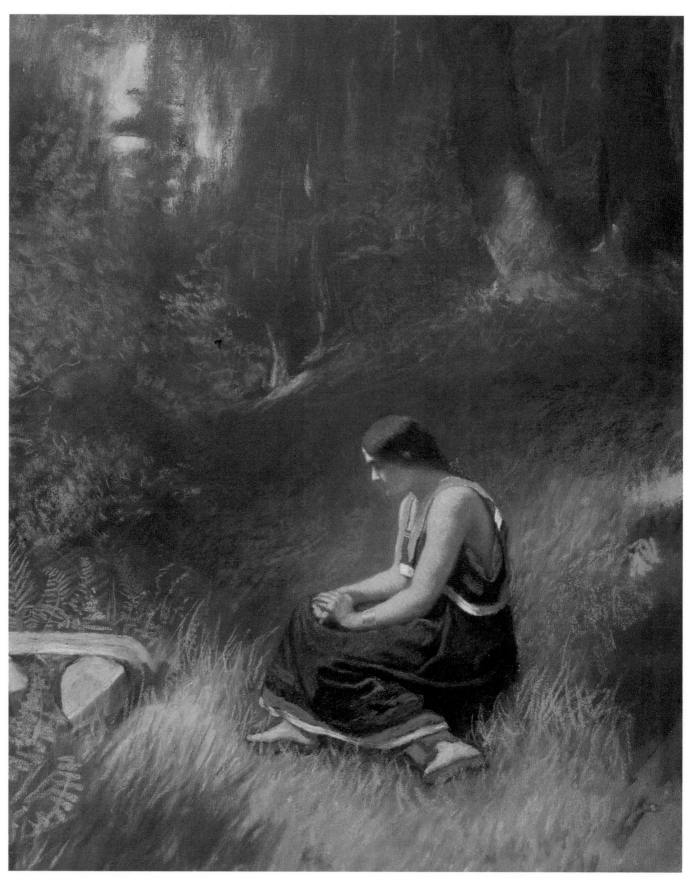

37. Eastman Johnson, *Hiawatha (Minnehaha)*. 1857

roof. Other Ojibwa dwellings, not shown here, include a small sweat lodge, a menstrual hut, and a religious structure called a Mide, or medicine, lodge. Still other housetypes might be used as temporary shelters for hunters and rice gatherers, or in camps where maple syrup was collected.

Kane passed through Sault Sainte Marie in August 1845, May 1846, and again in October 1848 on sketching tours. His two known oil versions of *Sault Sainte Marie* probably were based on sketches made during the 1845 trip, since some of the sketchbooks from this trip show encampment scenes with similar, domed wigwams. In his 1845 journal, Kane describes his first impression of Sault Sainte Marie as well as the sketch he made of the rapids, which later appears in two finished paintings:

> [The town] is situated at the lower extremity of Lake Superior, where it debouches into the river St. Marie, in its course to Lake Huron: having in this part of the river a considerable fall, for about a mile and a half in length, it soon becomes a foaming torrent, down which, however, canoes, steered by practised guides, ordinarily descend safely, although with terrific violence.
>
> I took a sketch of the rapids above alluded to, from the American side. . . . There is a small town called Sault St. Marie, on the American side, containing 700 or 800 inhabitants, with a well-built garrison, prettily situated on the river's bank.[53]

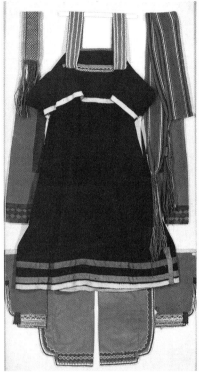

38. Indian Woman's Clothing. 1856–57

The topography that Kane describes is well articulated in the two oil versions of *Sault Sainte Marie*: the white waters of the Saint Marie River in the middle distance, with the Canadian mountains in the distant background, form a backdrop for the foreground activity, while the picturesque land forms and scudding clouds lend a bit of poetry to an essentially ethnological and reportorial canvas (see Kane discussion, pp. 146–51).

Circuitously, the Indians of the western Great Lakes provided nineteenth-century America with a famous literary character who correctly belongs in upstate New York, namely Hiawatha. Although Hiawatha was a semilegendary founder of the Iroquois League, he became confused in published accounts with Nanabozho (or Manabozho), the culture hero of the Ojibwa of the western Great Lakes. This error was repeated by Longfellow in *The Song of Hiawatha* (1855). The confusion that began a few years earlier was perpetuated by the historian and writer Henry Rowe Schoolcraft, whose publication Longfellow in turn consulted, in 1854, as he explored material for his poem. And complicating the cultural mix still further was Longfellow's literary model, the Finnish epic *Kalevala*. Far from upstate New York, and even more remote from Finland, *The Song of Hiawatha* was cast in Schoolcraft's scramble of Iroquois-Ojibwa history.[54]

Celebrated for his paintings of cranberry pickers and haymakers, Eastman Johnson (1824–1906) also made a series of drawings and paintings earlier in his career of the Ojibwa Indians near Lake Superior. The so-called *Hiawatha* is one of the remaining pictures in this series, made during Johnson's second trip to Superior, Wisconsin, in 1857 (plate 37). At that time he worked chiefly at Pokehama Bay and Grand Portage, about 150 miles above Superior, on the north shore of the lake at the Canadian border. An erroneous title, assigned to the artist's portrayal at a later date, has compounded the confusion by adding a question of gender. Retitled *Hiawatha* after the exhibition of Johnson's work at the American Museum

of Natural History in 1908, the painting at that time was owned by the artist's wife and was listed in the exhibition catalogue as *Minnehaha.*

Johnson and Longfellow first met in Boston in 1846, when the poet commissioned the artist to do portraits of himself and his family. Johnson undoubtedly was familiar with his friend's epic poem and naturally placed his subject in an Ojibwa rather than an Iroquois setting. In a forest dell, the contemplative figure wears an original Ojibwa woman's costume, purchased by the artist at Grand Portage (see plate 38). Although his Minnehaha seems placid and quiescent compared to Longfellow's quick and volatile maiden, Johnson undoubtedly intended his image to reflect Longfellow's lyrical description:

> Of the ancient Arrow-maker,
> In the land of the Dacotahs,
> Where the Falls of Minnehaha
> Flash and gleam among the oak-trees,
> Laugh and leap into the valley.
> There the ancient Arrow-maker
> Made his arrow-heads of sandstone,
>
> .
>
> With him dwelt his dark-eyed daughter,
> Wayward as the Minnehaha,
> With her moods of shade and sunshine,
> Eyes that smiled and frowned alternate,
> Feet as rapid as the river,
> Tresses flowing like the water,
> And as musical as laughter:
> And he named her from the river,
> From the water-fall he named her,
> Minnehaha, Laughing Water.[55]

By the mid-nineteenth century artists began to turn to contemporary literature about American Indians for their subjects, and Eastman Johnson was no exception. Like most artists of the time, he was caught by the view of the vanishing native American, now "a figure bathed in nostalgic fable and the rush of affection that one feels for the dying."[56] Most American writers believed that the demise of the Indian was inevitable and irreversible, that the noble savage had been shunted aside to meet the exigencies of civilization and the demands of Manifest Destiny. Pictorial imagery became the handmaiden of literature, reflecting the same romantic notions.

In 1855, after several years of European study, Johnson returned to America. As he searched for typically American themes and pondered his future, the artist made a second trip to Superior, Wisconsin. The beautifully rendered drawings he made on this visit attest to his skilled hand and his sensitivity toward the proud Ojibwa people. The attention he gave to his portraits, in particular, reflects his enchantment with his subject. In contrast to the often idealized images of the American Indian prevalent at the time, Johnson carefully caught the individuality of his sitters in these drawings. He also strove to leave an accurate historical record of Indian costumes and other artifacts. Records reveal that Johnson kept these works for himself and never exhibited them during his lifetime. Few people knew

of their existence except friends like art critic Henry Tuckerman, who praised them in extravagant terms:

> A recent glance into the [artist's] portfolio . . . convinced us that he would do peculiar justice to a comparatively unworked mine of native art. . . . We have never seen the savage melancholy, the resigned stoicism, or the weird age of the American Indian, so truly portrayed: a Roman profile here, a fierce sadness there, a grim, withered physiognomy, or a soft but subdued wild beauty, prove how the artist's eye had caught the individuality of the aboriginal face; and with the picturesque costumes, scenic accessories, rites of *fete* and of sepulture, it is easy to imagine what an effective representative picture of the Red Man of America, with adequate facilities, this artist could execute.[57]

Portraits and romanticized scenes from American history and literature dominate the view of the Woodland Indian in American art well into the twentieth century. Although many painters had first-hand acquaintance with native Americans, most did not consider themselves documentary artists. As a result, with the exception of several important artists—John White, Paul Kane, Seth Eastman—ethnographic accuracy was rarely a concern, and Indian subjects frequently became actors, cast in historical or literary roles outside the context of their native cultures. Much of this lack of ethnographic precision can be explained by the severe disruption of Woodland lifeways from the moment of European contact. And the widespread fascination with Europe and the classical world led many artists to "translate" American Indian subjects into the prevailing Europeanized mode. This attitude was reinforced by a public view of native Americans that was colored by romanticism in literature and manifest destiny in history and politics.

Subarctic

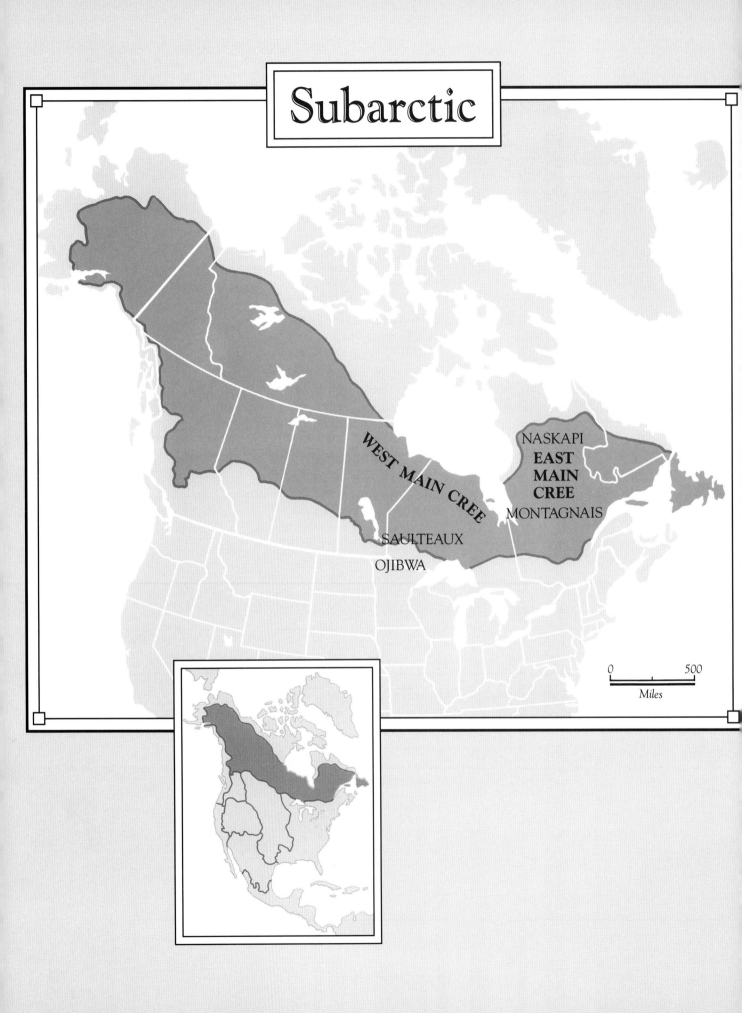

NASKAPI

EAST MAIN CREE

WEST MAIN CREE

MONTAGNAIS

SAULTEAUX

OJIBWA

0 500
 Miles

A complex and dynamic environment, the Subarctic culture area stretches across the northern reaches of the North American continent from the coast of Labrador to Alaska, encompassing approximately two million square miles. Most of the coastal areas on the east and west sides of the continent do not share the Subarctic climate or culture. A region of vast coniferous forests, it is bounded on the north by the treeless tundra whose primary inhabitants are the Eskimo; to the south its deciduous or mixed deciduous-coniferous forests are inhabited by Woodland Indians. Long, cold Subarctic winters and short, cool summers with a growing season too limited for agriculture made hunting, fishing, gathering, and trapping the predominant subsistence activities.

Scholarly studies of the Subarctic most often are based on the region's physiography, dominant cultural patterns, and languages. To a large extent, the four physiographic divisions of the Subarctic also mirror its cultural divisions: the Canadian Shield and the associated Hudson Bay and Mackenzie Lowlands, the Cordillera, the Yukon-Tanana-Kuskokwim plateaus, and the maritime fringe of the Alaska and the Coast ranges. From these four divisions, only the native inhabitants of the largest, the Canadian Shield, are represented in the paintings reproduced and discussed here.

Despite the language differences among Subarctic peoples, similar survival patterns evolved because of the essentially uniform environment. In historic times, the Canadian Shield's Athabaskan- and Algonquian-speakers (in the west and east, respectively) all practiced a hunting, fishing, gathering, and trapping economy. Extended families living in widely dispersed settlement patterns were the predominant social units, and they usually were organized into bands with patrilineal kinship ties. The typical residence group, however, consisted of one or two related nuclear families living in a single lodge. Larger bands assembled only for communal hunting or fishing. Although the fur trade, beginning in the seventeenth century, led to long-term economic involvement with Europeans, and later with Americans and Canadians, the aboriginal ties of man to nature were modified but not abandoned.

Among the major large mammals hunted in the north were the Barren Grounds caribou, while to the south moose, deer, and the woodland caribou were taken. Numerous small game animals as well as a variety of waterfowl also were hunted and trapped. Most fishing occurred during slack hunting times, along rivers and lakes. Among the more than two dozen species of fish that were caught, salmon were accessible only to tribes living along rivers with Pacific Ocean drainage. Distinctive cultural patterns, including rituals, stable housing, and more complex social organizations, are generally attributed to tribes that practiced salmon fishing.

While climate and physiography in other regions of North America attracted white farmers, Subarctic conditions helped prevent them from usurping Indian land. From the time of first contact in the sixteenth century until 1763, when New France was ceded to England, French and British powers competed for the furs of the Canadian Shield. Fur was the area's most valuable resource to the European colonial powers, and native labor was the primary and most expeditious means for extracting the animal pelts. Subarctic Indian men trapped and hunted the animals and then

transported the pelts to the nearest trading posts. Many of these animals also provided food, although the flesh of some was considered taboo.

During the early contact era, much of the fur trade was carried on by middlemen tribes, which led to numerous intertribal rivalries, despite the best efforts of white traders to maintain peace and productivity. To the Subarctic Indian, the fur trade brought not only trade goods—such as guns, knives, and kettles—but also a variety of previously unknown diseases. Rivalries among European traders also disrupted the native populations, especially when brandy and rum were used to curry the favor of Indians. Between 1763 and 1820, two trading companies, the North West and the Hudson's Bay Company, entered into intensive competition for furs. As many more traders penetrated the Subarctic, there was an enormous increase in the number and variety of European goods. This competition in turn spurred the native populations to overhunt large game—moose and woodland caribou were almost exterminated in some areas—and to over-trap small, fur-bearing game. An uneasy balance resulted between fur trapping and subsistence, with more and more reliance on smaller game, fish, and fowl. By 1821, when the two companies merged, Indian dependence on the fur-trade system was so substantial that in the Algonquian areas to the east trading posts stocked foods for the native inhabitants, and throughout much of the region local posts often had to dispense emergency rations. The standard unit of value for pricing trade goods and furs of all kinds was, fittingly, the beaver pelt.

Social organization as well as the material culture changed in response to the burgeoning fur trade. Domestic groups were reduced to two to four nuclear families, the optimal size unit for fur trapping in a limited area. In addition, the identity and orientation of bands (groups of related families) came to be centered on regional trading posts, and these groups were included in the Canadian government's census or "band lists." Indeed, some Indian families ceased to trap, preferring instead to work for the trading-post companies. As a rule, political leadership within the band depended on a man's personal qualities—his hunting proficiency, generosity, wisdom, oratorical skills, and on occasion, his supernatural powers.

Although early French Catholic (and Russian Orthodox) priests tried to missionize the Indians of the Subarctic, Christianity did not take permanent root throughout the Canadian Shield until the last quarter of the nineteenth century. It succeeded in part because native populations were concentrated in and around the trading posts, as a result of the adoption of dog-sled transport, canvas canoes, outboard motors, commercial fishing nets, and repeating rifles. Nevertheless, native populations often continued to practice their traditional religions, and belief in aboriginal guardian spirits, divination, and shamanic curing persisted alongside Christian rituals and beliefs.

The waterways of the Canadian Shield enabled Europeans to penetrate the interior Subarctic. As Europeans gained a foothold in each of the three great drainages of the Shield—in the Saint Lawrence River about 1500, Hudson Bay about 1670, and the Mackenzie River about 1780—a vast fur territory was opened to direct trade with the Indians. By 1500 the Montagnais ("hill people") were probably engaged in trade with Breton fishermen along the north shore of the Saint Lawrence Gulf. Algonquian-speakers,

probably the Ottawa and Ojibwa, on the western shores of Lake Huron and the northern shore of Lake Superior, also had trade relationships with these early Europeans.

In 1664, England took over a trade relationship with the Iroquois from the Dutch and began to develop trade in the Hudson Bay region. After the overland expeditions of Pierre Radisson and Sieur des Groseilliers, in 1668 and 1669, and the charter of the Hudson's Bay Company, in 1670, England firmly consolidated its hold on the fur-rich area. Instead of sending traders inland to collect furs from the Indians, the English established trading posts to barter with the natives at the mouths of the large rivers that drained the Shield into the bay. In 1713 the Treaty of Utrecht gave the Hudson Bay region to England. In 1821, when the Hudson's Bay Company merged with the North West Company, an effective trade monopoly was created.

A typical company facility was York Factory (formerly Fort Nelson), at the mouth of the Nelson River on Hudson Bay. It was established in 1684 as a Hudson's Bay Company trading post. Fishing probably had been a major source of food and hunting an important secondary subsistence activity until the fur trade imposed a cash economy on the region. To obtain flour, oatmeal, sugar, tea, and the other non-Indian commodities that became their new staples—as well as tobacco and alcohol—Indians engaged in extensive fur trapping and trading with Europeans.

The Indians of this region on the western side of Hudson Bay are the West Main Cree. They are separated not only geographically but also linguistically from the East Main Cree on the opposite side of the bay. Although both Cree groups are Algonquian-speakers, they use different dialects; both can be distinguished from their Ojibwa neighbors to the south who speak an Athabaskan language.

The territory inhabited by the West Main Cree is often described as *muskeg* (Ojibwa mŭskeg), and in earlier academic literature the inhabitants were called the Swampy Cree. A muskeg is a low-lying grassy bog or swamplike area traversed by numerous rivers and lakes. Low-growth spruce, tamarack, and willow are common, and the principal small animals in these woodlands—beaver, hare, fox, otter, marten, mink, muskrat, weasel, and squirrel—are still trapped by the Cree. Many of these animals provide meat, and their furs are a major source of income for many families today. The region's numerous lakes and ponds as well as the coastal marshes of Hudson Bay support fish and large numbers of migrating geese and ducks, which also are eaten.

Historically, the basic West Main Cree dwelling was a conical lodge with of a framework of light poles. The poles were thrust into the ground, tied together at the top, and then covered with hides, boughs, or bark. Lodges were heated by a central fire and frequently housed two or more related families. The severe climate of the Shield Subarctic made tailored clothing necessary during the winter. Preparation of animal skins and fashioning of clothing was a primary task for Subarctic women. The animal skins, usually dehaired moose and caribou hides, were made pliable by soaking, scraping, stretching, and rubbing with animal brains or grease and then smoked to make the suede supple and golden brown. Dressed hides were fashioned into coats and parkas, shirts, dresses, breechclouts, leggings, and soft-soled moccasins (see plate 39).

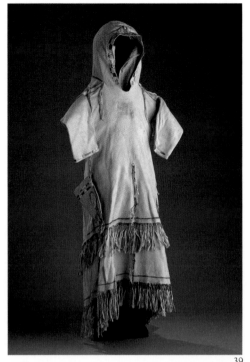

39

39

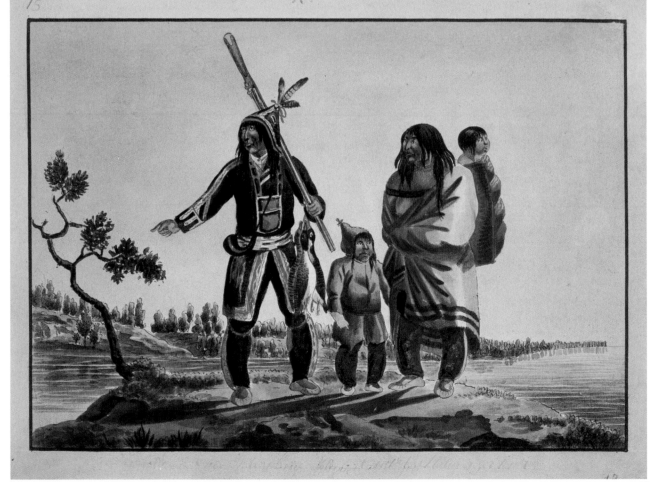

40

With the advent of the fur trade, native clothing changed along with other products of the material culture. European-made garments and broadloom cloth soon replaced many native articles of clothing. These changes as well as the introduction of firearms are very much in evidence in Peter Rindisbacher's *A Hunter-Family of Cree Indians at Fort York [Canada]* (plate 40). In 1821 Rindisbacher (1806–1834), a Swiss artist-émigré, settled in this area. At York Factory he depicted a hunter and family of West Main Cree Indians. In his painting the hunter's coat of dark wool broadcloth clearly shows European influence, especially its braid-trimmed shoulder seams and decorated, turned-back cuffs, suggesting livery or a military uniform. His leggings and moccasins, however, are of native design. Cree leggings are tailored pants, unlike Plains leggings, which are made from two pieces of hide without a connection at the crotch. Around his waist is a yellow, blue, and red sash made by finger weaving, a form of twining related to braiding in which the fingers replace the usual shuttle. The most popular of these sashes was the arrowhead (*ceinture fléchée*) or Assomption sash that was also worn by rural French settlers and *voyageurs,* who earned their living by paddling canoes into the wilderness, Indian-style, in quest of furs. Such sashes are finger woven only in North America, although they are found elsewhere. The woman's striped blanket is a Hudson's Bay Company import, although she carries the child on her back in a native cradleboard held by a traditional tumpline across her chest. The small girl's garment with its peaked hood is similar to the *capotes* worn by the area's *habitants*— the French-speaking farmers of Quebec. Although the decorative work on the man's headcovering is most certainly Indian, its color and design suggest that it is an attached hood rather than a separate hat, and thus of either indigenous or European origin.[1] Despite Rindisbacher's presence in the Subarctic at this relatively early date, many examples of cultural change can be seen in his watercolors.

The colony to which the young Rindisbacher had emigrated in 1821 with his family was Selkirk Colony, a small part of Rupert's Land, in the Red River of the North area of Canada. The colony had been granted to the Lord of Selkirk by the Hudson's Bay Company in 1811, to be used for an agricultural community of dispossessed Scottish peasants. Convinced that there were opportunities for other industrious Europeans in the Red River Valley, the Rindisbachers signed up as recruits along with fifty-six other Swiss families. Historical records tell of the hardships they endured during their first winter in Manitoba, when Peter Rindisbacher made these careful studies of the native inhabitants and their surroundings. The Rindisbachers remained in the Red River Valley from 1821 to 1826, and during that time the artist produced numerous sketches and watercolors for trade and sale.

Peter's brief formal training at the age of twelve with the Swiss view painter Jacob S. Weibel probably introduced him to topographical drawing and to engravings. Like other topographical artists of his day, Rindisbacher probably first sketched his subjects in pencil on squared-off paper and later translated them into finished watercolors. On request he often copied pictures like the Saulteaux family. This one was later reproduced as a colored lithograph in *Views in Hudson Bay.*[2] Rindisbacher's work as a whole provides some of the most ethnographically accurate pictorial records of the native peoples of the Subarctic and the Northern Great Plains.

39. Left: Subarctic Man's Pants (*Kaiyokhatana*); right: Girl's Dress with Hood (*Loucheux*)

40. Peter Rindisbacher, *A Hunter-Family of Cree Indians at Fort York [Canada].* 1821

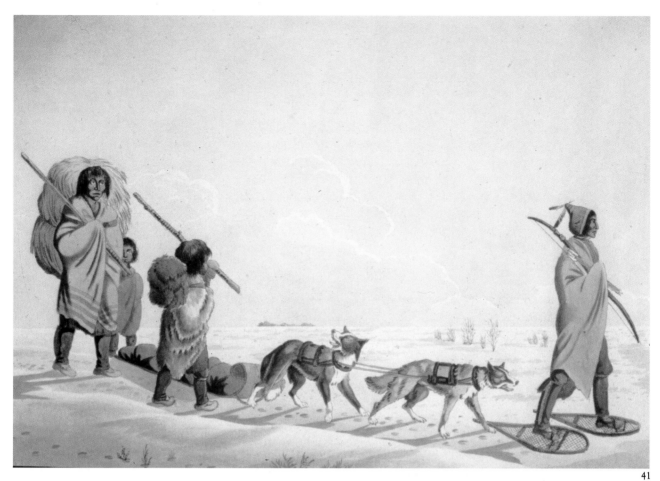

41

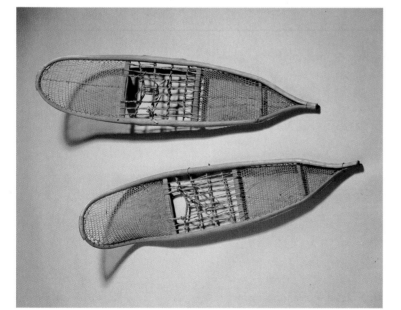

42

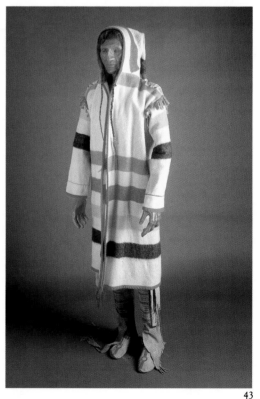

43

During his Red River Valley stay Rindisbacher depicted another native group—this one from the southern part of the Shield—in *An Indian Traveling with His Wife and Family in the Winter (Saulteaux)*, c. 1821–26 (plate 41). This group speaks a local dialect known as Saulteaux, which like the Chippewa, Ottawa, and Algonquian dialects is easily confused with Ojibwa, the language spoken by most tribes to the south of the Cree regions. These local dialects often resulted from cultural differences that arose from differing ecological conditions.

Most of the people known as Saulteaux live in the vicinity of Lake Winnipeg, along its southern shores and adjacent to the rivers that drain into it. In Rindisbacher's time, the Saulteaux were relatively recent migrants to the Lake Winnipeg area from northwestern Ontario. Many of them had moved as a result of the fur trade—shifting west in search of fur-bearing animals, or possibly relocating as employees of French or English fur-trading companies. Along with the Saulteaux came Cree-speakers from farther north, who heavily influenced Saulteaux culture in historic times.

Wild rice is a primary food for the Saulteaux, and it is harvested in early fall in the eastern and southern parts of Lake Winnipeg as well as in the numerous smaller lakes to the south and east. The Saulteaux who live north or west of this growing region migrate each fall to harvest wild rice. In the nineteenth century the area's lakes and rivers also abounded in fish—most important were sturgeon, trout, and whitefish—which the Saulteaux often harvested and prepared for communal storage. Hunting and fur trading were not the only activities that propelled the Saulteaux to travel. Maple sugaring was an important spring activity and more recently the Saulteaux have become wage earners in work that ranges from guiding tourists to mining. A social or religious event may have been the incentive for this winter journey.

Most journeys in the Subarctic were made before the winter "freeze-up" or the spring "break-up." During both of these periods all travel was restricted by the often treacherous nature of ice. Water routes—whether frozen or ice-free—were the preferred avenues of travel. When the lakes and rivers were frozen over, passage was open and relatively free; snowshoes and toboggans were typical native equipment. Throughout the Subarctic, snowshoes vary in size and frame design—in the east they are more oval and in the west narrower and longer—but all are designed to permit easier travel in the snow. The snowshoes in the Rindisbacher painting as well as in plate 42 are of the narrower rounded-toe design, and they are made of sinew in a fine diamond stitch, strung with thongs on frames of bent wood.

Dog-drawn toboggans were not widely used until after 1850, and the dogs used to pull them—imported from England by white traders—were larger and stronger than the native breeds. Indeed, the dog-team is one of the symbols of acculturation. Among the aboriginal Subarctic Indians toboggans were drawn by men; the dog team with its complex of gear and accessories was added long after European contact. Thus Rindisbacher, in the 1820s, records a transitional development—a toboggan drawn by small native dogs, who were admixtures of wolf or coyote. Prominently shown in his scene, too, are the woolen trade blankets adopted as clothing by the native population. At first the blankets were worn wrapped about the body, but later the region's Indians began to fashion *capotes*, from Hudson's Bay

41. Peter Rindisbacher, *An Indian Traveling with His Wife and Family in the Winter (Saulteaux)*. c. 1821–26

42. Northern Athabaskan Snow Shoes

43. Trade Blanket *Capote*

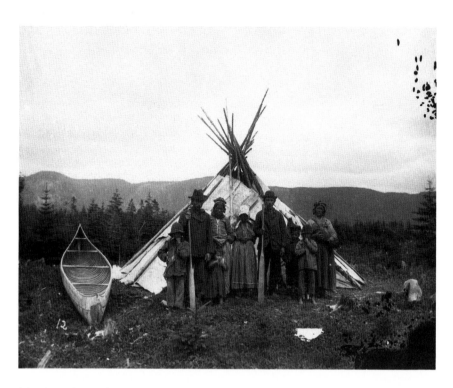

44. Jules-Ernest Livernois, *Montagnais, Godbout River, P.Q.* c. 1895

blankets (see plate 43), as seen also in Rindisbacher's Cree painting.

Much of Quebec and Labrador was inhabited by the Montagnais (named for the hilly terrain where they live), a tribal group that often appears in the anthropological literature as the Montagnais-Naskapi (see plate 44). Both groups are Algonquian-speakers, and along with the Eastern or East Main Cree, they have traditionally occupied almost the entire Labrador Peninsula. East of the Hudson and James bays, this region of Canada today is divided politically into the provinces of Quebec, Labrador, and Newfoundland. Within this region the Montagnais are found to the south and the Naskapi to the north. The Montagnais painted by Winslow Homer (1836–1910; see plate 45) in 1895, had divided into bands or subbands occupying specific territories for efficient trapping. Homer observed this band in the area around Lake Saint John.

In addition to trapping, the traditional subsistence base of the Montagnais included hunting, fishing, and gathering of wild plants, especially berries. They hunted moose, caribou, beaver, and bear and numerous waterfowl and smaller game. Turtle and eels as well as salmon, pike, sturgeon, whitefish, and smelt were the primary river and lake resources. With the advent of Europeans and the fur trade, however, commercial food became important in their diet. Wage labor in mining, forestry, and in tourist industries now contributes increasingly to their subsistence.

When Homer visited Quebec, in the 1890s, it was still a virtual wilderness, much as it was when the French discovered it in the seventeenth century. This bountiful province was a paradise for hunters and fishermen. With his brother Charles, Homer first visited Quebec in 1893; he made subsequent trips to Roberval, a fishing center on Lake Saint John, about a hundred miles north of Quebec City. Magazines and sportsmen's manuals promoted this settlement in the Canadian Adirondacks as "the most attractive fishing ground in North America." As industry encroached and

population centers spread in the United States, American artists and other travelers sought these less populated areas. At Roberval, as he had done on his Caribbean voyages, Homer produced many animated and vigorous watercolors of the country, its people, and their daily activities.

Homer's European trips, to France in 1866 and then to England in 1881, exposed him to Japanese prints and the Impressionists. He did not begin to work seriously in watercolor until the 1870s, and these early watercolors were rather straightforward, with broad, overlaid color washes, probably derived from his training in lithography. In his later work, including the Quebec watercolors, tilted perspectives, cropped images, jewel-like complementary colors against exposed white paper, and heavy atmospheric effects reveal his awareness of sophisticated means of expression.

In *Montagnais Indians,* definition gives way to abstraction and subtleties of expression. The slightly tilted perspective allows a view of the foreground activity—canoe making—and green meadows lead into the background, where Indians group around their summer shelters, which "were built by draping the covering over thin sticks arranged to create a long rectangular space."[3] The slender birchbark canoes, or *sheemauns,* played a vital role in the lives of the Montagnais, and the tourists who came to Lake Saint John and the Saguenay River adopted them for recreational fishing.

Homer's watercolor, with its middle ground tents, suggests something of the known social organization of the Montagnais. When the Europeans first came, the basic socioeconomic unit consisted of three or four families camped together in what is known today as a "lodge group." Lodge groups wintered in the same locale and depending on regional conditions spent all or part of the warm weather months together. Leadership among the Montagnais groups was informal. Most of the leaders were men of at least forty, whose religious and practical knowledge was respected and who were sensitive to the needs of others in the group. A conscientious leader's initiative in hunting, trapping, and travel was usually accepted. Yet a leader might defer to a man who received a dream about a favorable hunting spot. Women were in charge of camp operations, distributing provisions, collecting firewood and flooring boughs, and processing skins. Occasionally, they participated in the decision-making of the tribe. The fur trade changed this settlement pattern during the seventeenth century, causing the lodge groups to break into smaller units for efficient trapping. As a result, specific "hunting territories" and patrilineal kinship ties became more important. In the late nineteenth and early twentieth centuries, however, the Indian settlements around Canadian trading and commercial centers again came to resemble the lodge groups.

Like most nomadic Indians, the Montagnais-Naskapi depended on mobility for survival. They traveled in winter on snowshoes and toboggans and in summer in light, swift, birchbark canoes of several styles. Canoes were ideal for maneuvering the region's networks of lakes and ponds, which were connected by rivers and streams and often obstructed by rapids. Montagnais-Naskapi women usually steered from the stern of the canoe, while the men sat toward the front.

A birchbark canoe is manufactured in several stages, beginning with the gathering of materials. The most important element is the bark from the paper or canoe birch—*Betula papyrifera*—which yields not only bark for

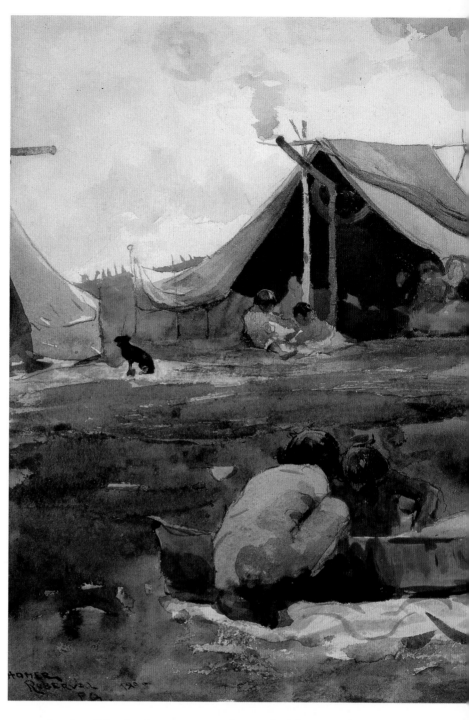

45. Winslow Homer, *Montagnais Indians (Indians Making Canoes), Roberval, P.Q.* 1895

canoes but for all kinds of containers and utensils. The paper birch is found from Alaska to Newfoundland, and many of the native people within its growing range made use of the tree, although some groups covered their canoes with bark from other trees or fashioned them from hollowed-out logs. Canoes were usually made during the spring, since the bark can be more readily removed from the tree in late winter and early spring. Canoe frames were carefully shaped of cedar, fir, or spruce, and the birchbark was lashed to the frames with cordage made from splitting black spruce roots. The seams that join the birchbark sheathing and the openings for the cordage were sealed with spruce and/or pine pitch mixed with lard or commercial vegetal fat. In time, canvas replaced birchbark sheathing for canoes, and several layers of paint became sealant for the seams. Canvas

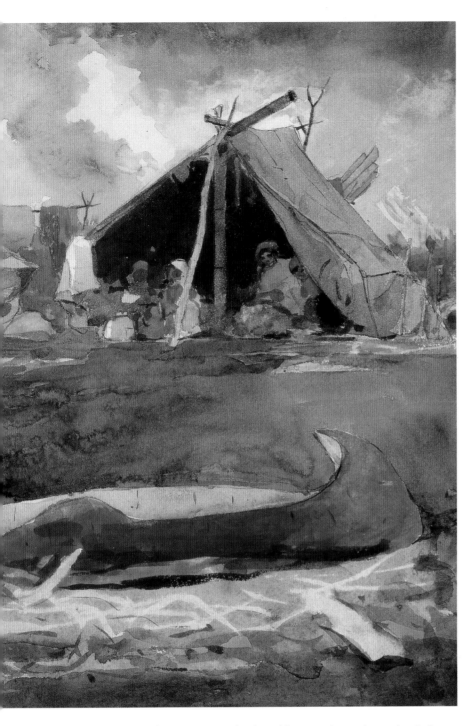

also replaced the earlier coverings for frond houses throughout the Subarctic. Frond supports—slender, sinew-tied branches—formed the structures of these earlier dwellings, which were covered with sheets of bark, woven water reeds, or animal skins.

After 1940 the Canadian government supplanted traders and missionaries in the field of social welfare among Subarctic Indians. Education, medicine, housing, food allowances, and old-age benefit programs resulted in part from the decline in fur game, the lower prices paid for furs, and the rise of social problems that followed the disruption of aboriginal groups by a modern society. By this time, the larger Canadian society also had begun to exploit other resources, including metals, hydroelectric power, timber, and tourism.

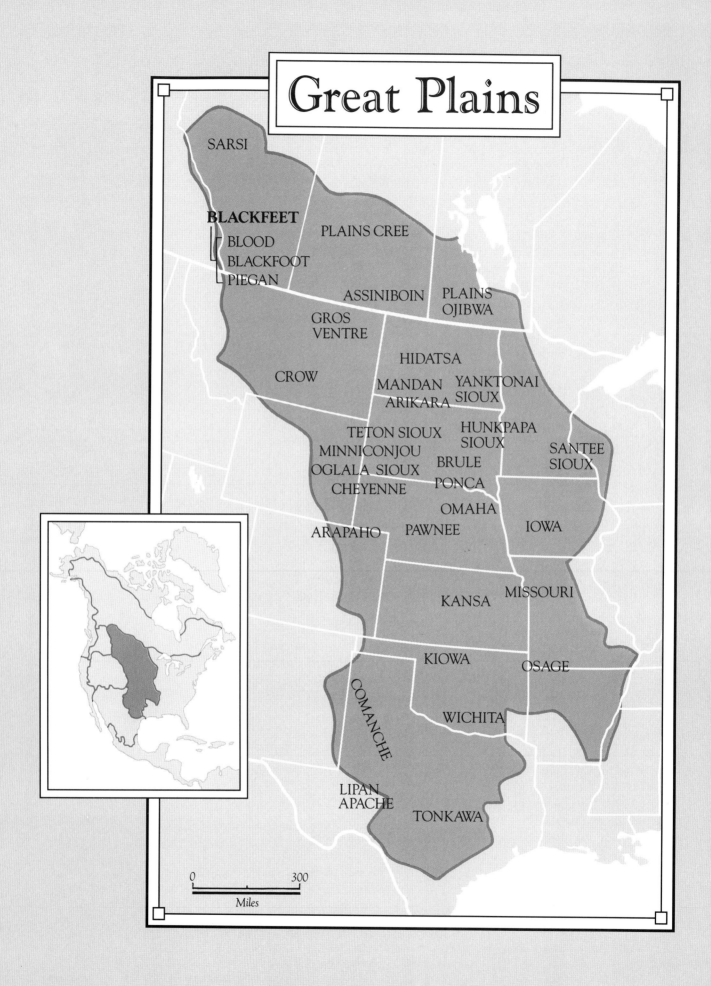

Great Plains

SARSI

BLACKFEET
BLOOD
BLACKFOOT
PIEGAN

PLAINS CREE

ASSINIBOIN

PLAINS OJIBWA

GROS VENTRE

HIDATSA

CROW

MANDAN
ARIKARA

YANKTONAI SIOUX

TETON SIOUX
MINNICONJOU
OGLALA SIOUX
CHEYENNE

HUNKPAPA SIOUX

SANTEE SIOUX

BRULE
PONCA

OMAHA

ARAPAHO

PAWNEE

IOWA

KANSA

MISSOURI

KIOWA

OSAGE

COMANCHE

WICHITA

LIPAN APACHE

TONKAWA

0 300
Miles

The heartland of North America, with its modern cities, factories, farms, and towns, was known to early travelers as the "Great American Desert." To Spanish explorers in the sixteenth century and later to other European and American adventurers, this was a grassy wasteland that lacked rainfall, trees, and topographic relief. Many early travelers in this seemingly bleak landscape overstated the size of both its bison herds and its native populations. From these exaggerations came the numerous myths about the Plains Indians and their cultures. Both the truth and the misinformation inherent in these myths are reflected in the art that portrays the Plains Indian.

The Great Plains is often defined roughly as the land mass between the Rocky Mountains and the Mississippi River, stretching north to south from western Canada to Texas. This vast territory is more accurately characterized by the terms Prairie for the eastern portion and Great Plains for the western. The demarcation between the Prairie and the Great Plains occurs near the 97th meridian in the north and the 98th meridian in the south. Some parts of the Prairie extend east of the Mississippi River into present-day Wisconsin and Illinois where there is greater moisture from rainfall and river drainage, a hillier terrain, and different plant and animal communities from those of the western Great Plains. Lack of essential rain on the Great Plains has made what little rainwater is available along with water from draining river systems even more important for survival. The lack of water also has conditioned the plant, animal, and human communities of the Plains. On the Prairie, annual rainfall averages between twenty and forty inches, while to the west, on the Great Plains, it averages ten to twenty inches. In addition to precipitation, the rate of evaporation, wind velocity in both summer and winter, and hail are important water-related weather phenomena on the Plains. These factors combined with soil conditions, annual temperatures, and the length of the growing season help to determine the plant communities found on the Plains. In Plains locations that had fewer than one hundred frost-free days or ten inches of average annual rainfall, the American Indians engaged in no agricultural activities beyond gathering useful wild plants.

Because of the scarcity of water, the dominant plant communities throughout the Plains are grasslands, commonly distinguished as tall and short grasses, or shallow- and deep-rooted grasses. For both the Prairie and the Great Plains, these grasses in turn have supported significant populations of both small and large mammals, such as rabbit, prairie dog, buffalo, and antelope. In addition to these grasseaters were two important predator mammals, the coyote and the wolf. Yet the buffalo was the animal that most attracted man. Although we now think of the buffalo as exclusively a Plains animal, in the past it was also prevalent in the Woodlands.

Beginning in the sixteenth century, two distinctive lifeways were identified by European travelers, a distinction later historians of Indian tribes continued to recognize. One depended largely on agriculture and the other on buffalo hunting and gathering wild food, although neither was practiced exclusively by the tribes that had moved to the Plains in prehistoric and historic times from the Woodlands, the Plateau, or the Southwest. A healthy trading relationship existed between the predominantly agricultural tribes and the buffalo-hunting tribes.

The differences between the agricultural and buffalo-hunting tribes only reinforce the popular misconception that aboriginal populations lived in a uniform Plains environment. In addition to its grasslands, river systems on the Plains (see map p. 78) provide important river-bottom and woodland environments for human habitation. Except for the Assiniboine and Saskatchewan river systems in the far north, flowing eastward into Lake Winnipeg, all of the Plains rivers drain either into the Missouri or directly into the Mississippi River. Along these major rivers and their tributaries, numerous deep, extended, flat valleys have been cut, providing sheltered village and farming sites as well as ecological niches for trees and woodland animal habitats.

Among the cultural traits of buffalo-hunting tribes in historic times were tipis, horse and dog transport, animal-skin clothing, an emphasis on warfare along with the presence of military societies, animistic beliefs and endurance rituals, a widely accepted sign language, and similar weapons, tools, horse equipment, and food-processing utensils. In their visual arts there was also considerable similarity in raw materials, technology, and social functions. In art, however, the symbol systems are best grouped in terms of shared-language families rather than by association with the entire Plains culture area. It is also a common error to extend the cultural traits of buffalo-hunting tribes to the agricultural tribes, who resided in earth-covered lodges, used pottery, and had a ritual and belief system largely oriented to an agricultural cycle. In a sense, this settled way of life placed them at a disadvantage when contact was made with Europeans and Americans, because they were at greater risk from foreign diseases, warfare, and competing lifeways.

The six language families of the Plains in historic times were the Algonquian, Athabaskan, Caddoan, Kiowan, Siouan, and Uto-Aztecan. At the beginning of the nineteenth century, the Algonquian language family consisted of the Blackfoot (Piegan-Blood-Northern Blackfoot), Cheyenne, Arapaho-Gros Ventre, Plains Cree, and Plains Ojibwa (Plains Chippewa) tribes; the Athabaskan family of the Sarsi and Kiowa Apache tribes; the Caddoan family of the Pawnee-Arikara and Wichita tribes; the Kiowan family of the Kiowa tribe; the Siouan family of the Mandan, Hidatsa, Crow, Dakota-Assiniboin, Iowa-Oto-Missouri, and Omaha-Ponca-Osage-Kansa tribes; and the Uto-Aztecan family of the Wind River Shoshone, Comanche, and Ute tribes.

Culturally, these Plains tribes have been organized by scholars in a number of different ways, most commonly perhaps as northern, southern, eastern, and western Plains tribes. The northern tribes are the Assiniboin, Blackfeet, Crow, Gros Ventre, Plains-Cree, Plains-Ojibwa, Sarsi, and Teton-Dakota. The southern tribes are the Arikara, Hidatsa, Iowa, Kansa, Mandan, Missouri, Omaha, Osage, Oto, Pawnee, Ponca, Eastern Dakota, and Wichita; and the plateau or western tribes are the Bannock, Nez Perce, Wind River Shoshone, Northern Shoshone, and Ute. These divisions indicate the regional variations among Plains Indian cultures. Southern Plains tribes adjacent to the Southwest, for example, were more influenced by southwestern groups than by other Plains tribes. Some of these southern tribes, such as the Apache and the Comanche, are almost certainly historic migrants onto the Plains from the Southwest. Northern Plains tribes,

however, most likely migrated there from both the Plateau culture area to the northwest and from the eastern Plains, while the Prairie tribes are closely affiliated with their neighbors in the Woodland culture area. Some scholars see the Plains river systems and their historic agricultural inhabitants as possible extensions of the Woodland Indian cultures to the west.

An enormous disruption of Indian cultures occurred on the Plains after the coming of Europeans and, later, Americans. The advent of the horse on the Plains from Spanish settlements in the Southwest (Santa Fe, New Mexico, and San Antonio, Texas) marked a major turning point in the region's cultural history. Although southern Plains tribes may have seen the horse as early as the mid-sixteenth century, most scholars believe that there were no horse (or mule) herds of any size on the Plains until the early 1700s. Objects of European manufacture—including firearms, metal cooking utensils and knives, and brass and glass beads—brought further, significant changes to the native culture, and this acculturation is evident in the work of artists who recorded the Plains Indians.

Curiously, most Americans associate the political idea of "Manifest Destiny" more than the economics of trade with this nation's expansion onto the Plains. By consummating the Louisiana Purchase of 1803, the United States assumed ownership of a land mass that included the Great Plains and its inhabitants. President Jefferson's desire to learn more about the resources gained by this purchase led him to authorize the Lewis and Clark expedition of 1804–6. Although no artists accompanied the survey, it inspired a number of them to recreate scenes widely reported by the explorers in their published journals. Some of the most informative and popular of these interpretations are the thirteen pictures by Charles Russell (1864–1926) of subjects derived from Lewis and Clark's travels in the Northwest. But by the time Russell painted this group of pictures the extermination of the buffalo, confinement of Indian tribes to reservations, fencing of the open range, plowing under of grasslands, and pollution of air by smoke from mines and smelters had desecrated the West he had known and loved.

Born of well-to-do parents in Saint Louis, Missouri, in early childhood Russell became infatuated with Indians, the frontier, and the West. At sixteen, he was finally allowed to accompany a family friend to Montana Territory, a trip that did nothing to lessen his romantic yearning to become a cowboy. Russell adopted Montana and stayed in the West for the rest of his life, working as a sheepherder, a cowboy, a wrangler, and an author, always with a sketchpad and watercolors nearby. Self-trained and self-confident, he felt neither the need for European study nor the desire to be tutored by established American artists. For Russell, Impressionism and other foreign persuasions were "crazy-quilt madness," approaches to making art that were too analytical, and therefore irrelevant. Intrigued instead by the drama as well as the reality of the West, Russell naturally followed the pattern of earlier American and European narrative painters in producing action-filled pictures of the Old West.

Russell favored stories from Lewis and Clark's travels for his subjects, probably because these explorers had traversed so much of his beloved Montana in their search for a transcontinental waterway to the Pacific. One of his most dynamic, monumental recreations is the mural in the Montana

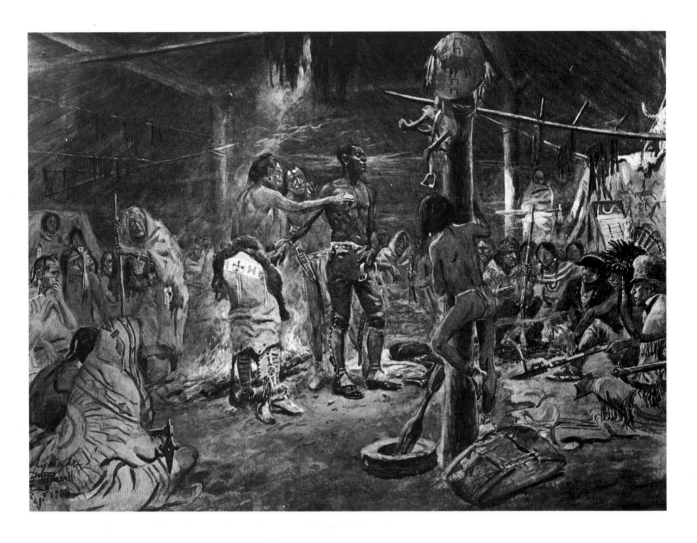

46. Charles Russell, *York*. 1908

State Capitol that portrays Lewis and Clark meeting the Flathead Indians at Ross's Hole, in Montana, on September 4, 1805. Another picture stemming from the same historical source is Russell's watercolor *York* (plate 46), named for William Clark's black servant who was a member of the explorers' party. The scene is based on an incident that took place, reportedly on March 9, 1805, when Clark met the Hidatsa leader, The Borgne, along the Missouri River.

In the *Original Journals of the Lewis and Clark Expedition, 1804–1806*, the entry of March 9, 1805, describes the meeting:

a Cloudy Cold and windey morning wind from the North. I walked up to See the Party that is makeing Perogues, about 5 miles above this . . . on my way up I met the (The Borgne) Main Chief of the Ma ne tar res [Hidatsas], with four Indians on their way to see us . . . I requested him to proceed on to the fort, where he would find Cap. Lewis and proceeded on myself to the canoes found them nearly fin[i]shed. . . . On my return found the Manetarre Chief about Setting out on his return to his village, having received of Captain M. Lewis a Medal Gorget, armban[d]s, a Flag Shirt, scarlet &c, &c, &c, for which he was pleased, those things were given in place of Sundery articles Sent to him which he Sais he did not receive, 2 guns were fired for this Great man.[1]

It seems clear from this journal entry that The Borgne met Clark as the explorer went upriver to view the construction progress on several large canoes. Clark directed The Borgne to Fort Mandan, the expedition's winter outpost a mile or so north of the second of three Mandan villages on the Missouri River near its juncture with the Knife River.

On meeting Lewis at Fort Mandan, The Borgne asked him to confirm a rumor spread by some young Hidatsa men that a black man was in the exploration party. York was immediately brought forth by Lewis, to The Borgne's astonishment. The Hidatsa leader "examined him closely—spit on his hand and rubbed it in order to rub off the paint. The negro pulled off the handkerchief from his head and showed his hair—on which The Borgne was convinced that he was of a different species from the Whites."[2]

Instead of locating *York* in the expedition's winter shelter at Fort Mandan, Russell clearly turned to the engraving *The Interior of the Hut of a Mandan Chief* by the Swiss artist Karl Bodmer as his compositional model.[3] Although Russell referred to his own copy of Lewis and Clark's journals, it did not describe York, the meeting place, or the costumes of the participants.[4] The headdress worn by the Indian chief between the two explorers, at the far right, seems to be copied from the *Dog Dance*, another Bodmer engraving. Smithsonian ethnologist John Ewers points out that some of the artifacts in the Russell watercolor—the painting on the hanging skin, the decoration of the willow backrest in the foreground, the dress on the seated woman in the right background, and the belt and knife scabbard of the man standing behind York—probably are more representative of late nineteenth-century Blackfeet culture than early nineteenth-century Hidatsa culture.[5] In the late nineteenth century, the Blackfeet lived in large numbers on a reservation in Montana. Russell predictably would have had convenient access to their artifacts, and he probably was unaware of the Indian artifacts that Lewis and Clark had collected during their journey. Indeed, one of the earliest known Mandan painted buffalo robes, depicting a battle fought about 1797 between the Mandans and their allies against the Sioux and the Arikara (plate 47), was among the articles Lewis and Clark sent to President Jefferson in April 1805. Moreover, Clark's field notes suggest that York was heavyset and not athletic, a somewhat different figure from the strapping well-proportioned male Russell portrayed. Clark's physical description makes it seem unlikely that York could have endured such an arduous overland trip to the Pacific Northwest. At the end of this journey, Clark freed York, who then returned to Louisville, Kentucky, where he married and engaged in freightage between Tennessee and Kentucky, underwritten in part by Clark. Years later, York became a heavy drinker and entertained his friends with stories about the Lewis and Clark expedition.

Even before early nineteenth-century European and American travelers arrived on the Plains, the trans-Appalachian area already had been ardently explored and recorded by a number of artist-naturalists, such as William Bartram (1739–1823). Yet the immense wilderness west of the Mississippi remained largely unexplored by scientists until Thomas Jefferson purchased the Louisiana Territory. No artists, however, accompanied the five earliest exploratory ventures into the trans-Mississippi West, made during Jefferson's administration. The first expedition to include trained

naturalists and artists as members of the official exploration corps was Major Stephen H. Long's expedition, of 1819, to explore the Missouri River and its principal tributaries. This also marked the first graphic record by Americans of the heart of the western interior—more than two centuries after Englishman John White and Frenchman Jacques le Moyne made their initial records of the New World.

Samuel Seymour (active ca. 1769–1823), a professional engraver and resident of Philadelphia, was assigned to the Long expedition to "furnish sketches of landscapes" and "paint portraits of distinguished Indians." Seymour began his work in spring 1819, when Long's forces left Pittsburgh for Saint Louis, on what was later called the Yellowstone Expedition, "to establish military posts on the Upper Missouri for the purposes of protecting the growing fur-trade, controlling the Indian tribes, and lessening the influence which British trading companies were believed to exert upon them."[6]

The journey began with the ascent of the Missouri River by boat to Fort Osage, near present-day Independence, Missouri. On August 6, 1819, a detachment of the Long expedition consisting of ten men led by zoologist Thomas Say, including the naturalist Titian Ramsay Peale and Samuel Seymour, traveled overland from Fort Osage to visit the Kansa Indians, a central Plains tribe living near the confluence of the Blue Earth and Kansas rivers. (Sometimes the Kansa, a Siouan-speaking tribe, are classified as the Dhegiha branch of that language group.) European and American explorers knew the Kansa as early as 1673, when the French priest-explorer Jacques Marquette first noted their existence on his map. The Say detachment arrived at the Kansa village on August 20 and stayed for four days before leaving for Council Bluffs. The first evening out, in their encampment beside a creek seven miles from the village, the party was overtaken by a group of 130 hostile Pawnees who stole the party's horses, forcing the men to return to the Kansa village the next day.

Retiring to a lodge set aside for them that evening, Say's party was startled by a group of armed and howling Indians who rushed in with bows, arrows, and lances. Noticing that several women nearby seemed undisturbed by the commotion, the visitors soon realized that no harm was intended them. Later, they vividly recalled the scene:

> The Indians collected around the fire in the centre of the lodge, yelling incessantly; at length their howlings assumed something of a measured tone, and they began to accompany their voices with a sort of drum and rattles. After singing for some time, one who appeared to be their leader struck the post over the fire with his lance, and they all began to dance, keeping very exact time with the music. Each warrior had, besides his arms, and rattles made of strings of deer's hoofs, some part of the intestines of an animal inflated, and inclosing a few small stones, which produced a sound like pebbles in a gourd shell. After dancing round the fire for some time . . . they departed, raising the same wolfish howl, with which they had entered; but their music and their yelling continued to be heard about the village during the night.[7]

During the dance Seymour managed to sketch the "attitudes and dresses" of the principal performers. Only after the ceremony was over did the party

47. Mandan Buffalo Robe

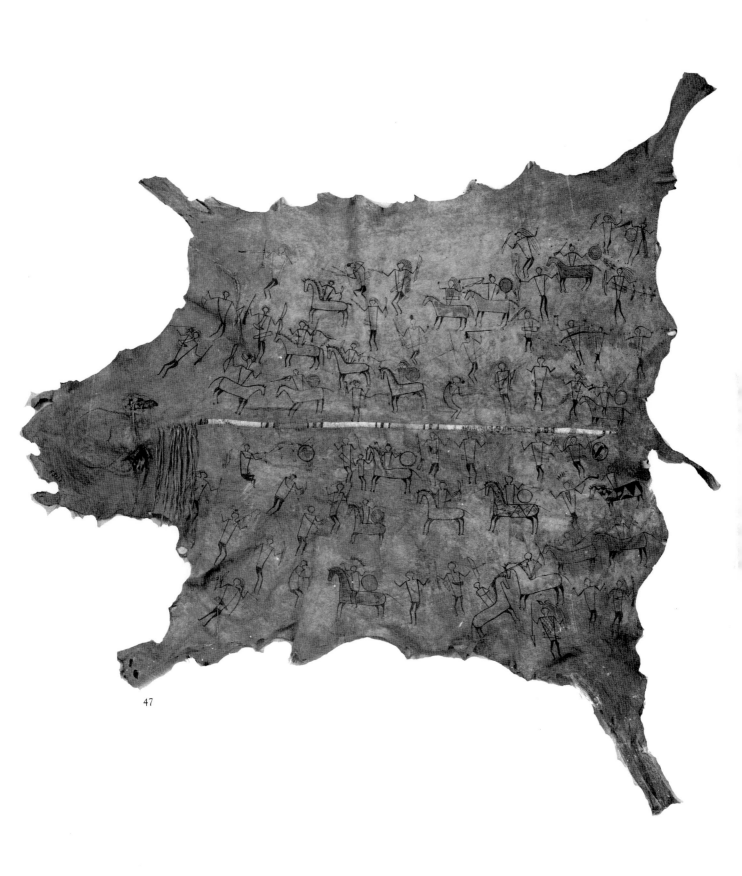

47

learn that the Dog Dance had been performed for their entertainment. This Kansa Dog Dance ceremony should not be confused with other Plains Indian rituals that include the consumption of dog meat as a kind of sacred food. Seth Eastman's description of the "Dog Dance of the Dacotah," for example, differs significantly from that of the Kansa witnessed by the Say party. The Kansa Dog Dance, one of seventeen dances performed by the Kansa Indians, seems to have aroused the most interest and excitement among visitors. It is usually performed at night, when visitors are about to retire. Whether the dance was performed solely for the party's entertainment or whether it was a modified version of the Kansa war dances is not clear. Early white visitors may have equated the sounds made by the dancers with the sound of barking dogs. The caption under Seymour's illustration of this scene, reproduced in the Atlas of Edwin James's account of the Long expedition, reads "War Dance"; but to agree with the report, this identification was changed to "Dog Dance" in an accompanying erratum.[8] Musical accompaniment for these tribal dances was an important aspect of Kansa culture. Rhythm was dominant, and simple chants, often improvised by the singers, related important historical events.[9]

In addition to documenting the "attitudes and dresses" of the principal dancers along with their weapons and musical instruments (drums and rattles), Seymour's watercolor *War Dance* [*Dog Dance*] (plate 48) offers a careful rendering of a Kansa lodge, even to the details of its construction. The report stated that there were 120 of these lodges in the village at the time of Say's visit, each more or less circular and semisubterranean. Say wrote in detail about the lodge in which the party stayed:

> [It] is larger than any other in the town, and being that of the grand chief, it serves as a council house for the nation. The roof is supported by two [circular] series of pillars, or rough vertical posts, forked at top for the reception of the transverse connecting pieces. . . . Poles rest with their butts up on the wall, extending on the cross pieces . . . and are of sufficient length to reach nearly to the summit. . . . They are placed all round in a radiating manner, and support the roof like rafters. Across these are laid long and slender sticks or twigs, attached parallel to each other by means of bark cord; these are covered by mats made of long grass, or reeds, or with the bark of trees; the whole is then covered completely over with earth, which, near the ground is banked up to the eaves. A hole is permitted to remain in the middle of the roof to give exit to the smoke. Around the walls of the interior, a continuous series of mats are suspended; these are of neat workmanship, composed of a soft reed, united by bark cord, in straight or undulated lines, between which lines of black paint sometimes occur. The bedsteads are elevated to the height of the common seat from the ground, and are about six feet wide. . . . Several [cylindrical] medicine or mystic bags are carefully attached to the mats of the wall . . . several reeds are usually placed upon them, and a human scalp serves for their fringe and tassels. Of their contents we know nothing.
>
> The fireplace is a simple shallow cavity, in the centre of the apartment, with an upright and a projecting arm for the support of the culinary apparatus. . . . Each person . . . carries a large knife in the girdle of the breech cloth behind, which is used at their meals, and sometimes for self-defence. During our stay with these Indians they ate four or five times each day, invariably supplying us with the best pieces, or choice parts, before they attempted to taste the food them selves.[10]

War dance in the interior of a Kansa Lodge

Seymour's watercolor corresponds closely to Say's descriptive narrative and thus is an accurate visual document of the Kansa lifeways observed by the party. In this first eyewitness pictorial record of a Plains Indian dance ritual inside the lodge of an agricultural tribe on the Great Plains, Seymour used the simple compositional formula of other topographical artists of his day. *Dog Dance* is symmetrically composed, with wooden poles dividing the space into equal parts. In the manner of English topographical art of the eighteenth and early nineteenth centuries, the artist applied his color washes with traditional restraint over a faint pencil outline.

Once initiated by the Long expedition, topographical records by artist-explorers remained an integral part of the United States government's survey operations in the West until the application of the camera in the late nineteenth-century. Field photography had been pioneered during the Civil War by Mathew Brady and his associates, and the photographer's record soon seriously rivaled that of the expeditionary artist. The development of portable, wet-plate camera equipment and the means for printing photographs for mass distribution and publication launched a new era in Western photography.[11] Today depositories like the United States Geological Survey, the National Archives, and the Smithsonian Institution in Washington, D.C., contain large collections of field photographs of Indians as well as of visiting Indian delegations photographed in Washington studios. Among the studio photographs is one of the Kansa warrior *Ka-Ke-Ga-Sha-Kansas* [*Pi Sing*], *Kansa Indian,* taken by Antonio Zeno Schindler in 1868 (see plate 49).

Plains Indian delegations began to visit the nation's capital in the first years of the nineteenth century. Several early visitors—such as the Osage—were portrayed by the French refugee artist Charles-Balthazar-

48. Samuel Seymour, *War Dance [Dog Dance] in the Interior of a Kansa Lodge.* 1820

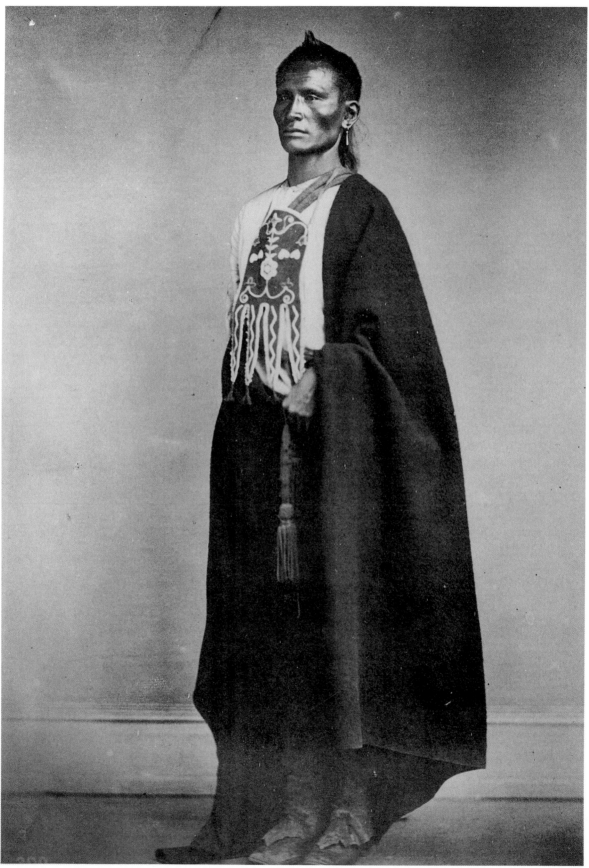

Julien Févret de Saint-Mémin (1770–1852) long before the camera had been invented. Saint-Mémin was born in Dijon, France, of Burgundian nobility.[12] His early training at the Ecole Militaire, from 1784, undoubtedly included instruction in topographical drawing and mapmaking. He also may have studied art briefly at the Dijon drawing academy, founded by the neoclassical French painter François Devosge.

Fleeing Europe after the French Revolution, Saint-Mémin and his father settled in New York in October 1793. There Saint-Mémin turned to drawing and engraving for a livelihood, and in 1796 formed a partnership with a former French military officer, Thomas Bluget de Valdenuit. Valdenuit introduced him to the physiognotrace, a device that had made profile portraits popular in France since its invention by Gilles-Louis Chrétien in 1786. The three-legged device was about five feet high, and in its center, on a flat vertical surface, it held a piece of paper about twenty inches high. Attached to the bottom of the stand was a pantograph, which extended upward across the paper, and attached to the top of the pantograph was a rod with a small eyepiece in the center. Looking through the eyepiece at the sitter, the operator moved the vertical rod along the subject's profile as a pencil at the lower end of the rod traced the profile on paper.[13] The blocked-out portrait was then completed in chalk. If the patron wanted an engraving, the image could be reduced in size with the pantograph.

Saint-Mémin probably drew *An Osage Warrior* (plate 50) in spring 1807. The artist first made a profile outline in crayon using the physiognotrace. With the device again, he profiled his sitter in a reduced size and then filled in the outline with watercolor. The stippled brushwork suggests his involvement with engraving. Although the physiognotrace enabled Saint-Mémin to produce a realistic portrait, he developed the image in a neoclassical style that suggests medals of the time. Each of the eight crayon drawings and five watercolors known to be by his hand—including the Osage—seems to convey a distinct personality. *An Osage Warrior* was purchased by Sir Augustus John Foster, secretary to the British ambassador in Washington from 1804 to 1807.[14]

Aside from the ear ornaments and the facial and body decoration, the most striking and unique feature of the watercolor is the bird attached to the front of the warrior's head with green plant material. Most likely it is the Carolina parakeet (*Conuropis cardinensis*), a wild species once native to the American Southeast, with egret plumes (*Egretta thula*) as added decoration. Emblematic of the personal medicine of this warrior, the bird is a protective spiritual power. It also may relate to the warrior's name or his clan affiliation, for in traditional Osage culture the hairstyle of a male designated his familial association. Bird medicine is commonly associated with specific physical attributes as well, such as keen eyesight or swiftness, that might be sought by the wearer.

There is some confusion over the precise identity of this Osage warrior, in part because three different Osage delegations traveled to Washington, D.C., beginning in January 1806. One group of Osage, along with Kansa, Oto, Pawnee, Iowa, and Dakota representatives, met with President Jefferson on January 4, and then went on to other East Coast cities. On April 11, other Osage tribesmen in company with Missouri, Kansa, Iowa, Oto, Sauk

49. Antonio Zeno Schindler, *Ka-Ke-Ga-Sha-Kansas [Pi Sing], Kansa Indian*. 1868

and Fox, and Potawatomi dignitaries, visited the capital and met the president. On December 31, a third group, six leaders of the Arkansas band of the Osage, met with Jefferson and toured a number of East Coast cities. (This delegation was led by Auguste Chocteau, the Saint Louis fur trader.) During these tours, they frequently received gifts, like the silver armband with eagle designs worn by Saint-Mémin's *Osage Warrior*. The silver armbands illustrated in plate 51 were made by David Windsor, a London silversmith active in the late eighteenth and early nineteenth centuries, and similar armbands, flags, medals, and gorgets (breastplates) were often among the gifts presented to Indian delegations at treaty signings. Although documentation relative to Saint-Mémin's travels and work is incomplete, the artist was active in Washington and Philadelphia in spring 1807, and he may have painted the *Osage Warrior* at that time.

President Jefferson welcomed these tribal-delegate visitations to Washington as opportunities to inform tribal leaders that the United States and not France or Spain now controlled the territory inhabited by the Indians. Jefferson's presidential role as "father" of the nation's Indian "children" is evident in several of his speeches to tribal delegates. Meriwether Lewis himself accompanied a tour of chiefs of the Mandan nation, along with a French interpreter, the wife of one of the chiefs, the interpreter's wife, and three children, arriving in Washington on December 28, 1806. Both this party and Chocteau's seem to have been sketched and painted by Saint-Mémin, probably early in 1807. Some scholars speculate that these portraits were commissioned by Lewis in spring 1807, because his ledger entry shows that he paid Saint-Mémin the sum of $83.50 for the "likenesses of the Indians &c necessary to my publication."[15] Supposedly, they were to illustrate Lewis's personal report of the Lewis and Clark Expedition, but the report was never completed, apparently because of Lewis's untimely death that year. In 1807, Saint-Mémin also painted a full-length portrait of Lewis in his explorer's outfit, possibly for the same publication. The watercolors purchased by Foster may well have been the same Indian portraits commissioned by Lewis.

The many Indian delegates who came to the capital to negotiate treaties with the government in the early nineteenth century also were portrayed by Charles Bird King (1785–1862). In this active period of government negotiations with Indians who ceded their lands for America's frontier expansion, at least eighteen treaties were signed in Washington, D.C., from 1824 to 1838, and each ceremony was attended by a delegation of tribal chiefs and leaders.[16] Charles Bird King and George Catlin (see p. 95ff.) made paintings of more Indian tribes than did any other artist of their times, and for more than twenty years King was the country's most important painter of Indian statesmen.

Trained in London at the Royal Academy and later under Benjamin West, King acquired the traditional skills to enlarge his understanding of Western painting before he returned to the United States on the eve of the War of 1812. In 1819 he established a permanent studio in Washington, D.C. His career as a Washington artist coincides with that of Thomas L. McKenney, who in 1817 became superintendent of Indian Trade and in 1824 superintendent of Indian Affairs. A natural outgrowth of McKenney's continuing interest in documenting Indian history and lifeways was the

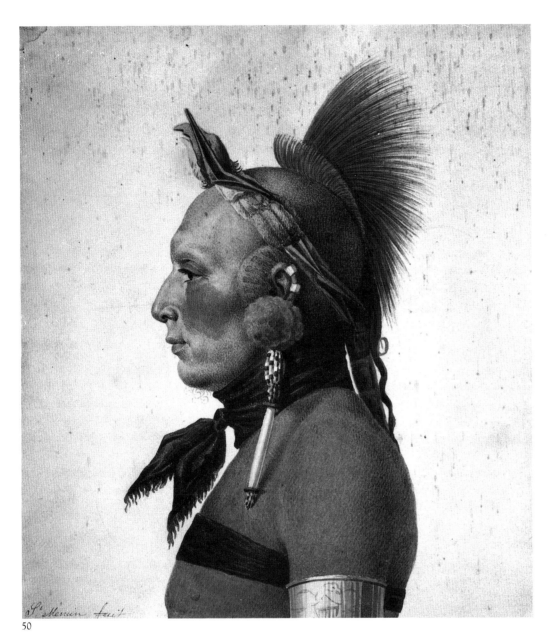

50

51

50. Charles-Balthazar-Julien Févret de Saint-Mémin, *An Osage Warrior.* c. 1807

51. Armlets

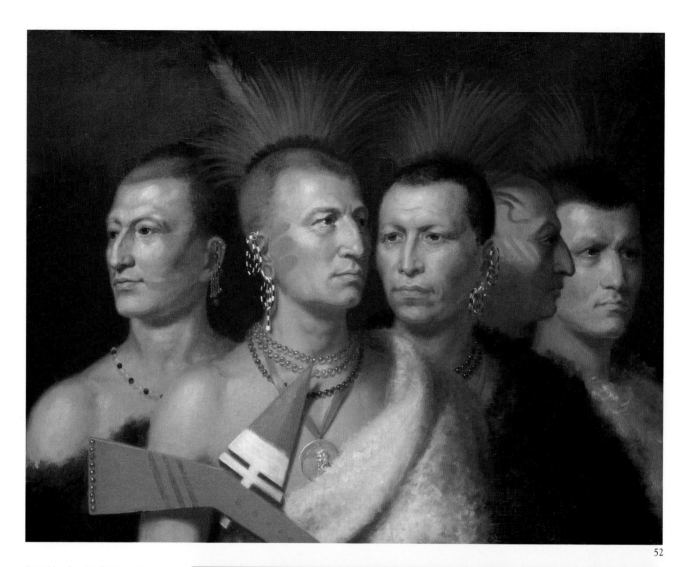

52

52. Charles Bird King, *Young Omawhaw, War Eagle, Little Missouri, and Pawnees.* 1822

53. Club (Gunstock). Before 1860

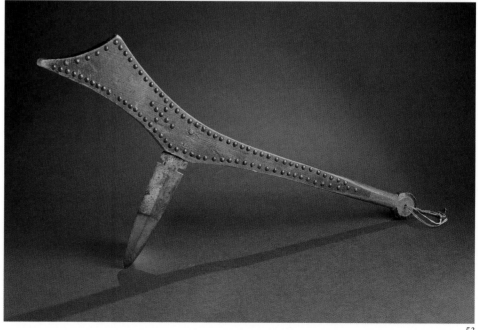

53

commissioning of portraits and cultural scenes. For these, he turned to King, whose own portrait gallery may have suggested the idea. Although the artist painted other Washington dignitaries and their families, his portraits of Indians gave him the most lasting fame. King painted approximately one hundred Indian portraits from 1821 to 1842 and copied almost thirty more from previously commissioned or government-owned portraits. Included in this legacy were representations of at least twenty different tribes from the Plains, the Great Lakes, and the Southeast, many of which were lost in the Smithsonian fire of 1865, three years after King died. Much of King's work was copied by John Inman and published as lithographs in the monumental, three-volume work *The Indian Tribes of North America . . .*, first offered to the public between 1836 and 1844 as a joint venture by McKenney and James Hall.

Charles Bird King's initiation into Indian portraiture began when a group of tribal leaders from the Plains (Kansa, Missouri, Omaha, Oto, and Pawnee) visited Washington in winter 1821–22. The warriors King portrayed were members of the delegation led by Benjamin O'Fallon, then an Indian agent in Saint Louis (see plate 52). Generally considered among his best Indian portraits, *Young Omawhaw, War Eagle, Little Missouri, and Pawnees* was not painted for the Indian Gallery in McKenney's office in the Department of War, but rather for King's own picture gallery in his Twelfth Street studio, where John Chapman acquired it.

In *Young Omawhaw, War Eagle, Little Missouri, and Pawnees*, King has made the striking figure of War Eagle the focal point of his composition. The directions of these bold faces and the strong patterning of light and dark create a sense of movement within a symmetrically composed picture.[17] The close resemblance among the five faces invited criticism from King's contemporaries. (A resemblance can be seen between the Pawnee on the far right and the bust portrait of another Pawnee, *Peskelechaco*, painted by King.)[18] Although the faces are somewhat idealized, in many respects each subject seems to be an individual portrait. Brought together in a single painting, however, they do not really relate to each other. If we can rely on the words of the English traveler William Faux, who also saw the leaders of the 1821–22 delegation in Washington, the artist seems to have captured the essence of his sitters: "All of them were men of large stature, very muscular, having fine open countenances, with the real noble Roman nose, dignified in their manners, and peaceful and quiet in their habits."[19]

King's observations of ethnographic detail have enhanced our knowledge of Indian lifeways. The most prominent artifact in this painting is the knife-blade club held by War Eagle (plate 53). Knife clubs like this (also called "gunstock clubs") were recorded as early as the seventeenth century on the Plains; their distinguishing features are the rifle-stock shape of the wooden club and the form of the attached knife blade. Such knife blades were manufactured and commonly traded to Indians without handles, to be used as knives (commonly called "dags," short for daggers), fitted into clubs as this one is, or fastened to long stick handles to use as spears. The slits on either side of the blade near the base hold the handle fast to the knife blade. Here, they are decorative notches. Other decorative elements are the brass tacks at the end of the club and the painted designs at its center.

54. James Monroe Peace Medal, obverse and reverse. 1817

55. Mathew B. Brady, *Four Delegations of Indians (One of Them Pawnees), at the White House, Washington, D.C., December 31, 1857*

Painted designs like those on the faces of four of the warriors, usually relate to personal protective medicine and on occasion to requirements for certain religious rituals. Because these are half-portraits, it is impossible to know the positions of the buffalo robes, which were conscious means of communication, sometimes referred to as the "language of the robe." Of the nine message-conveying robe positions that are known, two present the robe off one shoulder. One of these is a courtship message and the other a message of admonition. Variations in hairstyle within both the Omaha and Pawnee tribes signify clan affiliation. At least three of the figures sport hair "roaches"; but only the backs of their heads reveal their hairstyles and thus their clan affiliations. Bead ear ornaments and necklaces as well as the President Monroe "peace medal" (worn by War Eagle) complete the picture's ethnographic and historical content (plate 54). The American Indian considered the peace medal among his most prized possessions. It gave him status among his people and at times showed his allegiance to the United States government. The custom of giving peace medals began with the Spanish and French governments, and it was continued by the English and Americans. The solid-silver American medal, bearing the image of the

94

incumbent president, was made in several sizes, the largest for the most important chiefs.

Within a few decades, government offices turned to photographers for documenting Indian delegations. Two of the earliest known photographs of Indian delegations in Washington were made on December 31, 1857 (see plate 55). In one of these photographs, Indians, interpreters, and dignitaries are gathered in front of the south portico of the White House, and in the other the same group is seen on an adjoining lawn. Four separate delegations are represented: Pawnee, Ponca, Potawatomi, and Sac and Fox. They had come to the capital to discuss grievances and to negotiate treaties with the "Great Father," in this case President James Buchanan. At the conclusion of the meetings and ceremonies the entire party, except for the president, assembled outside for pictures.

A decade after Seymour and Peale's travels of 1819–20, a large corpus of work was made of Plains Indians in situ. In 1832–33, George Catlin (1796–1872) and Karl Bodmer (1809–1893), traveled to the Upper Missouri River to record the tribes residing there. Their extra-artistic contribution is particularly valuable because the smallpox epidemic of 1837 decimated the agricultural tribes of the Upper Missouri—the Mandan, Hidatsa, and Arikara.

Catlin and Bodmer each made two portraits of the Mandan warrior Mató Tópe, painted within two years of each other (plates 56 and 57). These pictures along with Catlin and Maximilian's written accounts of Mató Tópe (Four Bears) are important documents of northern Plains Indian history. Both artists, as well as Prince Maximilian, Bodmer's employer, found Mató Tópe a remarkable individual. According to Maximilian, Mató Tópe, as second chief of the Siouan-speaking Mandan, lived at Metutahanke (Mih-Tu Ta Hang Kush), one of the two Mandan villages remaining on the Upper Missouri River after the epidemic. There he enjoyed a reputation among both whites and Indians as the most popular Mandan leader. Among the Mandan, the position of primary chief was usually inherited from one's father or possibly from another, older, male relative, which probably made Mató Tópe's rank the highest attainable for a Mandan male not related to a primary chief.

There may have been as many as nine Mandan villages in the eighteenth century, but by 1800 intertribal warfare and European diseases had sharply reduced their number. In 1804, for example, Lewis and Clark reported the tribe's population to be about 1,600, living in two villages. For the most part the Mandan were horticulturalists, growing corn, beans, squash, and tobacco on the river's alluvial plain. They also engaged in widespread trade, primarily with the hunting tribes to the north, west, and south. Mandan agricultural products were bartered for dried buffalo meat and dressed animal hides as well as other items abundantly available to their more mobile hunting and gathering neighbors on the Plains. Later, European and American manufactured goods—especially firearms—were considered particularly desirable, and the Mandan villages became important centers for exchanging these new products and for horse trading. All this ended for the Mandan with the epidemic of 1837. Mató Tópe was not among the survivors, since he took his own life after his wife and at least one child died of smallpox.

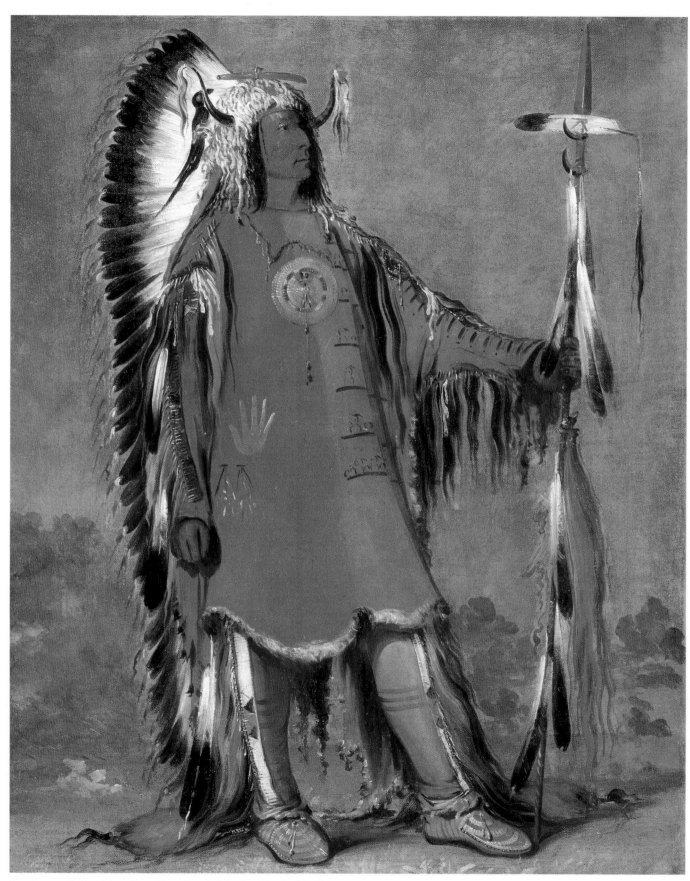

56. George Catlin, *Mató-Tópe (Four Bears), Mandan Chief.* 1832–34

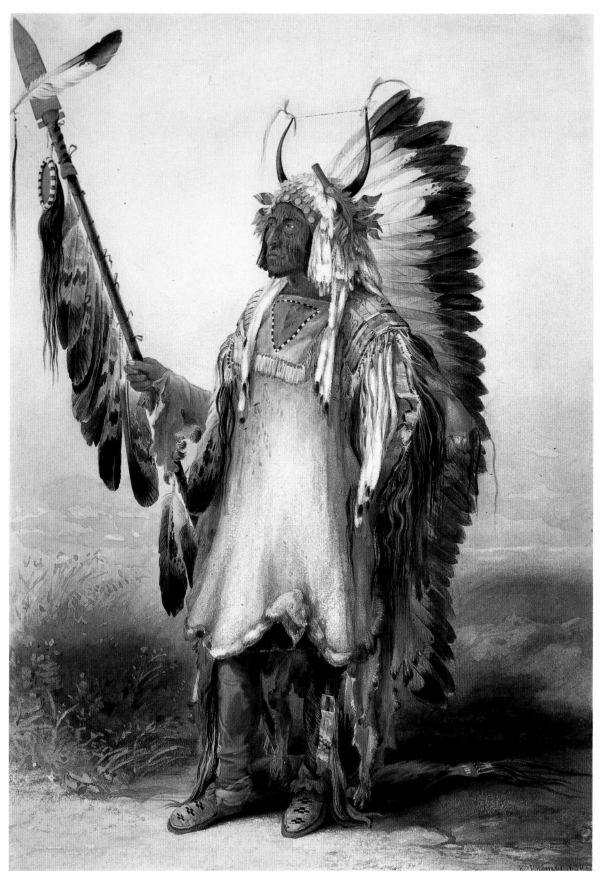

57. Karl Bodmer, *Mató-Tópe (Four Bears), Mandan Chief.* 1833–34

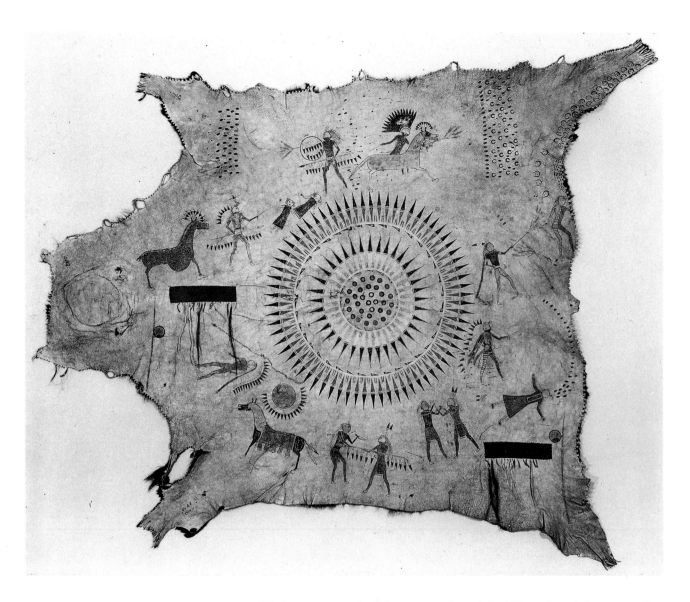

58. Mandan Buffalo Robe

We know a considerable amount about Mató Tópe, largely because of his friendships with James Kipp, George Catlin, and Prince Maximilian. A trader in charge of Fort Clark, the American Fur Company outpost adjacent to Metutahanke, Kipp was Catlin's interpreter in summer 1832, when the artist painted Mató Tópe, and then later for Maximilian in winter 1834, when Bodmer painted the chief. Each artist made two portraits of Mató Tópe in situ—one full-length and clothed and the other half-length with a bare upper torso—and typically Catlin later returned to this and other subjects several times.

Mató Tópe acquired the name Four Bears as a young man because of his brave acts in combat. At the time, he was leading a force of Mandan warriors when they encountered a larger number of Assiniboin in battle. Although his men retreated, Mató Tópe stood his ground, counterattacking and killing the leader of the Assiniboin. His fearless actions were likened by the Assiniboin to those of "four bears." To appreciate fully the significance of this adopted name, one must be aware of the important Bear Cult that existed among the Assiniboin. Most Indians fear the bear as a

powerful, vicious animal, and they believe that some men possess the bear's power, which makes them much fiercer than other warriors.

Mató Tópe's painted buffalo-skin robe and shirt are the principal sources of his biography. For Catlin and Maximilian, Mató Tópe interpreted the painted records of his military exploits that decorated these garments. Their friendship with the chief was permanently sealed when he gave each of them a replica of his handsome robe, which both Catlin and Maximilian's artist, Karl Bodmer, depicted.

Although Catlin's robe is lost today, it is known through the artist's illustration.[20] A third buffalo-skin robe, believed to have belonged to the warrior too, compares closely with the two documented examples given to Catlin and Maximilian (see plate 58). On each robe, eight episodes of war (Catlin's depicted twelve) surround a large, central, stylized sun motif. The drawings are outlined in brown-black and filled in with the brown-black, green, red, or yellow. The figures seem to correspond to the personal record of Mató Tópe on the robes depicted by Catlin and Bodmer, indicating that this robe probably belonged to the warrior.[21]

Both Catlin and Maximilian's writings state that the spear Mató Tópe holds in Catlin and Bodmer's portraits was one that had tasted the blood of his enemies. The chief acquired the spear when he removed it from his dead brother's body, after Won-ga-top, an Arikara, had killed him, and later Mató Tópe used it to avenge the murder. Catlin tells us that the eagle feather crossing the spear blade in both portraits was placed there on the chief's directive. Avenging the murder, Mató Tópe drove the spear into Won-ga-top, dislodging an eagle feather from the shaft. The feather remained in the fatal wound, until Mató Tópe retrieved it before escaping from Won-ga-top's lodge in an Arikara camp. From that day forward, he believed that he possessed "good medicine."

The miniature, red-painted, wooden knife atop Mató Tópe's buffalo-horned headdress in the Catlin and Bodmer portraits is related to another battle feat by the chief, an instance of hand-to-hand combat. Grasping a Cheyenne warrior's knife, Mató Tópe severely wounded his palm. After disarming his enemy, Mató Tópe killed him.

Aside from the lance and the headdress, no other item of clothing seems to be duplicated in these two full-length portraits. Both Catlin and Maximilian have left careful written descriptions of the chief, and these present no major inconsistencies. Both observers note that Mató Tópe had many changes of clothing and that most of the shirts he wore were acquired as trade goods rather than manufactured by the Mandan. Mandan men rarely wore animal-skin shirts, except in winter or on festive occasions, preferring in warm weather to wear only a breechcloth or a buffalo robe wrapped about the upper body. For each of the portraits illustrated here, however, Mató Tópe wore a different shirt of mountain sheepskin.

While there are obvious costume differences in the two portraits—the shirts and the moccasins—the legging decorations deserve special comment. The three stripes on the leggings painted by Catlin indicate that Mató Tópe had "touched" an enemy. The same iconography applies to the red leggings in the Bodmer portrait, though generally only the left legging would be painted from the knee down. "Touching," or coup-counting (see p. 100), also explains the coyote tails tied to the chief's ankles in the Catlin

59. Mandan Bonnet. c. 1830

portrait. And the voluminous eagle plumage displayed by Mató Tópe in both portraits signifies his status as a great warrior and leader of men.

Mató Tópe's arrival at Catlin's makeshift studio was chronicled by the artist:

> Mah-to-toh-pa was coming in full dress! I looked out of the door of the wigwam, and saw him approaching with a firm and elastic step, accompanied by a great crowd of women and children, who were gazing on him with admiration, and escorting him to my room. No tragedian ever trod the stage, nor gladiator ever entered the Roman Forum, with more grace and manly dignity than did Mah-to-toh-pa enter the wigwam, where I was in readiness to receive him. He took his attitude before me, and with the sternness of a Brutus and the stillness of a statue, he stood until the darkness of night broke upon the solitary stillness. His dress, which was a very splendid one, was complete in all its parts, and consisted of a shirt or tunic, leggins, moccasins, headdress, necklace, shield, bow and quiver, lance, tobacco-sack, and pipe; robe, belt, and knife; medicine-bag, tomahawk, and war-club, or po-ko-mo-kon.[22]

Catlin's full-length ceremonial portrait of Mató Tópe shows a striking resemblance to heroic Roman images such as the *Augustus of Prima Porta* in the Vatican Museum, in Rome, primarily because of the profile stance and the arm extended with a ceremonial spear. The Swiss artist Karl Bodmer adopted the same pose for his full-length portrait of Mató Tópe and costumed him in a manner befitting his rank. Again, the warrior wears the Mandan bonnet reserved for distinguished chieftains. Both Catlin and Bodmer painted him wearing a feathered headdress with ermine-skin fringes crowned by shaved bison horns. As a rule, northern Plains tribes used the feathers of the young golden eagle to symbolize battle achievements either by the owner of the bonnet or, at times, by several warriors within a tribe. Battle honors often took the form of coup-countings, meaning that a warrior had "touched" and thus disgraced his enemy, gaining prestige for himself. The more coup-countings, the braver the warrior. Most scholars find the greatest elaboration of feather headdresses among the northern Plains tribes, for whom coup-counting was most important. Among these tribes are the Mandan, Hidatsa, and Arikara of the Upper Missouri and the Dakota, Crow, Omaha, and Plains Cree surrounding them to the east, west, south, and north, respectively. A Mandan bonnet like Mató Tópe's shows the same shaved buffalo horns that Catlin and Bodmer painted (plate 59). The owner of this bonnet, like Mató Tópe, was a member of the Dog Soldiers' warrior society, a group within the tribe, whose major task was to police the hunt. A man was chosen for this society because of demonstrated bravery.

Although Catlin took certain artistic license in his depictions of Indians, his animated portraits and scenes are important documents that augment our knowledge of early Plains Indian culture. Bodmer's work reveals a surer hand, reflecting his formal training in art, which is seen in the crisp detailing, subtle shadings, and graphic textures of Mató Tópe's costume. Ethnographically, the work of Catlin and Bodmer is of equal importance to anthropologists.

Catlin worked on with messianic fervor for almost six years (1830–36) to

chronicle the "living manners, customs, and character" of native Americans on the Great Plains, traveling along the frontier of western civilization from the Upper Missouri to the headwaters of the Mississippi and to the Mexican Territory of the Southwest. His mission was "to visit every tribe of Indians on the Continent . . . for procuring portraits of distinguished Indians, of both sexes in each tribe, painted in their native costume; accompanied with pictures of their villages, domestic habits, games, mysteries, religious ceremonies . . . with anecdotes, traditions, and history of their respective nations."[23] Some years later, he reflected on his luck at being "born in time to see these people in their native dignity, beauty, and independence."

In July 1832, on one of his many trips, Catlin journeyed down the Missouri River to observe and draw the Mandan's elaborate four-day religious ceremony called the O-kee-pa, a ritual that dramatizes their mythology of creation and the traditions of Mandan history. Catlin explained the threefold objectives of these ceremonies:

> First, they are held annually as a celebration of the event of the subsiding of the Flood, which they call *Mee-ne-ro-ka ha-sha;* secondly, for the purpose of dancing what they call *Bel-lohck-na-pic* [sic] (the bull dance), to the strict observance of which they attribute the coming of buffaloes to supply them with food during the season; and thirdly . . . for the purpose of conducting all the young men of the tribe, as they annually arrive to the age of manhood, through an ordeal of privation and torture, which, while it is supposed to harden their muscles and prepare them for extreme endurance, enables the chiefs who are spectators to the scene, to decide upon their comparative bodily strength and ability to endure the extreme privations and sufferings that often fall to the lots of Indian warriors; and that they may decide who is the most hardy and best able to lead a war-party in case of extreme exigency.[24]

In the third phase of the ceremony, the participants skewered the skin on their upper chest and back with long leather thongs attached to posts. In both pictures and letters Catlin recorded this gruesome test of manhood and fertility, well known only to a few frontiersmen until the artist published his detailed account in a letter in the *New York Commercial Advertiser* on August 5, 1832.

Catlin's *Bull Dance, Mandan O-kee-pa Ceremony* illustrated here, is an annual ritual and the second phase of the celebration (plate 60):

> This very curious and exceedingly grotesque part of their performance, which they denominated *Bel-lohck nah-pick* (the bull dance) . . . was one of the avowed objects for which they held this annual fête; and to the strictest observance of which they attribute the coming of buffaloes to supply them with food during the season — is repeated four times during the first day, eight times on the second day, twelve times on the third day, and sixteen times on the fourth day; and always around the curb, or "big canoe" (the drum-like shrine in the center of the open arena).[25]

The eight principal actors, almost naked and painted in an "extraordinary" manner, covered their backs with buffalo skins with horns, hoofs, and tail intact; with bent bodies they simulated the buffalo's behavior. Divided into

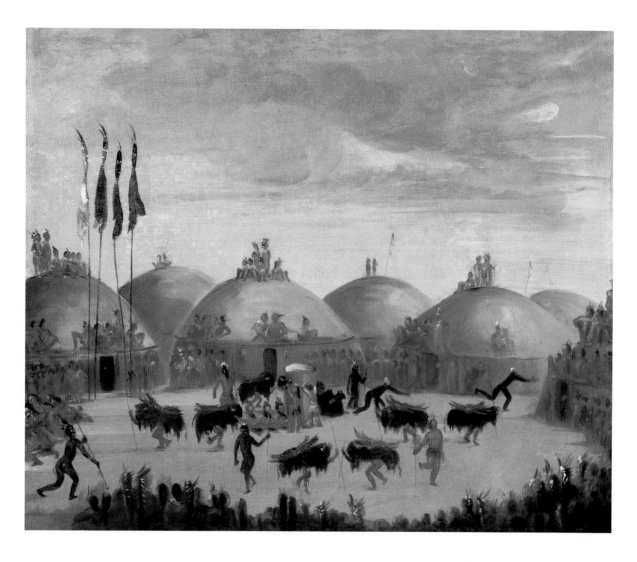

60. George Catlin, *Bull Dance, Mandan O-kee-pa Ceremony.* 1832

four pairs, the actors positioned themselves on the four sides of the "canoe," representing the four cardinal points. Elaborately painted, two actors were entirely in black, as night, with white dots representing stars; the other two were in red with white streaks, representing "ghosts which the morning rays were chasing away." Although there were only twelve dancers, "a great number of characters engaged in giving the whole effect and wildness to this strange and laughable scene," Catlin wrote. In *Bull Dance* the artist has vividly captured the entire scenario with all its paraphernalia, including a dance rattle made from the skin of a buffalo's scrotum (see plate 61).

At the conclusion of the four-day ceremony, Catlin retired to his Mandan earth lodge and transferred the strange scenes he had observed from sketches to canvas. He made four paintings of the ceremony, each representing a day's events, and these images closely follow the descriptions in his letters. Yet, because he felt the urgency of his mission and the exigencies of time in the field, Catlin often treated his subjects summarily. To provide the essential ethnological details, he often used a shorthand technique in his anecdotal scenes, painting the background first and then the figures over it. Despite limited time in the field, Catlin made a contribution to the field of American Indian ethnology unsurpassed by any other artist.

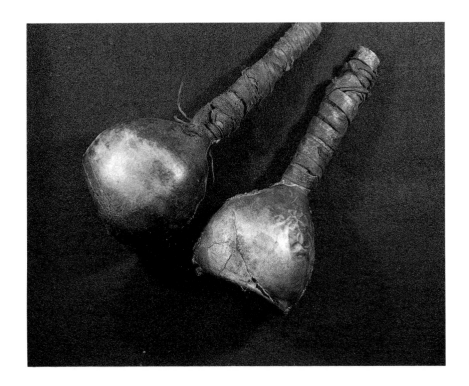

61. Mandan Rattles. c. 1840

Catlin's comments on the O-kee-pa brought the most telling criticism of his work, not as an artist but as an ethnographer. His allusion to a similarity between the Mandan language and the Welsh dialect, for example, was questioned in the 1850s by Henry Rowe Schoolcraft in his six-volume *Indian Tribes of the United States*. Schoolcraft rightly criticized Catlin's statement about the extinction of the Mandan after the smallpox epidemic of 1837. Indeed, over 120 Mandans survived the epidemic and a few years later affiliated with the Hidatsa and Arikara at a single village, Like-a-Fishhook, on the Missouri River near Fort Berthold. In 1852, in a brief article on the Mandan, Colonel David D. Mitchell, the Saint Louis superintendent of Indian Affairs, praised Lewis and Clark's report, damning Catlin's in a sentence: "The scenes described by Catlin, existed almost entirely in the fertile imagination of that gentleman."[26]

Catlin's granddaughter, Marjorie Catlin Roehm, has commented on Schoolcraft's criticism of Catlin: "Because George would not permit Schoolcraft to use his Indian paintings to illustrate his work, this petty politician was intent on killing the artist's former publications and the sale of his gallery. George later wrote that the French government had planned to purchase his Indian collection, and that he had learned from a reliable source that the negotiation was stopped from information received that the United States government had condemned his works as deficient in truth."[27]

To refute these charges, Catlin published *O-kee-pa*, in 1867, with a detailed account of the Mandan torture ceremony accompanied by engravings of the four paintings. The book did not sell because, by the authority of the United States, it was fiction. Catlin then made one last appeal to Congress: he pointed out that Schoolcraft had seen the paintings of the ceremony with certificates of authenticity attached to them, and as added

proof of his honesty there were letters from Baron Alexander von Humboldt and Prince Maximilian; he then asked that Congress do justice by purchasing copies of *O-kee-pa* for libraries that also owned Schoolcraft's books. Congress refused.

Two other tribal groups lived in lodges in settled villages along the Upper Missouri—the Hidatsa and the Arikara. Along with the Mandan, these tribes represent the agricultural Plains people who are more like the Woodland tribes than like the buffalo-hunting groups of the Great Plains. During the early part of the nineteenth century, the Assiniboin were among the nearest neighbors of these lodge-dwelling tribes. Confusion arises because the Assiniboin called themselves Dakota (as did the Sioux), meaning "our people." The Sioux called them Ho'-hai, or "fish-eaters," perhaps because they subsisted principally on fish when the territory belonged to the British. The Cree and Chippewa call them As-see-nee-poituc, or "Stone Indians," a name that was eventually translated into the English Assiniboin. Both Catlin and Bodmer painted the Siouan-speaking Assiniboin.

Assiniboin, or "stone boiler," according to Catlin, was the name given them because of a curious custom, "a singular mode they have of boiling their meat." He described the method: "When they kill meat, a hole is dug in the ground about the size of a common pot, and a piece of the raw hide of the animal, as taken from the back, is put over the hole, and then pressed down with the hands close around the sides, and filled with water. The meat to be boiled is then put in this hole or pot of water; and in a fire, which is built near by, several large stones are heated to a red heat, which are successively dipped and held in the water until the meat is boiled."[28]

The Assiniboin once belonged to the Sioux Nation, living on the tributary streams of the Mississippi at the heads of the Des Moines, Saint Peter's, and other tributaries. Separating from the Sioux, they moved northward, made peace with the Cree and Chippewa, and took possession of uninhabited land near the Saskatchewan and Assiniboine Rivers. Some time after 1777, the rest of the Assiniboin (about twelve hundred lodges) migrated toward the Missouri River and settled there in a location that was superior for game and trade. Until 1838, the tribe still had a thousand to twelve hundred lodges, before smallpox cut that number to fewer than four hundred.[29]

Catlin noted in his journal that the Assiniboin were "a fine and noble looking race of Indians" and that they were "good hunters, and tolerably supplied with horses; and living in a country abounding with buffaloes."[30] Among Catlin's portraits of distinguished Assiniboin is his double portrait of the warrior *Pigeon's Egg Head (The Light) Going to and Returning from Washington,* one of his best-known images of a Plains Indian (plate 62). Along with Catlin's descriptive account of the warrior, the portrait gives us a full sense of this colorful personality. His biography is often cited as epitomizing "the great American tragedy"—the native American's inability to cope with the white man's world and its corrupting influences. Catlin may well have intended such a statement, because he vividly relates the scenario of the tragic downfall of Pigeon's Egg Head in his *Letters and Notes.*[31]

This portrait is the second of two Catlin made of Pigeon's Egg Head. The

first was painted in Saint Louis, in fall 1831, when Pigeon's Egg Head and a small delegation of Assiniboin, Plains Cree, Plains Ojibwa, and Yanktonai Sioux were enroute to Washington to meet with President Jackson. Catlin states that "Wi-jun-jon was dressed in his native costume, which was classic and exceedingly beautiful; his leggings and shirt were of mountain-goat skin, richly garnished with quills of the porcupine and fringed with locks of scalps taken from his enemies' heads. Over these floated his long hair in plaits; his head was decked with the war-eagle's plumes—his robe was of the skin of the young buffalo bull, . . . rich emblazoned with the battles of his life."[32]

The artist's second encounter with this group of Indians occurred in spring 1832, on their return from Washington, D.C., while traveling upriver to Fort Union on the steamboat *Yellowstone*. According to Catlin, Wi-jun-jon made his appearance on deck in a

full suit of regimentals! He had in Washington exchanged his beautifully garnished and classic costume, for a full dress 'en militaire.' . . .It was broadcloth, of the finest blue, trimmed with lace of gold; on his shoulders were mounted two immense epaulettes; his neck was strangled with a shining black stock, and his feet were pinioned in a pair of waterproof boots, with high heels. . . . On his head was a high-crowned beaver hat, . . . surmounted by a huge red feather. . . . A large silver medal was suspended from his neck by a blue ribbon—and across his right shoulder passed a wide belt, supporting by his side a broad sword. . . . In this fashion was poor *Wi-jun-jon* [Pigeon's Egg Head] metamorphosed, on his return from Washington; and, in this plight was he strutting and whistling Yankee Doodle.[33]

In his double portrait, Catlin seems to express his shock and dismay at what had happened to this warrior since their last meeting. The artist intentionally shows him from behind to indicate how far this native American had strayed from his customs by adopting the trappings of the white man. A slight tipsiness and the arrogance of the dandy is suggested by Catlin as the warrior puffs on a cigarette, which has replaced the calumet he holds in the other half of the portrait (see plate 63). Perhaps in the meaning and use of tobacco Catlin has most subtly stated the degree of cultural change experienced by this Assiniboin warrior. For the Indian, the use of tobacco in a pipe—the act of smoking and passing the pipe—is one of great reverence and symbolizes affirmation, friendship, and even peace. In contrast, the use of tobacco in a cigarette suggests the white man's addiction to a narcotic as well as its trivial, commonplace status in American and European cultures.

Nor can the military uniform of the dandy compare with the colorful native costume represented before the departure for Washington, D.C., in which we see a carefully described, two-disk shirt and the soldier's headdress (plates 64 and 65). A similar shirt and leggings once belonged to a Teton Sioux warrior who traveled to Europe in the mid-nineteenth century, possibly with Catlin. Both items were found in Paris in the 1950s and subsequently returned to the United States. Like the decorations on the two-disk shirt depicted by Catlin, the design on this shirt consists of two small, porcupine-quilled circles affixed to the shirt front above the breast. Disk shirts, traded throughout the Upper Missouri area, may have held

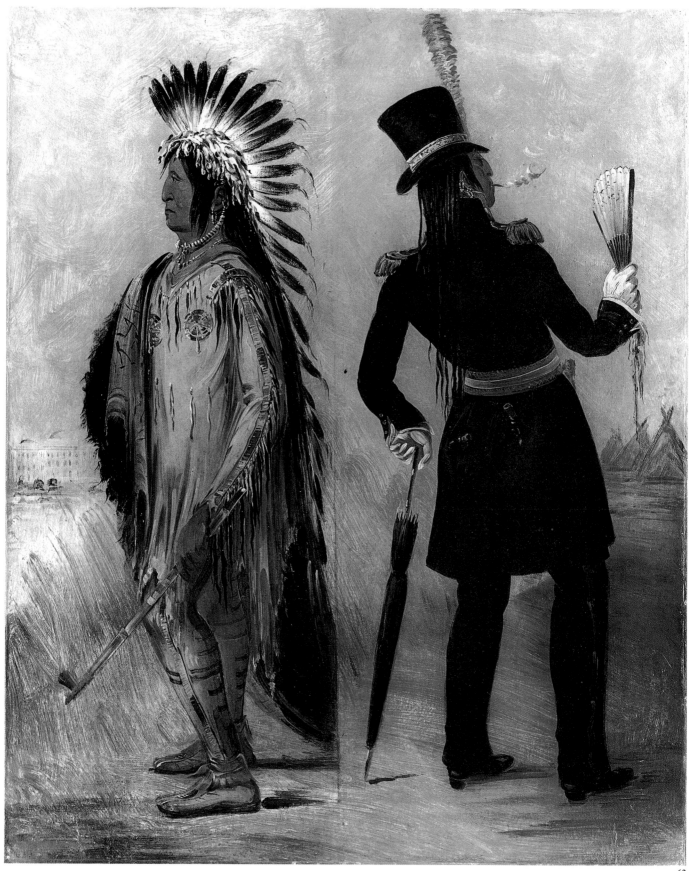

63

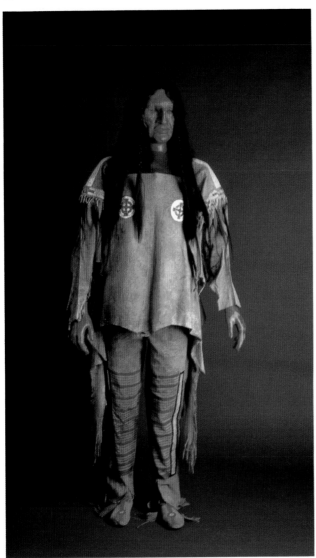

64

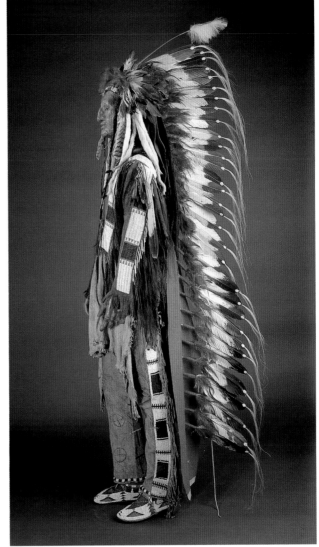

65

62. George Catlin, *Pigeon's Egg Head (The Light) Going to and Returning from Washington.* 1837–39

63. Sioux Pipe

64. Teton Sioux Two-Disk Shirt. c. 1830

65. Dog Soldier Headdress. c. 1850

some spiritual protective power for the wearer. The leggings are also painted. Like those of Pigeon's Egg Head, both shirt and leggings are made from antelope hide. Similar in type to the bonnet Pigeon's Egg Head wears, with some variations, the one illustrated here was collected at Grand River, South Dakota, on the Standing Rock Sioux Reservation. It belonged to a Hunkpapa Sioux who, like Pigeon's Egg Head, was a member of the warrior society. This bonnet differs in that a long eagle feather at its very center has had the feather removed from three-quarters of the shaft. The feather signifies that the bonnet's owner has made a Sun Dance, a religious ritual that attests to his endurance and ability to witness pain. (The beaded shirt and leggings on the mannequin have no relationship to Catlin's painting.)

For Pigeon's Egg Head, a circle of disillusion started with his trip to the great "White Father" in Washington and ended with his death at the hand of one of his people. Catlin related his story: returning to his people on the northern Plains, the warrior recounted his experiences, and many of the Assiniboin questioned the veracity of his reports. After one such challenge, he beat his accuser with a cane, defending his action as what a white man might do to a servant who had the audacity to question him. The same night the questioner killed Pigeon's Egg Head.

An account by the Upper Missouri River trader Edwin Thomson Denig employs what is now the widely accepted transliteration of the warrior's Assiniboin name "The Light"—Ah-jon-jon—instead of Catlin's Wi-jun-jon, or Pigeon's Egg Head. Plains Indian authority Paul Dyck suggests that the question may be moot, because native Americans often had more than one name. John Ewers observes that Denig's account carries the history considerably further, however. Denig spoke Assiniboin and his Assiniboin wife was Pigeon's Egg Head's sister. As a trader at Fort Union, Denig probably had better access to the warrior's story than did Catlin, who was constantly on the move. The murder of Pigeon's Egg Head provoked a series of revenge killings, first by his brother Le Sucre, costing him his life, and then by a third brother, Broken Cloud, who in turn lost his life within two years. Two more revenge killings followed. The chain was broken only by the smallpox epidemic of 1837–38, which severely disrupted all the native populations of the Upper Missouri.[34]

Why Pigeon's Egg Head was initially invited to Washington can only be surmised. Instead of the usual explanation that he was brought there to witness the might of the United States, he and other early native American delegations from the northern Plains may well have been invited East to be wooed in the fur trade competition between American and British companies. Ewers postulates that the warrior and his fellow delegates traveled at taxpayer expense on the urging of John Jacob Astor's American Fur Company, which was locked in competition with the Hudson's Bay Company for the fur trade in the northern Plains.

The Plains Indians certainly were not living in an autochthonous state when Catlin and Bodmer painted them. Contact during the seventeenth and eighteenth centuries with European and American traders had already led to significant dislocation to both Woodland and Plains tribes. A year after Catlin's 1832 travels, Prince Maximilian of Wied-Neuwied with his expeditionary artist, Swiss watercolorist Karl Bodmer, closely followed both the trail and the philosophy of documentation set by Catlin. At

twenty-three, Bodmer's skill as a draftsman came to the attention of the prince, who was inspired by the great German explorer-naturalist Alexander von Humboldt. Maximilian's consuming passion for natural history had led him on an extended expedition to Brazil, which resulted in a two-volume account of his journey. In North America he continued to collect artifacts as well as natural history specimens and to record the customs and languages of the Indian tribes he observed—all with the intention of producing another multivolume work, illustrated this time by a professional artist.

In May 1832, Bodmer and his patron left for America, and after visiting prominent scholars and German-American citizens in several cities the pair reached Saint Louis in March 1833. A warm welcome awaited them from the former explorer General William Clark, who gave them maps of the Upper Missouri region first surveyed by Lewis and Clark as well as an opportunity to see the work of George Catlin and Peter Rindisbacher.

Clark persuaded Maximilian to alter his original plan to travel overland to the Rocky Mountains and then to the Spanish colonial capital of Santa Fe. Instead, he recommended that the pair travel up the Missouri River under the protection of the American Fur Company, a dominant force in the fur trade as well as in the administration of Indian affairs. Their contact, therefore, was with "friendly" Indians at the company's river trading posts, and the company's boats conveniently accommodated their supplies and collections. Leaving Saint Louis on the *Yellowstone,* on April 10, they traveled up the Missouri River. They frequently ran aground on treacherous sandbanks or had to unload their belongings and disembark because of impending storms. At Fort Lookout, the Sioux Agency, Maximilian met his first Sioux, Wahktageli, a Yankton chief. At Fort Pierre, a large American Fur Company post, they met many more Yankton and Teton Sioux, and Maximilian's journal abounds with information about the physical appearance, dress, and customs of these people.

The term Sioux is often misunderstood and misused. Sioux or Siouan is a designation of linguistic affiliation, although it is frequently applied to a confederacy of Siouan-speakers, more accurately termed the Dakota. But this term is problematic, too, in that there are three Siouan dialects spoken by the Dakota: a western variant referred to as *Lakota,* a central dialect termed *Nakota,* and an eastern group properly called *Dakota.* At the time of first contact with Europeans, Siouan-speakers were the most numerous Indian group north of Mexico.

The Siouan-speakers that Bodmer and Catlin encountered on the Upper Missouri River used Lakota and Nakota. Relatively recent migrants to the Plains in the seventeenth century, the Lakota had lived in present-day north-central Minnesota. Under pressure from other tribes in the western Great Lakes, they moved west onto the Plains, beyond the Missouri River, where Lewis and Clark found them in 1805. There they were known as Teton, or Teton Sioux, the English-language corruption of a Siouan word meaning "dwellers on the prairie." Within their Teton Sioux confederacy are a number of bands or subgroups, including the Oglala, the Brule, the Blackfoot (not to be confused with the Blackfeet), the Miniconjou, the Sans Arc, the Two Kettle, and the Hunkpapa. All speak the western dialect of Sioux, namely Lakota. Maximilian estimated that in all, the

66. Karl Bodmer, *Chan-Chä-Uiá-Teüin, Teton Sioux Woman.* 1833–34

Horizontal striped *Bilaterally symmetrical* *Feathered circle* *Border-and-box* *Border-and-hourglass*

Teton Sioux comprised about one-half of the tribe now popularly termed "the Sioux."

Named after the French trader Pierre Chouteau, Fort Pierre was the newest and one of the largest American Fur Company outposts on the Missouri. On the west side of the river, Maximilian pointed out a group of thirteen Sioux tipis, the remnants of a much larger camp:

> We visited the Indian tents uninvited; in that which we first entered there were several tall, good-looking men assembled; the owner of the tent was a man of middle-size; his complexion very light, and his features agreeable. His wives were dressed very neatly, and were remarkably clean, especially the one who appeared to be the principal; she wore a very elegant leather dress, with stripes and borders of azure and white beads, and polished metal buttons, and trimmed as usual at the bottom with fringes, round the ends of which lead is twisted, so that they tinkle at every motion. Her summer robe [a buffalo hide with the hair removed to make it lighter in weight], . . . dressed smooth on both sides, was painted red and black, on a yellowish white ground.[35]

Bodmer painted *Chan-Chä-Uiá-Teüin* at Fort Pierre (plate 66). The young woman's Teton name, generally translated as "Woman of the Crow Nation," has never been fully explained.[36] Her beautiful costume, particularly her robe, is probably decorated with what John Ewers called a border-and-box pattern, although little of the painted design is visible. Undoubtedly it is one of the five generalized geometric patterns used to decorate women's robes. The other four patterns are border-and-hourglass, feathered circle, horizontal striped, and bilaterally symmetrical—terms applied by American historians and anthropologists, not by native Americans (plate 67).

Traditionally, a kind of gender differentiation has existed in paintings by Plains Indian men in contrast to those by Plains women. Geometric, nonrepresentational, or "abstract" painted designs are considered the work of women, while representational painted designs are attributed to male artists. Although there are exceptions, this division persisted until the end of the nineteenth century, when traditional Plains Indian culture became widely disrupted.

The border of the border-and-box design generally is said to derive from the outline of a skinned-out, or splayed-out large animal (such as a buffalo) and the interior box from the animal's viscera. Beyond this iconography are the underlying religious implications of the animal design—the Indian's vital need for the animal's procreation to ensure tribal success in hunting.

67. Painted Design Styles for Plains Woman's Buffalo Robe

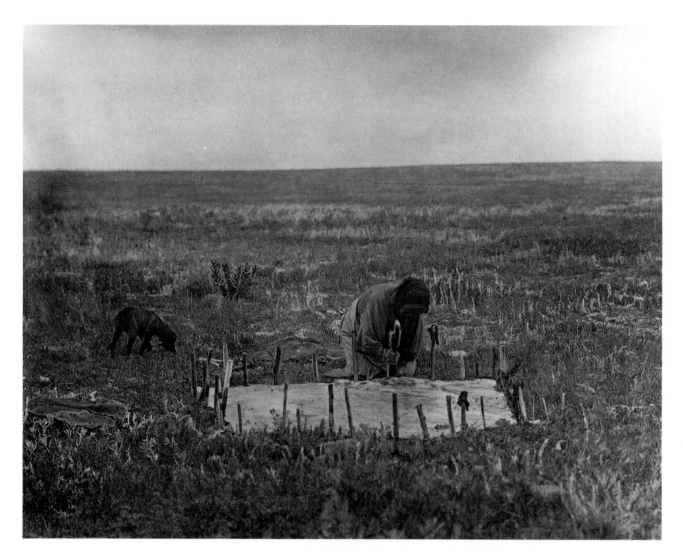

68. Walter McClintock, [Blackfeet Woman] Tanning a Skin—Fleshing a Hide. c. 1900

The robe itself reflects a gender division of labor among the Plains Indians. In hunting large animals, especially the buffalo, men tracked down and killed the animal, and women and children prepared the meat and hide for eventual use. Women tanned the buffalo skins, stretching them on the ground to dry in the sun, working the skins with the animals' brains to make them soft. A woman's painted robe was a tangible daily reminder of the animal's place in her culture as well as of her role in that world. The photograph of a Blackfeet woman tanning a hide with a bone tool sharpened at one end (plate 68) was taken by Walter McClintock (1870–1949), who was commissioned by the United States government to photograph the tribe. In spring 1896, McClintock made the first of many visits to Blackfeet reservation lands in northwestern Montana and the Province of Alberta, at the foot of the northern Rockies.[37]

After a two-week stay at Fort Union, from June 24 to July 6, 1833, (where Maximilian's *Yellowstone* reached the limits of its passage on the Missouri), the party boarded a keelboat, the *Assiniboine*, on July 6 and headed for Fort McKenzie, 500 miles upstream. Arriving at the fort on August 9, they were greeted by "800 Blackfeet men and throngs of women and children." During their five-week stay, Maximilian observed the Black-

feet closely and filled his journal with details of their customs and dress.

Although scholars disagree to some extent about the meaning of the word "Blackfeet," this tribal name is probably a contraction of two Algonquian words that literally mean "black" and "foot." Discoloration caused by the ashes and residue of prairie fires on the moccasins worn by these Indians is one explanation for the origin of this name. Another suggests that the practice of painting the tops of their moccasins black may have resulted in the term being applied to their wearers. Today the term Blackfeet is used to signify a three-part division of a confederacy of Algonquian speakers—the Blood, the Piegan, and the Blackfeet proper (sometimes called the Siksika)—that historically occupied a huge area of the northern Plains in both Canada and the United States.

Maximilian's journal describes the party's five-week stay at Fort McKenzie until September 14, 1833. At this westernmost outpost of the American Fur Company, the European visitors as well as their American trader-hosts were at the edge of the white man's world on the northern Plains. There is obvious trepidation when Maximilian mentions the size of the Blackfeet party camped outside the fort and the forceful actions taken to limit Indian entry to the fort, as well as the rivalry between Indian groups for access to the traders.

At Fort McKenzie, Bodmer made many detailed portraits of prominent Blackfeet men. John Ewers notes that Bodmer's subjects were "chiefs or medicine men, many of them beyond middle age," such as the Plains warrior pictured here, dressed in an elk-hide robe emblazoned with his war exploits. Sketched at the fort on August 31, 1833, *Piegan Blackfeet Man* (plate 69) reappeared later, a small figure in the foreground of Bodmer's engraved panorama of the closely pitched Piegan camp.

Bodmer worked in a style characteristic of topographical artists of the late eighteenth and early nineteenth centuries. Over a faint pencil outline he laid fine washes of color and then built up his colors and details meticulously. One can observe his working methods, because many of his fine watercolors are unfinished. The Fort McKenzie watercolors undoubtedly were preliminary field sketches, executed as memoranda for his *Atlas* illustrations.

A close reading of Maximilian's journal gives an insight into Bodmer's resourcefulness in such a wild setting: "New arrivals at the fort generally came soon to us, and looked at Mr. Bodmer while drawing, which he continued very diligently, and without any opposition being made to it, because he had remarked that none of the men whose portraits he had drawn had been lately killed or wounded." Other methods of attracting and holding subjects for Bodmer to paint included "the musical box, in which they fancied that there was a little spirit, and many other European toys, [which] generally made a lively impression on these people, and afforded them much amusement."[38]

Bodmer's Piegan Blackfeet man wears an excellent example of the pictorial robe traditionally used by men on the Plains. Most scholars today classify these pictographic paintings according to the information they intend to convey—time counts on calendars, personal records or biographies, and imaginative records of visions.[39] The pictographic symbols on this man's robe detail the owner's major achievements in combat as well as

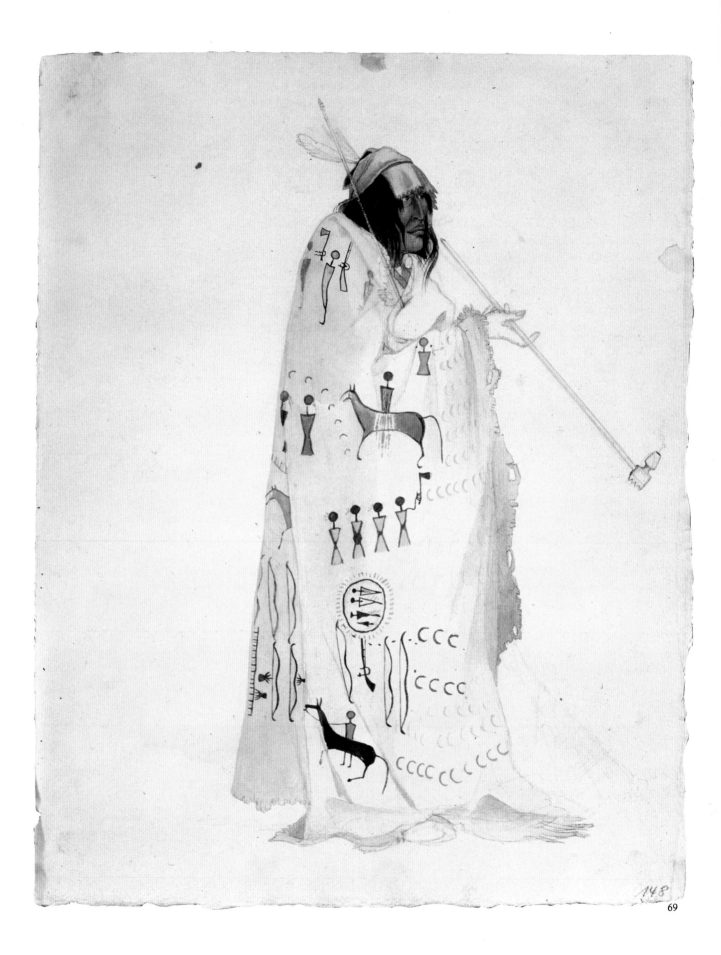

in raiding, and possibly, on part of the hide that is hidden from view, his romantic involvements. The painted symbols have meaning on at least two levels. First, they give evidence of the various tribal styles in which the image—a horse or a person—is depicted; and second, they can be read in terms of conventional meanings for a given symbol. For example, the man in blue, on the blue horse, is obviously wounded, and the red stripes (blood) slashing his upper chest indicate bravery and courage. The blue, red, and yellow-gold colors used on the human figures also designate tribal differences. Although Bodmer's painting does not show enough of the robe to allow a specific biographical interpretation, the pictographs imply that this Indian had successes in battle, stole many horses, captured many weapons, and killed or wounded several enemies during his lifetime as an active warrior.

Contrary to the expectations of English-speakers and readers, the placement of pictorial designs on robes of this age is rarely in a sequence from left to right or from top to bottom. They are often placed in a circular or circuitous pattern, without an easily discernible order. This native mode of pictorial representation usually ends when artists are exposed to persons from non-native cultures who "assist" them in portraying their life histories. With literacy comes the imposition on the native American's art of the white man's way of expressing himself in verbal and written form.

The importance of the buffalo to the Plains people of the nineteenth century can hardly be overstated, although the smaller aboriginal Plains population depended much less on the animal. The "buffalo culture" began to flourish with the arrival of Spanish horses after 1700, and the introduction of new technologies, especially firearms and metal-cutting implements and cooking utensils, made the Great Plains much more attractive to groups that formerly inhabited the Eastern Woodlands, Plateau, and Southwest fringe areas.

Plains culture was so strongly buffalo-oriented that even the settlement pattern of the hunting tribes mirrored the buffalo's pattern of movement. In winter, when the great herds dispersed, tribal groups also broke up, and in summer, when the herds came together again, tribal groups reformed. In this way the most efficient hunting units were maintained. Hunting buffalo by drives to a kill or jump site, imaginatively pictured in *Hunting Buffalo* by Alfred Jacob Miller (1810–1874), is a practice that predates the horse (plate 70). Indeed, horses and firearms may have been of minimal value in these hunts, since they were likely to frighten the buffalo into erratic behavior. Many scholars believe that men, women, and children on foot, using traditional weapons, achieved better results than men with rifles on horses. Scholars also have questioned the efficiency of jump-site buffalo hunting, because of the problems of butchering, processing, and transporting meat and other buffalo by-products. Horses, however, may have lessened the burden of transportation from distant sites.

Accounts of early European and American travelers, especially on the northern Plains, as well as Indian accounts and archaeological evidence, offer considerable evidence about such buffalo drives. They usually occurred in late fall, when the animals were at their prime after a summer's grazing. Although the drive was a communal activity, it involved a number of specialized personnel. On the northern Plains this included a pound-

69. Karl Bodmer, *Piegan Blackfeet Man.* 1833–34

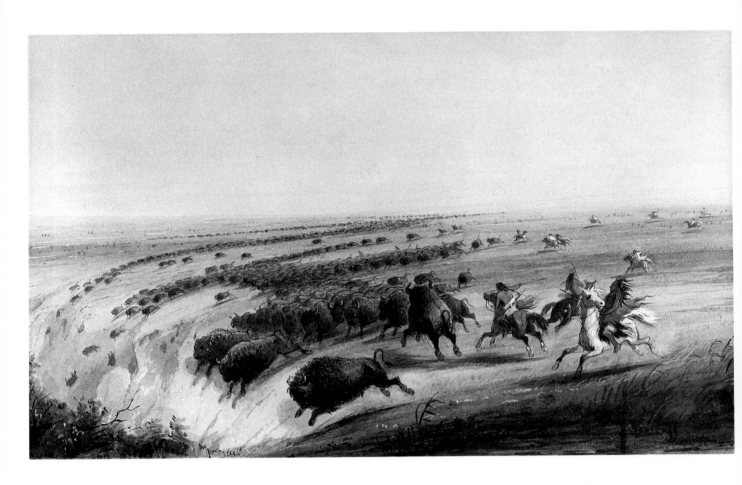

70. Alfred Jacob Miller, *Hunting Buffalo.*
c. 1858–60

maker, a holy woman, and a decoy runner. Despite the excitement and spectacle of driving buffalo to a jump site—less precipitous than the one shown by Miller, which would have smashed the animals to pulp—most buffalo drives ended in enclosures called pounds. Pounds were corral-like structures that often took advantage of features of the terrain, such as a box canyon, to contain the live buffalo. Frequently, they had sides, or "wings," that helped funnel the buffalo into the enclosure. They were constructed during late spring or early summer by a band or possibly an entire tribe under the direction of a pound-maker. A pound-maker in turn might depend upon a group of adult males (often members of a military society) to police the construction as well as the hunt itself. A religious specialist performed the necessary rituals before a drive, to ensure its success, and among many tribes these specialists were women. To attract a buffalo herd to the wings of a pound, a decoy runner enticed the lead buffalo toward the enclosure, arousing the animal's curiosity by dressing in an old buffalo or antelope skin (a scene George Catlin depicted). Once positioned, the herd could then be stampeded, trapped, and killed. Generally, a wounded or a captured buffalo would be killed with a short spear, sometimes called a killing spear, and subsequently butchered with a sharp knife (plate 71). The metal lancehead of the spear illustrated here is a Spanish trade item, and the brass tacks adorning the knife sheath were traded by the Hudson's Bay Company to the Indians of the northern Plains.

Alfred Miller traveled to the Wind River Mountains of western Wyom-

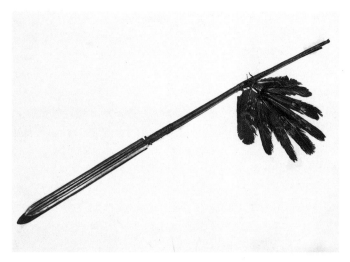

71. Left: Buffalo-skinning Knife with Scabbard; right: Killing Spear. c. 1840–50

ing with Scottish explorer Captain William Drummond Stewart in 1837. On this trip Miller accumulated enough sketches to turn out Western images for the rest of his life. A buffalo drive to a jump site was the subject of several paintings, and in *Taking the Hump Rib* and *Roasting the Hump Rib,* Miller recorded the butchering and cooking of buffalo meat.[40] In one sketch, Captain Stewart stands beside his white horse observing the removal of a buffalo's hump rib, an event Miller also recorded in his journal.[41] Most of Miller's sketches were done in pencil and embellished later with ink washes highlighted in China white. More immediate and spontaneous than his formal paintings, these studies better convey the character of the events.

Miller and his patron met by chance in the New Orleans studio Miller had established not long after his return from two years in Europe. Study and visits to Paris, Lyons, Rome, and Florence had led the young Baltimore artist to the work of Eugène Delacroix and J. M. W. Turner and to instructive studio visits with the history painter Horace Vernet.[42] Admiring Miller's work, Captain Stewart invited him to join his next exploratory trip.

Traveling artists, like Miller, rarely in residence for long in any one place on the Plains, may never have witnessed the more typical, time-consuming, buffalo drive to impoundment. His exaggerated jump-site scene, like many pictures by other nineteenth- and early twentieth-century artists, such as Russell, presents a rather distorted view of buffalo hunting on the Plains. Unlike George Catlin, Miller did not feel compelled to arouse public response to the native American. Instead, his work was intended to decorate the walls of his Baltimore clients as well as his explorer-patron's castle in Scotland.

Another recorder of the Plains Indians was Charles Wimar, whose 1853 painting *The Abduction of Daniel Boone's Daughter* appears in the Woodlands chapter (see p. 36). After his journey through Indian country along the Mississippi with artist Leon Pomarede, in 1849, Wimar continued his studies at the Staatliche Kunstakademie, Düsseldorf, where Indian themes persisted in his work. Returning to Saint Louis in winter 1856, he discovered that in his absence the American Fur Trade Company had expanded

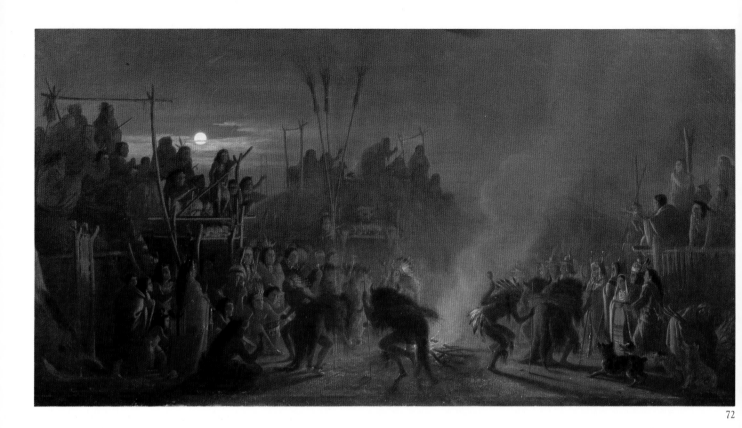

72

72. Charles Wimar,
The Buffalo Dance. 1860

73. After Karl Bodmer,
*Bison-Dance of
the Mandan Indians.*
c. 1839–43

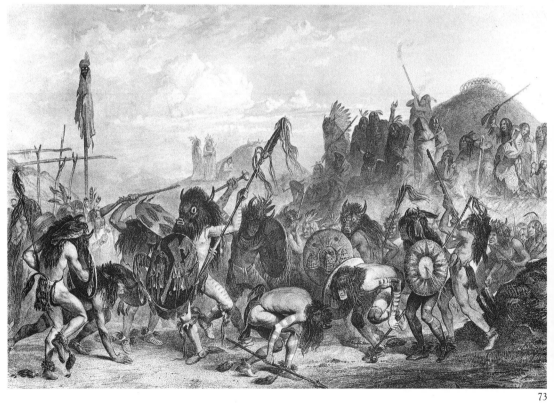

73

its network of fortified trading posts along the Missouri River and its tributaries, and "had encouraged the Indians, living on reservations, to bring fur to the company depots."⁴³ With fewer Indian traders coming to Saint Louis, Indian models were less accessible. Consequently, in spring 1858, Wimar made the first of several trips aboard an American Fur Company steamboat, traveling as far as the headwaters of the Missouri. To obtain pictorial matter firsthand, he carried sketchbooks, drawing blocks, oil colors, chalks and pencils; an apparatus for taking ambrotypes he used with limited results because of Indian superstitions about the primitive box.⁴⁴ Numerous stops at the various forts along the river (Forts Randall, Pierre, Clark, Berthold, Union, and Sarpie) gave him an opportunity to make careful studies of many Indian tribes, including the Brule Sioux, Arikara, Mandan, Gros Ventre, Assiniboin, and Crow.

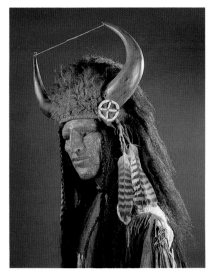

74. Plains Buffalo Headdress. c. 1865

Three of the field sketches made on his brief visit to the Mandan villages attest to the artist's deft hand and eye for ethnographic detail. The freshness and detail of these studies were lost, however, when the sketches were transformed into more melodramatic canvases typical of Wimar's earlier Düsseldorf pictures. Several historians have noted a change in his style after his return to America because of his direct contact with the Indians. Yet, when one examines his *Buffalo Dance* (plate 72) and other work of this period, they are only slightly less staged than the paintings that predate his frontier travels.

Although the buffalo and its regeneration played a major role in Plains religious life, the incomplete records of Wimar's life offer no confirming evidence that he was eyewitness to a Mandan buffalo dance.⁴⁵ According to the artist's letter, he had a short time to view a Mandan Buffalo Dance when he was near Fort Clark, in 1858: "In the afternoon . . . we . . . arrived at the village of the Mandans, a tribe which had been decimated by the virulent small pox. These Indians live in huts constructed of mud and clay, and their warriors in all amount to but sixty-four. Though small in number they are regarded as the bravest of tribes. We only remained here half an hour, and then continued our journey, arriving the next morning at Fort Berthold."⁴⁶ It is possible that Wimar saw Mandan dance rituals at Fort Berthold, but more likely he turned to Karl Bodmer's imagery for his inspiration, as he had five years earlier. Wimar undoubtedly knew of Bodmer's engraving of a Mandan Buffalo Dance reproduced in Maximilian's *Atlas* (see plate 73).

Like Bodmer, Wimar depicted an elaborate Mandan rite, performed to ensure both the presence of buffalo and good hunting. Unlike Bodmer, he chose to represent his scene under a full moon and by a firelight redolent with eerie, supernatural effects, harking back to the Düsseldorf school of painting. This complex work, with many figures massed on different planes, reminiscent of classical friezes, is one of Wimar's masterpieces. Predominant red coloring and strong contrasts of dark and light against a full moonscape heighten the ritual's drama and mystery; the moon itself may have a symbolic reference to the dance. Wimar adopted the basic design of Bodmer's composition, but at the same time he emphasized the theatrical by using the moon, smoke, and fire for atmospheric effects. In addition, Wimar's two buffalo dancers in the center foreground correspond more closely to Catlin's dancers in the *O-kee-pa Bull Dance* (see plate 60). In both

instances, the dancers wear full buffalo headdresses (plate 74). The illustration shows a Blackfeet headdress made of buffalo scalp and horns, tied together to keep them upright and shaved slightly to lessen their weight; hawk feathers and a circle decoration of dyed porcupine quills are further elaborations.

The Mandan Buffalo Dance has also been called the Bull Dance, because two sets of buffalo rituals were sometimes combined. One of the Mandan Buffalo Dance rituals is part of the Mandan O-kee-pa ceremony, effectively depicted and described by Catlin. Other Mandan Buffalo Dances are associated with the tribe's Bull Society. The Buffalo Dance painted by Wimar probably relates to the Bull Society, and the dance is intended to attract buffalo to the vicinity of a Mandan village for successful hunting.

In either the Buffalo or the Bull Dance there were usually two men, of unquestioned bravery, who danced wearing the upper portion of a buffalo head with its horns intact. They moved at the outer perimeter of a group of dancers carrying weapons and wearing red cloths tied to their backs, with a piece of buffalo hide simulating a tail. Around the dancers one or possibly several "Bull Women" circulated, to provide the dancers with water. Because the dance was intended to effect the all-important return of the buffalo, these rituals became marathons of endurance, with the participants dancing until they were exhausted, only to be replaced by other society members.

Many art historians give greater credence to Bodmer's depiction of the dance movement, rhythm, and spirit of this ritual, as well as its ethnographic detail than to Wimar's because Bodmer observed the dance in 1833, when the Mandan population and culture were still viable. Because the Mandan population that Wimar encountered had already been decimated by the smallpox epidemics of 1836–37, such ceremonies were radically reduced in number. (In 1858, the date of Wimar's visit, the population was between the 1850 estimate of 150 and the 1871 estimate of 450.) This decline from the early part of the century along with the Bodmer image have prompted the speculation that Wimar's composition is after Bodmer and not a scene the artist witnessed directly.

Recreational rather than subsistence hunting seems to be the primary subject of *Gambling for the Buck* by John Mix Stanley (1814–1872; plate 75). In this painting of 1867, the trophy from a hunting expedition is the prize for the winner of a card game. Stanley already had painted several other pictures of Indians playing cards, including *Game of Chance* (1860), *Assiniboin Encampment* (1865), and *Indians Playing Cards* (1866). From Stanley's paintings, as well as from other sources, we know that gambling and games of chance were important parts of Indian culture (see p. 176).

Plains or Chippewa Indians at that time used the English-French deck of fifty-two cards—as they probably do in Stanley's painting—and not the Spanish deck of forty-eight cards, which was used almost exclusively in the Southwest. Indeed, the Apache had rawhide copies of the Spanish deck and played a game similar to tarot (plate 76). The more northern tribes, and especially the Dakota Sioux—who seem to be represented here—played a game like poker with a fifty-two-card deck.

Stanley's records provide a fairly good account of his travels and thus pinpoint the times and places of his contacts with Indians. His youthful

experiences near the edge of the Woodland frontier probably led him to travel as far as Fort Snelling, in 1839, to paint likenesses of nearby Indians. Between 1839 and 1843, he worked in the Midwest and the East as an itinerant portrait painter, in cities where Catlin had toured with his Indian Gallery, and, most likely encouraged by the older artist's success, he assembled a collection of portraits of North American Indians.

In Troy, New York, he met Sumner Dickerman, who became his touring companion and part owner of an Indian gallery modeled after Catlin's. From 1842 to 1846 they traveled the southwestern frontier, where Stanley sketched and made daguerreotypes of Indians in Arkansas, Texas, Oklahoma, and New Mexico.[47] Some of his more important documentary portraits were made in summer 1843, at the intertribal Indian Council in Tahlequah, Oklahoma. These sketches and others made during his travels in the 1840s were the basis for much of his later, idealized studio work. Most of this work was lost in the fire of January 14, 1865, at the Smithsonian Institution, and the daguerreotypes made in the West during the 1840s and 1850s are missing, which prevents us from knowing about these firsthand experiences.

Stanley was one of the most celebrated of eleven artists who worked in official capacities with the Pacific Railroad Surveys in the West. By the time he joined the Isaac Stevens Expedition in 1853—to survey a northern railroad route from Saint Paul, Minnesota, to Puget Sound in Washington—Stanley already had spent more than a decade painting the West and its people. His marriage later that year marked the end of his travels among the Indians.

Most of the colorful genre pictures of Indian subjects that Stanley painted after 1854 have limited value as ethnographic documents.

Certain details of *Gambling for the Buck,* for example, tend to negate the possibility that Stanley directly observed this scene, including the combination of unlikely props. Ostensibly, the scene took place in a tipi on the eastern Great Plains, possibly in western Minnesota or the eastern Dakotas. The clothing style worn by the Indians, particularly the leggings on the standing male, also suggests an eastern Plains location. However, the card players sit on a platform that is anomalous in a tipi interior. An animal skin covering the tipi floor would have served for seating (see plate 77). A photograph of the 1890s by Walter McClintock shows a typical Plains tipi interior. Although the clothing of these Indians is decorated with beadwork, seemingly made of small beads (a later beadwork development), the eastern Plains clothing that Stanley saw before the mid-1850s probably would have been decorated with porcupine quillwork (plate 78). Glass beadwork eventually replaced quillwork as traders brought beads to the Plains Indians. The first beads introduced were the large "pony beads," unlike the seemingly large fields of small beads on the Indian clothing in Stanley's painting, an indication that they are a seed variety. Although his subject is gambling and hunting, Stanley has dressed his sitters for a social occasion and not for the hunt. For this composition, Stanley fell back on a prototype of his own, *The Disputed Shot* (1858), in which three trappers ponder the same large buck. His lack of concern for ethnography reflects the strong appeal to public taste of storytelling themes from the 1860s onward.

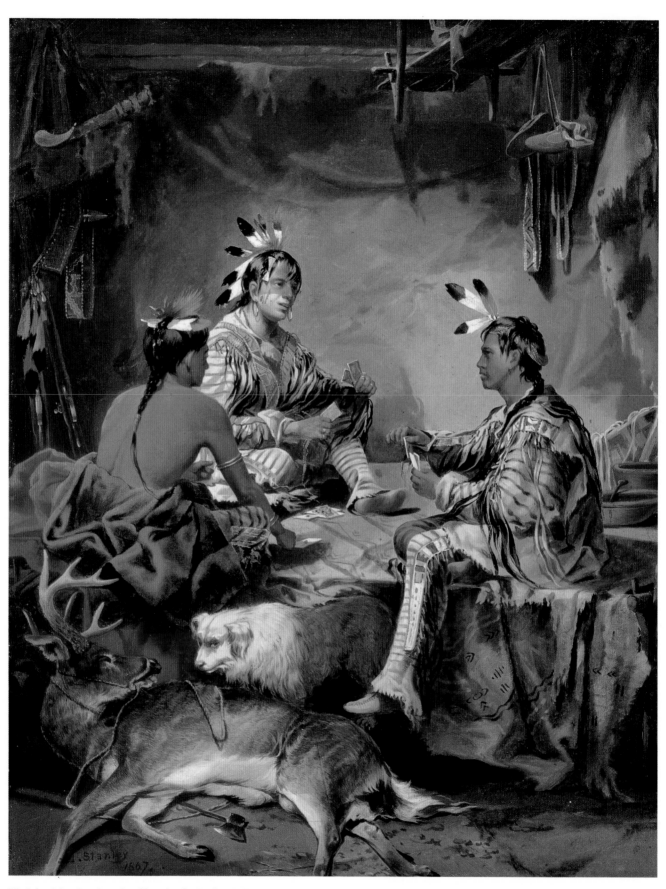

75. John Mix Stanley, *Gambling for the Buck.* 1867

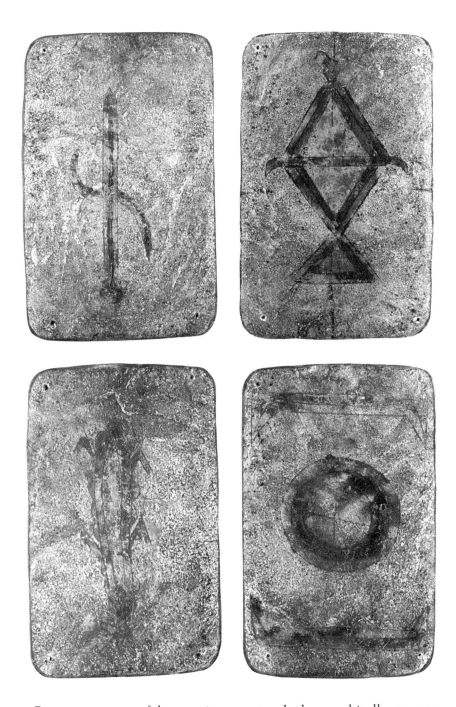

76. Apache Playing Cards. Before 1866

By contrast, some of the most important and ethnographically accurate studies of the Dakota Indians were made by the soldier-artist Seth Eastman (1808–1875). Although he is known primarily for his pictorial record of Dakota lifeways, Eastman's army assignments gave him the rare opportunity to study Indian life in Florida and the Upper Mississippi River area during both war- and peacetime. When his friend historian Henry Rowe Schoolcraft, was asked by Commissioner of Indian Affairs Charles E. Mix to testify to the artist's qualifications for extended duty in Washington, D.C., Schoolcraft replied that Eastman's long service on the nation's frontiers enabled him to represent the manners and customs of the Indians "with a truthfulness, which a strange artist, whatever be his talent, could

77. Walter McClintock, *Sun Dance Ceremony (Fasting [Blackfeet] Woman and Her Helpers)*. c. 1896

not do."[48] At Mix's request, Eastman took an official leave of absence from field duty, on March 1, 1850, to prepare illustrations in Washington after his Indian pictures for the engraver of Schoolcraft's multivolume work *Indian Tribes of the United States*.[49] Eastman's illustrations were based on his original field paintings as well as pictures he made in Washington and paintings after works by other artists.

Many of Eastman's pictures affirm his role as a social historian of Indian customs. His several versions of *The Indian Council* (plate 79), for example, suggest that the artist saw this scene many times during his two tours of duty at Fort Snelling, during 1830–31 and from 1841 to 1848. The Dakota Indians he portrayed were located at the time in south-central Minnesota, near Fort Snelling, a major outpost for the United States Army and the site of many transactions with Plains and Woodland Indians.

This oil version of *The Indian Council* was based on a field sketch in pencil and a watercolor of the same subject. Both were made during Eastman's duty in Washington, D.C., in the 1850s. Even without the artist's comments, the tipi identifies this scene as Sioux and not Chippewa, because the Chippewa inhabitants of the area lived in wickiups. (A wickiup is made of birchbark and reed mats over a framework of bent poles. In another oil version of the same subject, completed in 1868, Eastman substituted wickiups for the tipi.)[50] Had he provided a closer detail of the pole tops, a more specific tribal identity might be advanced for the tipi dwellers. Each Plains tribe set up its poles in a distinctive way, and Sioux construction methods can be seen in plate 80. The number of poles and the method of crossing and tying the first few poles is characteristic of Sioux tipis.

The feathered headdress of the principal standing figure gives another clue to tribal identity. A Sioux bonnet in time became almost a cliché for

stereotyping Indians. The bonnet, in fact, was an emblem of office and status. A later bonnet, similar in type, belonged to the Sioux warrior Lame Deer, a veteran of the Battle of the Little Big Horn (see plate 81). Its many eagle feathers and its trim of red, blue, and yellow ribbons fastened to a beaded leather strap around the face attest to Lame Deer's bravery.

Eastman may have chosen the theme of the Indian-as-orator because of its appeal in the nineteenth century. In his later *Indians in Council* (1868), he included Red Jacket in the group to reinforce this theme. While Eastman undoubtedly observed Indians in council and was making an ethnographic pictorial record, he also may have chosen this theme to make a philosophic or symbolic statement about political leadership on the Plains. The stance of the tall, dignified chief who addresses the group closely resembles the pose of the *Apollo Belvedere*, a popular classical reference for artists of Eastman's day; and the classical robes of the Greek orator are substituted for native American costume. In an Indian council meeting many decisions were made about community life—from hunting to warfare to disputed settlements—by discussion until consensus was reached. Mary Eastman refers to this custom as well as to her husband's painting in *The Aboriginal Portfolio* (1853):

> Among our northern tribes the great council-fire was always to be found burning in the lodge of the principal chief. Around it could be assembled in every emergency their wisest men, to decide upon affairs concerning the good of their nation.
>
> At the present day the Indians still meet in council, though with less parade than formerly. They could once dictate to us; now we propose, and they must submit. Yet, still as of old, they meet to deliberate, not within walls, and with secret purpose, but in the open air, under the shadow of their ancient trees, where their young men may be attracted by the sound of the eloquent language of the orator. . . . The picture represents such a scene. The orator, with his head ornament of eagle's feathers, and his robe gathered loosely about him, is not afraid of interruption while he is delivering to them his sentiments; nor are they hastily uttered, for he has doubtless consulted the public will, as well as the best interests of the band, ere he assumed the prerogative of being their adviser . . . and he stands armed with the authority of their opinions and wishes, as with energetic gestures and forcible language he delivers his own. For we must remember the Indians are genuine democrats, and would one of them be a leader, he must be guided by the people.[51]

Another variation on tribal life of the eastern Plains is provided by the Osage. Historically, they lived in semipermanent villages along the Laramie, Osage, and Missouri rivers, most of them in the present-day state of Missouri, and their annual subsistence cycle was one of seasonal hunting, farming, gathering wild foodstuffs, and raiding their neighbors. As a rule, large groups of Osage left their villages for the months of February and March and returned for April planting, only to leave again for the summer buffalo hunts, return for harvesting, and leave once more for fall hunting. They also hunted bear, deer, elk, wild turkey, prairie chicken, and other smaller game.

Early Spanish and French travelers among the Osage often commented that the men were both handsome and warlike and that the women aged early and seemed to bear the brunt of a difficult life. Although the Osage

78. Sioux Legging. Early nineteenth century

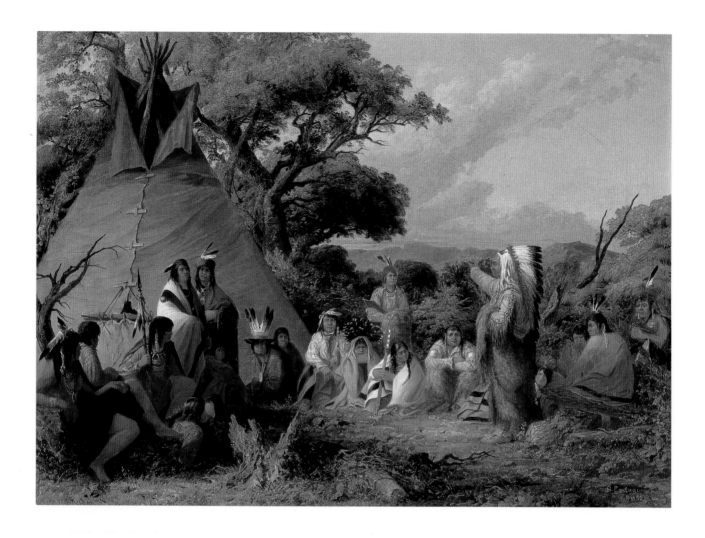

79. Seth Eastman, *The Indian Council.*
1852

were preyed upon by the Comanche and other tribes, the Osage view of death provided for a village afterlife not unlike the one they experienced every day.

Like many other Plains Indians, the Osage were sometimes portrayed in an unflattering or even prejudicial way. During the 1920s, '30s, and '40s the Osage Indians of northeastern Oklahoma, for example, were caricatured as drunk with wealth. The discovery and development of oil on their reservation after World War I transformed many Osage overnight from poverty-stricken to affluent. As a result they were defrauded by hucksters and swindlers who fueled a desire for luxury automobiles, mansions, and other conspicuous material possessions. Many Osage were photographed in costumes and circumstances completely at odds with their previous lifeways, and the term "Osage" became a comic pejorative in parts of the southern Plains. Earlier images, however, like *Concealed Enemy* (plate 82) by Missouri artist George Caleb Bingham (1811–1879), suggest a very different view of the Osage Indian.

Two explanations are given for the origin of the Osage. Their own oral tradition places their beginnings in the lowest of the four upper worlds. Ascending through them, they obtained "souls" in the uppermost world. There, Wekonda—the life force of the universe—instructed them in the

ways of people and directed them to descend to earth on the branches of the red oak tree. On reaching earth they were divided into two groups, the peace people who lived on roots and the war people who subsisted on buffalo hunting. Soon they merged to form one tribe—the Children of the Middle Waters—whom we know today as the Osage.

A more academic explanation of their origin describes the Osage as a southern division of Siouan-speakers that migrated south from the Osage River in Missouri and adopted lifeways consistent with those of the southern or central Plains. Thus in historic times the Osage shared many cultural traits with the neighboring Ponca, Omaha, Kansa, and Quapaw. All had subsistence economies based on hunting buffalo and on cultivating corn, squash, pumpkin, and beans. Until they had access to horses, which gave them greater mobility in hunting and warfare, the Osage used only dogs to assist them in transportation.

Warm-weather clothing of an Osage warrior was a loincloth and moccasins, with deerskin leggings and a buffalo robe added in winter. Facial and body hair, except for a narrow portion in the middle of the skull, was eliminated. A "roach" of deer hide, horsehair, and porcupine quills was attached to the hair (see plate 83), in this case to a mannequin's wig. The warrior's roach in Bingham's picture also shows small white breast feathers, probably from an eagle, which convey spiritual power. Some of these hair ornaments also included a portion of a wild turkey. John James Audubon's print *The American Wild Turkey* (see plate 84) offers a good view of the tuft below the bird's throat that is incorporated into the roach. The lower part of the roach is dyed red while the upper part is blackened, and the porcupine quills are used as stiffener. Ears were pierced and stretched by the weight of several attached earrings and beaded ornaments of shell or bone. Often, the warrior's body was tattooed and/or painted.

Death in Osage society often occasioned elaborate and prolonged mourning, to a degree that almost always impressed early European and American travelers among the tribe. In 1811, H. M. Brackenridge described an early morning ritual:

> This morning we were awakened by daylight, by the most hideous howlings I ever heard—they were proceeded from the Osages, among whom this is a custom. On inquiry, I found that they were unable to give any satisfactory reason for it; I could only learn that it was partly religious, and if it be true, as is supposed by many, that they offer their worship only to the Evil Spirit, the Orison was certainly not unworthy of him. I was told, also, that it arises from another cause; when any one, on awakening in the morning, happens to think of a departed friend, even of some valued dog or horse, which has been lost, he instantly begins this doleful cry and all the others hark in, as soon as it is heard. [52]

Among the Osage any death provoked violence, because of their belief that the deceased required vengeance, or at least company, on the journey after death. Traditionally, the preferred fellow-traveler was the spirit of an enemy killed for the occasion, but any non-Osage could be killed to fulfill this requirement and his scalp was placed at the grave of the deceased Osage.

This Osage vengeance killing became ritualized in a male warrior ceremony called Wa-Sha'-Be-A-Thi, often referred to as the "mourning-war

80. Three-Pole Sioux Tipi (Start of Construction)

81. Minniconjou Sioux Bonnet. c. 1870

82

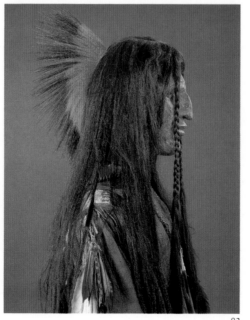

83

84

82. George Caleb Bingham,
Concealed Enemy. 1845

83. Black-ridge Roach. c. 1870

84. John James Audubon, *The
American Wild Turkey.* c. 1825

ceremony." This ceremony has often been blamed for the seemingly sense-less deaths of non-combatant Indians and whites (especially lone trappers and traders) in western Missouri, where the Osage lived prior to their removal to the Oklahoma Indian Territory.

Once proclaimed, usually by a relative of the deceased, the Wa-Sha'-Be-A-Thi ritual could not be stopped without disgrace or dishonor to the participants. The ceremony produced three days of mourning followed by an immediate search for a victim—and thus a scalp. In time, bears and human hairlocks were substituted, but in Bingham's era the inhabitants of the Missouri frontier still feared this Osage ritual. Thus one explanation of *Concealed Enemy* may be rooted in the Wa-Sha'-Be-A-Thi of the Osage culture.

We know that Bingham painted *Concealed Enemy* in 1845, following the Indian Removal Act and the lessening of hostilities between white settlers and Indians in Missouri. In many ways, this is a curious, atypical subject for this Missouri artist who became famous later for his paintings of riverine flatboatmen. The lone Indian, partially shadowed by an outcropping and a tree, crouches on the bluffs high above the Missouri River, stalking his prey with a "Kentucky rifle," a flintlock Pennsylvania Rifle (c. 1810–25).[53] His prey may be the French fur trapper and his halfbreed son who appear in another picture, *Fur Traders Descending the Missouri,* painted by Bingham the same year and submitted for exhibition with *Concealed Enemy* to the American Art Union in 1845. The two pictures are perhaps companion or pendant pieces that symbolize a nostalgia for an earlier way of life, a backward reference to the opening of the Western frontier. Surely Bingham was aware of public interest in Western lore and the demand for accurate illustrations of Western scenes and characters described by travelers, and this cannot be discounted as a motivating factor for these pictures.

Bingham's two paintings of 1845 may well have been the subjects for one of the political banners he made in October 1844 for the Whig convention at Booneville, Missouri, in support of Henry Clay's candidacy for the presidency. An analogy might be made between these pictures and one of Bingham's banners. On one side of the banner, Daniel Boone engages in a death struggle with an Indian, and on the other, there are "peaceful fields and lowing herds." Bingham described the Boone image as "emblimatical [*sic*] . . . of the early state of the west, while . . . the other side [is] . . . indicative of . . . present advancement in civilization."[54] In the paintings, the idyllic setting of the fur trader may correspond to the "peaceful fields" and "civilization," while the Indian stalking his prey may evoke the frontier before the white man. Bingham's sympathy for the goals of the Whig party and its anti-Jacksonian position may have played a role in his choice of subjects. Jackson's policies on expansion and commerce—which were de-structive to Indian lifeways—were embraced at the time by many Americans.

More than a half century after George Catlin, Cincinnati artist Joseph Sharp (1859–1953) responded again to a disappearing era in American history and to the now even more pressing importance of making a pictorial record of traditional Indian lifeways. Although Sharp's travels took him first to the Southwest in the 1880s, he had vowed early in his career to paint the warriors and political leaders of the northern Plains before time ran out.

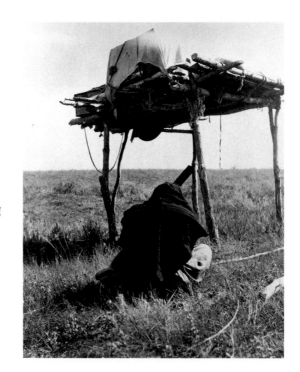

85. Joseph Sharp, *Crow Indian Burial Platform*. c. 1901–8

From 1902 to 1910 he divided his time between the Southwest and the Plains. During the fall and winter months he worked in his studio-on-wheels at the Crow Agency in Montana, photographing and painting the northern Plains Indians with an acuteness that he exhibited on his later trips to the Southwest.

At the Crow Agency, Sharp painted some two hundred portraits as well as scenes of daily and ceremonial life. His fascination with Crow beliefs and mortuary practices is evident in numerous paintings and photographs of their tree and scaffold burials (see plate 85). In Sharp's day scaffold burial was still practiced on the Crow Reservation. Other Crow mortuary practices and beliefs, however, continued long after elevated burials. In *The Great Sleep* (plate 86), Sharp has included some of the objects that the deceased would need in his future life—his shield, his quiver, and possibly his personal medicine.

Death in Crow society provoked a number of different responses. Mortuary rituals for a man who died in battle, for instance, were quite different from those of a man who died of old age. Usually, the body of a Crow who died within a tipi was removed by an entrance or exit not regularly used—under a lodge cover, for instance. Preparation of the body—painting it and dressing it in the dead person's finest apparel—was normally the work of women. The body was then wrapped in a special portion of the tipi cover. Added to the corpse bundle were small items of personal property, locks of hair, and sometimes even ends of fingers from a wife, relatives, or friends. As they wrapped the body, the women recited statements of passage like, "You are gone, do not turn back, we wish you farewell."

Men then transported the body to the scaffold platform set on top of four forked poles or to a platform in the crook of a tree. Often, a man's favorite horse was killed and laid beneath the platform, or his scalps or clothing were placed on the platform or atop a lodge pole erected beside the scaffold. Eventually, scaffold and body decomposed, and Crow men with blackened faces retrieved the bones and disposed of them beneath a pile of rocks or in

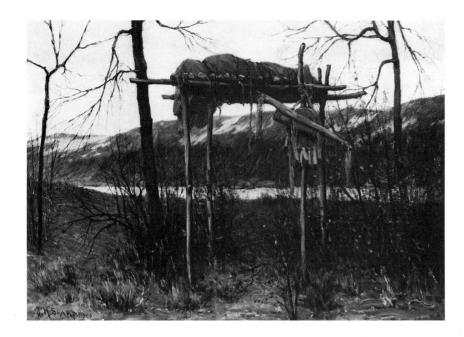

86. Joseph Sharp, *The Great Sleep.*
c. 1900

the crevices of large boulders. Robert Lowie, principal ethnographer of the Crow, cites still another burial practice for a famous chief. His tipi was painted with horizontal red stripes and his body placed on a burial scaffold erected within the tipi. Then, both tipi and burial scaffold were left to the elements.

Rarely did the Crow visit the burial sites of their people, because such places were both sacred and dangerous. There are recorded instances of offerings made at such sites by the Crow, but this behavior is exceptional. Other Crow prohibitions about death involved not talking about the deceased, especially in front of his or her relatives. Lowie also reports that the Crow had little concern with life after death, except for the fact that it was a condition "superior" to life.

In the course of the nineteenth century, the life conditions of native Americans changed radically. Independent, self-sufficient nations became trusts of the federal government, and with this change came dependency on one or another federal agency. To meet their responsibilities, various governmental offices required information and on occasion visual documentation. After the Revolutionary War, the United States government became an important source of patronage for artists who painted the American Indian. This patronage was often as direct as commissioning artists to travel with exploration or survey parties to the West—such as Seymour's appointment to the Long expedition—or commissioning artists to paint (or later to photograph) members of tribal delegations who visited the nation's capital or toured East Coast cities. Gilbert Gaul (1855–1919) was employed by the federal government in the 1880s to make pictures that would be rendered as etchings or lithographs to illustrate the Eleventh Census of 1890. Gaul was designated a "special agent" along with four other artists—Peter Moran, Henry Poore, Julian Scott, and Walter Shirlaw—and their work appeared in the voluminous *Report on Indians Taxed and Indians Not Taxed.*[55]

Although Gaul is generally recognized for his illustrations of military

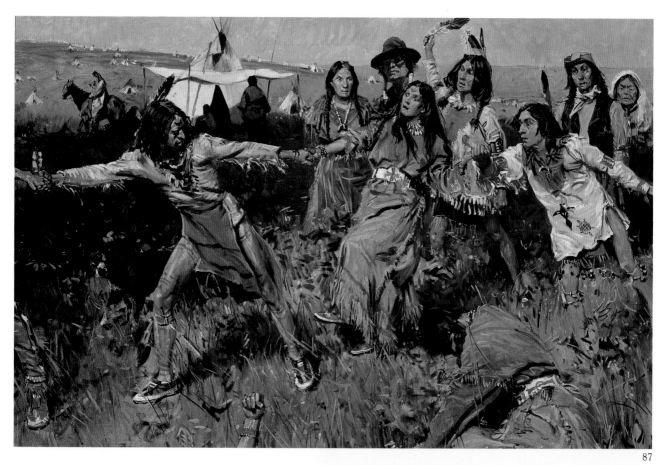

87

87. Gilbert Gaul, *Ghost Dance.* c. 1890

88. Sioux Ghost Dance Shirt

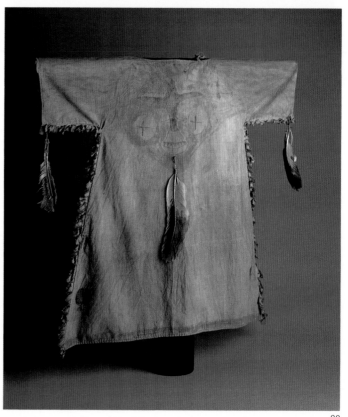

88

subjects, he may have been chosen for this assignment because of his knowledge of the Eastern Plains gained on a previous trip, in 1876. No large body of work survives from the earlier trip, but we know that he traveled among Siouan-speakers with a camera and color box to record Western scenes for later studio works.

Gaul had already begun to work as an "objective realist," influenced by his teacher L. E. Wilmarth at the National Academy of Design in New York and by the well-known genre painter J. G. Brown, to whom he apprenticed for a short time. This "objective realism" is apparent in *Ghost Dance* (plate 87) and the comments attributed to Gaul in *Indians Taxed* suggest something of his perspective toward native Americans: "All of the Indian past is now largely reflection and retrospection. Crooning squaws and tottering old men on reservations, in most cases in squalor, rags and hunger, retell the fierce battles of their people, each tale exaggerated with age, every person mentioned here; all now legend and myth. These past Indian splendors and glories can never come again; but the Indian does not realize it, and so he invokes their return with his ghost or Messiah dance."[56] Gaul's verbal picture is stark but accurate. By the late 1800s military defeat, starvation, and deprivation had reduced most Plains tribes to a desperate state. Most tribes had become prisoners-of-war, often with their leaders confined in faraway prisons or on reservations patrolled by the United States Army. Without buffalo to hunt, they were at the mercy of government agents, many of whom stole their rations of food, clothing, and medicine. Often, the agents then sold the supplies to traders who in turn sold them back to the Indians.

The poverty and desperation of the time made members of many Plains tribes responsive to the vision of Wovoka, a Nevada Paiute, who was also called The Prophet. Wovoka's vision foretold that if the Indian followed his teachings, the old lifeways along with the buffalo would return and the white men would disappear. Part of Wovoka's teaching was a ritual drama, or dance, now called the "Ghost Dance" because of his prophecy that the Indian dead and their culture would reappear.

A special style of dress developed among practitioners of the Ghost Dance, characterized by large painted designs, especially of a star and a dovelike bird on the front and back panels of their garments (see plate 88). Among the Dakota of the eastern Plains, a belief developed that the wearer of such a garment was divinely protected from bullets. This belief was tragically disproved, and the Ghost Dance movement on the Plains effectively ended, on December 29, 1890, when almost three hundred Dakota men, women, and children were massacred at Wounded Knee by the United States Seventh Cavalry (see plate 89). A number of the dead were wearing Ghost Dance garments, some of which are now in museum collections throughout the country.

An eyewitness description of the Dakota version of the Ghost Dance and the dancers' clothing offers substantiation that Gaul witnessed the dance, or at least talked with participants or observers. "The persons in the ghost dancing are all joined hands. A man stands and then a woman, so in that way forming a very large circle. They dance around in the circle in a continuous time until some of them become so tired and overtired that they became crazy and finally drop as though dead. . . . All the men and women

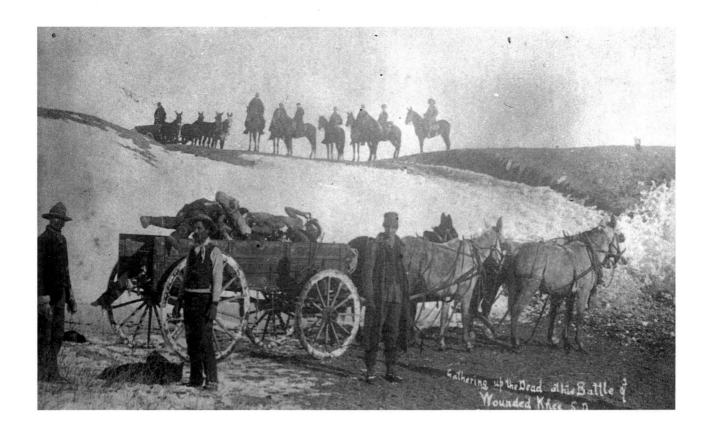

89. George Trager, *Gathering Up the Dead at the Battle of Wounded Knee, S.D., January 1, 1891*

made holy shirts and dresses they wear in dance. . . . The ghost dancers all have to wear eagle feather on head."[57] If any feature of Gaul's *Ghost Dance* fails to ring true, it is the excessive animation conveyed by this otherwise representational painting. Yet the very quality of desperation expressed by the dancers most certainly parallels the plight of these native Americans at the turn of the century.

Perhaps no other painter better portrayed the action of armed combat between Plains Indians and the United States Army than Frederic Remington (1861–1909). His imagination was probably stirred early by his father's colorful stories about his service in the Eleventh New York State Volunteer Cavalry during the Civil War. These tales, as well as his father's interest in breeding race horses, certainly influenced Remington's depiction of the Plains Indians in paintings like *Indian Warfare* (plate 90). After achieving fame as an illustrator of Western subjects, he made his first trip to the West, in summer 1881. There he spent several weeks in Montana and returned with a portfolio of sketches; in 1883–84 he owned and operated a sheep ranch in Kansas. Continuing to travel in the West with camera, sketchbook, and field notebook, Remington by the end of the decade had made over four hundred illustrations for numerous popular magazines and periodicals, often illustrating his own stories. His rugged, pragmatic, individualism as well as his large collection of ethnological material, cavalry accoutrements, and Western dress gave candor and credibility to his work. His backgrounds were as specific as his anatomical renderings of people and animals. As Remington's reputation as an illustrator grew, however, he increasingly tried to free himself from the confinement of illustration to

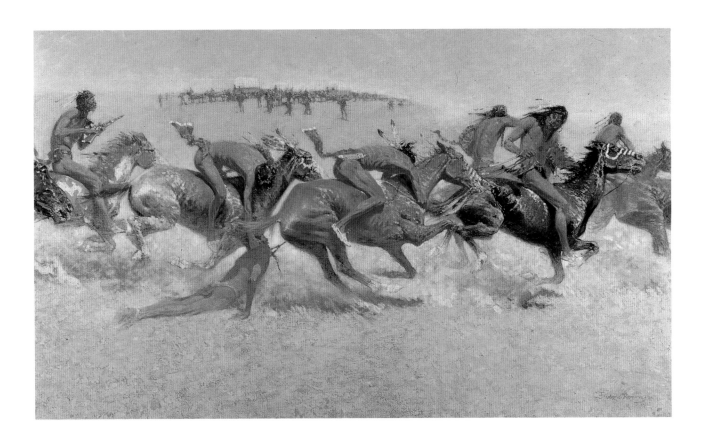

become recognized as a painter; by the turn of the century he was able to begin painting on a private commission basis.

90. Frederic Remington, *Indian Warfare.* 1908

Remington began to generalize and romanticize his subjects as he became more involved with painting. "Big art," he told Edwin Wildman in an interview for *Outing* magazine in 1902, "is a process of elimination . . . cut down and out. . . . What you want to do is just create the thought—materialize the spirit of a thing, and the small bronze—or the impressionist's picture—does that: then your audience discovers the thing you held back, and that's skill."[58] His technique changed, too: his brushstrokes broadened and his colors lightened as a conservative Impressionism came into play. To implement this "process of elimination" Remington focused the viewer's attention on one aspect of a picture; in *Indian Warfare* he focuses on the Indian figures in motion. To sharpen the dynamics of his pictures, Remington may well have studied the stop-action photographs of running horses by Eadweard Muybridge.

Remington wrote that the riders in *Indian Warfare* are Cheyenne warriors. Pressure from the Chippewa and the Sioux forced the Algonquian-speaking Cheyenne to move, in the eighteenth century, from present-day Minnesota onto the Plains, where at first they practiced agriculture and lived in earth-covered lodges. Continued pressure upon them from other tribes forced them into a buffalo-hunting, tipi-dwelling, nomadic culture. Most Plains Indians had well-developed patterns of warfare, both mounted and on foot, depending on their purpose. Cheyenne horse-stealing raids were generally made on foot, but after a successful action, the raiders rode off with their booty. Cheyenne scalp-taking or revenge raids were usually

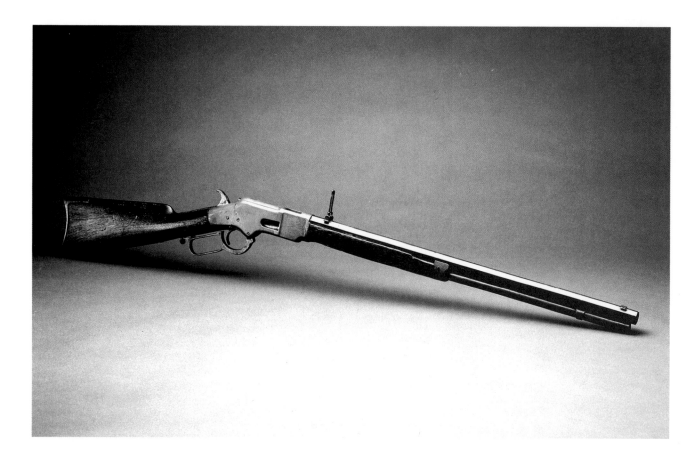

91. Winchester Rifle ("Goldenboy").
c. 1890

mounted. The military action depicted by Remington, however, had a very different purpose from warfare between tribes. Ultimately, it was taken to defend a homeland and a way of life. Cheyenne defeat came only after many years of battle with the United States Army.

Traditionally, a Cheyenne warrior rode to a battle site on a horse that he would not use in combat. His war horse was led to the site, to be fresh for battle. Usually, the war horse was the same horse that was used for buffalo hunting, since both activities demanded stamina, speed, sure-footedness, bravery, and a trained response to the rider. A mounted charge in battle, like some modes of buffalo hunting, was aimed at forcing the breakdown of coordinated resistance and putting the enemy to flight. Thus the pursuit of the routed war party became a series of individual actions. Many observers of intertribal warfare have noted that mounted Indian warriors were hard-pressed to make repeated, coordinated, cavalrylike charges after an initial shock-rush was successfully repelled.

The clear hazard for Cheyenne warriors in the action depicted by Remington lies in the army's tactic of fighting at a distance with rifle fire, while the Cheyenne practiced close combat, on foot or mounted—largely as a proof of manhood. In mounted fighting, the Cheyenne preferred the lance, the war club, and the bow and arrow. When Indians on horseback used a rifle, it was almost always a breech-loading weapon with the barrel cut down for easier handling (see plate 91), because reloading a flintlock was too difficult astride a horse. In Remington's scene, at least two or three riders carry knives, a weapon used most often when the warrior is on foot.

Army rifles prevented an effective mounted charge when advance warning allowed the troops to begin firing at a distance. In such cases, a bullet that killed or wounded a horse was almost as telling as one that struck the rider. The Indian goal of "touching" or counting coup on an enemy was incompatible with United States Army warfare.

Body-painting on both the horses and riders, and the eagle feathers in the riders' hair (not shown by Remington) symbolize the spiritual protection that each warrior sought before battle. A bundle of ritual paraphernalia often was transported and used before a battle to gain the spiritual protection necessary to avoid danger and emerge victorious.

Remington predicted the transformation of the American West on his first trip to Montana in 1881. In autumn 1900 he wrote to his wife from Española, New Mexico, lamenting what he saw: "Shall never come west again. It is all brick buildings—derby hats and blue overalls—it spoils my early illusions—and they are *my* capital."[59] Remington's father's stories and later the artist's direct association with Indians, cowboys, and soldiers were key influences in determining the character of his work, as Peter Hassrick has observed: "Remington had set his stage. First he grouped his cast into recognizable types: the soldier, the cowpoke, the Indian or half-breed being the cast of characters. Then he established a code of behavior and a psyche for each. Finally he pitted one against the other. Nature was the backdrop, and she was generally pitted against man as another antagonist in the plot. For Remington, 'The western experiences implied . . . the presence of man in potentially hostile natural surroundings.' In his drama, the individuals had to generate their own order within the system, each forced to contrive his own defense."[60] Remington's name became synonymous with the West, but in his cast of characters the Indian came out second best. While the artist appreciated their struggles, believing that they were doomed, he reduced them to "a class of defeated antagonists who required occasional policing."[61] Failing to understand the Indian, he was readily able to identify with the army and its trials on the Plains as it struggled to "win" the West. Plains Indian culture not only lost its war with the United States Army but it also suffered greatly at the hands of the dominant American culture.

Many turn-of-the-century artists—Russell, Remington, Sharp—and even many of today's cowboy artists have ignored the deprivation of Indian communities on the nation's reservations in favor of a nostalgic return to former Plains lifeways. Most photographers, too, like McClintock and Miller, have chosen picturesque summer tipi scenes rather than the images of rural poverty evident in the substandard housing, unemployment, and alcoholism of reservation life.

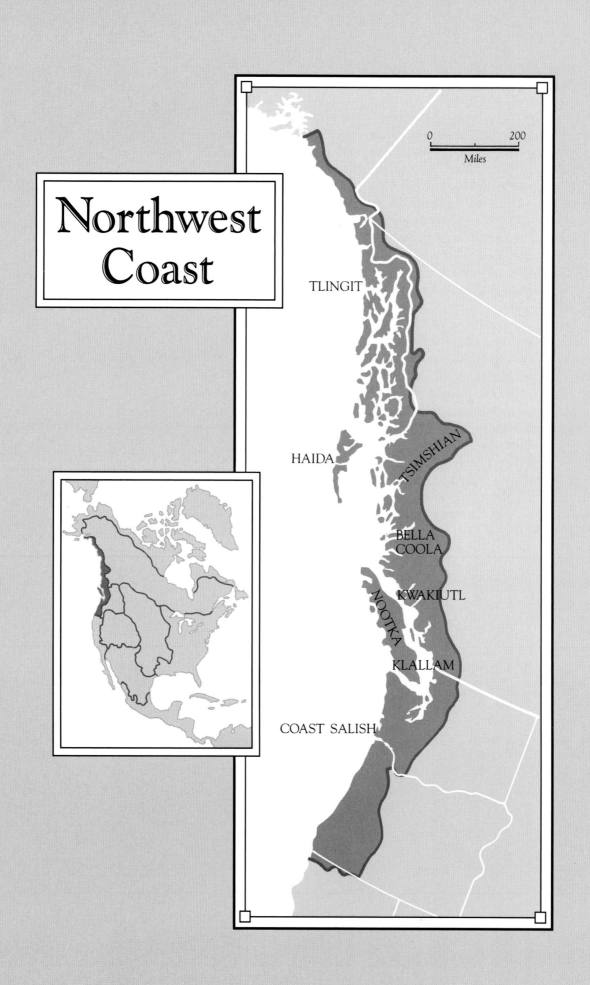

Northwest Coast

TLINGIT

HAIDA

TSIMSHIAN

BELLA
COOLA

KWAKIUTL

NOOTKA

KLALLAM

COAST SALISH

0 200
Miles

One of the most complex culture areas of native North America extends for more than two thousand miles along the Pacific Rim from southern Alaska to northern California. Commonly identified as the Northwest Coast, this cultural region is comprised of two habitats—the Oregonian to the south and the Sitkan to the north. In both, the resources of conifer forests and ocean have attracted man for at least nine thousand years.

Two physical features of the region have worked together to shape the region's character. The Japanese Current brings a continuous body of warm water out of Asia to the Americas, and a coastal chain of mountains reaching from Alaska to California acts as a rain barrier. Water warmed by the Japanese Current is picked up by prevailing winds over the Pacific Ocean and carried ashore. There it falls as rain on coastal islands and a narrow ribbon of land backed by the coastal mountains, which in turn are cut by numerous rivers and streams. Some locales on the Northwest Coast have one hundred inches of rainfall per year, and this along with favorable soil conditions produced the coniferous forests that helped to develop the region's other flora and fauna.

Offshore, the marine and riverine environments combined to sustain the region's major food resource—salmon. The juxtaposition of freshwater river systems for spawning and the saltwater ocean for living resulted in an optimum environment for five species of salmon harvested annually by native peoples. Halibut, cod, herring, smelt, candlefish, and several other fish species also were taken, and marine game species, such as seal, sea lion, otter, porpoise, and whale, were hunted. Along the shores, seaweed, clams, and other mollusks and shellfish were gathered. On the land there were wild berries and other vegetal foods as well as game animals. The region is also an important part of the Pacific Flyway for many species of migratory birds and water fowl. Except for tobacco, no crop was cultivated by the traditional cultures, and except for dogs, no animals were domesticated.

Although native inhabitants of the Northwest Coast are frequently called "tribes," the political unity that term implies was generally absent. Language, family, extended kinship ties, and particularly the geographic location of one's winter village were more meaningful identities to the region's inhabitants than the concept of tribe. The languages spoken by inhabitants of the Northwest Coast include Athabaskan (by the Tlingit and Haida), Penutian (by the Tsimshian), Wakashan (by the Nootkan, or the West Coast People, and the Kwakiutl), and Salishan.

Most of these people followed a cyclical pattern of movement from winter villages to spring, summer, and fall fishing camps and berrying locations. In the winter villages the social, political, religious, and artistic lifeways of the Northwest Coast people were most evident. Alvin Josephy writes that "the mild, idle winters were for luxury, a luxury that created fantastically intricate ceremonials; of clans and the groups of clans known to the anthropological trade as phratries; of secret societies; a wealth of decorated blankets, baskets, and boxes; an outpouring of fantastic wood carving; and a fantastic elaboration of social climbing."[1]

Many anthropologists, historians, and geographers separate the cultural patterns of the Northwest Coast into northern and southern variants. This

has particular relevance for the art of these people, which can be distinguished by stylistic differences as northern and southern styles (and possibly even transitional styles). In terms of social organization within the various "tribes" on the Northwest Coast, a rigid caste system of nobility, commoners, and slaves was almost universal, and the three northern groups of the Tlingit, Haida, and Tsimshian have matrilineal clans that help to determine social status, eligibility for marriage, inheritance, and so forth.

Much of the native art of the Northwest Coast was concerned with the public display of wealth and inherited privilege, including the rights to certain dances, songs, rituals, masks, and society membership. One important characteristic was the use of the clan crest design, rendered in a semiabstract, two-dimensional graphic style in both relief carving and painting, and displayed on house posts and door poles of the gabled plank houses. From the family crest the wooden memorial monuments known as totem poles developed (totem, from the Central Algonquian language, means literally "family" or "clan," or its emblem or armorial bearings). On ritual occasions, elaborate wooden clan hats and woven tunics and blankets of mountain goat wool were worn to proclaim the owner's social standing. Huge wooden clan houses were also built and a variety of totem poles erected. A rich masking tradition existed, and spectacular pieces—often with elaborate movable parts—were used in dramatic dances and ceremonies.

First contact with the Northwest Coast may well have been from Asia, and sustained European interest and investment in the area did not begin until the eighteenth century. The first European explorers were seeking a sea lane from the Atlantic to the Pacific Ocean (the so-called Northwest Passage). Ultimately, five of the region's natural resources supported European, American, and Canadian interests: furs, fishing, forest products, mining, and tourism. As with other areas of native North America, the presence of non-Indians brought significant changes to the native populations and their cultures, and these cultures themselves were a source of commercial interest to whites.

The first known European contact with the Northwest Coast was made by Russia in July 1741, in a voyage of exploration. Two Russian ships, the *Saint Peter* and the *Saint Paul*, commanded by the Danish Captain Vitus Bering, left Kamchatka in eastern Siberia that June. After about three weeks at sea, the ships were separated by severe storms. The *Saint Peter* reached the Kayak and Trinity islands and the *Saint Paul* sailed into Sitka Sound, where the Russians encountered Tlingit Indians. Although no permanent colonies were established by this first Russian expedition, it resulted later in Russian trade and settlement in the region and the establishment, in 1799, of the first Russian Colony at New Archangel (Sitka).

The Russian advances and presence in the New World impelled the Spanish government, in 1773–74, to organize a voyage from the west coast of Mexico to sixty degrees north latitude in the North Pacific in order to remove any Russian settlement from Alta California, land claimed by Spain. Although the leader of the voyage, Juan José Pérez Hernández, never reached that latitude, he made contact with the Haida Indians on the small islands surrounding the Queen Charlotte Islands in 1774. Two subsequent

Spanish voyages, in 1775 and 1779, were made to assert Spain's sovereignty on the Northwest Coast.

The first English sailor with prolonged contact on the Northwest Coast was Captain James Cook. On his third and last voyage in search of a Northwest Passage, Cook reached the west coast of Vancouver Island March 7, 1778, and dropped anchor in Nootka Bay, where his official artist, John Webber, made important pictorial documents of the Nootka Indians (see pp. 142–46). From the Nootka Indians, Cook and his crew received sea-otter pelts in trade, which found an eager market when his returning expedition reached China en route to England. Thereafter, Spanish, English, and, later, American ships called with increasing frequency at Nootka Sound to trade with the natives, who had earned a reputation for their toughness and prowess as whale hunters.

For much of the eighteenth and early nineteenth centuries Russia, Spain, and England competed for the resources of this region. By 1800 American merchant traders had joined the competition. Fur-bearing animals, particularly seal and sea otter, but also beaver, marten, mink, and other land animals were in the greatest demand by white traders. Most trade negotiations were conducted by village or clan chiefs, and shamans often accompanied the trading parties. Songs and other rituals were frequently performed in conjunction with trade negotiations. Firearms and metal goods of all kinds were eagerly sought by the Indians, along with trade beads, buttons, and woven cloth. Almost from the start, the Indians of the Northwest Coast were extremely skilled in bargaining with whites.

The first European settlements on the Northwest Coast were the Russian-American trading posts at Sitka and Yakutat. The settlers here were often in conflict with their Tlingit Indian neighbors, in marked contrast to the docile acceptance of the Russians by the more northern Aleuts. In 1802, for example, the Russian fort at Sitka was destroyed by Tlingits, and two years passed before a stronger Russian force could retake the site.

Given the insatiable demand by white traders, the depletion of sea otters was a foregone conclusion. By the 1830s the animal was almost extinct in the waters of Alaska and British Columbia. The resultant competition for other fur resources initially pitted the British-backed Hudson's Bay and North West companies against Jacob Astor's American Fur Company. From 1824 until 1849 the Hudson's Bay Company had its headquarters at Fort Vancouver near the mouth of the Columbia River; and after 1849 it was moved to Fort Victoria on Vancouver Island. Farther north, in 1834, a Hudson's Bay Company post was established at Fort Simpson, near the mouth of the Nass River, which brought the company into direct and continuous contact with the Haida and Tlingit.

Although the Canadian-American boundary dispute was settled by 1846, the territory of British Columbia was not sufficiently populated by whites to become a province of Canada governed by Ottawa until 1871. Four years earlier, Alaska had become a United States territory upon its purchase from Russia. By this time, the resources most sought after by whites had changed from furs to gold, timber, and salmon. As the white population increased, so did foreign diseases, especially smallpox, which decimated the Indian populations here, as elsewhere on the continent.

Along with increased commerce and white settlement came Christian missionaries. In Alaska, among the Tlingits, this meant the Russian Orthodox Church, whose rich ceremonialism was much favored by the Indians. In British Columbia and to the south, Roman Catholic and Protestant groups, especially Anglicans, were active missionaries. Certainly the best-known missionary of the nineteenth century was the Anglican William Duncan, who, in 1862, formed the utopian community of Metlakatla with converted Tsimshian.

Primary among the native religious practices that the missionaries tried to discourage were the winter ritual dramas, the curing practices of shamans, and the potlatch. Shamanic curing lost much of its power with the advent of European diseases against which traditional healing practices were ineffectual. Eventually the Canadian government enacted legislation prohibiting the potlatch. A word derived from the Nootka *patshatl* ("giving"), the potlatch became a feast for any occasion. Extravagant gifts of furs, blankets, and cedar chests reflected the wealth and prestige of the potlatch giver. Beginning in 1884, laws prohibiting the potlatch were vigorously enforced against the Kwakiutl and West Coast tribes on Vancouver Island. In 1921, not only were forty-five Kwakiutl who were attending a potlatch at Village Island arrested but family heirlooms brought to the potlatch were confiscated as well. In 1951 the revised Indian Act dropped this provision.

When Captain Cook's third and last expedition dropped anchor in Nootka Sound, the party encountered a wealthy and energetic society living in two villages on the shores of the sound. The region was rich in salmon, sea mammals, and fur-bearing animals. Both of these villages and their inhabitants were depicted by Captain Cook and drawn by the English topographical artist John Webber (c. 1750–1793). Webber's assignment, Cook wrote, was to correct "the unavoidable imperfections of written accounts, by enabling us to preserve, and to bring home, such drawings of the most memorable scenes of our transactions, as could only be executed by professed and skillful artists."[2]

John Webber was the son of a Swiss sculptor who had emigrated to England, and the young Webber had studied in Switzerland, Paris, and London before his appointment to Cook's expedition. While Cook and his party were anchored at Nootka Sound, they visited the Indian villages along the shore. Webber's drawings of the interior of a Nootka house are one of the earliest and most important visual records of native American architecture. Sketched at Friendly Cove on the west coast of Vancouver Island, in 1778, these drawings document the southern coast house and village. A photograph by Richard Maynard (1832–1907) shows the Nootka people gathered before a group of houses (see plate 92). Maynard and his wife, Hannah, both photographed the Indian settlements of British Columbia before pressures from white society caused massive changes in the native cultures.

Because the native peoples on the Northwest Coast practiced seasonal migrations to meet their food requirements, families often had a permanent winter dwelling and a second, temporary dwelling for the summer season. The summer dwelling was used primarily as a base for processing fish and other marine resources as well as for gathering wild foods such as berries.

The houses Webber depicted are winter lodgings, and these are considerably larger and more substantial than the other seasonal dwellings (see plate 93). On Vancouver Island, the winter houses were wider than they were deep, with typical dimensions of eighty by forty feet. A standard roof was ten or twelve feet high.

A careful examination of Webber's drawings and watercolors of West Coast winter houses shows a basic post-and-lintel construction. The central lintel is two to three feet higher than the end lintels, producing a slight gable for draining the roof. The larger the roof lintels, the greater the wealth, power, and prestige of the owner and his family, since only potent individuals could command the resources to erect such heavy frameworks. Horizontal cedar planks framing the house were detachable, as were the roof planks, and both were sometimes dismantled for use at a summer house. Side planks overlapped (much like clapboards) and were held in place against high winds by heavy logs. Usually, the roof planks above the hearth were not fixed and could be moved from the inside with a long pole to adjust the draft of the hearth fire.

Around the inside walls a low platform served as sleeping and living quarters of the several families and/or persons that occupied the house. Individual quarters within the house were separated by partitions of storage boxes, baskets, household utensils, cedar seats, and hunting and fishing gear. The placement of living quarters within the house also reflected an individual's social position. Residents of the highest rank were located along the back wall and those of lowest rank—especially the slaves taken from other tribes—near the entrance.

Larger houses sometimes had more than one fire for cooking, food processing (fish smoking), and heating. Here Webber shows a central hearth with fish stored above it and several members of the household engaged in food preparation. In all likelihood, Webber is depicting a cooking method that uses a liquid-laden wooden box or bowl containing heated stones. As a rule fires were fueled by driftwood or cedar bark, but for the smoky fires needed to preserve food, rotted hemlock was sometimes used. Because starting a fire was so difficult, fires were rarely extinguished.

Most of the figures in Webber's watercolor wear yellow-cedar capes. Cedar capes were worn by both men and women until they were replaced by woolen blankets after the arrival of European trade goods. Men usually wore their capes over the right shoulder and under the left arm, without undergarments. The woman's robe was longer and almost dresslike, and beneath it was a brief, apronlike skirt. The wet climate made headgear common, and all of the West Coast people wore basketry hats. These conical hats with an onion-shaped knob at the top were made from the fibers of cedar roots. The hat illustrated here (plate 94) is decorated with a scene representing men standing in canoes and harpooning whales. Probably of Nootka origin, the hat is thought to have been collected on Cook's third voyage, in 1778.[3]

The two "totem poles" depicted in Webber's interior scene are more accurately termed house posts, and they represent a style that differs considerably from the one found among the more northern tribes on the coast (Tlingit, Haida, and Tsimshian). Absent here are the "ovoid," "U," and "split-U" design geometries that characterize so much of the sculpture

92. Richard Maynard, *Nootka Sound.*
1890

and painting of the northern tribes. Again, in contrast to the more northern tribes, free-standing house posts in front of a building were rare among the West Coast people.

Webber's art, together with the artifacts collected by Captain Cook, provides a vital base line for much of our knowledge of historic Northwest Coast art in the south. Popular interest in Cook's published journals and the accompanying visual material about the Pacific prompted Webber to publish a series of sixteen views, etched and hand-colored by the artist, between 1787 and 1792.

Concerning his sketch of the Nootka interior (see plate 93), Webber relates an amusing anecdote that is indicative of the Indian's reaction to the white man in the early stages of contact:

After having made a general view of their dwellings I sought for an inside which would furnish me with sufficient matter to convey a perfect Idea of the mode these people live in. Such was found. . . . While I was employ'd a man approach'd me with a large knife in one hand semingly [*sic*] displeas'd when he observ'd I notic'd two representations of human figures which were plac'd at

93

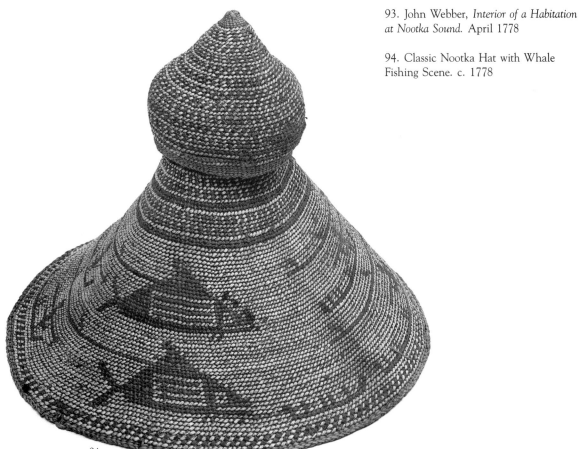

94. John Webber, *Interior of a Habitation at Nootka Sound.* April 1778

94. Classic Nootka Hat with Whale Fishing Scene. c. 1778

one end of the appartment [*sic*] carv'd on a plank, and of a Gigantic proportion: and painted after their custom. However, I proceeded, & took as little notice of him as possible, which to prevent he soon provided himself with a Mat, and plac'd it in such a manner as to hinder my having any further a sight of them. Being certain of no future oppertunity [*sic*] to finish my drawing & the object too interresting [*sic*] for leaving unfinish'd, I considered a little bribery might have some effect, and accordingly made an offer of a button from my coat, which when of metal they are much pleas'd with, this instantly producd [*sic*] the desir'd effect, for the mat was remov'd and I left at liberty to proceed as before, scarcely had I seated myself and made a beginning, but he return'd & renewd [*sic*] his former practice, till I had disposd [*sic*] of my buttons, after which time I found no opposition in my further employment.[4]

This region continued to attract artists traveling with maritime expeditions and, somewhat later, independent traveling artists. More than fifty years after Webber's visit, Paul Kane (see pp. 60–63) visited Vancouver Island on a cross-country journey that began in Ontario, Canada: "I left Toronto on the 17th of June 1845 with no companion but my portfolio and box of paints, my gun, and a stock of ammunition, taking the most direct route to Lake Simcoe [north of Lake Ontario]."[5] This was the start of a saga that lasted three years and four months and took Kane through the western Great Lakes, the western plains of Canada, the Oregon Territory, up to Vancouver Island, and then back home, which the Canadian artist reported in his published journal, *Wanderings of an Artist Among the Indians of North America* (1859).

Kane's inspiration for this trip was George Catlin, whom he met in London in 1843 when Catlin was exhibiting his Indian paintings and artifact collection. Like Catlin, his goal was to make paintings of Indian cultures and to acquire artifacts for an Indian gallery. Catlin's influence was instrumental in the recognition that Kane received years later as a painter of Canadian Indians.

At the age of nine Kane had emigrated with his family from Ireland to York (present-day Toronto), Canada. After an apprenticeship to a decorative furniture painter, he worked as a coach, sign, and house painter. Tradition says that he studied with "Toronto's eccentric art master," the landscapist Thomas Drury, and Kane's landscape settings are far surer than the anatomical renderings of his figures. Kane began his career in the 1830s, as an itinerant portraitist, and by 1843 he was able to travel to Europe for further study.

Two years later, Kane returned to Toronto to pursue his goal—to make a permanent record of native Americans in Canada. Carrying light, compact equipment, Kane filled his sketchbooks with rapid pencil and watercolor drawings taken directly from life. He also made oil studies on paper while in the field. When Kane returned to Toronto, in September 1848, his portfolio bulged with sketches of remarkable quality and interest, an impressive output for someone constantly on the move in the wilderness. The subjects he chose provide a panorama of a time in history that cannot be reconstructed from written reports or oral tradition alone, as well as an invaluable ethnographic record of many Canadian tribal groups. In Toronto, about 1850, when he translated his studies into finished oils,

historical accuracy occasionally gave way to a reliance on memory, lending a sense of romanticism to scenes like *Medicine Mask Dance* (plate 95). In his effort to record Indian life, Kane traversed four culture areas—the Woodlands, Plains, Plateau, and Northwest Coast—and made more than two hundred images in pencil, watercolor, and oil.

In his journal, Kane states that he left Nasqually, a Salishan community in Puget Sound, on April 8, 1847, and traveled by canoe for "the whole day and the following night, as the tide seemed favourable, not stopping until 2 p.m., when we reached Fort Victoria on Vancouver's Island, having travelled ninety miles without stopping."[6] Kane remained at Fort Victoria until early June 1847, but he did not publish his experiences until 1859. Nevertheless, his journal is an important source of early ethnographic information on the people of the Northwest Coast.

During his two months at Fort Victoria, Kane explored various native habitations in the surrounding area, traveling north along the Vancouver Island coast as well as east across the Straits of Juan de Fuca to the mainland. On Vancouver Island, he made contact with Klallam Indians, a tribal group of Salishan-speakers who lived on the opposite side of the harbor, facing the fort. Kane also made contact with another Salishan-speaking tribe, the Cowichan, as well as the Makah, a Wakashan-speaking group from Cape Flattery, the Babine, an Athabaskan group to the north on the British Columbian mainland, and probably other Wakashan-speakers from the island's west coast, its northeast coast (the Kwakiutl), and the adjacent mainland.

In attempting to determine the provenances of the masks and textiles in Kane's painting *Medicine Mask Dance,* it is important to know which tribes he came into direct contact with in his travels and which tribes traded at the Hudson's Bay Company outpost at Fort Victoria. Although the picture looks like an imaginative recreation by the artist, Kane in his *Wanderings* vividly recalls observing a Medicine Dance:

> The Medicine Mask Dance is performed both before and after any important action of the tribe, such as fishing, gathering camas [root bulbs], or going on a war party, either for the purpose of gaining the goodwill of the Great Spirit in their undertaking, or else in honour of him for the success which has attended them. Six or eight of the principal men of the tribe, generally medicine-men, adorn themselves with masks cut out of some soft light wood with feathers, highly painted and ornamented, with the eyes and mouth ingeniously made to open and shut. In their hands they hold carved rattles, which are shaken in time to a monotonous song or humming noise (for there are no words to it) which is sung by the whole company as they slowly dance round and round in a circle.[7]

Nineteenth-century ethnographers have documented three distinct Klallam mask styles worn by the participants in a Salish Medicine Dance: one represents the human male performer, another the thunderbird, and a third the wolf who taught man the mysteries of the thunderbird performance. Although all three styles are clearly represented in Kane's *Medicine Mask Dance,* the makers of these masks probably were not Klallam. The mask worn by the third figure from the right has been cited as the earliest known example of the "Old Wakashan style" of carving. Its tribal origin

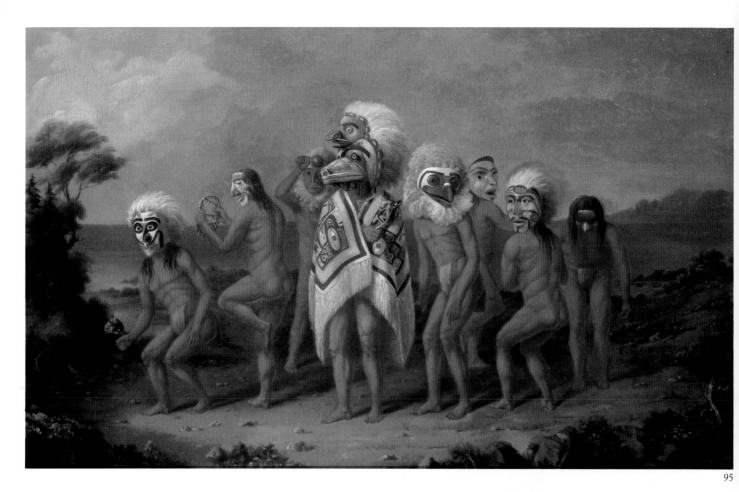

95

95. Paul Kane, *Medicine Mask Dance.*
c. 1850

96. Quaatelhl (attributed), *Haida Mask,
Queen Charlotte Islands.* 1870

97. Top: Tlingit Chilkat Blanket; bottom:
Raven Rattle. 1860

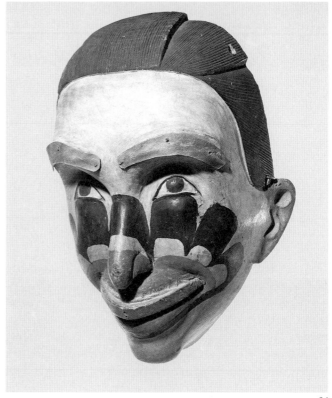

96

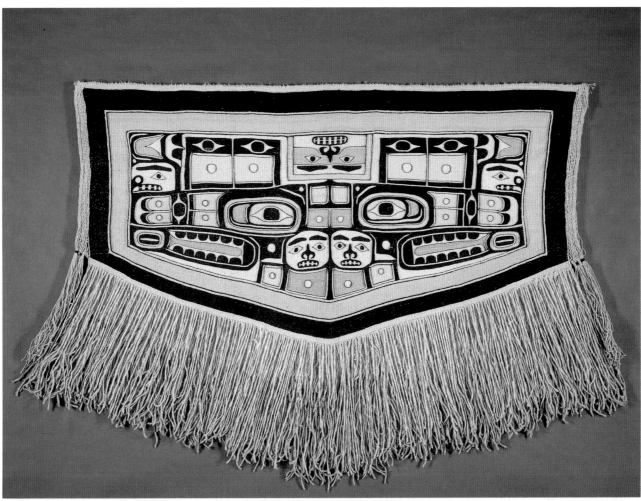

97

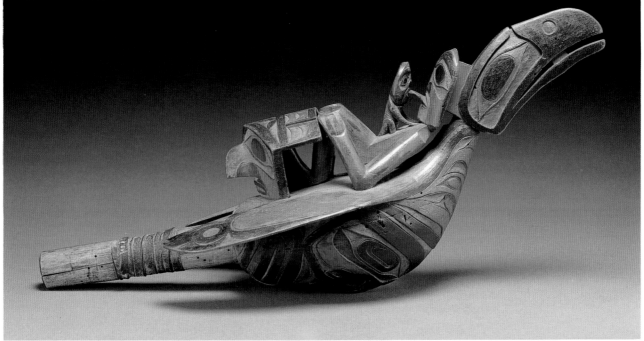

97

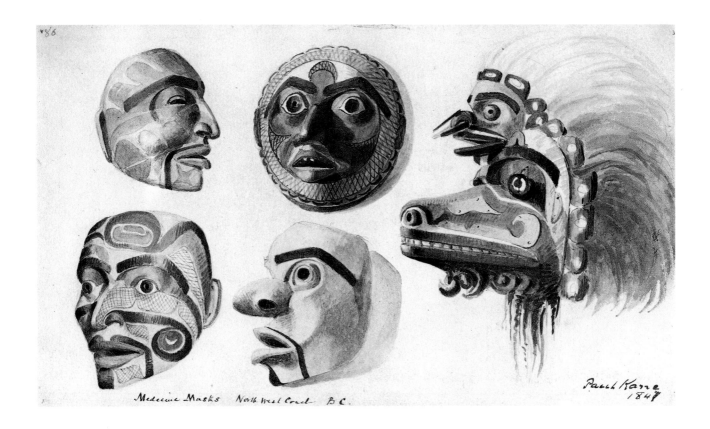

Medicine Masks North West Coast B.C.

Paul Kane 1847

98. Paul Kane, *Medicine Masks—North West Coast, B.C.* 1847

would be to the east and north of the Klallam, probably among the northern Kwakiutl, Southern Haida, or Bella Coola (see plate 96).

More than one explanation is possible for the choice of artifacts in this painting. While Kane probably did see the Masked Medicine Dance performed by Klallam men who were members of a secret religious society, the participants in the dance may have used masks that were traded from more northern tribes. It seems certain, however, that some of the ritual paraphernalia in the painting belonged to the artist. Kane notes in his writings that he purchased numerous artifacts both from the Indians of the area and from the Hudson's Bay Company trader at Fort Victoria, and he specifies a dance mask and a dancing blanket like the one worn by the central figure in the painting. The Chilkat blanket was woven from cedar bark and the hair of the wild mountain goat into a mystic design that was imbued with the power of speech, and the rattles held by the dancers on the left are made by tribes farther north on the coast—the Tsimshian and the Tlingit. The example reproduced here is of Tlingit origin (see plate 97).

What seems certain, at least in regard to this painting by Kane, is that some ethnographic reconstruction and artistic license may have been taken at the expense of historical accuracy. It may not have been Kane's intention to express the religious theme of the dance he saw while he was among the Klallam, but to place the masks and other paraphernalia he owned on the dancers. In a watercolor drawing, *Medicine Masks of the Northwest Coast Tribes* (see plate 98), presumably made at Fort Victoria, Kane depicted five masks in the northern style. The masks may have been owned by Kane and used as props for his pictures. Indeed, several of the masks reappear in his

oil painting. Kane employs a sweeping view of the Northwest coastline as a backdrop for his dancers, who normally would have performed at night in ceremonial houses rather than outdoors in the daytime. In his painting, Kane has chosen to freeze one phase of the dance in time.

North of Vancouver Island, and also off the coast of modern-day British Columbia, are the Queen Charlotte Islands. Here, the Haida Indians live at the edge of two major ecosystems—the Sitkan evergreen forest and the Pacific Ocean. Their homeland is both the Queen Charlotte Islands and the southern portion of Prince of Wales Island, in southeastern Alaska. Like their Tlingit neighbors to the north, they speak an Athabaskan language and have a social organization that divides all Haida into either the Eagle or the Raven clan. These clans are composed of extended family groups called lineages, and both clans and lineages regulate marriage, the inheritance of wealth (including fishing rights and honorary titles), and the use of heraldic-crest symbols on totem poles and other important art forms.

All of the tribes of the Northwest Coast carved a type of monumental sculpture generally known as a "totem pole." Unfortunately, the term suggests a totemic religion and a single type of totem pole. Totemism is not a part of Northwest Coast Indian religions; the carved figures are not deities per se nor are there any food taboos associated with the bird, fish, and animal figures represented on these sculptures. There are several kinds of carved poles, each with a different function. Some are structural supports or houseposts, others burial or mortuary poles, still others memorial poles, doorway or portal poles, or ridicule or mocking poles—used to insult an enemy. In the past most totem poles were found among the region's three northern tribes, the Tlingit, Haida, and Tsimshian.

Haida totem poles relate to the social, political, economic, and religious status of a family. A ceremonial feast or potlatch accompanies the dedication of a pole, and the figures carved on a Haida pole represent part of the family mythology and history, especially the honorary titles owned by the family or individual to (or by) whom the pole is dedicated.

The *Queen Charlotte Islands Totem* depicted by Emily Carr (1871–1945) is thought to represent the beaver figure at the bottom of a very tall memorial pole once located in the village of New Gold Harbor (also called Haina or Xaina; see plates 99 and 100). New Gold Harbor is on the eastern end of Mande Island, only a few miles by sea from Skidegate. Today, Skidegate and Masset are the two most important surviving Haida villages. The prehistoric village site at New Gold Harbor was reoccupied by the Haida in about 1850, but after 1884 the village population declined significantly, European-style houses were built, and the traditional culture changed.

The most important analysis of the historic village, its architecture, and its totem poles by George MacDonald (1983), states that, in 1870, New Gold Harbor was a village of approximately ten houses stretching roughly north to south along the beach line. The beaver pole painted by Carr was located in front of the second house from the southern end of the village. The English translation of the Haida name for this house is "House Passers-by Always Looked Up At." It was probably erected in the 1850s by "He Whose Word Is Obeyed," a man described as "a nephew of the family chief, 'Great Supernatural Power.'" The memorial pole that Carr painted "had a

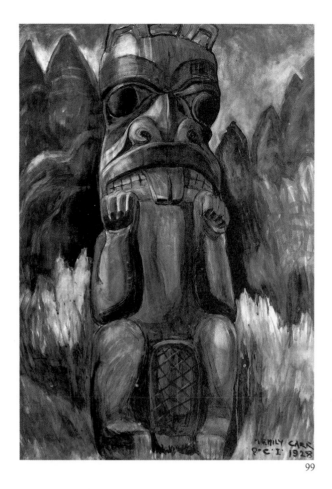

99

100

99. M. Emily Carr, *Queen Charlotte Islands Totem*. 1928

100. Richard Maynard, *Haida (Xaina) Village of Haina (New Gold Harbour), Chief "Highest Peak in a Mountain Range."* c. 1885

beaver at the base with a high pole on its head carved to represent potlatch rings. At the top is a separate carving of a bird. Nailed above the beaver is a copper 'One Man' of the Striped Town People."[8] "Potlatch rings" are the circular collars above the beaver that signify not only the number of potlatches given or attended, but also the major honorary titles individuals hold. The "copper" is a distinctly Northwest Coast artifact made of trade copper, a type of artifact that symbolized wealth and social status.

In historic times, Haida ownership of the beaver symbol rested with the Eagle clan and its lineages, and the rights to its use on art objects still belong to that clan. Misappropriations of such a symbol by a member of the Raven clan or any individual not entitled to use it would bring retaliation, and among some Northwest Coast tribes there are historic incidents of intra-village warfare over such occurrences. Even today, the use-rights for such symbols are carefully protected by individuals and families.

The visual and spiritual power of the totem strongly affected Canadian-born artist M. Emily Carr, who dedicated her art to Northwest Indian themes. "The Indian theme was also sufficiently complex and compelling to engage her for many years, revealing deeper layers of meaning as her understanding of it developed," Doris Shadbolt wrote.[9] Carr came to understand the Northwest Coast carvings as the expression of spiritual as well as physical experiences. Born in Victoria, British Columbia, Carr early recognized her commitment to art, and after art school in San Francisco,

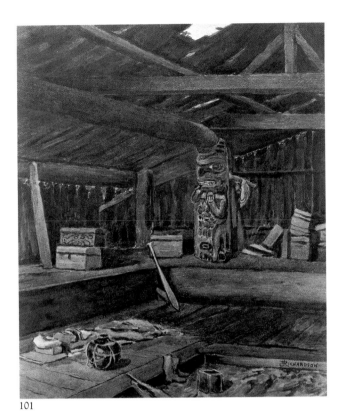

101

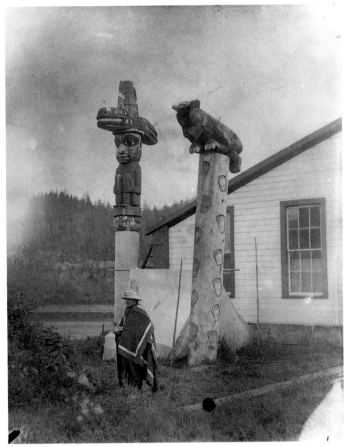

102

she studied in London and Paris. Carr's prolific writings detail her evolution as an artist, the important influences on her work, and her involvement with metaphysics and theosophy. The writings reveal her passion for uncontaminated nature as well as her warm interest in native Americans. "She embodied the Indians' art in her own, and her writing conveys respect for them as a people . . . she knew."[10]

In summer 1928, Carr made her second and last trip to the Nass and Skeena rivers to study Tsimshian culture. On the same trip she revisited the Queen Charlotte Islands, where she executed a number of watercolors, until a constant rain set in and forced her to leave. Carr managed, however, to block in the carved image on *Queen Charlotte Islands Totem*. She once described her working methods and the formal aspects of her art in a way that could easily apply to this image:

> I was working on a big totem with heavy woods behind. How badly I want that nameless thing! First there must be an idea, a feeling, or whatever you want to call it, the something that interested or inspired you sufficiently to make you desire to express it. . . . Then you must discover the pervading direction, the pervading rhythm, the dominant, recurring forms, the dominant colour, but always the *thing* must be top in your thoughts. Everything must lead up to it, clothe it, feed it, balance it, tenderly fold it, till it reveals itself in all the beauty of its idea.[11]

101. Theodore J. Richardson, *Tlingit Interior, Alaska.* n.d.

102. Richard Maynard, *Chief Shakes House and Pole, Wrangell, Alaska.* 1880s

In *Queen Charlotte Islands Totem*, the largeness of Carr's vision and the boldness of her statement can be seen in the monumental form that totally occupies the picture's frontal plane. Although she has sacrificed numerous details that appeared in her earlier work, the strong design of the totem expressively links artist and object. Few non-Indian artists have been so consumed by Indian subjects.

Another scene of the Northwest Coast region is the lively watercolor *Tlingit Interior, Alaska* (plate 101) by Theodore J. Richardson (1855–1914). The Athabaskan-speaking Tlingit Indians occupied the north Pacific Coast from Yakutat Bay south to the northern end of Prince of Wales Island. Near Sitka, where Richardson worked, were the remnants of a once sizable Tlingit community. In 1800 the Tlingit population was more than five thousand persons; but by 1900 only about one-third of this number lived scattered throughout their former homelands as well as in western Canadian and American urban centers. To the north of the Tlingit were the Eyak Indians, whose culture was outside of the Northwest Coast complex, while their neighbors to the south were the Kaigani Haida (on Prince of Wales Island), and on the British Columbia mainland were the Tsimshian. European explorers and traders as well as the Americans later often found the Tlingit unfriendly and not unwilling to do battle, often with great success.

Richardson traveled annually from his home in Red Wing, Minnesota, to this island-studded region that became his favorite artistic haunt from 1884 to 1914, except for a six-year stay in Europe. He had studied art in Boston, and then returned to Minnesota to teach art, penmanship, and geometry in the Minneapolis public schools. In 1884 he made his initial trip to Alaska, the year Congress passed Alaska's first Organic Act, creating its district government. Shortly after his last visit, Alaska became a territory of the United States.

Only a handful of artists had worked in Alaska before Richardson's first visit. Traveling through the Inland Passage by steamer, he arrived at the former Russian town of Sitka, which eventually became his summer residence. Establishing himself as Alaska's premier artist, he gained numerous commissions on each visit, and he enjoyed a special relationship with the Alaskan pioneer communities, who followed his travels and exhibitions in other parts of the United States through their local papers.

Richardson's watercolors are a legacy of Alaska's unspoiled wilderness and traditional lifeways. Although he was headquartered in Sitka, he often journeyed to very remote areas in Indian-guided canoes to make faithful sketches of the "choicest bits of scenery," Indian villages, totem poles, and house types like those seen in the photograph *Chief Shakes House and Pole, Wrangell, Alaska* (see plate 102).

Among the early descriptions by Europeans of the Tlingit, few are as pertinent to the theme of Richardson's painting as those of the German geographer Aurel Krause. Originally published, in 1885, as *Die Tlinkit Indianer*, the study represents field research undertaken in 1879–80 among the Tlingit. Writing of the Tlingit villages, Krause comments:

> One of the larger Tlingit villages is an impressive sight if one sees it from across the water and at a fair distance. The regular row of solid wooden

structures on the shore, which is covered with canoes and fishing gear, presents in this wilderness, a friendly picture of a civilization that would bring thoughts of home, if the sight of an occasional totem pole or grave post and Indian figures wrapped in woolen blankets did not again transpose one into a strange world.

Since fishing supplies the principal subsistence of these people, the choice of a place for settlement depends largely on the proximity of good fishing grounds and safe landing places for canoes. . . . Some [villages] consist of only a few houses which are set in a single row, others have as many as fifty to sixty houses of varying sizes which are arranged in two more or less regular rows, for the houses of each clan form a separate group. . . . The houses themselves are built close to the shoreline, barely out of the reach of high tide. Almost without exception they are set with the gable end, in which the door is cut, facing the shore.

Krause continues, detailing the Tlingit method of house construction:

. . . great posts are first sunk into the ground at the four corners of a square, the sides of which are about ten meters long. These posts, called "gat" by the Tlingit, . . . serve as the support of the plate beam with prominent projections and grooves. . . . The four corner posts protrude slightly above the roof and are especially well worked. The gable end between the vertical corner posts is enclosed with planks called "Chrangejet" which are . . . lapped so that they fit together like the logs of a blockhouse. Four round beams which extend from the four posts at the gable wall of the front to that of the back form the framework of the roof. As a cover there lie on these two to three courses of shorter boards like shingle which are weighted down with stones, or are held in place by means of thin poles laid lengthwise. . . . In the middle of the low pitched roof a large square opening is left through which the light comes in and the smoke goes out. A movable board covering which extends over the opening on the windward side also offers some protection from rain and snow.

Krause also describes household life among the Tlingit:

If we step through the narrow doorway into a Tlingit house, we will see the occupants squatting around the fire in the living quarters. . . . Chairs or benches are nowhere to be seen; only matting lies here and there on the floor on which the Tlingit squat or lie stretched out with the head resting on one arm. He can maintain this position, which we would consider uncomfortable, for hours. . . . However, for his white guests he always quickly finds a seat, either in the recognized place of honor, opposite the door, or on a box used for storing household goods, which is set out and covered with a piece of cloth or a blanket. . . . Obtaining wood for the fire is the duty of men and boys. Every day they go into the woods to get fallen pieces. . . . Only enough for each day is gotten.

The principal care of the day is the preparation and eating of food. Since in some of the larger houses, there are several families numbering as many as thirty individuals, but all using just one fireplace, it is almost constantly in demand by men and women, preparing the greatest variety of dishes. The principal dish of every day is always fish, boiled, roasted, dried, but never raw. . . . Wheat flour is being used more and more, either as a porridge or with the addition of yeast, baked as bread in pans or on flat stones. Butter is also one of those items of diet now purchased from white traders.[12]

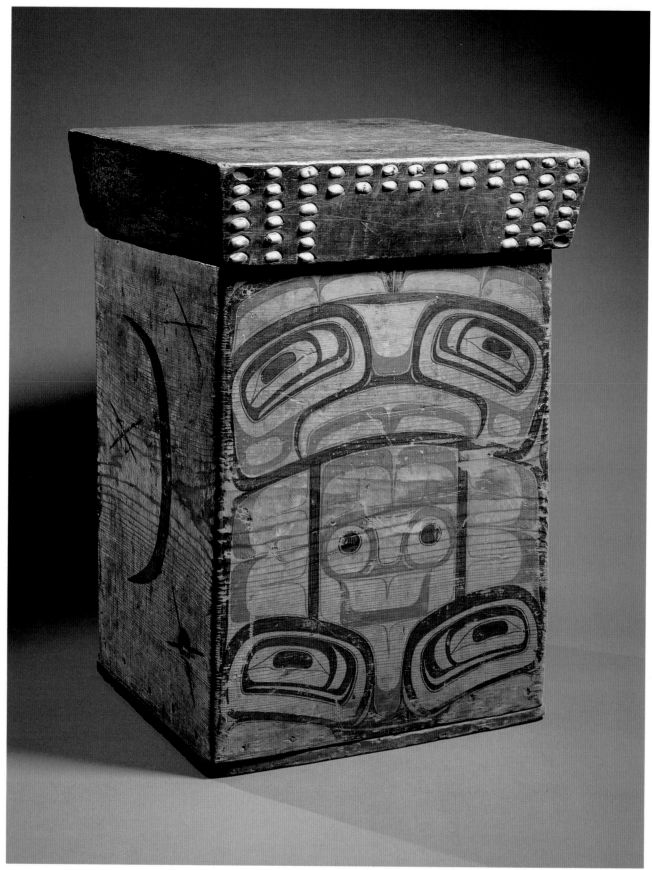

Before contact, cooking was done in wooden vessels or in closely woven, watertight baskets of roots and split twigs, which in time were replaced by metal containers.

The "totem pole" in the middle ground of Richardson's watercolor is more accurately termed a housepost, a structural support for the lintel above. The primary figure is a bear, although secondary designs appear on the lower front. Two examples of exterior Tlingit totem poles are seen in plate 102. The Tlingit, like the Haida and Tsimshian, observe stylistic rules in their painting and sculpture that scholars generally call "Northern Style." In addition to the ovoid, U, and split-U design geometries of this style, black, red, and blue-green designate primary, secondary, and tertiary levels of meaning. A decorated box made by a Northwest Coast artist exemplifies this style (see plate 103). The two sides of the box shown are painted with totemic designs in black and red, a third side with a moon and stars, and a fourth with a vertical line; the front and back of the lid are inlaid with cowrie shells. An important element of the art of these tribes is the relationship of their painted and carved figures—land and marine animals, fish, birds, mythical beings—to their social units—clans and lineages. For the northern tribes on the Northwest Coast, these figures are property owned by families and incorporated into the art in much the same way that heraldic crests "belong" to European noble families. Tlingit families, like their Haida neighbors to the south, are allied to one of two clans, the Raven or the Wolf.

Pictorial images of the Northwest Coast culture have been conditioned by the exigencies of travel by water. Travel through this area by water usually took place in summer, when many of the winter villages were all but abandoned and there were none of the major rituals that dramatize tribal religious beliefs. In many parts of the Northwest Coast, much of the traditional culture had already disappeared by the late nineteenth century. For example, European diseases had devastated the native population by the 1890s, and later artists often found deserted or at best heavily depopulated village sites. In earlier times, only a few explorer-artists traveled in the region, and their visits were often limited to villages that were altered by the presence of commercial trading posts or government outposts. John Webber and a few other early artist-explorers were exceptions, because they made contact with relatively undisturbed native settlements.

103. Northwest Coast Painted Box. c. 1860–80

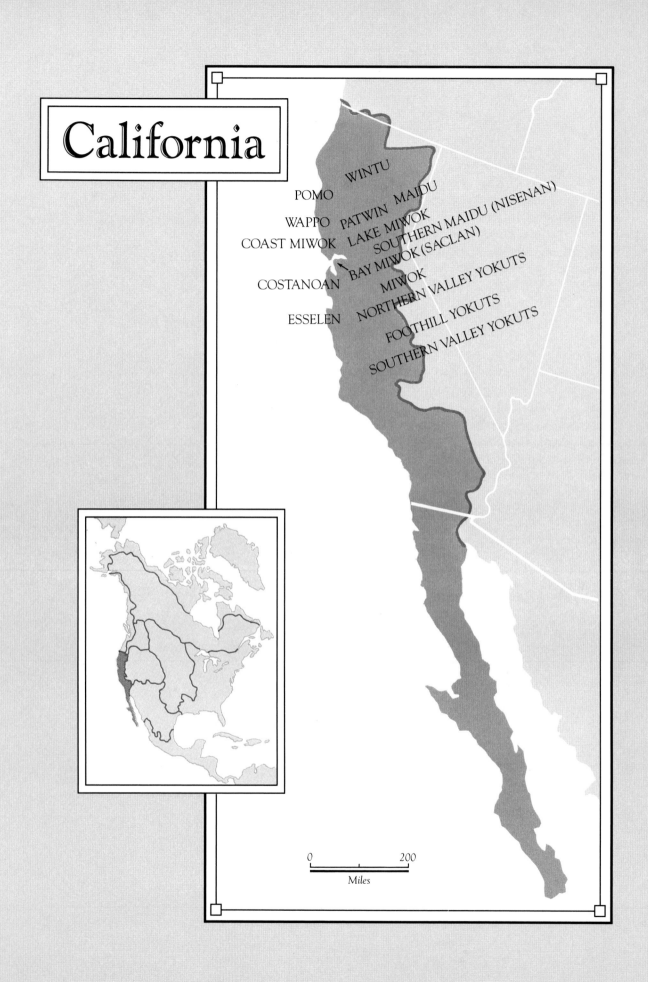

California

WINTU

POMO

WAPPO PATWIN MAIDU

COAST MIWOK LAKE MIWOK

SOUTHERN MAIDU (NISENAN)

BAY MIWOK (SACLAN)

COSTANOAN MIWOK

NORTHERN VALLEY YOKUTS

ESSELEN

FOOTHILL YOKUTS

SOUTHERN VALLEY YOKUTS

0 200

Miles

Although a sense of cultural homogeneity is implied by the concept of a California culture area, there is considerable variation in both the native cultures and the environment. The boundaries of this culture area only approximate those of the state of California, which were fixed in 1850, when California became the nation's thirty-first state. The culture area includes in addition the northern half of Baja California and excludes the state's southeast and northwest corners, eastern desert, and northeast fringe, which belong to the Southwest, Northwest Coast, and Great Basin culture areas, respectively. Along the eastern fringe of the California culture area, the Sierra Nevada and the Gulf of California offer natural barriers that foster distinct lifeways.

California's physiography is characterized west to east by coastal ranges, central valleys, and the Sierra Nevada Mountains. Its climate varies by region both north to south and east to west, and the elevation within any given region is equally important. Regional culture areas within the larger boundaries are generally distinguished as Northwest California, Northeast California, the North Coast Range, the Sacramento Valley, the San Joaquin Valley, the South Coast Range, and the Southern Coast. The native cultures in these regions differed in part because of the available resources. Thus tribal groups in the northwest developed extensive fishing practices for exploiting the salmon runs in the river systems of that region, a subsistence pattern that differed considerably from that of the tribes in the North Coast Range, who depended primarily on acorns and hunted game. Tribal groups did not confine themselves to exploiting only a single region, and the uniformity of any given region should not be overstated. Indeed, there were important microenvironments within each region, and later discussions of the Pomo groups in the North Coast Range detail this variation (see p. 171).

An extremely bountiful environment for its native people, the California culture area north of Mexico was the continent's most densely populated at the beginning of the sixteenth century. Hunting, fishing, and gathering—seven varieties of acorns flourished as well as other wild plants—provided basic subsistence, and most California Indian groups moved seasonally to optimize their search for food. Except for a very small area in the south, no agriculture was practiced in aboriginal California.

Throughout the culture area, seven major language families, or stocks, are found among the sixty or so California tribes of historic times. These are the Penutian, Hokan, Shoshonean, Athabaskan, Algonquian, Lutumian, and Yukian language families, and all have representative speakers in tribal groups outside of California. More than three hundred different dialects of these language families were spoken in aboriginal California, evidence of the cultural complexity of this area.

The California Indian population in 1769 (the year the first permanent European colony was established in San Diego) has been estimated at more than 300,000, in contrast to about 20,000 in 1900. This decline of more than 90 percent in 130 years was caused primarily by European diseases, military action, and the destruction of native habitats, which resulted in starvation, exposure, and death. Certainly, the salient factor in cultural change for all of California's native populations was the Spanish and later the American colonization of the area. The founding of San Diego by the

Spaniards marked the beginning of significant cultural change for the region's Indian population. To a large extent, the founding of this settlement, over two centuries after Spanish explorers first landed in Alta California, was a response to perceived challenges to Spanish sovereignty in North America by Russia. Added to this were exaggerated rumors of mineral wealth. In the subsequent fifty-three years of Spanish rule (1769–1821), Hispanic settlements dotted the California coasts from San Diego to San Francisco.

Three types of communities were established: towns (some of them with associated presidios, or garrisons), missions, and cattle ranches. In these communities Spanish and Indian cultures mixed, but we know considerably more about cultural change in the Spanish missions than in the towns or ranches. From 1769 to 1823, the Spaniards established twenty-one missions along the coastal strip from San Diego to San Francisco. Large groups of California Indians were forcibly relocated to each of the missions to be "civilized" by conversion. Neophytes, newly baptized Indians, were introduced to Spanish farming, livestock, craft industries, construction methods, medicine, and especially religion. Unfortunately, at the missions and in other white settlements the native population also contracted foreign diseases. Living conditions at the missions, where men and women were separated and forced to live in crowded dormitories with poor ventilation and sanitation, contributed to the spread of disease. During the Spanish period, native resistance to colonization often was violent and in several locations missions were destroyed. Resistance also took the forms of infanticide, escape, and a kind of physical and emotional passivity to the Spanish overlords, often characterized by Europeans as "laziness" or "mental inferiority."

A moment in California mission history is depicted in the watercolor *Danse des Californiens* (plate 104) by (Louis) Ludovik Andrevitch Choris (1795–1828). The setting for the dance is the Spanish mission of San Francisco de Asís, near present-day San Francisco. The sixth mission founded by Father Junípero Serra, in 1776, it is also known as "Dolores," named after a nearby creek, the Arroyo de Nuestra Señora, which no longer exists. Many different tribal groups came to this mission, including Saclan or Eastern Miwok, Lake Miwok, Coast Miwok, Costanoan, and Patwin. All five of these tribal groups are Penutian-speakers, although Costanoan refers to a language group made up of eight related dialects. Most of the Miwok and Patwin lived north of San Francisco Bay, while the Costanoans were situated east and south of the bay.

The story of Louis Choris's encounter with the mission of Saint Francis and its Indian inhabitants, in fall 1816, began in the European capital of Saint Petersburg. To test the strength of the Spanish colonial presence in the Pacific, the Russian government sent the naval vessel *Rurik* under the guise of a scientific expedition to the California coast. Sponsored privately by Count Romanzoff, the former chancellor of the Russian Empire, the *Rurik's* scientific staff included both the naturalist Adelbert von Chamisso and the artist Louis Choris.

The nationalities of Chamisso and Choris are somewhat confused. California historian Hubert H. Bancroft, for example, refers to Chamisso as "a Frenchman of noble birth." Chamisso's birthplace was in Champagne,

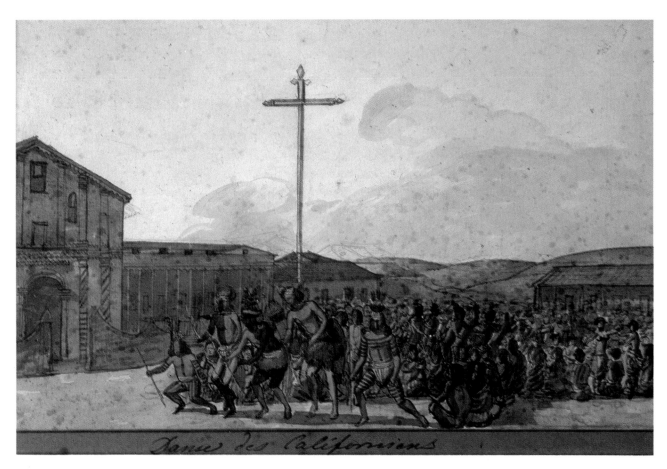

104. Louis Choris, *Danse des Californiens* (*Dance of the Californians at Mission San Francisco de Asís*). 1816

but he spent most of his formative years in Germany. So too did Choris, who is identified by Chamisso as a German "by origin." But because Choris published his folio of California scenes in France, as *Voyage pittoresque autour du monde,* many writers regard him as French. Records disclose that Choris was born in Ekaterinoslav (now Dnepropetrovsk), in the Ukraine, of German-Russian parentage on March 22, 1795. Educated in Moscow, he was already an experienced traveler by the age of twenty, having worked in the Caucasus as an artist-naturalist with the German botanist Baron Friederich August Marschall von Bieberstein. In 1815, Choris set off on a new adventure when, as he later wrote,

> the brig *Rurik,* commanded by Captain Otto von Kotzebue, sailed from St. Petersburg for a voyage of discovery around the world. At scarcely twenty years of age, I went as draftsman with this expedition, the expenses of which were covered by Count Romanzoff, [former] Chancellor of the Russian Empire. . . . During the course of this voyage, which lasted three years, all the objects which struck my youthful imagination and my eyes were gathered and drawn by me, sometimes with the leisure permitted by an extended sojourn, sometimes with the rapidity made necessary by a short appearance.[1]

After the party returned to Europe in 1818, these on-the-spot sketches were made into finished watercolor drawings for the artist's first set of engraved illustrations, prepared for Captain von Kotzebue's report on the voyage of the *Rurik.* Choris's unfamiliarity with the intaglio techniques of engraving, etching, and aquatint produced rather rigid results. Soon the

artist moved to Paris, where he studied in the ateliers of Gérard and Regnault. Choris's monumental *Voyage pittoresque autour du monde*, based on his travels with von Kotzebue, was published in Paris first in facsimile, in 1820, and then in book form by Firmin Didot, in 1822. The artist's lithographs, printed by Langlumé, were an instant artistic success. After the release of his second publication, *Vues et paysages des régions équinoxiales*, in 1827, Choris embarked on another adventure, this time to Central America. On his way from New Orleans to Vera Cruz, Mexico, the artist-explorer was robbed and killed by bandits on March 22, 1828.

The watercolor shown here is an illustration from *Voyage pittoresque*, and it depicts a dance performed by the Indians at the mission of San Francisco de Asís shortly after the expedition arrived in San Francisco Bay on October 2, 1816. In his account of the trip Choris places the mission "two leagues to the southeast of the presidio and on the southern shore of the harbour. . . . The mission church is large and is connected with the house of the missionaries, which is plain and reasonably clean and well kept. . . . The village is inhabited by fifteen hundred Indians."[2]

The permanent church shown in Choris's painting was begun in 1782 and completed in 1791. Although this is difficult to discern in the watercolor, the church's walls are four feet thick and constructed of adobe faced with fired brick. The schematic sketch, however, reveals the ornamentation on the lower columns, which might be interpreted as painted decoration. Of the several structures Choris depicted, only the church survives today.[3]

Dominated almost emblematically by the tall, slender cross, Choris's composition is symmetrically arranged along horizontal lines in the manner of topographical art. Faint pencil outlines and watercolor washes summarily indicate the many spectators and Indians assembled for the dance, while the dancers in the foreground are portrayed in greater detail. The descriptions of the Indians' costumes and their striking body paint are further elaborated in the artist's journal.

Two of the costumed dancers shown in the drawing appear again in another sketch by Choris in which they are carefully detailed and drawn in larger scale.[4] The sketch was probably done as a study for the *Danse des Californiens* since several of the other dancers are sketchily indicated in the left foreground. Although the drawing is small, the details of the costumes, such as skirts, headdresses, and hand-held paraphernalia, seem quite similar to known artifacts (see plates 105 and 106). The sketch is inscribed "costumes de danse de guerre des habitants," which raises the question of the dance type in the drawing. Choris does not refer to a war dance in his journal, leaving one to puzzle over the inscription. Perhaps the nature of the dance was unknown to the artist and his party at the time, or the dance may have been stereotypically interpreted by the Europeans as exotic and warlike. Captain von Kotzebue's own report, however, refers to a "war dance" in which the Indians wore "military array."[5] One of the earliest known photographs of Miwok, a carefully posed picture taken forty years after Choris made his drawing, shows some similarities in the costumes and paraphernalia (see plate 107).

What is certain is that *Danse des Californiens* depicts a ritual dance by the San Francisco mission's native American inhabitants, a ritual that probably took place at the end of a Sunday service. Choris may have witnessed this

scene and recorded it on October 9, 1816, the feast day of the mission's patron saint. The artist's description of the dance in the *Voyage pittoresque* reads as follows:

> On Sunday, when the service is ended, the Indians gather in the cemetery, which is in front of the mission house, and dance. Half of the men adorn themselves with feathers and with girdles ornamented with feathers and with bits of shell that pass for money among them, or they paint their bodies with regular lines of black, red, and white. Some have half their bodies (from the head downward) daubed with black, the other half red, and the whole crossed with white lines. Others sift the down from birds on their hair. The men commonly dance six or eight together, all making the same movements and all armed with spears. Their music consists of clapping the hands, singing, and the sound made by striking split sticks together which has a charm for their ears; this is finally followed by a horrible yell that greatly resembles the sound of a cough accompanied by a whistling noise. The women dance among themselves, but without making violent movements.[6]

Like other Californian tribes, this group is more accurately termed a "tribelet," and both Choris and Chamisso recognized these smaller units in their descriptions. Unfortunately, Choris's tribelet references are to individual portraits, and the group shown in *Danse des Californiens* is not identifiably Maidu, Patwin, or Costanoan. Perhaps the cultural identity of the ritual is to be found in the intermingling of cultures that occurred within the Spanish missions. In any event, the pagan meaning of the ritual probably eluded the mission priests, who may have viewed it as a diversion for their visitors or as a means of indulging the Indians and thereby bonding them to the mission system. Choris commented on the Catholic services that preceded the Indian dance:

> On Sundays and holidays they celebrate divine service. All the Indians of both sexes, without regard to age, are obliged to go to church; and worship [there they simply kneel down]. Children brought up by the superior, fifty of whom are stationed around him, assist him during the service which they also accompany with the sound of musical instruments. These are chiefly drums, trumpets, tabors, and other instruments of the same class. It is by means of their noise that they endeavor to stir the imagination of the Indians and to make men of these savages. It is, indeed, the only means of producing an effect upon them. When the drums begin to beat they fall to the ground as if they were half dead. None dares to move; all remain stretched upon the ground without making the slightest movement until the end of the service, and, even then, it is necessary to tell them several times that the mass is finished. Armed soldiers are stationed at each corner of the church. After the mass, the superior delivers a sermon in Latin to his flock.[7]

Louis Choris was one of many early artist-explorers who accompanied maritime expeditions to California during the Spanish and Mexican periods to supplement the reports that most such expeditions of the eighteenth and nineteenth centuries were required to compile. Generally, these documentary sketches or drawings were executed on the spot in pencil, ink, watercolor, or combinations of these mediums; many of them were translated later into engravings and published in the journals of ships' officers

105

105. Maidu Dance Headdress and Miwok
Headband. c. 1900

106. Miwok Dance Skirt. c. 1900

106

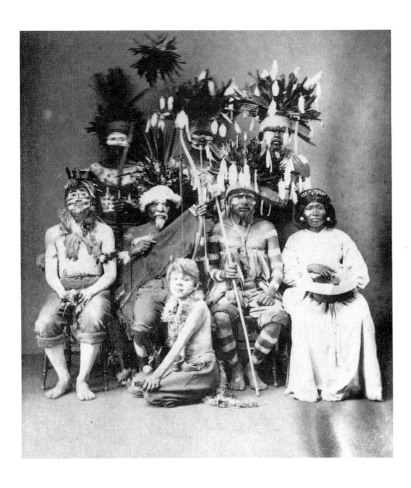

107. W. H. Rulofson, *Central Sierra Miwok Dancers*. c. 1856–60

and in other official reports. The excellence of Choris's drawings make them notable exceptions to the largely untutored works left by other artist-explorers of that period.

Indeed, Choris answered the expressed desire of the famous German scientist-explorer Alexander von Humboldt, who sought artists of "breadth and vision" to travel with expeditions in order to capture the true image of remote places with "genuine freshness." In von Humboldt's opinion most artists appointed to expeditions were chosen "without due consideration, and almost by accident," and they proved to be "less prepared than such appointments required."[8]

Another image that would have met the baron's criteria, *Ein Tanz der Indianer in der Mission in St. José in Neu-Californien,* was made a decade earlier by the artist-naturalist Georg Heinrich von Langsdorff (1774–1852; plate 108), who was on a voyage to California with Count Nikolai Petrovitch Rezanov. The mission buildings, inland from San Francisco, were pictured in photographs taken almost fifty years later (see plate 109).

In 1803, von Langsdorff had started out on a round-the-world voyage commanded by Captain A. J. von Krusenstern, but en route he left the expedition to accompany Count Rezanov on another voyage, this one to the Aleutian Islands and the Northwest Coast of North America. From the Russian settlement of Sitka, von Langsdorff and Rezanov sailed on the *Juno* to San Francisco. Thirty-two days later, on March 28, 1806, the *Juno* dropped anchor in San Francisco Bay, near the shores of the Spanish

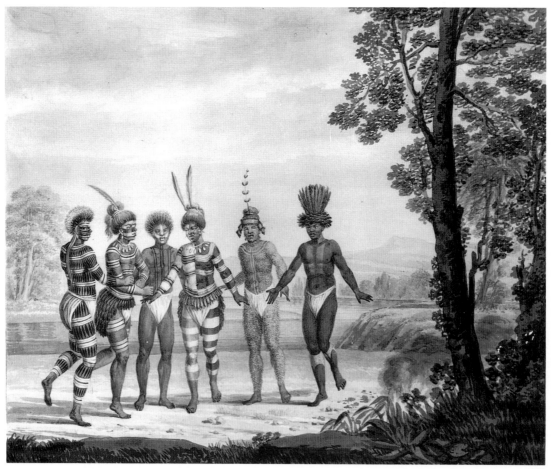

108

109

Presidio. At the sight of an unknown foreign ship, a general alarm was raised at the Presidio, but after some shouting from ship to shore the Russians were permitted to land. Von Langsdorff, who was conversant in Latin, acted as the interpreter for the Russians with the Spanish padres from the mission of San Francisco de Asís, and he meticulously recounted their arrival and other incidents in the illustrated, two-volume publication *Bemerkungen auf einer Reise um die Welt in den Jahren 1803 bis 1807* (*Voyages and Travels in Various Parts of the World, in the Years 1803 to 1807*).[9]

In *Voyages and Travels,* von Langsdorff offers a brief summary of his background, remarking on his excellent preparation for a journey around the world. With a medical degree from Göttingen in 1797, he began his career as a military surgeon. Far more interested, however, in natural history, he gained permission to participate in one of the first Russian maritime explorations. Ostensibly, Count Rezanov's mission was to establish trade relations between Japan and Russia and to further the development of the Russian-American Trading Company's colonies, the fur-trading outposts in the Far North. But when Rezanov learned of the miserable state of these colonies, he chartered an American vessel wintering at New Archangel and headed for "Neu-Californien" to exchange a cargo of trade goods for foodstuffs.

Von Langsdorff's journal describes the visit to San Francisco in detail, particularly the long negotiations that ensued between the governor of Monterey, Don José Joaquín de Arrillaga, and the count over the exchange of goods. In addition, the journal recounts the artist-naturalist's excursion by boat to the mission of San José, which was realized on the second attempt. On April 20, 1806, von Langsdorff wrote:

108. Georg Heinrich von Langsdorff, *Ein Tanz der Indianer in der Mission in St. José in Neu-Californien (Indian Dance at the Mission of San José in New California).* 1806

109. Carlton E. Watkins (attributed), *St. Joseph Mission de Guadalupe.* c. 1854

> I set off in a three-seated baidarka, accompanied by a sailor and a huntsman. Early in the morning we left St. Francisco, and towards noon reached the level before St. Joseph, and began to seek for the principal channel. . . . Wearied at length with perpetually going astray, I contrived to get on shore, and ascended a neighbouring hill. . . . The country over which we were now to wander rises by degrees above the low plain, and is bounded by a chain of hills which stretch from north-north-west to the south-south-east. Numerous herds of horses and cattle were running wild here, without any attention. . . . A little before sun-set we arrived at the mission, exceedingly fatigued.[10]

They were greeted with "open arms" by one of the mission's two ecclesiastics, Father Pedro, who had promised in San Francisco to entertain von Langsdorff with a dance performed by the Indians living at the mission. On the following day, the Indian converts were relieved of their work duties by Father Pedro to prepare themselves for the dance, and the best dancers put on their costumes. Near a small stream, the Indians began busily "smearing their bodies over with charcoal-dust, red clay, and chalk." Von Langsdorff notes that

> one was ornamenting his breast, another his belly, another his thighs, and another his back, with regular figures of various kinds. Some were ornamenting their otherwise naked bodies all over with down feathers which gave them rather the appearance of belonging to the monkey species than of being men.

Their heads, ears, and necks, were set off with a great variety of ornaments, but the bodies, except a covering about the waist, were naked. The women were at the same time performing the offices of the toilet in their houses; they were all, consistently with the laws of decorum, dressed; their faces and necks only were painted, and they wore also a profusion of ornaments of shells, feathers, and beads.[11]

The physiognomy of these people, he wrote, "is tolerably well shown." They are of "middling stature," "dark complexioned," and "their hair is very coarse, thick, and stands erect. In some it is powdered with down-feathers. Their bodies are fantastically painted." He describes the very scene he depicted here: "The second from the [viewer's] right is covered all over with down-feathers. . . . The dancer at the [viewer's] extreme right has had the whimsical idea of painting his body to resemble the uniform of a Spanish soldier, with his boots, stockings, breeches, and upper garments. Near this Indian, at the foot of a tree, is a fire, from which the dancers every now and then snatch out a glowing coal and swallow it."[12]

Von Langsdorff made sketches of this scene just before the Indians left to assemble for the dance in the large courtyard of the mission. Unlike Louis Choris, he chose a closeup view of the ornamented dancers. Clearly visible in von Langsdorff's drawing is the distinctive headdress of magpie feathers, worn by the dancer on the far right, common to north-central California (see plate 110). He presented the Indians in a simple lineup, with the two flanking figures turned inward. The dancers' poses belong to long-standing European painting conventions, like those in the sixteenth-century work of John White on the Atlantic Coast (see pp. 17–19). Distant hills, a middle-ground stream, and foreground dancers are organized in horizontal planes. Another artistic convention, the repoussoir screen of trees on the right, must have been intended to enhance the scene, because the artist's journal tells us that the plains were treeless.

Although von Langsdorff did not depict the dance itself, his journal vividly describes the performance that took place in the courtyard that day:

They were divided into companies. . . . One of the divisions consisted of the inhabitants on the coast, the others were people from the more inland tribes. . . . These people formerly lived in great enmity with each other, but are now united here by religion. . . . In their dances they remain almost always in the same place, partly with the feathers they hold in their hands and wear upon their heads, partly by measured springs, by different movements of their bodies, and by the variations of their countenances, to represent battles, or scenes of domestic life. Their music consists of singing, and clapping with a stick, which is split at one end. The women have their own particular song, and their particular manner of dancing. They hop about near the men, but never in concert with them; their principal movement or action is striking with the thumb and forefinger upon the belly, first on one side, then on the other, in a regular measure. As soon as the men begin to dance, the women begin also, and cease the moment that the men cease.[13]

During the Spanish rule of California a Russian colony was established at Fort Ross, about ninety miles north of San Francisco. Active from 1811 to 1841, Fort Ross was tri-ethnic in its social composition, its population

110. Eastern Mono Headdress. c. 1900

made up of Russians, Aleuts, and California Indians. Settled by the Russian-American Trading Company to pursue the fur trade, the colony was abandoned because of the depletion of the sea otter as much as because of Europe's international political struggles.

Spanish rule of California gave way to Mexican sovereignty in 1822–23, and Alta California continued to be a distant outpost for another government, this one in Mexico City. Although the Indians of the region became citizens under Mexican law, the regime brought them few positive changes. With the secularization of the missions between 1834 and 1836—the confiscation of church property by the Mexican government and the redistribution of mission land—large private cattle ranches became important users of Indian labor. The Indians who had been conscripted by the missions fled to the ranchos and the Spanish pueblos, and in both of these new locations they were exploited economically. The progressive loss of their cultural identity continued, as did population decline from disease.

Under Mexican rule, occupation and political control continued to be limited to the coastal strip, and the inland areas of California became

refuges for the Indians of the region. Raids were mounted against the ranchos in retaliation for real and imagined Indian thefts and ranch losses; in effect, open warfare characterized many of the political relations between whites and Indians throughout the Mexican period. The intent of whites in this warfare was to take slaves for work on the ranches or to extract revenge for Indian cattle raids. Much of this action was small scale, localized, and even private rather than government sanctioned. By this time, however, the California Indians often had horses and firearms and knew how to use them effectively.

When the Mexican-American War reached California, both sides recruited Indians. Although each promised benefits, American victory in the war only worsened the plight of California's native population. With American rule, land-seeking American colonists soon displaced the Indians from their land. American land claims for both settlements and minerals brought whites deep into eastern California, leaving few refuges for the Indians.

In the tradition of Spanish and Mexican settlers, Americans saw the Indian not only as cheap wage labor but also as slave labor. Most heinous was the practice of kidnapping Indian children for work as domestic servants in American households. Americans also wrought havoc on the natural environment, disturbing the delicate ecology that maintained the plant, animal, and fish communities that were traditional food resources for the California Indians. Nowhere is this better illustrated than in the salmon streams of northern California, where mining operations destroyed salmon-spawning habitats. The depletion of the native food supply led directly to an increase in stock raiding.

The armed American response to Indian raiding was both private and governmental, and both were brutal. United States government policy toward the California Indians was to place them on reservations. Initially, Northern, Central, and Southern administrative divisions were set up, each with civilian personnel backed by military force. Graft and greed were common, and the agents hired to protect Indian interests more often than not were among their principal exploiters. After the Civil War, an attempt was made to use Christian churches to carry out United States government Indian policy in California. By 1881 this program was abandoned, and the courts, especially, began to address the long-neglected questions of Indian land ownership, legal status, and other fundamental issues of Indian rights.

Although Congress passed the Dawes Severalty Act in 1887, seeking to give individuals title to reservation land, this largely was aimed at Eastern and Great Lakes reservations. Four years later, however, Congress authorized the purchase of sizable tracts of reservation land for California Indians, especially in the southern part of the state. At the same time efforts were being made to upgrade and enforce compulsory education for native Americans.

Perhaps the greatest assistance to California Indians at this time came from numerous white lobbying groups that had emerged to plead the case of justice for all Indians and for California Indians in particular. Chief among these groups was the Sequoya League.

A good deal of confusion regarding the legal status of Indians was clarified in 1924, when Congress conferred citizenship on all Indians. This

was done largely out of gratitude for their service in World War I.

At the time of early contact, perhaps as early as the sixteenth century, the California Indians known as the Pomo occupied a territory north of San Francisco Bay within the boundaries of modern-day Mendocino, Sonoma, Lake, Glenn, and Coluss counties. This territory extended about 130 miles north to south and about 100 miles east to west, or from just north of Point Reyes to Fort Bragg and from the Pacific Ocean to the Sacramento River. Scholars today estimate that when the Spaniards first arrived in the San Francisco area, in 1769, the total Pomo population was 75,000. The population remained relatively stable for about 100 years, until the enormous influx of Mexican and then American settlers in search of precious metals and land caused a massive decline in Pomo numbers.

The aboriginal Pomo were distributed across four topographic zones—the Coast, the Redwood Forest, the Valley Foothills, and the Lake regions—and these zones corresponded to at least four different cultural patterns within an encompassing Pomo culture. Further complicating the picture of Pomo culture were seven variations of the Pomo language, which itself was part of the Hokan family of languages. The distinctions among these seven languages were greater than dialect differences, and scholars often prefer to speak of the seven as comprising the Pomoan family of languages. Bruce Berstein points out that "what we call Pomo—the Indian had no word for it—refers to no definable cultural entity, but only to a sort of nationality expressed in speech varying around a basic type. . . . There was therefore no Pomo culture except as an abstraction made by ethnographers and other white men. There was a series of highly similar but never quite identical Pomo cultures, each carried by one of the independent communities or tribelets."[14]

Pomo Interior, Fort Ross, California (1884) and *Pomo Indians, Fort Ross, California* (c. 1897), by the German-American artist Henry Raschen (1854–1937), provide insight into the lifeways of the Pomo people called the Kashaya (Southwestern). Before European contact, this Pomo group was located along thirty miles of California's coast in northwest Sonoma County and extended inland for several miles. Their history differs somewhat from other Pomo groups in that their first contact was not with Spaniards or Anglo-Americans but with the Russian colony at Fort Ross (1811–41). This resulted in their relative isolation and their freedom from forced relocation to missions. Anthropological literature refers to them as Southwestern as well as Kashaya.

Pomo Interior, Fort Ross, California (plate 111), portrays two Kashaya Pomo preparing food inside a redwood winter hut, with an ethnographic accuracy that reveals Raschen's familiarity with the lifeways of this group. Raschen had spent his childhood on his father's ranch at Ocean Cove, just above Fort Ross.[15] From 1884 to 1890, he shared a studio in San Francisco with the landscapist Carl von Perbandt, and the two made painting excursions to Pomo country around Fort Ross.

In Raschen's *Pomo Interior*, the heaped seafood to the left of the seated figure as well as the redwood slabs and bark of the house walls and roof suggest that this is a dwelling of a Kashaya family (see plate 112), a Pomo group who lived along the coast or near the Redwood Forest. Very few Pomo lived within the forest, preferring instead to exploit the resources of that

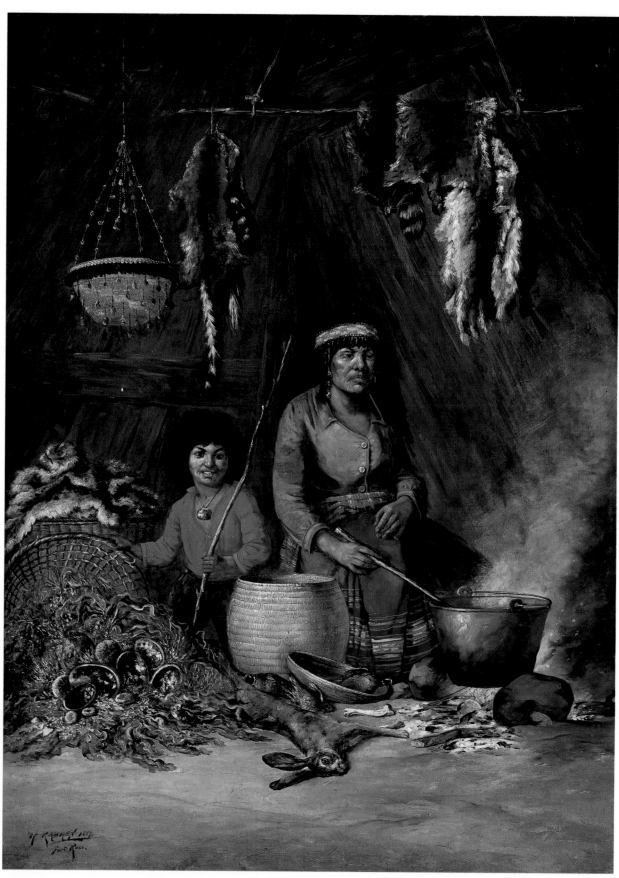

111. Henry Raschen, *Pomo Interior, Fort Ross, California.* 1884

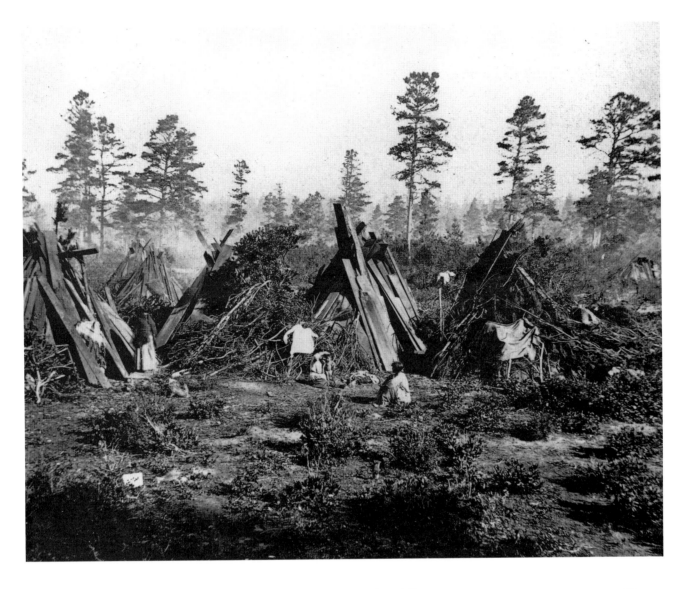

112. Carlton E. Watkins, *Pomo Village, Mendocino County, near Mouth of Big River.* 1863

area by making seasonal forays. Unlike the Kashaya Pomo, the Valley or Central Pomo constructed conical winter houses of grasses, while the Lake Pomo used tule reeds as their principal building material.

Acorns were an important food for all Pomo groups, who gathered them from the five species of oak that grow in this part of California. The Coastal Pomo, however, relied most on the bounty of the Pacific Ocean. A careful examination of Raschen's small picture of heaped shellfish provides an excellent overview of the marine and terrestrial ecologies they exploited.[16] (Not shown are foods secured from a freshwater ecological base, such as those available to the Lake Pomo.) In addition to acorns and shellfish, there are rabbit and bird carcasses (possibly dove or pigeon), raccoon, lynx, and other animal skins—probably sea otter or mink. Seaweed, kelp, and abalone shells overflow the gathering basket to the left of the figures. The purple-red, ribbon-like substance is probably *Porphyra perforata,* a Pacific coastal seaweed that was gathered and then preserved by sun drying after being shaped into edible cakes for storage.

The bird feathers adorning the hanging basket in the *Pomo Interior*

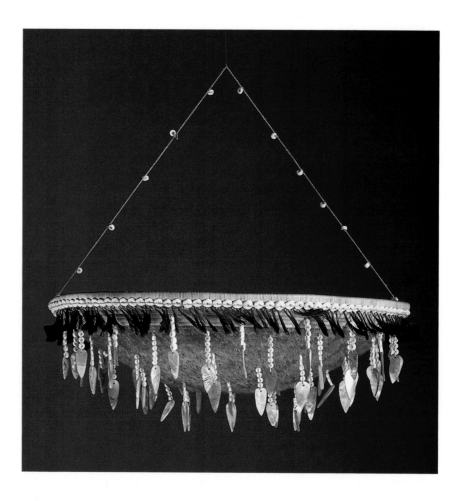

113. Pomo Basket

provide the viewer with evidence of at least three bird species taken for their feathers (see plate 113)—the redheaded woodpecker, yellowbreasted meadowlark, and blackheaded California quail. Other bird species were taken for black feathers, especially the valley and the mountain quail. A feathered container like this one was usually made as a gift or presentation basket, woven or commissioned, for example, to be presented at the birth of a child. Frequently, such a basket would be destroyed upon the owner's death.

Both of Raschen's paintings illustrate a most important art form of the California Indians—basketry. Indian basketmakers of California far excelled all other Indian basketmakers of North America in artistry, methods of manufacture, and range of materials. And among the California tribes, the Pomo Indians were the most prolific basketmakers.

The Pomo used baskets as implements and utensils for gathering, transport, storage, preparation, cooking, and serving of food. Baskets also cradled infants, held ceremonial paraphernalia, and wrapped the dead. In 1908 an ethnologist observed that "from birth to death a Pomo used basketry for every possible purpose."[17] As important, perhaps, as the prevalence of basketry, is its place in Pomo cosmology. Basketry was a gift of Marumda, the mythic hero in Pomo creation, during the fifth and final creation of the world. In the Pomo belief system, he is responsible for the four earlier creations and destructions of the universe, and historic Pomo

saw themselves as living in Marumda's fifth creation. Marumda is said to have given Kubum—the generic Pomo term for basketry material—to women at this time. He also directed them to willow for making baskets, distinguishing it from other raw materials associated with basketmaking.

Three Pomo techniques of basketry manufacture are known: twining, coiling, and plaiting; the first two are more common (see plate 114). Five distinct forms of twining were practiced: plain, diagonal, lattice, three-strand, and three-strand braided. In addition, two coiling methods were known, one on a single rod and the other on a three-rod foundation. Twining and plaiting may be described as weaving processes; coiling is a sewing process. Certain types of baskets—namely fish traps, baby carriers, and coarse openwork for storage or transport—are produced only by men. There was also a gender distinction based on method of manufacture. All close-woven or close-coiled baskets were the product of female basket-makers (see plate 115), and most twined or plaited open-weave baskets were made by male weavers.

Most variations in the surface designs of Pomo basketry result from different manufacturing techniques. In twined basketry, horizontal designs are more common than parallel, diagonal, or crossing diagonal designs. In coiled basketry, horizontal designs occur more frequently than parallel, diagonal, crossing diagonal, vertical, or separate groups of design patterns. The Pomo also sewed feathers to baskets, but only to three-rod coiled baskets.

The design on the hanging feather basket in *Pomo Interior* is a series of yellow rectangles moving diagonally across a red field that encircles the basket. This is a relatively common design in Pomo basketry and carries two names. For Pomoan speakers of the Northern and Central areas it is *bice-mao* and *pce-mao*, respectively, and both mean "deer-back." For Eastern Pomo speakers it is *du-dile*, or "potato-forehead." In all three dialects, however, when the rectangles are very small the design is called *bitu-mtu* or "ants." Frequently, a string of connected rectangles occurs with other elements that comprise a much more complex design.

The metal cooking pot in Raschen's painting is clearly a European trade item to the Pomo. Before contact, basketry containers served as cooking vessels, and the heat source was fire-heated stones placed on wooden racks within the container. Of European character, too, are the costumes of the woman and the child, influenced perhaps by the proximity of the Pomo to Fort Ross, the site of the former Russian colony in California. The child wears an abalone shell necklace and the woman a headdress of woodpecker feathers, called flickers. The feathered band of the headdress extends about three-quarters of the way around the head and is tied at the back by a string. The physiognomy of the two figures, carefully detailed by Raschen, suggests that we may be observing a Pomo Indian woman with a child of mixed blood.

Raschen emigrated with his parents to America in 1868 and returned to Europe twice to study at Munich's Royal Academy of Fine Arts, from 1875 to 1883, under Ludwig Loefftz and Wilhelm Lindenschmidt, and then again from 1890 to 1894. His Indian scenes of northern California and Arizona, painted between 1884 and 1890, reflect the academic style he learned abroad—a tight, detailed construction, based on the old masters,

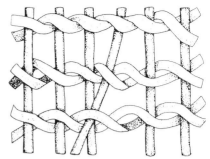

Twining technique

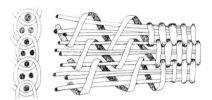

Coiling technique

Plaiting technique

114. Basketry Techniques

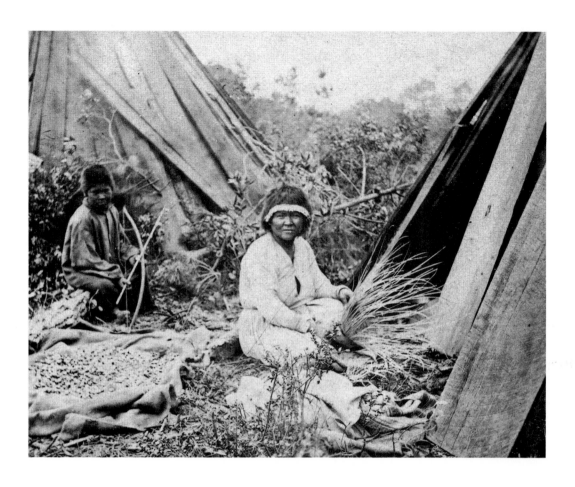

115. Carlton E. Watkins, *Pomo Village, Mendocino County, near Mouth of Big River.* 1863

that characterized Munich training at the time.

On his return in 1894, Raschen was encouraged to share the management of his father's ranch near Cazadero in Mendocino County, but the artist spent more time sketching and painting the farm's laborers—the Pomo—than on farming. Soon he returned to the city to open a studio, and there he exhibited his recent, large canvases of the Pomo. Raschen's dated paintings reveal that he made repeated excursions to the area for a number of years. The later works, like *Pomo Indians, Fort Ross,* of about 1897, show a broader painting technique, characterized by vigorous brushwork and dexterous manipulation of pigment, which nonetheless sacrifices some of the incisive ethnographic detail present in his earlier work (plate 116).

Pomo Indians, Fort Ross portrays an Indian group at leisure, engaged in a game of chance—probably the Kashaya Pomo because of the basket types and the conical, redwood-bark slab house seen in the background. Games of chance and gambling were not purely recreational among Indian groups. They were often a way of settling disputes, of relieving friction between individuals or groups, or of displaying skill. Among the Pomo, the Kashaya were known as expert gamblers. In Raschen's picture, the hand motions of the woman on the left and the the man pointing on the right also indicate a gambling activity. The sticks pointing upward on both sides are markers or counters—one stick equals one point. Strings of clamshell beads on the ground in the center may be the wager, and the baskets scattered among the group also may be associated with betting. The hand motions suggest that

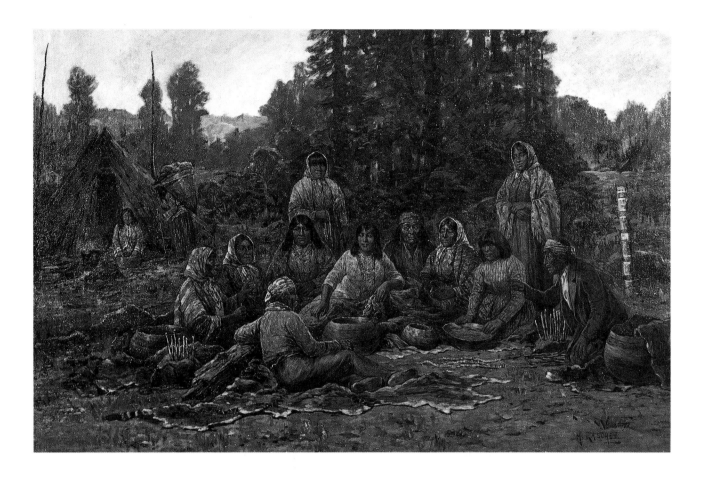

116. Henry Raschen, *Pomo Indians, Fort Ross, California*. c. 1897

the group could be playing the "hand game," or possibly the "stave game," or the "women's dice game."[18] It is also possible that the artist combined two games. A recent source, however, reinforces the conjecture that the game being played is stave:

> Although a women's game for most California Indians, [stave] was always played by both men and women among some groups [such as the Kashaya]. . . . In general, the game is played by two opposing players or sides and consists of tossing six wooden staves, accompanied by the singing of special gambling or "luck" songs to ensure a player's or team's success. And, depending upon how the staves land, points, twelve in all, are won or lost until one player or side has them all and wins the game, including the bets. . . . Along with six staves, twelve counters are also used in the game. . . . [Unlike the staves], the counters, 8 to 12 inches long and ¼ to ½ inches in diameter, are made from hazel, ash, and dogwood . . . [and] are undecorated except for removing the bark.[19]

Beside the man on the left is a "daum," a log struck by a stick to keep time with the music. Songs to ensure good luck accompanied games of stave. The two tall poles near the bark house at the picture's upper left are probably harvesting poles, used for striking the branches of trees to fell acorns and other nuts. Near the house a stooped woman carries a heavily weighted burden basket, attached by a tumpline across her forehead.

Although Raschen did not usually identify his models, the point man is

"Old Salomon—medicine man, Fort Ross Indians," who appears in a dated and inscribed portrait by the artist in the Lowie Museum Collection. Undoubtedly, he was a village leader because he reappears in several large paintings by Raschen, and he is still remembered by some of the present-day Kashaya from this area. In an interview with a reporter, Raschen referred to Salomon as "an old philosopher" who had "a really strong and thoughtful countenance" and who had sat for him for a full week "at one dollar a day, and every day he cut a notch around a stick. For a half-day the notch was cut half-way around. . . . Salomon is a real bohemian—lives anyhow and is very happy.[20]

Raschen used the white-man's derogatory term "digger" (see p. 247) to refer to these Indians, but he nevertheless had a strong desire to present these people accurately. In the same interview, Raschen remarked that if his paintings of Pomo were exhibited in New York, they would "give Eastern people a new idea of Indian life at home. They will see something different from the stage Indian in war paint and feathers. . . . The Indians love one another and have many good qualities for which credit is not given them. Pictures expressive of this life have not been truthfully painted heretofore." At the same time Raschen remained conscious of the "picturesque" possibilities of the Pomo, and, like most artists, he wanted to sell his work. In the late nineteenth century, European interest was stronger than American in America's native population, for Raschen remarked that he sold his work in Europe "at prices five times as great" as San Francisco prices.[21]

All four Pomo groups utilized temporary shelters for seasonal subsistence activities, especially for processing freshwater fish and acorns. *Ka-ma-ko-ya (Found in the Brush)* by Grace Hudson (1865–1937) probably depicts a temporary shelter used during acorn gathering in early fall (plate 117). Canvas, or a similar fabric, has been stretched to form a windbreak. In Eastern dialect, the term for the tenth moon of the lunar calendar translates "we will be camping and gathering acorns." The huge storage basket to the right of the children in Hudson's picture held the acorns, while the mortar and basket to their left were essential parts of the equipment for processing the nuts. At least five of the seven different California species of oak grow in the territory inhabited by the Pomo, and the preparation of acorns for human consumption required leaching the tannic acid from the mortar-ground nutmeal. Acorn meal was a staple cooked as a gruel or mush, usually flavored with berries, or made into cakes for use when the Pomo traveled.

Like Raschen's painting, Hudson's illustrates the art and function of California Indian basketry. In the Hudson picture, the large storage basket for acorns has three separate bands of horizontal decoration (see plate 118). Although the designs are difficult to distinguish, the design bands of the large basket seen in the painting probably did not completely encircle the basket. Pomo tradition would have broken the design at a point called a *dau*, *ham*, or *hwa*, believing that failure to leave a break would blind the weaver. At the turn of the century, researchers at the University of California, Berkeley, sought to identify the Pomo terms for all of the known basketry designs by Pomo weavers. Of a total of approximately forty-six named designs, only twenty-six were in common use. The terms for twenty of these twenty-six were in the languages spoken in the Northern dialect,

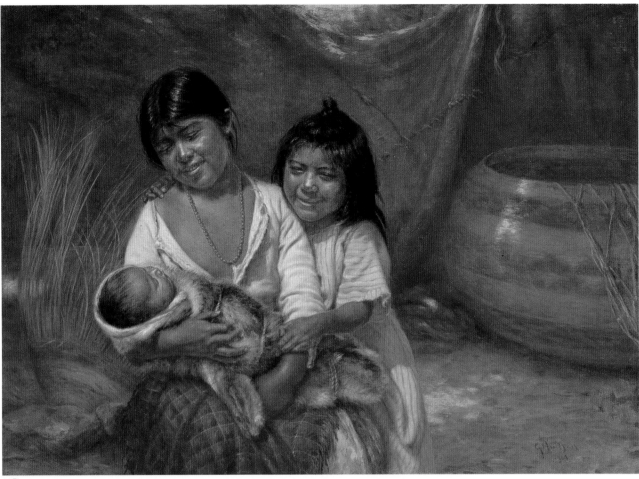

117

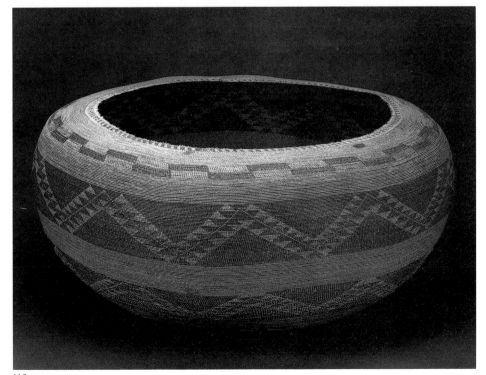

118

117. Grace Hudson,
*Ka-ma-ko-ya (Found in the
Brush).* 1904

118. Pomo Storage Basket

seventeen in the Central, and fourteen in the Eastern.

Known for her Pomo Indian pictures, Grace Hudson selected her young models from among her Pomoan neighbors and friends on the *rancherías* in the Ukiah and Potter valleys. Her essentially straightforward portrayals embrace a sense of human warmth and feeling for her subjects. In addition to capturing the moods and attitudes of her Pomoan sitters, Hudson consciously documented the traditions, lore, and artifacts of these neighbors. Hudson was devoted to children and might well have found in her paintings of them some compensation for her own childlessness.

Growing up among the Central Pomo people, Grace Carpenter showed an early propensity for drawing and after high school studied at the California School of Design in San Francisco. In 1889, she opened a studio in Ukiah and gave art lessons. That year she met her future husband, John Wilz Napier Hudson, a practicing physician who later gave up medicine to pursue ethnology. Somewhat later, the artist began devoting all of her time to painting the children of the Pomoan tribelets of Mendocino County, undoubtedly encouraged by her husband. Their marriage of forty-five years developed into a long professional partnership based on a profound interest in the Pomoan Indians and their material culture.

One California historian wrote of Hudson that "she was particularly adept at capturing the elusive, half-sad and yet winsome moods of the very young."[22] Early in her career, Hudson responded to a critic who asked how she was able to produce so many sympathetic portraits of her young subjects:

> When I see a baby that I want to paint, I cannot borrow it for an indefinite period by telling its parents it's the sweetest thing on earth. I have to kidnap it first and then overcome the natural inclination of a baby to do everything except what is desired. There is a popular superstition among the Indians that . . . to be sketched or photographed is sure to bring some terrible calamity down on the head of the subject. . . . When I want a subject, I first have to find a squaw with a papoose. If the child's face suits me, I enter into negotiations with the mother to do some work for me. . . . She leaves the baby strapped up in his basket and braced up against the side of the house. . . . The next maneuver is to get possession of that papoose.[23]

Hudson said she then promptly sketched the subject, coaxing it into assuming the pose she desired. She undoubtedly gained the confidence of her Indian models, since most of the subjects in her mature works seem naturally posed. According to her twin brother Grant, Hudson, like many artists of the time, completed her pictures with the help of photographs.[24] A view of the artist in her studio suggests that she also may have used dolls on occasion as stand-ins for live subjects (see plate 119).

As Hudson's work demands increased, she began to copyright her paintings and enter them in a ledger by number, date, title, and subject, which makes it possible to identify her subjects by name, completion date, and title. For 1904, the year *Ka-ma-ko-ya* was executed, Hudson listed a record forty-two works in her ledger. Most of her Indian subjects were from the Mitchell, Duncan, and Peters families, and all had close ties with the Hudson-Carpenter family.

No documentation remains on how Hudson selected the title *Ka-ma-ko-*

119. Grace and John Hudson in the Artist's Studio. c. 1895

ya, since it does not spring from any known Pomo legend or myth about creation and birth, although according to her biographer, Searles R. Boynton, "Pomo women . . . described their first children as 'being found in the brush.'"[25] We do know, however, that three of the five Peters children posed for this picture: Angel, the oldest, Rosita, the next in line, and William, the newborn baby. All are prominently placed in the foreground, with the sisters' eyes directed tenderly toward the new family member, who probably would have been bound in a cradle rather than in a fur. One might assume that his arrival was premature and the basket cradle not yet ready to receive him. Although Hudson was occasionally criticized for her sentimental portrayals, she has clearly caught the relaxed, unselfconscious gestures of tenderness her subjects express toward one another.

In the 1870s, when the German-American artist Albert Bierstadt (1830–1902) traveled north and south of San Francisco in search of subjects, he encountered numerous groups of Penutian-speakers. Known

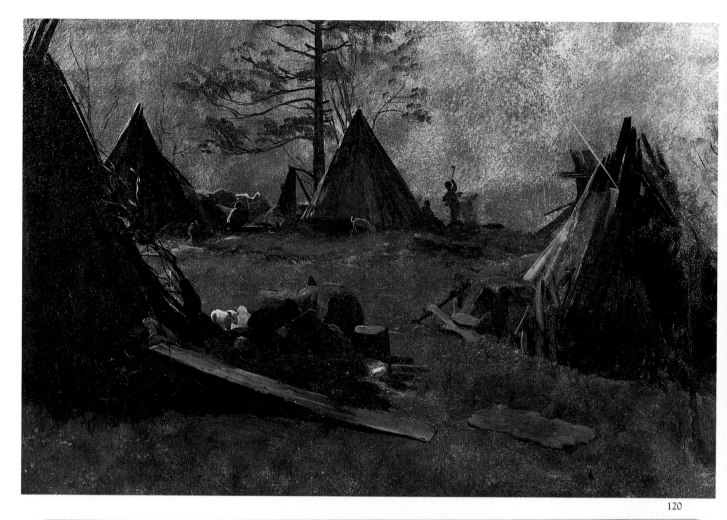

120

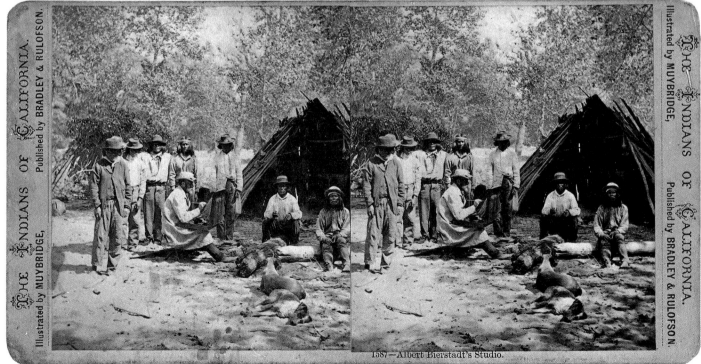

1587—Albert Bierstadt's Studio.

121

today as the Wintun, Maidu, Miwok, Yokut, and Costanoan, these Indians subsisted by hunting and gathering a wide variety of acorns, nuts, seeds, roots, plants, and berries as well as large and small game animals, fish, birds, and insects. Among the several house types built by these groups, one of the most common in the higher elevations was the type Bierstadt depicted in *Indian Camp, Mariposa* (plate 120), a conical structure of pine- or fir-bark slabs. Within each house, the central focus was the hearth and its earthen oven. They slept and ate around the hearth during inclement weather, made more comfortable by a carpet of pine needles and animal-skin beds. Much of the time, however, was spent outdoors, as is suggested by the equipment stored outside in Bierstadt's painting.

The native groups portrayed by Bierstadt are southern Miwok, whom anthropologists distinguish by their dialect differences and their slightly different cultural patterns. Miwok settlements are parts of larger political units in which people living in defined territories owned the resources within them. Today anthropologists call these Miwok political units "tribelets." The extended identity of individuals was determined by both their village and their tribelet. Within each tribelet a dominant village was host to the primary political authority—a "chief"—and all the important social and religious events took place in an assembly house in that village. Encampments without chiefs were headed by the male leader of the primary lineage, whose members were related through the male line. Although the most characteristic artifacts from this part of California are baskets, Bierstadt traveled in this area at a time when metal tools and containers were replacing more traditional basketry materials, as well as stone, bone, and wooden implements.

Bierstadt's persistent fascination with the Far West may well have been heightened when he saw Carleton E. Watkins's remarkable photographs of Yosemite Valley at Goupil's Art Gallery in New York, in December 1862. In spring 1863, his hopes for a second western expedition were realized when he and his friend Fitz Hugh Ludlow, writer for the *New York Post*, headed across the Great Plains toward Colorado and then on to California. Their principal objective was the Yosemite Valley, where Bierstadt made numerous sketches for his later studio work. In the early 1870s, Bierstadt returned to California, this time establishing a studio in San Francisco. At an art reception in San Francisco, he met the acclaimed photographer Eadweard Muybridge. The two men subsequently became friends and traveled to Yosemite together in spring 1872—Muybridge to photograph and Bierstadt to sketch the native people and the scenery.

Indian Camp, Mariposa is typical of Bierstadt's impressionistic plein-air studies, in which he reproduced only the essential character of a scene in a rather abstract, simplified manner. The scene is in Yosemite along the Merced River, at what is known locally as Steamboat Springs, and it suggests the same vantage point as Muybridge's photograph. Indeed, the photographer shot Bierstadt at work on the picture (see plate 121). Bierstadt's unvarnished, intimate scene offers an insight into the simplicity of Indian life—in contrast to the stereotypical image of the Indian dressed in finery and posed near his native dwelling.

Bierstadt's paintings were among the first to convey the wonder and excitement that artists and other early trailblazers felt when they con-

120. Albert Bierstadt, *Indian Camp, Mariposa*. 1872

121. Eadweard Muybridge, *Albert Bierstadt's Studio*. 1872

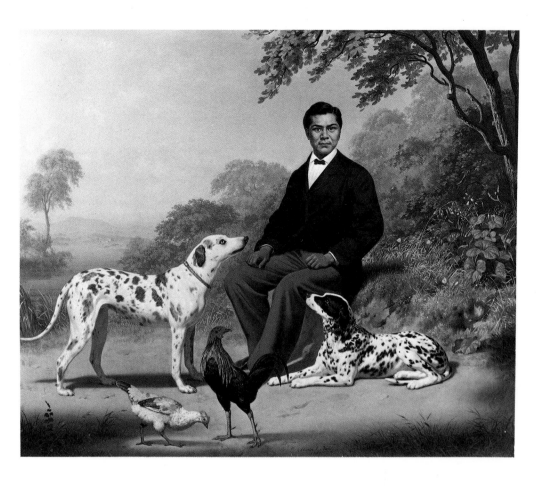

122. Charles C. Nahl, *Sacramento Indian with Dogs.* 1867

fronted the spectacular landscapes of the West. His monumental pictures were often criticized for using a style he learned in Düsseldorf—snowcapped, pink-tinged mountain peaks, elevated and sharpened; highly polished lake surfaces mirroring foliage; plunging declivities; and above all, theatrical lighting—to emphasize the sublimity and magnitude of America's scenic wilderness. Yet, there was another side to Bierstadt's art: the small, sketchy, outdoor oil studies, which appeal more to contemporary taste. These were often field studies from which he developed larger works. During his travels, the artist recorded his immediate impressions of the landscape, the animals, and the Indians he observed in facile, simple brushstrokes. Like other artists of his time, he believed that rapidly vanishing Indian customs and manners should be recorded by the painter as well as by the writer—"a combination of both will assuredly render . . . [their history] more complete."[26] Bierstadt's expression of the prevailing romantic view of the plight of native Americans competed at the time with an equally important philosophy, advanced by commercial and economic interests, that pressed for the extermination of the "Red Man."

California writers of the mid-nineteenth century frequently referred to the state's Indians in terms of their village, tribelet, or even their geographic location because the Indians so identified themselves. This may shed light on the twentieth-century title given to Charles C. Nahl's *Wahla, Chief of the Northern California Yuba Tribe* (also known by an earlier title, *Sacramento Indian with Dogs*; plate 122).

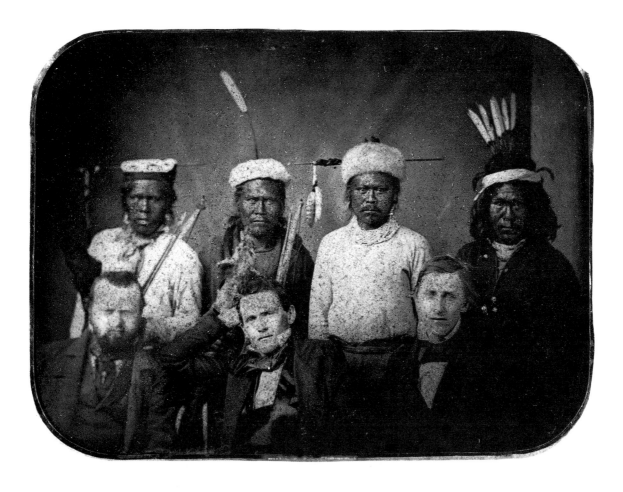

Contrary to the later title, the Yuba were never a *tribe*. Yuba was simply the name of a major village of the Nisenan Indians, who were also known as the Southern Maidu (see plate 123). This photograph, perhaps a copy of a missing ambrotype by Robert H. Vance, was taken at Yuba City in 1851. It was made during the visit of United States Indian commissioners who were negotiating treaties with the California Indians, and it shows the Southern Maidu (Nisenan) people dressed in the regalia of the religious dance society known as the "Kuksu Cult." The down-filled headnets worn by the two men in the center, the woodpecker-scalp wreathed pin with pendant prairie-falcon feathers worn by the man at left center, and the other accoutrements are all characteristic of these people.[27] Eighteen treaties "of friendship and peace" were negotiated with California tribes between April 1851 and August 1852. The Senate failed to ratify them and had them "filed under an injunction of secrecy." The injunction was not removed until 1905.[28] Thus the commercial interests of white landowners and speculators were protected for more than half a century.

Yuba, or Yubu, village was located near the juncture of the Yuba and Feather rivers, about forty miles northwest of Sacramento. Here the Nisenan subsisted by hunting, gathering, and fishing. At least three dialect units have been identified within the group, and in all likelihood the so-called "Wahla" spoke Southern Hill Nisenan. Instead of setting his painting in the Nisenan village of Yuba, however, Nahl seems to have chosen an idyllic landscape on a property belonging to Milton S. Latham, a Califor-

123. Robert H. Vance (attributed), *View of Indian Commissioners—Dr. Wozencrast, Col. Johnson—Indian Agent and Clerks in Treaty with the Indians (Southern Maidu).* 1851

nia governor who served the shortest term in the state's history, January 9–14, 1860. After his fifth day in office, Latham resigned to accept an appointment as a United States senator.

Latham was not reelected in 1863, and after a two-year sojourn in Europe he returned to northern California to manage the London and San Francisco Bank. By 1867, he was head of the California Pacific Railroad, which had built a rail line from Vallejo to Marysville (near Beckwith Pass, which cuts across the Sierras) to exploit the timber resources along the Feather and Yuba rivers. The terminus of the railway at Marysville (formerly Mountain City) is only a few miles from the village of Yuba.

Contact with the Nisenan chief and his people probably resulted from Latham's railroad activities, although the title *Sacramento Indian with Dogs* suggests that they met in Sacramento and not in Marysville or Yuba village. Indeed, the winding river in the background may suggest the Sacramento. In 1916, Mrs. Latham donated *Sacramento Indian with Dogs* to the M. H. De Young Memorial Museum in San Francisco. Only after its exhibition, in 1935, at the California Pacific International Exposition in San Diego, was the painting's title changed to *Wahla, Chief of the Northern California Yuba Tribe*. The title change was probably made on the basis of the following information given to the museum: "Wahla, Chief of the Northern California Yuba Indian tribe, became the protegé [sic] of California Governor Milton S. Latham in the eighteen sixties. The Governor arranged for the education of the young chief, and employed him as his personal coachman. Latham, whose mansion on the San Francisco peninsula in the town of San Mateo was ornamented with a collection of sculptures and paintings by artists in California, probably commissioned Nahl to create this particular image of Wahla as a civilized Indian, with coach dogs beside him and dressed as a gentleman."[29] It has been suggested that this portrait would serve to convince Latham's friends that all Indians were not savages.

Although the portrait probably was among the many works of art that adorned the mansion on the estate Latham purchased in San Mateo, in 1872, five years after the painting was completed, neither the commission nor Latham's relationship to "Wahla" or to any member of his tribe can be documented. However, the wide disparity between the description above of Latham's altruism and an editorial in the Marysville *Appeal* on December 6, 1861, reveals the true prevailing social climate of the 1860s in this area, and it leaves ample room for conjecture about what actually might have occurred between Latham and Wahla:

> But it is from these mountain tribes that white settlers draw their supplies of kidnapped children, educated as servants, and women for purposes of labor and of lust. . . . It is notorious that there are parties in the northern counties of this state, whose sole occupation has been to steal young children and squaws from the poor Diggers, who inhabit the mountains, and dispose of them at handsome prices to the settlers, who, being in the majority of cases unmarried but at housekeeping, willingly pay fifty or sixty dollars for a young Digger to cook and wait upon them, or a hundred dollars for a likely young girl. Recent developments in this vicinity are sufficient proof of this.

German-born Charles Nahl came from a distinguished line of successful artists, dating from the seventeenth century. Although the family was

affluent, Charles's childhood was clouded by his parents' divorce. During this unsettled period, Nahl began to prepare for an artistic career, probably studying first with his father and then at the academy of art in his native Kassel.

In Paris, later, he studied under the history painter Horace Vernet. Possibly because of the political uncertainty during the French revolution of 1848, Nahl left for America with his mother, sisters, and half-brothers, arriving in New York on June 30, 1849. In 1851, caught by gold rush fever, they headed for California to try to recoup their fortunes. The mining country offered Nahl subject matter for the remainder of his career, and his bawdy, robust scenes of miners and early settlers are full of humor and violence. In the 1870s and '80s, his newspaper and magazine illustrations became models for other San Francisco artists who hoped to recapture the flavor of early California gold rush days.

During the 1860s, Nahl painted many portraits based on his own daguerreotypes, and *Sacramento Indian* may be one of these. The portrait symbolizes the acculturation of the Indian to the white society, an evolutionary process that took place over many years, heightening and intensifying in the late nineteenth century as the West finally was won. This metamorphosis is clear in Nahl's painting.

Pictorial representations of native Americans from the California culture area range from the work of early explorer-artists to those of later visiting and resident artists. The rigors of early sea or overland travel limited all non-Indians to routes on or near navigable waterways accessible from the Pacific Ocean, or to established trails for horses and pack animals. Most artists who came before the missions were secularized observed native Californians in mission enclaves that were incipient urban centers. In time, many of these missions became the sites of major cities, which in turn attracted resident artists.

Overland trails built during the rush for gold and, later, farmland in California, like those built in the quest for fur-bearing animals in other parts of the continent, helped to determine the routes and the destinations of many artists who traveled inland at mid-century. Other artists depended at least in part on these routes to reach spectacular scenery at sites such as Yosemite in the Sierra Nevada. Access to all of these locations was eventually made easier by railroad and ultimately by automobile and truck routes.

Yet, even more limiting to artists than the transportation routes were the subsistence and settlement patterns of California Indians. Unlike the year-round earth-lodge villages or summer gatherings of the native peoples of the Great Plains or the permanent villages of the Puebloans in the Southwest, the small and seasonally shifting camps of the California Indians made their inhabitants difficult to locate.

By 1930 there were about 20,000 Indians in California. As a part of the nationwide effort in the '30s to cope with the Great Depression, laws were enacted to extend some of the New Deal legislation and benefits to poverty-stricken Indian communities. More than thirty years later, the national War on Poverty sought similar improvements for Indian communities. Today, there is a greater sense of self-determination among California Indians than there has been in almost a hundred years.

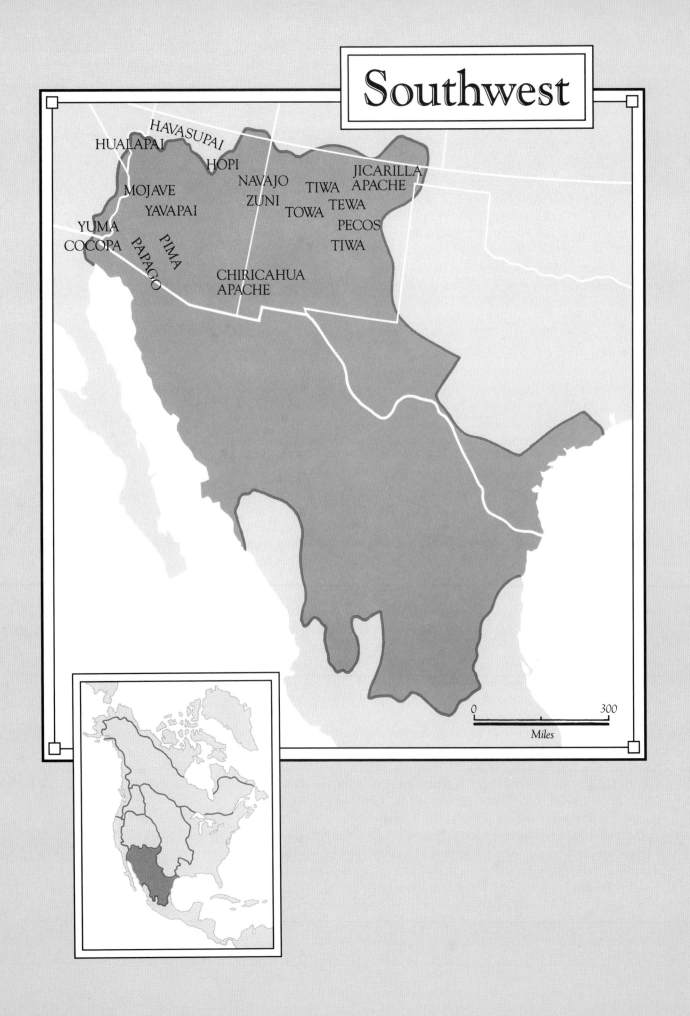

Southwest

HAVASUPAI
HUALAPAI
HOPI
MOJAVE
NAVAJO
TIWA
JICARILLA
APACHE
YAVAPAI
ZUNI
TOWA
TEWA
YUMA
PECOS
COCOPA
PIMA
TIWA
PAPAGO
CHIRICAHUA
APACHE

0 300
Miles

Like all preindustrial societies, Southwestern tribal groups have traditionally cycled their movements to the rhythms of nature. In the Southwest this usually included a pattern of seasonal migrations along with a strategic mix of agriculture, hunting and gathering, trading, and/or raiding. Since 1540, when the Spaniards arrived, these patterns have been modified increasingly, as native groups reacted in distinctive ways to Spanish and later to Mexican and Anglo domination. In more recent times, except for agriculture and the sale of tribal crafts, traditional subsistence patterns have been replaced by livestock production, wage labor, and welfare.

Indian groups in the Southwest have adapted to a predominantly arid landscape in a terrain of deserts, mountains, and plateaus, at elevations from sea level to over 10,000 feet. North of the region's Sonoran and Chihuahuan deserts, a high mountainous belt, the Mogollon Rim, arches from southern Nevada through central Arizona into southwestern New Mexico. Still farther north, the dry Colorado Plateau rises from 5,000 to 8,000 feet above sea level. Each of these landforms is cut by several major river systems: the Colorado, the Gila, and the Salt, which drain west to the Pacific; and the Rio Grande, which flows east to the Gulf of Mexico.

Although the Southwest is popularly called "the Four Corners" (the nexus of Utah, Colorado, Arizona, and New Mexico), as a culture area it is much broader and more complex. Scholars sometimes place their emphasis on the American Southwest—the southern portions of Utah and Colorado and all of Arizona and New Mexico; or they may study a more extended area known as the Greater Southwest—a continuous culture area cutting across the boundary that separates the United States from Mexico and includes the Mexican states of Sonora, Chihuahua, and parts of Sinaloa and Durango. Here, our primary emphasis will be on the American Southwest.

Today anthropologists classify the historic Indian tribes of the Southwest not only by their traditional subsistence patterns but also by their language affiliations. Thus the linguistically related Athabaskans—the Navajo and the Apache—are distinguished from neighboring Piman-speakers—the Pima and the Papago—as well as from their Puebloan neighbors, who speak several other languages. Scholars think that the Navajo and the Apache were once a single people who spoke a common Athabaskan language. This is suggested by the presence of many Athabaskan-speakers in interior western Canada and the likelihood of a Navajo and Apache migration from that region to the Southwest in prehistoric times. Most Athabaskans were hunters and gatherers, and the adoption of agriculture and herding by the Navajo and the Apache is a relatively recent phenomenon, resulting from contact with the Puebloans after 1300 and with the Spaniards after 1540.

The Spanish explorers who arrived in 1540 were the first Europeans to reach the Southwest. For almost three hundred years—until about 1820—Spain was the only important European presence in the region, and its impact was far-reaching. With contact, changes came about not only in Indian material culture but also in social and political organization as well as in religious practices. Sheep, goats, horses, and cattle were introduced, along with wheat bread and the beehive oven (see p. 235); and, almost immediately, onions, watermelons, peaches, apples, and grapes began to

augment the staples of the native diet—corn, beans, and squash. Metal axes and knives soon replaced stone tools. Wool embroidery and the use of the needle were added to textile weaving, and some new design ideas infiltrated both textile patterns and pottery decoration. As cultural contact extended through colonization and missionization, several different patterns of Spanish-Indian acculturation emerged. Eastern Pueblo groups accepted many Spanish cultural traits, and these modified but did not fundamentally change the native culture. The Navajo and the Apache, however, accepted fewer Spanish cultural traits, but these became more central to their own cultures. Still other adjustments occurred among Western Pueblo groups; the Hopi, for instance, almost completely rejected Spanish religious traits. Resistance by the Pueblo Indians to missionization was severely repressed; but, a century later, the Pueblo Revolt of 1680 forced the Spaniards to retreat down the Rio Grande to El Paso. The lost territory was reconquered by the Spanish in 1692, and from that time on most Pueblo groups coexisted in relative peace with their conquerors. The Hopi, however, built new villages high on the mesas to fend off further Spanish, and later American, intrusion.

Early Spanish explorers often referred to the Indian groups they encountered on the basis of obvious settlement patterns: Indians living in compact villages were called *pueblos,* and groups living along water courses on dispersed homesteads *rancherías.* River locations provided the *rancherías* with a reliable source of water for growing crops, while the drier plateau sites of the Western Pueblo groups led to a fuller development of religion, especially of kachina cults to invoke essential rain.

For all Puebloans, kachinas are spiritual beings that control rain for fertility and good harvests. The term also refers to the masked performers that personify these beings in ritual dances and dramas observed by the Hopi between the Winter Solstice in mid-December and the middle of July, a few weeks after the Summer Solstice. While every Pueblo group has kachinas, the kachina cult is much more elaborate among the Western Pueblos, such as Hopi, Zuni, and Acoma—where the water supply for crops is far less predictable—than it is in the Eastern Pueblos along the Rio Grande and its tributaries. Kachina dolls, carved by Pueblo men, often are given to the young girls of the village as a way of bonding them to this aspect of their tribal religion; the dolls also are hung on dwelling walls as teaching devices for children of both sexes. The strong sensitivities of Pueblo groups in this century against depicting images or recording the sounds of the kachina rituals prevent illustration here of either the ritual or the kachina dance costumes and masks.

Artists did not begin to hazard travel to the distant, little-known Southwest until the nineteenth century, and only the more adventurous made the journey before the 1880s. The earliest artists were not independent travelers but artist-explorers attached to scientific expeditions, military reconnaissance, and land surveys. Spanish dominion over the Southwest devolved to Mexico with Mexican independence from Spain in 1821, and the United States acquired the territory, in turn, as an outcome of the Mexican War (1846–48). By the 1880s, intertribal warfare had subsided, and the railroad connected the eastern part of the country with the Southwest.

Perceptions of Indian cultures began to change increasingly during the second half of the nineteenth century with diminishing Church influence and the advent of modern anthropology. New archaeological finds revealed a rich, prehistoric native tradition that not only seemed to link the high civilizations of Central America with aboriginal North America but also linked prehistoric Southwestern cultures to modern Pueblo Indian life. Work of the geologist-ethnologist John Wesley Powell led to congressional authorization of the United States Geological Survey in 1879, which Powell directed from 1881 to 1894; in 1879, the Bureau of American Ethnology also was created; and the Archaeological Institute of America, founded that same year in Boston, sponsored a study of Pueblo lifeways by the Swiss anthropologist Adolph Bandelier. The work of these and other early investigators led to the realization that Pueblo culture had remained fairly constant for centuries; but at the same time it became clear that this continuity would soon be broken for the economic advantage of the whites. Most of the reports of these scientific studies were intended for specialists, but some found their way into books and popular magazines. In fall 1881, the first installments of "My Adventures in Zuni" by anthropologist-ethnologist Frank Hamilton Cushing were published in *Century*; and, in 1884, the first written account of the Hopi Snake Dance appeared in *Snake Dance of the Moquis of Arizona*, a book by the soldier-turned-ethnologist John G. Bourke. And writers on American art and culture as influential as Hamlin Garland, who also was a catalyst for contemporary regional art, brought the Southwest to the attention of a wider public with articles such as "Among the Moki Indians," published in *Harper's Weekly* on August 15, 1896.

By 1878, the Santa Fe Railway had crossed from Colorado over the Raton Pass into New Mexico. Many of the Pueblo villages—Acoma, Isleta, Laguna, and Zuni—were now either on the main line or a day or so away by wagon, and in 1880 the town of Santa Fe was connected by a spur. An enterprising art patron, well aware of the Southwest's touristic potential, the railroad soon began to collect, display, and subsidize the work of many artists who were attracted by the "picturesque" Indian lifeways and landscape of the region. The Santa Fe Railway Collection was initiated in 1903, and *Moki Snake Dance* by E. Irving Couse was acquired a year later (see plate 172). In time, the collection grew to include, among others, the work of Oscar Berninghaus, Ernest Blumenschein, Gerald Cassidy, Victor Higgins, William Leigh, Warren Rollins, Joseph Sharp, and Walter Ufer, all of whom are represented in this chapter. The crafts of Pueblo artisans were displayed along with the work of Anglo painters and photographers in the Santa Fe Railway stations as well as in the hotels and restaurants of its affiliates along the route, particularly the Fred Harvey Company. Some of these paintings also were reproduced on menu covers (e.g., work by Couse and Leigh), and in calendars, train folders, and mass-magazine advertisements. During the 1890s the railroad began to offer artists free excursions, to select and study firsthand subjects for pictures to be used promotionally (Thomas Moran made such a trip, in 1892, in exchange for reproduction rights to a painting of the Grand Canyon; and William Leigh later made a free trip to Laguna in return for a proposed painting).

Overwhelmingly, artists attracted to the Southwest from 1850 to 1950

gravitated to Pueblo subjects, despite the multiplicity of cultural patterns in the region. Three non-Pueblo subjects are considered in this chapter, in comparison to fourteen Pueblo themes; and among the Pueblo groups, artists portrayed Taos and Hopi most often. The strong interest in Taos is explained only in part by practical and professional advantages: the nearby railroad and the minimal cost of living, along with the presence of an artists' colony after 1900 and the Taos Society of Artists from 1915 until it disbanded in 1927. An immediate success, the society was founded by six artists—including Berninghaus, Blumenschein, Couse, and Sharp—to plan traveling exhibitions for selling their work. Certainly, the close juxtaposition of a Hispanic population in the small city of Taos with an Indian culture in the adjacent Pueblo of Taos brought many well-traveled artists, as did the salutary climate, the natural light, and the serene monumentality of the Sangre de Cristo Mountains rising just beyond the four- and five-story architectural complex of Taos Pueblo (see Higgins, plate 139). Some of the same conditions attracted many artists to Hopi. After 1890, the railroad made northern Arizona more accessible, and, still later, roadways linked the Hopi Mesas with the Grand Canyon to the northwest and the transcontinental highway (Route 66) to the south. The physical setting of Hopi differs from that of Taos: at Hopi the San Francisco Peaks are at a considerable distance from the village, and it is not the mountain backdrop but rather the compelling beauty of the Hopi Mesas and the nearby Painted Desert that has intrigued artists for more than a century. And to many artists the Hopi may have seemed more remote and exotic than other Southwest Indian groups. Their ritual practices to ensure rain, particularly the all-important Kachina Dances and the colorful Snake Dance, provided a wealth of subjects.

From the end of the Civil War through the early twentieth century, Hopi and Taos were also photographed extensively. Large concentrations of photographers at Pueblo Indian activities, especially ritual events, are documented in numerous photographs of that period (see plate 124). These now historic photographs of Southwestern tribal groups were often consulted by painters of Indian subjects, and it was not unusual for artists to make their own photographs. Yet non-Pueblo tribes, such as the less-accessible Athabaskans, Yumans, and Pimans, have received more attention from photographers than from painters. Photographers were usually hired to accompany the later railroad surveys to remote areas, and artists on these expeditions were primarily topographers and mapmakers. Ultimately, disruptive Anglo photographers prompted many Pueblo groups to restrict photography: at Hopi, for example, all photography of religious rituals by Anglos was prohibited about 1910.

From the outset, almost every Indian subject appears in paintings of the Southwest: topographic landscapes, historical and cultural themes—especially rituals—and portraits. Early artist-explorers who accompanied government and private scientific expeditions in the nineteenth century, however, were naturally most concerned with accurately documenting their observations. Yet many of them were able to combine the factual and the pictorial successfully. Official government reports published after each expedition assiduously charted and catalogued the scientific data that was collected, and often these reports were profusely illustrated with meticu-

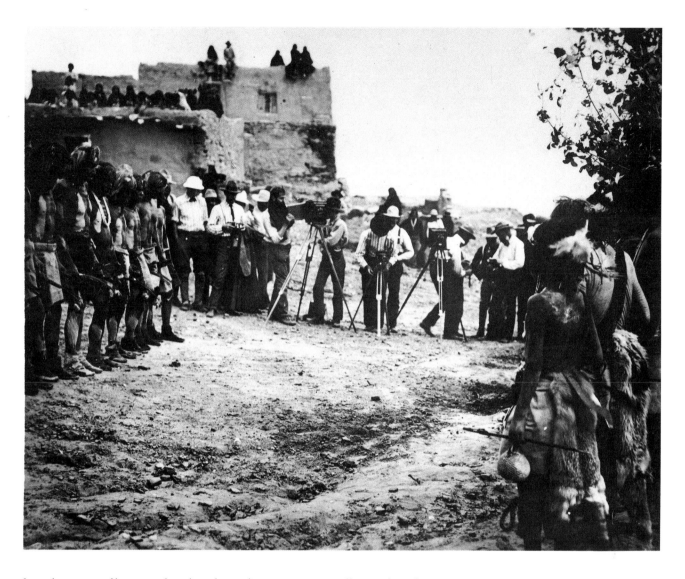

124. George Wharton James, *Hopi Snake Dance, Oraibi.* c. 1900

lous drawings of botanical and zoological specimens as well as archaeological and ethnological material. Even after the invention of the camera and its commercial application, exploratory parties continued to employ artist-draftsmen. The wet-plate photographic technique with its cumbersome equipment made it impracticable to rely exclusively on photography in the Southwest; when the dry-plate technique became available in the 1890s, photographs began to replace the work of artists (see Great Plains, note 11). Until then, visual records of exploratory surveys were made by artist-draftsmen who were often self-taught, like the German-born Balduin Möllhausen (1825–1905). After traveling with three expeditions to America in the 1850s, Möllhausen returned to Germany, where he ultimately published 150 volumes of travel narrative, fiction, and poetry. There his adventure stories of the American West became so popular that his biographer Preston Barba named him "The German [James Fenimore] Cooper."[1]

In November 1853, Möllhausen traveled through Navajo country as artist-topographer on a government expedition commanded by Lieutenant A. W. Whipple to survey a railroad route along the 35th parallel from Fort Smith, Arkansas, to Los Angeles. This was Möllhausen's second trip to

America; the first, in 1851, took him over the Oregon Trail as far west as Fort Laramie in the company of an inveterate adventurer, the German Duke Paul von Württemberg. Möllhausen's travels were motivated by his need to escape the political turmoil at home as well as to satisfy his longing for the exotic. He shared the attitude of another European artist, the Swiss Rudolf Friederich Kurz, who had realized his dream of spending a carefree existence among the Indians on America's frontier in the 1840s: "From my earliest youth the primeval forest and Indians had an indescribable charm for me. In spare hours I read only those books that included descriptions and adventures of the new world. . . . I longed for unknown lands, where no demands of citizenship would involve me in the vortex of political agitation." Nineteenth-century European Romanticism had transformed the Indian in the popular mind into a noble savage, a man of nature unspoiled by white civilization. Möllhausen's response to the native American was colored by this romantic vision, and his documentation of Indian lifeways sometimes verged on the picturesque.

Although we know that Lieutenant Whipple's party traveled through Navajo country, precisely when and where Möllhausen made this drawing of a Navajo group is still puzzling. It seems that the brief account of the Navajo in his *Diary* (vol. 2) was not based on firsthand observation but rather on information he gained in Albuquerque, where the expedition spent five weeks. According to Whipple's journal and Möllhausen's diary, no one in the survey party had extended contact with the Navajo, except for a brief encounter with two Navajo on November 30, 1853. The exchange was primarily with the survey's interpreters, Whipple wrote, adding that the Navajo had no wish for further contact because there were cases of smallpox in the survey camp.[2]

In his unpublished watercolor drawing *Navahoes-Indianer* (*Navajo Indians*), Möllhausen has posed the figures against a background that suggests the sweep of Navajo country with a hogan dwelling on the right (plate 125). The horse, a legacy of the Spanish conquest, had become a prominent feature of Navajo culture. The rather wooden figures, arranged to show tribal lifeways and dress, suggest that the drawing may be derived from European engravings or pattern books of costumes. Möllhausen also describes the Navajo in his diary:

The Navahoes are almost the only Indians of New Mexico who keep large flocks of sheep, and lead them with a nomadic life. They know, too, how to spin the wool, and weave from it very close blankets of various colours, of a quality seldom surpassed by those manufactured in the civilised world.

These parti-coloured blankets, in which the Navahoes envelope themselves, have a peculiar and rather agreeable effect, when a troop of them are seen together. Their costume in other respects resembles that of other tribes,—unless indeed, of such as wear no costume at all. A cotton shirt is considered a garment of rather superfluous elegance; but the Navahoes devote much care to the manufacture of their deer-skin *chaussures*, being very anxious to have strong soles turning up into a broad peak at the toes, on account of the *cacti* and other thorny plants. . . . They wear on their heads a helmet-shaped leather cap, usually decorated with a gay bunch of eagle, vulture, or turkey feathers. Besides bows and arrows, they carry a very long lance, in the management of which they are extremely skillful, and when

125. Balduin Möllhausen, *Navajo Indians.* 1853

126. Navajo Chief's Blanket, First Phase. c. 1840–50

127. Timothy O'Sullivan, *Aboriginal Life Among the Navajoe Indians near Old Fort Defiance, New Mexico.* 1873

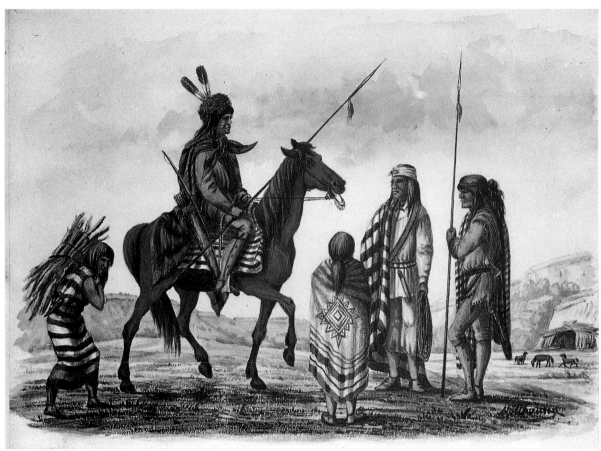

125

126

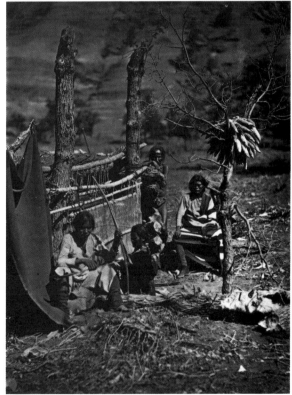

127

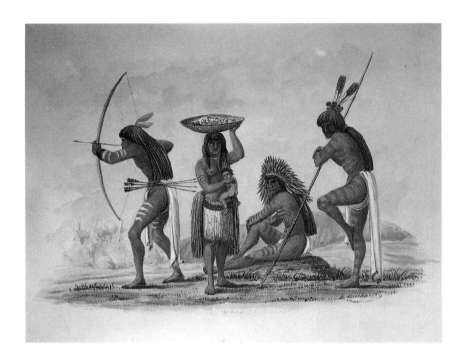

128. Balduin Möllhausen, *Mohave Indians*. 1858

thus armed, and mounted on their swift horses, are antagonists not to be despised.[3]

Möllhausen's drawing records two of the Navajo blanket types used in the 1850s, the striped "Chief's Blanket" and the Saltillo *sarape* from northern Mexico, the latter worn by the woman in the center. Chief's Blankets (see plate 126) are worn by the woman on the left and the two standing men; another covers the rider's saddle. A Navajo blanket would probably not have been tied at the throat—as Möllhausen's rider does—but it might fall in soft, rounded folds like those the artist has drawn. Navajo men usually wrapped their blankets over their backs, letting them fall open over the shoulders at the front. The technology for these weft-faced weavings was developed over a period of two hundred years; it was learned from contact with the Pueblo Indians, who had woven cotton for more than a thousand years but gradually substituted wool after the Spaniards arrived in New Mexico in 1540. At the left in an unromanticized photograph by the Civil War and frontier photographer Timothy O'Sullivan (1840–1882; see plate 127), a Navajo woman is weaving, her loom supported by two vertical posts that hide the hogan directly behind; the seated man at the right wears a Chief's Blanket.

Today, Navajo striped blankets like the one in Möllhausen's drawing are called "First Phase." Within ten years of his visit, style preference changed to a design now called "Second Phase," and in another decade to "Third Phase." In First Phase blankets (about 1840–65), solid stripes of blue, black, brown, and white extend through the entire textile; in Second Phase blankets (1865–75), the stripes are interspersed with rectangles; and in Third Phase blankets (1875–95), triangles or diamonds are the primary design elements. The blue comes from an indigo dye supplied to the Navajo by Mexican or Pueblo traders, while the blacks, browns, and whites are the natural colors of sheep's wool.

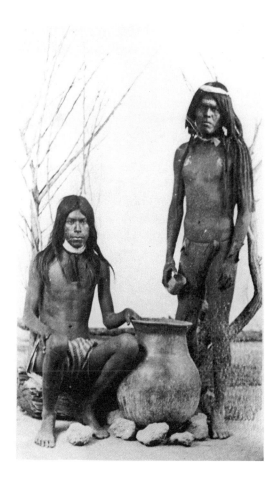

129. Elias A. Bonine, *Two Men with a Pot (Yuman-speakers Along the Colorado River)*

Early in 1857, after spending three years in Germany, Möllhausen returned to America; that August the secretary of war appointed him to a topographical survey of the lower Colorado River and the Grand Canyon, an expedition commanded by Lieutenant Joseph Ives. On this trip to an area rarely visited by artists, Möllhausen was assigned to help gather scientific specimens and to prepare drawings of significant topographic and ethnographic phenomena observed by the party.

On February 10, 1858, as their steamer emerged from the Grand Canyon, the expeditionary party beheld the "broad and noble" Mojave Valley and on the banks of the Colorado River a "cluster of Mohave Indians." Lieutenant Ives's detailed description of the Mojave closely matches Möllhausen's *Mohaves* (see plate 128):

> The men, as a general rule, have noble figures. . . . Having no clothing but a strip of cotton, their fine proportions are displayed to the greatest advantage. . . . The women, over the age of eighteen or twenty, are almost invariably short and stout. . . . Their only article of dress is a short petticoat, made of [shredded willow] bark, and sticking out about eight inches behind. . . . [The infants of a few months are] carried upon the [front of the] projecting petticoat, where they sit astraddle, with their legs clasping their mother's waist and their little fists tightly clutched in her fat sides.[4]

The gestures of the Mojave men as well as the spear and the bow and arrow may symbolize the prominent role of warfare in their lives, although a

Mojave warrior usually wielded a rudimentary, short-handled club as well as a shield in close-quarter fighting with an enemy. Mojave warriors streaked their long hair with red and white mineral color and striped their torsos, arms, and legs with clays or iron oxides in reds, whites, and sometimes blue-greens. Elaborate Mojave headdresses, like the one on the seated warrior, have all but disappeared, making this a useful record, even though Möllhausen was sometimes imaginatively inaccurate. This staged photograph by Elias A. Bonine (1843–1916) of two Mojave men, carefully posed with an authentic pottery prop, exemplifies the frequent representation of nude or partially clad nonwhites in a period that did not allow such exposure of white bodies (see plate 129).[5] A broad, shallow basket, like the one the woman carries on her head in the watercolor, is most often used in food preparation. Here the bearer assists in an event of the next day: on February 11, 1858, the Mojave leader, José, welcomed the Ives survey party with a gift of cooked beans.

Today the Mojave are identified by language as Yumans, or Yuman-speakers, one of several tribes that speak a northern dialect of the Yuman language. In historic times the Mojave have lived along either side of the Colorado River from its delta at the Gulf of California, in Mexico, to southern Nevada. To the east and west were other Yuman-speakers, in the Upland areas of modern-day Arizona and California. Among the best-known Upland Yumans are the Havasupai, Hualapai, and Yavapi. These tribes were rarely subjects for painters, because they seemed neither picturesque nor accessible.

The Mojave (whose residence pattern led the early Spanish explorers to call them *rancherías*) traditionally practiced a relatively balanced subsistence economy based on hunting, wild food gathering, agriculture, and fishing. Extended families, the primary social units in Mojave households, belonged to larger sociopolitical units called bands, headed by a chief and several subchiefs; and in historic times a political leader served the tribe as a whole.

Unlike the Navajo and the Mojave, recorded by Möllhausen and other traveling artists, the Pueblo tribes with their village settlement pattern, agricultural economy, and among most of them at least the appearance of Christian tradition—churches, priests, Sunday and Holy Day services—made these groups seem more familiar. This sense of familiarity rendered prolonged visits to their villages more comfortable and convenient for artists, government officials, and other early Anglo travelers to the Southwest.

Of the four distinct languages used by Puebloans, Hopi and Zuni are unique and are spoken in areas geographically separate from the other Pueblo sites. A third, Keresan, is spoken at Acoma and Laguna in western New Mexico and at Zia, Santa Ana, San Felipe, Santo Domingo, and Cochiti to the east, on or near the Rio Grande. The fourth language, Tanoan, is divided into three subgroups: Tewa, spoken at San Ildefonso, San Juan, Santa Clara, Hano, Nambe, Pojoaque, and Tesuque Pueblos; Tiwa, spoken at Picuris, Taos, Sandia, and Isleta Pueblos; and Towa, now spoken only at Jemez Pueblo.

In 1540 the Spaniards found at least sixty Pueblo groups in the American Southwest. The twenty-one groups that remain today are remnants of what

was once a more vigorous culture. The village of Jemez is a good example of Puebloan population decline and convergence. Today it is home to refugees from several other Towa-speaking villages. The best known of these Towa villages was Pecos, once located east of Santa Fe but abandoned about 1838. An estimated 5,000 Towa-speakers lived in the Southwest in the sixteenth century; today, some 1,800 Towa-speakers or their descendants live at or near Jemez. When Peter Moran (1841–1914) visited Jemez in 1881, the pueblo had fewer than 500 inhabitants.

Peter Moran, a painter of animals and rural landscapes, was the youngest brother of the celebrated landscapist Thomas Moran. Unlike Thomas, whose concern was with the fleeting character and poetry of his subjects, Peter Moran belongs to a long line of reportorial artists. In 1864, Peter sketched in New Mexico, on a trip to the West that predates his brother's first Yellowstone excursion by almost a decade. On one of his subsequent forays into the Southwest, in August 1881, Peter Moran toured the pueblos of New Mexico and Arizona with the soldier-ethnologist John G. Bourke.[6] A month later, after Bourke had left for Chicago, Moran went on to Jemez Pueblo where he filled his notebooks with pencil sketches of Pueblo lifeways.

At Jemez, Moran undoubtedly observed the activity depicted in *A Stampede/Jemez Pueblo/New Mexico* (plate 130), a livestock stampede crossing what seems to be the village's Dance Plaza (see plate 131 for Charles Lummis's photograph of the plaza). Such stampedes were a real and not uncommon occurrence in the Eastern pueblo villages. Livestock herded through narrow streets often bolted for freedom from the confines of the pueblo, and the inhabitants naturally tried to escape the panicking herd. Harvard-educated Charles Fletcher Lummis (1859–1928), who photographed the Jemez Dance Plaza a few years later, was an editor, traveler, and photographer of the Southwest. Many of his photographs, made from 1888 through 1926, were reproduced in periodicals such as *Harper's, Land of Sunshine,* and *Out West,* and his photographs and those of his colleagues often became source material for artists.

Most numerous among the animals in Pueblo villages in the 1880s were mules. Like the horse, the mule was introduced by the Spaniards, and throughout the Southwest it was preferred to the horse as a beast of burden because it was more sure-footed, had greater stamina, and could forage more easily. And not surprisingly, in Moran's time a mule often cost three times as much as a horse. In addition, mules probably went unshod, an important advantage because iron was a costly import, first from Mexico and later from distant production centers in the United States.

The severe population decline that led gradually to the consolidation of Pueblo villages was caused in part by new diseases brought by Europeans, against which the native populations had no immunity. Another factor that contributed to this decline was the introduction of the horse by the Spaniards, not only to the Puebloans but to other tribes as well. And when firearms became more available, in the eighteenth and early nineteenth centuries, many of these tribes—the Navajo, the Apache, and southern Plains groups such as the Kiowa and the Comanche—now armed and skilled horsemen, became more formidable foes than ever of the Pueblo, able to raid more widely and transport their booty more easily. This

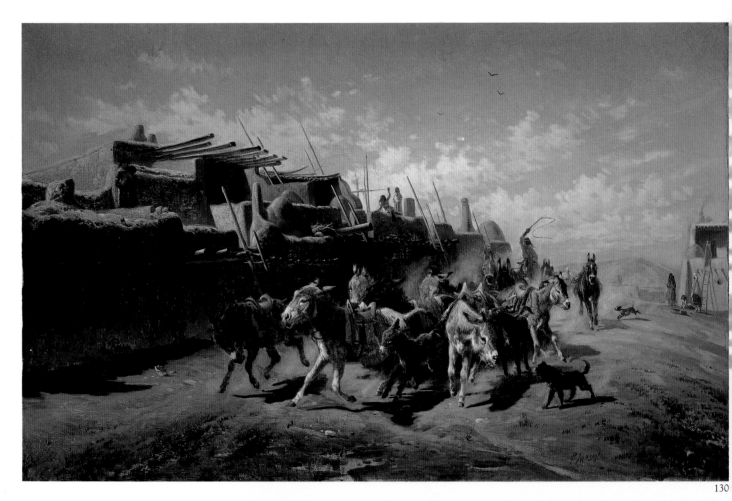

130

130. Peter Moran, *A Stampede/ Jemez Pueblo/New Mexico.* 1881

131. Charles F. Lummis, *Dance Plaza, Jemez Pueblo.* c. 1890

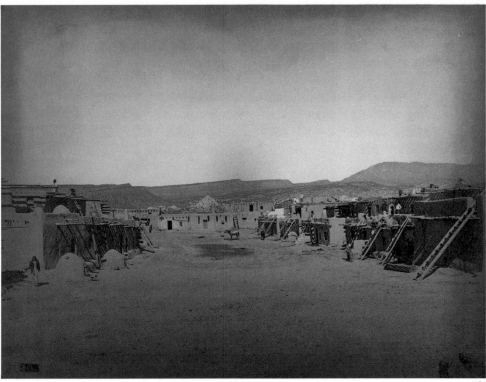

131

intertribal warfare led to both the relocation and consolidation of Pueblo villages.

Perhaps no other tribe became more famous—or infamous—as raiders than the Apache. Probably because of their prolonged warfare with the United States Army more than their raids into the territories of the Pueblo and other tribes, the Apache have been mythicized by generations of writers, painters, and film-makers. And although their historic homeland is in the American Southwest, the Apache also raided deep into Mexico.

After migrating to the Southwest from the interior of western Canada some time after A.D. 1200, the Apache separated into several smaller groups. By the time the Spaniards arrived in 1540, the Apache had spread over a territory extending from western Texas to south-central Arizona. Throughout the next 350 years these diverse Apache groups adapted to localized ecological niches, which in turn fostered their cultural and linguistic separateness. Today anthropologists recognize six major Apachean tribes: the Jicarilla, the Lipan, the Kiowa, the Mescalero, the Chiricahua, and the Western Apache. (The Athabaskan-speaking Navajo could be considered a seventh group.)

Almost certainly the Indian group depicted in *Renegade Apaches* (see plate 132) is Chiricahua Apache, but from evidence to date Henry Farny (1847–1916) probably never traveled to the Southwest to make studies for this picture. As a narrative painter Farny is best known for his paintings of Plains Indians, and although he achieved considerable stature during his lifetime, his career was overshadowed by two of his contemporaries, Charles Russell and Frederic Remington. In recent years Farny's work has been rediscovered, and his skillful interpretation of the West has begun to receive the acclaim it deserves.

As a child Farny first encountered Indians—Iroquois of the Onondaga tribe—in an encampment only a few miles from his family homestead in rural Pennsylvania. Fascinated by Iroquois culture and history, he soon developed a consuming interest in the native peoples of North America. Farny began his career as an illustrator, but his desire to become a painter led him to several years of European study during the 1860s and '70s. He made the first of many trips west to Indian country in 1880—to Standing Rock (Fort Yates) on the Upper Missouri. He had expected to do a portrait of the then captive Chief Sitting Bull, but the chief had already been moved to Fort Randall, South Dakota. Farny, nonetheless, spent several months sketching and photographing the Plains Indians in and around Fort Yates; he also began what became a sizable reference collection of artifacts, costumes, implements of war, and other tribal accoutrements, in addition to photographs and sketches.

Farny's years of study and his voluminous notes and sketches led to an unmistakable style that united precision of detail, sharp value contrasts, a shifting angle of perspective, and cropped foregrounds. He combined a photographic technique with the asymmetrical composition of the Japanese print. In *Renegade Apaches,* Farny views the scene from a low vantage point in the foreground, which leads the eye first to a small group of renegades and then upward along the cliff's sharp edge to the intersecting peak. Dwarfing the group huddled by the fire, Farny crops the mountain forms on the left and right to give full strength to the central peak. He

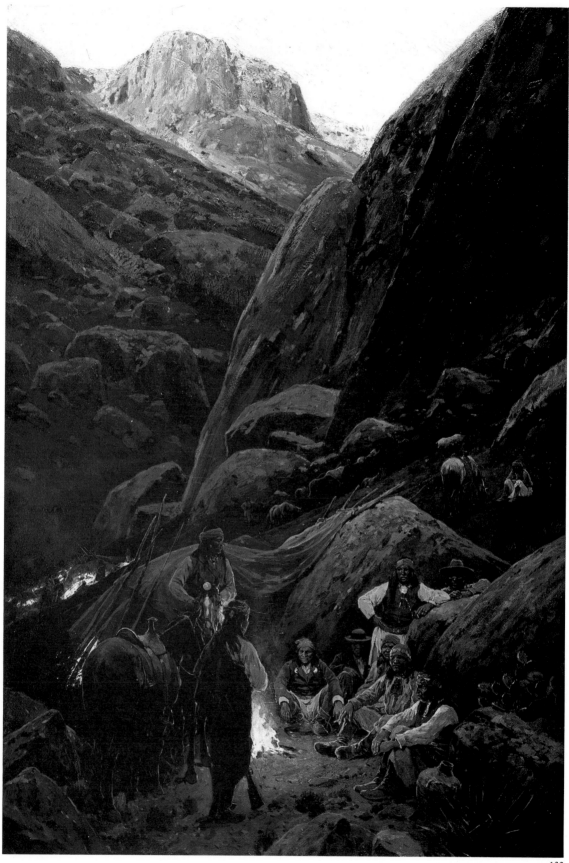

132

133

132. Henry Farny, *Renegade Apaches.*
1892

133. Apache Man's Boots. Late
nineteenth century

134. Camillus S. Fly, *Apaches at the
Surrender, General Crook and Geronimo.*
1886

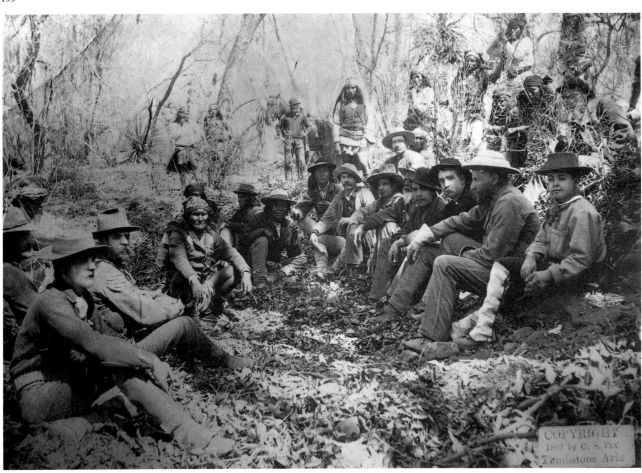

134

models the craggy stone formations with geological precision, and his exquisite coloring and light and dark contrasts have the qualities of some modern photographs. Firelight and daylight bounce off the rocks, highlighting the carefully defined groups of figures presumably scattered in the Dragoon Mountains, a hiding place for the men of the Chiricahua Apache leader Geronimo.

Most of the men in Farny's picture wear typical Apache headbands, made by folding and tying a large rectangle of cloth. The lower body is covered with a still larger length of cloth, wound under the crotch and then pulled over a waistband at front and back. Heelless Apache boots made their wearers especially hard to track as they moved through southern Arizona, New Mexico, and northern Mexico (see plate 133). Although their vests and shirts—and some of their hats—were adopted from the whites, Farny's renegades are portrayed in more traditional Apache attire than those photographed by Camillus Fly (1850–1901), a Tombstone, Arizona, photographer who witnessed the United States Army defeat of the Chiricahua Apache in 1886. Farny's painting may well have incorporated elements from Fly's photograph of a council group (plate 134) as well as from a number of other photographs by Fly of Geronimo and his surrendering warriors. Indeed, Geronimo's pose and attire in this photograph (he is fifth from the left) closely resemble those of the central seated figure in Farny's painting. Charles Lummis also was on the scene at the surrender, reporting for the *Los Angeles Times,* and both Lummis's accounts and Fly's photographs of the event were widely circulated.

More pacific than Farny's view of the Apache is the one seen in *Gifts from the Apaches* by Joseph Henry Sharp (1859–1953; see plate 135), a friend and former student of Farny in Cincinnati. Sharp's models are Taoseños, who are admiring baskets made by another tribe—the Jicarilla Apache. Traditionally, the Jicarilla ranged from the high plains country in southern Colorado to the mesa and plateau country of north-central Mexico, a territory with elevations of 4,000 to 14,000 feet. The Jicarilla Apache culture has two distinct orientations: some of this group has adopted Pueblo traits and others Plains traits, which are described by the Spanish words *olleros* (potters) and *llaneros* (plainsmen). Although irrigation agriculture was practiced by the Jicarilla, hunting and gathering were their mainstays. Among the large game animals, buffalo were most important but they also hunted deer, antelope, elk, and mountain sheep; their wild foods included berries and fruits, acorns, piñon, and the seeds of grasses. The economies of all Apache groups depended on raiding, and in time they developed extensive rituals associated with this practice. Although Mexican rule in the Southwest had been largely ineffective in controlling Apache raiding, it was greatly curtailed after New Mexico became an American territory as a result of the Mexican War. Repeated United States Army campaigns in the Southwest ultimately led to the pacification of the Apache.

With time, Apache raiding expeditions against the Pueblo were replaced by trading parties of the kind that Sharp depicted in *Gifts from the Apaches.* In exchange for agricultural products or other Pueblo manufactured goods the Apache often traded meat or craft items. Acting as both intermediaries and trading partners, Taoseños often sheltered or fed Apache visitors, and these relationships were maintained in part through gift exchange.

All Apache groups make large, coiled basketry trays with geometric designs in natural colors as well as coiled water bottles (covered with pine pitch when in use). In Sharp's painting both basketry types are shown (see plate 136). The coils are formed and anchored by passing thin strips from the narrow-leaf yucca plant over and around foundation materials through openings made by a bone or metal awl. Jicarilla women work with any one of three basketry foundations: two rods and a bundle of grass; three rods and a bundle of grass; or a wood slat and a bundle of grass. In each case, the foundation materials are curved to shape the circular side walls of the basket and then aligned to form wide, flat, flexible containers that are used for food gathering, preparation, storage, and possibly religious rituals. Since such coiled baskets were not usually made by the Eastern Puebloans, they were often received as trade items or gifts from the Apache.

Like other artist-illustrators who settled in Taos early in this century, Sharp fully sensed the passing of an era and was eager to record traditional Indian customs before they were lost. He had a hearing disability, which is said to have made his eyes especially keen in perceiving "more in nature, people, and things than the ordinary individual,"[7] and his passionate understanding of the plight of the Indian imbued his reportorial works with a strong feeling for the native American's characteristics, idiosyncracies, and aspirations.

Aware that "the real, picturesque Indian was fast disappearing," Sharp lamented that "the small boys wear short hair and a shirt, while the girls are tidied up and in calico. It is heartbreaking to the artist, and particularly so if he has not had the foresight to collect costumes and various articles which become more rare each year."[8] Recognizing his studious approach to native cultures, his Taos Society colleagues referred to him as "the anthropologist." A facile, academic style enabled him to represent the distinctive physiognomies and costumes of various Indian tribes with considerable ethnographic accuracy (see plate 151). At the same time, Sharp's European training led him to idealize and romanticize his Indian subjects and, later in his career, to focus on the more exotic and picturesque aspects of their lives. In his elaborate, carefully lit studio pictures his Indian models become depersonalized even though they are surrounded by the necessary storytelling props.

In the narrative scene *Gifts from the Apaches*, Crucita (New Corn), Sharp's favorite female model, and Frank Martínez (Bawling Deer) stand before an open window, with the rugged New Mexican landscape in the distance. The Jicarilla baskets no doubt are from Sharp's extensive collection of Indian artifacts (see plate 137). The two figures are modeled by the soft yellow sunlight that also sets the mood of the scene. Sharp once remarked that "the Pueblo Indians did not interest him as subjects until he 'got them in the sun or firelight.'"[9]

Sharp's sales ledger reveals that Crucita posed for many of his pictures, from about 1915 until the time of her marriage, in 1924.[10] She is usually costumed in the same Pueblo dress with or without its colored underblouse, and her hair is arranged in the manner typical of Taos. Hairstyles vary somewhat from the eastern to the western pueblos; at Taos, a woman's hair was cut in bangs across the forehead and shaped down to the earlobes, with the longer hair pulled back and tied at the nape of the neck. Contrary to

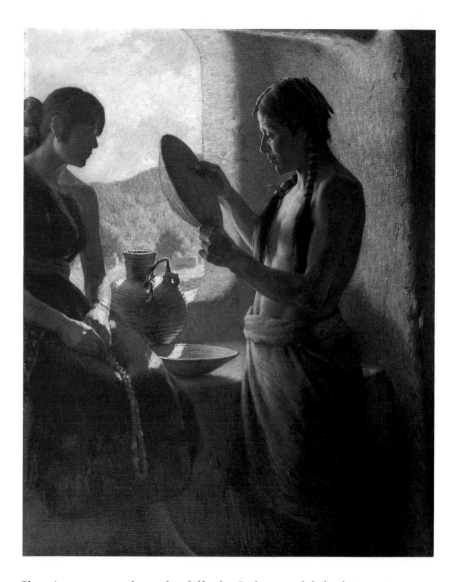

135. Joseph Sharp, *Gifts from the Apaches.* 1914

Sharp's comments about the difficulty Indian models had in posing naturally, Crucita seems relaxed and contemplative in most of his paintings. The window and its alcove seat are those in Sharp's adobe studio, but the picture conveys the stark simplicity of a traditional Taos interior and indeed the sparseness of all Pueblo dwellings. In strong contrast to this material simplicity is the rich and complex nonmaterial culture of Pueblo philosophy and religion, a culture that is strongly female-oriented in its emphasis on "Mother Earth" and other female spiritual beings that relate to materials such as clay, corn, turquoise, and salt.

Taos Pueblo, the northernmost Rio Grande Pueblo, has been a subject for more artists than any other Pueblo village in the Southwest. Its distinctive four- and five-story, apartmentlike structures, North House and South House, once served as defensive positions against marauding Plains tribes (see plate 138). Another settlement pattern evolved gradually, from the start of this century, and today scattered, separate, one-story houses occupy land to the west and south of the older dwellings. What used to be agricultural and grazing land, now accommodates most of the population of Taos, outside the historic setting of North and South Houses.

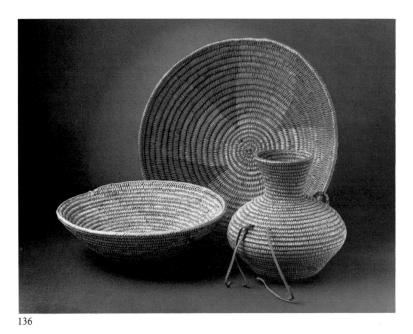

136

136. Jicarilla Trays and Water Bottle.
Early twentieth century

137. Joseph Sharp in His Taos Studio
Surrounded by His Artifact Collection.
c. 1940

137

138. Charles F. Lummis,
*North and South Houses at
Taos Pueblo.* c. 1888–96

139. Victor Higgins, *Pueblo
of Taos.* c. 1927

138

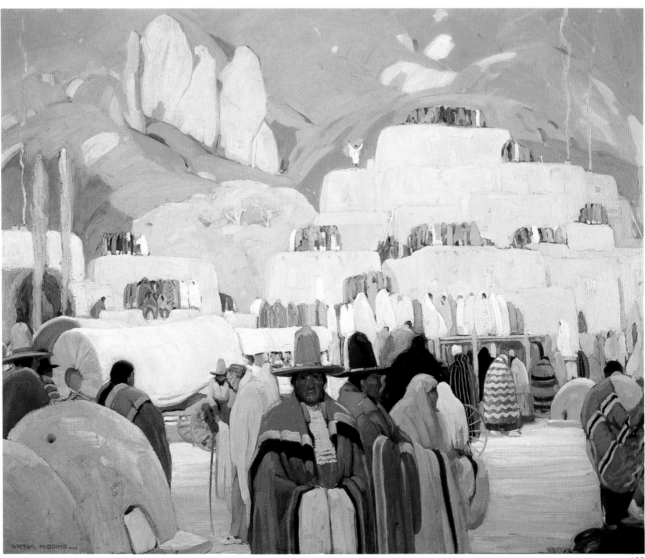

139

North and South Houses are situated within a low, eighteenth-century, defensive wall that encircles the pueblo, and isolated remnants of the wall still remain. Traditionally, Taoseños believed that the ground within the wall was hallowed: cowboy boots and other hard-soled footgear were proscribed to avoid cutting "Mother Earth." Even members of Plains tribes respected such traditions when trading in Taos.

Pueblo of Taos, by Victor Higgins (1884–1949; plate 139) is also about visitors to the village, engaged here in the bustle of commerce and identifiable by their attire. As early as the eighteenth century, long before Anglo artists visited Taos, other visitors came each year in July and August for trading, for new supplies and equipment, for women, and to drink the local *aguardiente.* Some were mountain men, others were merchants or government officials, still others were Indians. Among the Indian visitors were other Puebloans as well as Navajo and Apache from the Southwest, and Ute, Comanche, Kiowa, and Arapaho from the southern Plains. From about 1700, the evergrowing Hispanic settlement of Taos, just south of the Pueblo village, added to the lure of the annual Taos rendezvous. And about this time some intermarriage and other close social relations began to occur among colonists and native groups. After Mexican Independence, in 1821, this settlement was used as a government outpost for regulating trade between the United States and Mexico along the Santa Fe Trail.

Some of this late summer excitement can be seen in Higgins's narrative painting *Pueblo of Taos.* A visit to Taos by Plains Indians illustrates a pattern of Pueblo interaction with Indian trading partners, trading relationships that are well documented by early travelers as well as by later scholars. The tribes of the Great Plains, who lived beyond the Sangre de Cristo Mountains northeast of Taos, were not always friendly toward the Taoseños, but their trading contact resulted in a substantial intermingling of cultural traits that is evident at Taos even today. Cultural borrowings by the Taoseños include elements of Plains costumes, hairstyle, and some features of religious ritual. Plains groups, in turn, traded meat and hides with the Taoseños for Pueblo clothing and baskets. Plains Indians did not tend sheep or grow cotton, and therefore were not textile weavers; and, except on the northern plains, they did not weave baskets but customarily made their containers of rawhide.

In Higgins's painting, the most obvious difference in costume between the two groups is the wide-brimmed, high-domed felt Stetson worn by the Plains Indians. Borrowed from early nineteenth-century visitors to the region, it is often referred to as a Crow hat, although it was worn by all Plains groups (see plate 140). Taos Pueblo men borrowed the Plains hair braid but not the hat.

From his first trip to New Mexico in 1914—sponsored by his Chicago patron, ex-mayor Carter Harrison—until about 1920, Higgins divided his time between Chicago and Taos. In response to the New Mexican land and its inhabitants, Higgins began to change his storytelling approach to painting. One of the most experimental members of the Taos Society of Artists, he gradually simplified and strengthened his forms. At the same time, his brush became more vigorous and his muted palette gave way to vivid color. His wife, Sara Mack Higgins, described the "immediate mating of Victor the painter and New Mexico the state. . . . As soon as he settled

140. Plains Indian Hat (Crow)

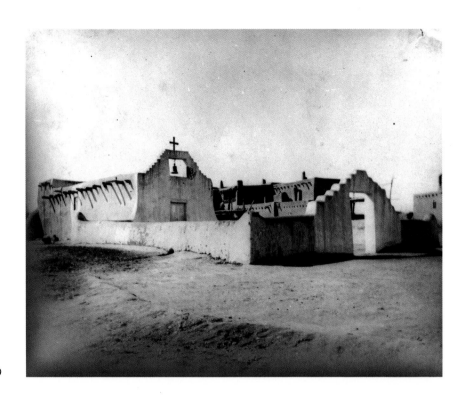

141. *Mission Church, Taos.* c. 1899

in Taos, the rich and subtle colors of New Mexico blossomed on his palette and canvases. New Mexico's charm and magnificence instantly cleared his senses of all the mustiness of his long academic training."[11]

Higgins's view of the multistoried pueblo of Taos is almost abstract in its imagery, in the modified cubic forms of the native adobe architecture and rugged rock formations of the background mountains. Although the foreground figures are rendered in detail, the clusters of brightly attired Indians are reduced to rapid strokes of color, in rich contrast to the monochromatic Pueblo structures. Rows of figures wind through the pueblo, "creating a tightly woven pattern of shapes that move fluidly into the distant mountains."[12] Yet the cultural identity of the figures is retained in costume details, such as the unmistakable hats.. Indeed, some of Higgins's artistic sureness sprang from an understanding and respect for the Pueblo Indian, particularly the Taoseño.

Taos is the northernmost pueblo of Tiwa-speakers, and it shares many cultural traits, including language, with nearby Picuris Pueblo to the south. Tiwa is also spoken in the more distant pueblos of Sandia and Isleta, north and south of Albuquerque, respectively; in Indian communities in Texas, near El Paso; and in northern Chihuahua, Mexico. Location more than language, however, is essential to an appreciation of Taos history and culture. Its situation on a broad, well-watered plateau at the base of the Sangre de Cristo range, gave Taoseños easy access to the nearby mountains and eastward to the Plains. In the mountains deer, elk, bear, turkey, grouse, and squirrel were sought by lone hunters; to the east there were buffalo; west of the pueblo, amid the sagebrush, rabbit and antelope were hunted communally; trout were taken in the numerous streams and rivers that drained the mountains; and many edible and medicinal species of wild plants were gathered in both the mountains and the plains. Taos relied

much less on agriculture than did the more southern pueblos, because of a shorter growing season, a more erratic weather pattern, and the presence of abundant game and other wild foods. Before the Spanish settlers arrived, the agriculture of Taos and other Pueblo groups consisted of corn, beans, and squash. After contact, other crops were added, especially wheat; and, perhaps even more important, domesticated animals from Europe, including horses, sheep, goats, cattle, pigs, mules, and donkeys. Today subsistence food production is less important to the economy of Taos than are home craft industries and wage labor.

Traditionally, the spiritual substance of Taos Pueblo has been found in the nearby mountains. There the runoff of winter snows flows into numerous alpine lakes; and the Río Pueblo de Taos provides both irrigation and drinking water for the pueblo. One of these alpine lakes, Blue Lake, has immense spiritual importance for Taos: each summer in August, Taoseños travel there to observe rituals they consider necessary to their welfare. From the time of Spanish contact, Pueblo and Christian religions have mingled, a process that accelerated with Spanish colonization during the eighteenth century and the construction of a mission church in Taos Pueblo about 1720. The church was destroyed during the bloody Taos rebellion of 1847, an incident of the Mexican War. On January 19, 1847, Governor Charles Bent, a well-known Taos merchant, and several other Taos notables were murdered by an insurgent group of Mexicans and Indians who planned to attack Santa Fe; their move was countered by General Sterling Price, who entered Taos on February 3 and besieged the mission church, which was defended by a small group of Taos Indians left behind by Spanish residents. After Price battered and stormed the church, he and his soldiers pursued the defenders through the pueblo and into the mountains, killing fifty-one Taos Indians. A few years later, a new church was rebuilt nearby by the Taoseños (plate 141).

The Indian, the Spanish-American, and the adobe architecture of both the Hispanic-Anglo village and the Pueblo of Taos captivated Oscar Berninghaus (1874–1952), too, and became the subjects of his insightful pictures. Traveling the Denver and Rio Grande Railroad through New Mexico in 1899, he became intrigued with stories of the quaint, historic village of Taos. A side trip there changed the course of his life: "I started on a twenty-five mile wagon trek over what was comparatively a goat trail. After a hard journey I arrived in Taos late in the afternoon, the sun casting its glowing color over the hills that gave Sangre de Cristo mountains their name. . . . I stayed here but a week, became infected with the Taos germ and promised myself a longer stay the following year."[13] Berninghaus not only kept his word but returned every year, until he settled in Taos permanently in 1925. At the time of his initial visit, he already had made the crucial decision to switch from lithography to painting.

In New Mexico, Berninghaus's search for the essence of native life in Taos Pueblo led to a long friendship with one of his favorite models, Santiago Bernal, who is portrayed in *One of the Old Men of the Pueblo* (see plates 142 and 143). Bernal posed for a number of Taos artists when he was not performing religious duties and tilling crops. Berninghaus found him a "very satisfying and understanding model. . . . Between times he would come to the studio frequently and sit for hours . . . very few words would be

142. *Santiago Bernal*

exchanged between us—silence was well understood." Unlike other Taos models Berninghaus employed, Bernal was not a domestic servant. Many years after Bernal's death the artist wrote:

> Santiago Bernal . . . represents a generation of which there now are but a very few—if any. He was a stately, dignified, venerable old man who carried on the cultural traditions of his people as only he knew it [*sic*].
> I always knew him as a hard and industrious worker in the fields, tended faithfully to his crops and also to his pagan religion—attributes that call for high regard and respect from his people. In later years he was one of the war chiefs whose duty it is to marshall the forces of the men and over see and carry out the activities peculiar to the life of the Pueblo.[14]

At Taos, Santiago Bernal was the secondary "chief" of the Big Earring People, one of three kiva societies that included the Day People and the Moon People on the north side of the pueblo, near North House. The kiva—a large, underground ceremonial chamber—was the special preserve of Pueblo Indian men. As second chief, Bernal assisted the head of his kiva, whose title is usually translated "Big Earring Man." Both positions were inherited and held for life, and because he would succeed him, Bernal shared his chief's knowledge of kiva ritual. Among the possessions held in trust by the Big Earring Man were the kiva society's ceremonial bundles of ritual paraphernalia and fetishes—spiritually charged objects of great importance to the kiva group, such as altar figures, masks, and smoking pipes. These secret objects were rarely seen by most outsiders. (In the 1920s, the Big Earring Man also was responsible for organizing rituals for the Saint's Day, the Deer Dance, and the Buffalo Dance.)

In keeping with Bernal's religious role in the pueblo, Berninghaus presents him as the contemplative elder rather than the warrior or farmer as he had portrayed him in several other paintings. The silver earring Bernal wears is not only personal adornment but also a symbol of the communal body—the Big Earring People—whose spiritual welfare was his primary concern. Berninghaus was at the height of his career in the 1920s when he painted *One of the Old Men of the Pueblo,* part of an important group of major canvases depicting daily Indian life. He composed these pictures outdoors, usually placing his models prominently in the foreground; in the studio he blocked in his canvases with very thin oil washes, built up large, impastoed areas of color, and finally added details with the help of a maulstick.

Here, the two figures are dressed in the traditional white blanket of Taos, set against a background of the Sangre de Cristo Mountains. Whether the hanging textiles are of native or commercial origin is uncertain. In all likelihood they were among the many artifacts in the artist's collection. Bernal wears his hair in wrapped braids with a bun at the back of the neck, a style adopted from the Plains tribes. He seems to be standing on one of the upper levels of North or South House; some of the vertical poles extending above the roof lines probably represent ladders, made from peeled logs that have weathered gray-white. Most likely these are pine logs from the nearby forest, and they continue to be used in Taos house construction today.

The artist has used the pueblo's drying racks to advance and repeat the contours of the background mountains. Mounds of yellow-gold alfalfa,

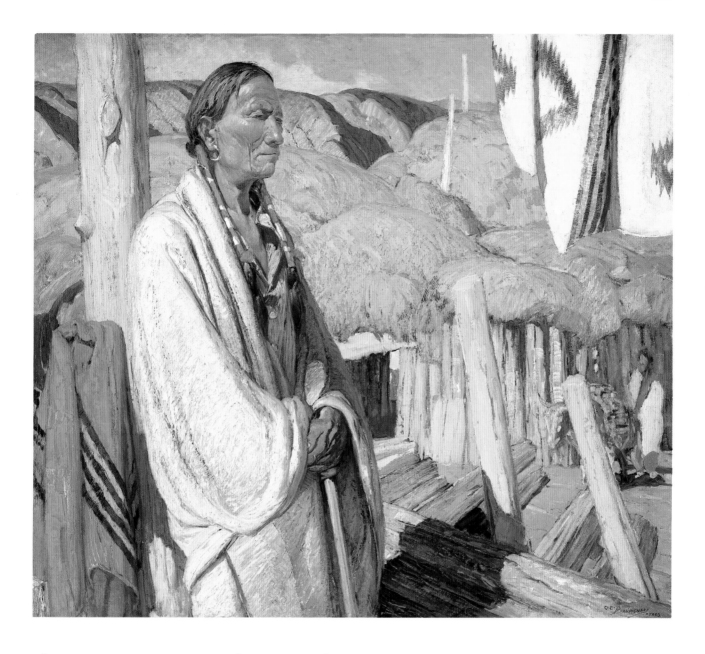

143. Oscar Berninghaus, *One of the Old Men of the Pueblo.* c. 1927

wheat-straw, or sometimes cornstalks, were stored as animal fodder on racks made of upright posts supporting open log platforms for air circulation (see plate 144). In and around North and South House, these racks are still used to dry crops. In the past, they also kept fodder out of reach of foraging animals, preserving it for the villagers' cattle, horses, donkeys, pigs, and possibly even oxen. Modern farming equipment as well as a reduced animal population in the pueblo have made the racks less important today. Berninghaus's picture has recorded transport before the automobile or the pickup truck, when a man guided a donkey loaded with firewood.

Ritual practices of the Taoseños fascinated Ernest Blumenschein (1874– 1960), and his painting *Moon, Morning Star, Evening Star* (plate 145) derives from repeated observations of the Taos Deer Dance. A ritual responsibility of the Big Earring Kiva, the Deer Dance is performed regularly at Taos on Christmas Day or on January 6, Kings' Day or Epiphany

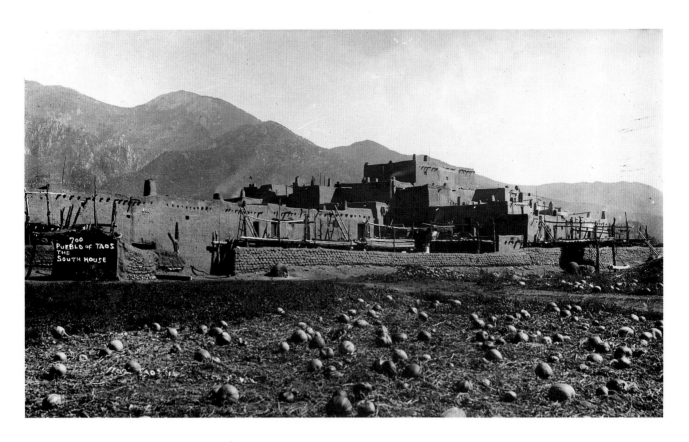

144. Charles Lummis, *South House, Taos Pueblo, with Drying Racks*. c. 1888–96

in the Roman Catholic liturgical calendar, a date that commemorates the visit of the three gift-bearing kings to the infant Jesus in Bethlehem. This coincidence of timing undoubtedly was the work of early Spanish missionary priests who tried to diminish the importance of native rituals with Catholic celebrations. Most scholars, however, presume that the Deer Dance occurred at this time of year to satisfy subsistence needs long before the arrival of the Spaniards and Catholicism. The Deer Dance usually begins in the afternoon, following a Harvest or Corn Dance in the morning. Deer dancers traditionally come from the Old Ax and Water kivas, two of the south-side kiva groups, while the chorus is provided by the Big Earring Kiva of North House.

Two lines of male dancers march to the plaza in front of the church, each line led and followed by designated watchmen. Dancers range in age from young boys to middle-aged men; each wears a deer headdress and a deerskin on his back and each carries two sticks, one in either hand, to simulate the four-legged deer as he moves with hunched torso before the crowd of spectators (see plate 146). White clay body paint is visible on the upper torsos of several of the dancers, including the two central figures. At times other animal dancers join the Deer, especially the Buffalo and the Mountain Lion. Integral to the Deer Dance, but not shown in Blumenschein's painting, are two lead dancers, called Deer Mothers, who guide the other dancers through the intersecting spirals, circles, and diagonals of the ritual movements. On the periphery are the Black Eyes, or Jesters, who mimic and tease the dancers and occasionally attempt to snatch away a young Deer, only to be chased and stopped by male or female spectators. Other Black Eyes pretend to shoot the Deer with miniature bows and arrows. After

"killing" a Deer they carry it to one end of the dance plaza; the ritual killing continues until all of the dancers are slain.

After the dance the Deer Mothers are escorted away and the slain Deer retreat out of sight to await the next performance, which follows an intervening Harvest or Corn Dance. In the next Deer Dance, the Harvest or Corn dancers form a circle, or a half-circle, around the Deer Dancers, the scene Blumenschein has recreated.

More than any other artist who painted Pueblo dance, Blumenschein seems to have sensed the deeper significance of this ritual; or perhaps he was better able to translate his response to it into visual symbols. The geographic center of the Pueblo dance plaza is the spiritual power center of all activity. In line dances, such as the Deer or the Buffalo Dance, performers are strung out across the plaza, with the best singers and dancers in the center of the line. While the choreography varies, dancers who break away from the center of the dance area will always return to it, and their movement about the plaza defines the space in which the center is formed. Contemporary scholars refer to this as "the concentration on the center."

What is there in the Pueblo world view that causes this concentration on the center? In part, it is a cosmology that orders the universe into three levels: the Underworld, the Earth, and the Upper World. Man has emerged from the Underworld by way of a *sipapu*, or earth navel, often conceptualized by Puebloans as a village and frequently as one's own village. Within this space there are increasingly more sacred spaces: one's home or one's kiva, and within that kiva, near the hearth, the *sipapu* of the kiva group. To think like a Puebloan is to think centripetally, in ever-diminishing spirals to the *sipapu*.

Like many Taos artists of his time, Blumenschein was trained in nineteenth century academic principles and worked as a book and magazine illustrator before he moved to Taos, in 1919, to devote himself to painting. The impact of New Mexico's landscape and its people rapidly freed him from academic conventions to explore new imagery and styles. The mystical quality and color of the environment became a stage for paintings invested with symbolic associations. Blumenschein chose the Deer Dance to express the "full reality of the deeper emotional qualities of life as revealed to him in significant symbols."[15]

Although he observed the Deer Dance often, Blumenschein composed *Moon, Morning Star, Evening Star* and its preparatory sketches from memory. For him, "the complicated weaving of these fifty or sixty figures, the intricate counterplay of the 'Chifonetes' (or clowns), the nobility of slow dance movement, and the accompaniment of the singers and drummers equaled any folklore dance in the world."[16] The structure of the composition was important to him, and the relationship of line, mass, and color conveys his emotional response to the dance. Trained as a violinist, Blumenschein once remarked that this early musical education had shaped his expression by contributing to his innate feeling for harmony. To express this, he altered somewhat the factual details of the dance. He has omitted the two Deer Mothers, emphasizing the oval formation of the dance chorus and two of the male dancers to convey what he saw as the "primitive sentiment" of this ritual drama. The oval form of the multitude of stylized figures and the "crude Indian drawings of the moon, morning star and

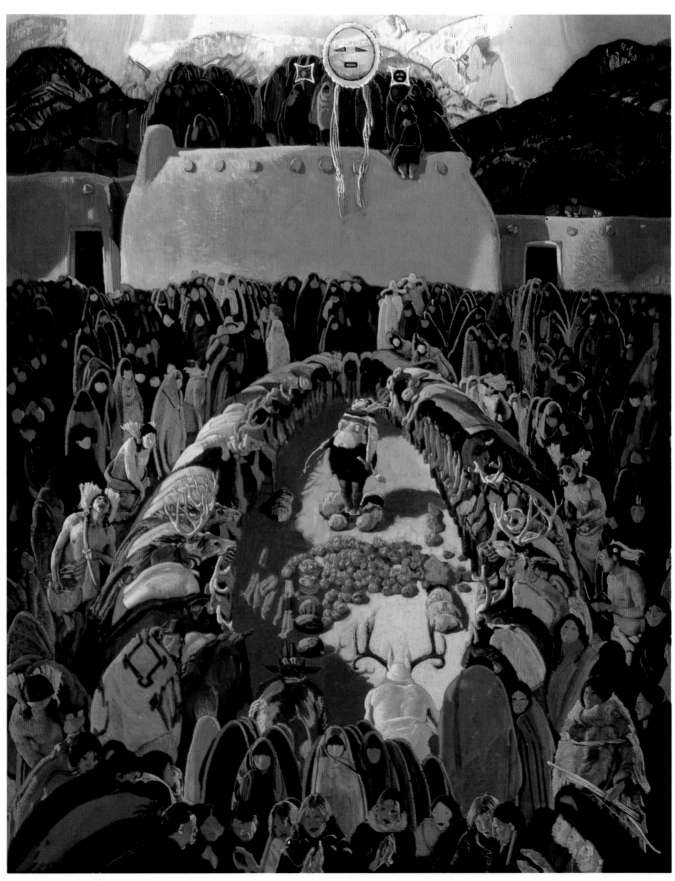

145. Ernest Blumenschein, *Moon, Morning Star, Evening Star.* 1922

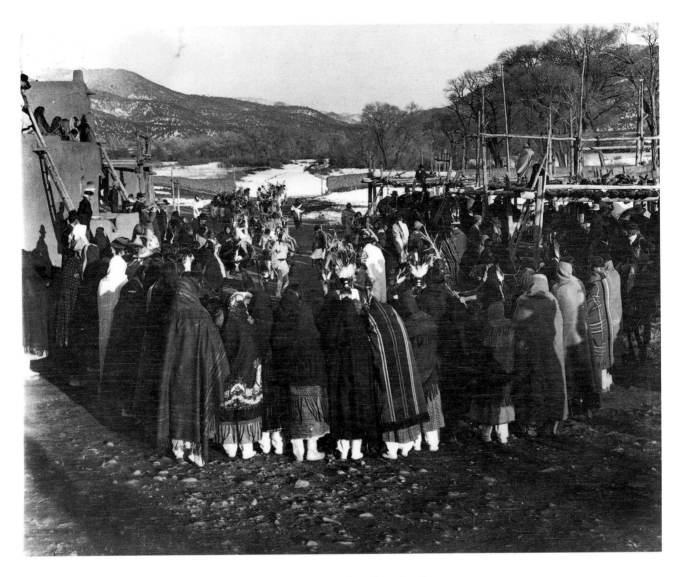

evening star" all suggest a female sexual configuration related to fertility rites for Mother Earth.

In sacrificing a degree of ethnographic accuracy to expressive form, Blumenschein was not unlike most Taos Society artists. Paradoxically, at the same time, these men saw themselves as recorders of disappearing cultures. Another artist who sensed this urgency was Walter Ufer (1876–1936), and like Higgins he visited Taos under the patronage of Carter Harrison.[17] A midwestern illustrator and lithographer, Ufer had worked in Chicago after studying in Dresden and Munich. The impact of the Southwest not only prompted him to become a painter but also led him to work with a brighter palette and more vigorous brushstrokes. Abandoning academic studio practices, he portrayed his models in their own environments. Like his social realist contemporaries, such as Robert Henri, whom he admired, Ufer favored themes that dealt with human and social concerns. Further, he saw in the tricultural Southwest the source of a truly national American art. And like other Taos artists, Ufer in time came to attribute the disappearance of Indian cultures to the pressure of "Americanization": "The Indian has lost his race pride. . . . He wants only to be American.

146. Carter Harrison, *Deer Dance Spectators*

217

Our civilization has terrific power. We don't feel it, but that man out there in the mountains feels it, and he can not cope with such pressure."[18] Ufer's interest in social values led him to paint the Indian "in the garden digging—in the field working—riding among the sage—meeting his woman in the desert—angling for trout—in meditation."[19] His focus on the transitional Indian culture was a personal one. He explained this in a letter to the owner of *Hunger* (plate 147), written March 8, 1920, a little over a year after the end of World War One:

> If my painting called "Hunger" gives you pleasure I am highly pleased and I will endeavor to explain its meaning. Ordinarily one should never do this as an artist hardly wishes to be forced into the illustration class. The painting in question could be called either "Peace" or "Hunger" or "Thirst."
>
> I claim that Religion or its present day philosophy did not hold out or give much under the strain of the last big War. It was too small a thing as compared to the destructiveness of the War and what the War has caused. If you can imagine a 4 or 5 Act Drama representing life before and during the war—I would explain such as follows.
>
> The Cross or the Crucifix is symbolicle [sic] of Christianity and if the Cross or Crucifix is not actually hanging on the walls of our homes it is so embedded in our minds that it belongs in our minds on the walls of our homes.
>
> So we will place an immense Crucifix in the center of this stage, cold & grey and keep this Crucifix there throughout the entire drama and in back of the Actors who represent Life.
>
> Everything that is taking place on this stage is happiness. Men & women are walking & talking. Young boys are chasing young girls—there is laughter. Birds are singing and a ripened grain field in the background. . . .
>
> Another scene: In the mean-time War has been declared and one hears the distant rumbling of cannon. Women are becoming frantic because their men have been reported as lost. This shell fire becomes so terrific that each shell as it strikes vibrates the Crucifix and the Image of Christ is eventually falling.
>
> Women in despair fall to the ground before this Crucifix begging that something be done. . . .
>
> I have a Penitente Crucifix on a whitewashed adobe wall. . . . My image is also falling from the Cross. This is a dead carved thing and really can not give relief to anything living.
>
> The three figures (Indians) represent a family. Man in center in an attitude of despair appealing to this dead thing for whatever relief he desires—mental and physical. The woman to the left appealing again through her man by laying her hand on his shoulder. The child to the right is merely curious and looking in wonder at the Image of Maria standing before her. The mouse to the extreme left is also in an attitude of prayer—it by this time is beginning to feel the pangs of actual hunger. (Hunger or Thirst for mental and physical relief.) This painting has nothing to do with Indian life—it means the world at large.
>
> I paint in Taos where there are many Indians. I would not explain the meaning any better if I had used white people as my models—nor would I explain the symbolism any better.[20]

Ufer's letter as well as the symbolic Puebloan figures and Hispanic Cristo in *Hunger* relate to an often misunderstood cultural phenomenon of Hispanic New Mexico—the Penitente Brotherhood. The group originated as a secret, lay order of Catholics, which emphasizes charity and protection

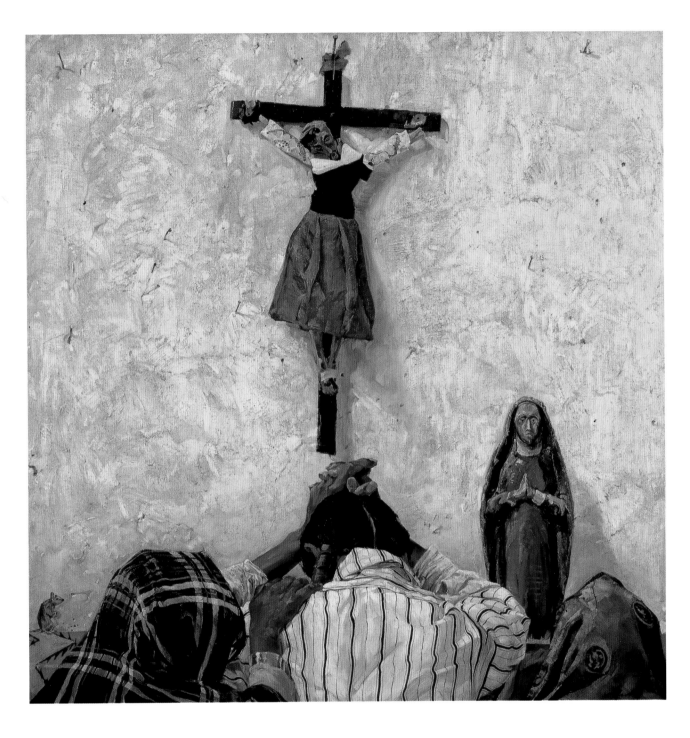

147. Walter Ufer, *Hunger*. 1919

among its members. Today, it is better known to the outside world for its ritual practices during Lent. The brotherhood evolved from the Third Order of Franciscans (Los Hermanos Penitentes del Tercer Orden de Franciscanos) during the eighteenth and nineteenth centuries, when shortages of Catholic clergy necessitated considerable secular involvement in church rituals in isolated Hispanic communities of New Mexico. This isolation perpetuated archaic religious practices long after their disappearance in other parts of the Catholic world, including the flagellation and self-torture practiced by the Penitentes. Best known among these ritual

148. New Mexico School, Penitente
Crucifix (*Cristo Crucificado*). c. 1850

practices is the Good Friday procession, which until the late nineteenth
century culminated in the crucifixion of a Penitente Brother. This ritual
was condemned in 1889 by the Archbishop of Santa Fe; and with reform
movements in the New Mexican church after 1900, the laity-dominated
Penitentes were separated from the clergy-dominated parish churches.
Today a number of rural Hispanic communities have two places of worship,
a parish church and a Penitente meetinghouse, or *morada*. Penitente prac-
tices still persist in modified form in small New Mexican villages—
especially near Taos and Mora—although there are Penitentes in commu-
nities ranging from south of Albuquerque to as far north as Pueblo,
Colorado.[21]

Penitente crucifixes, like the one seen in plate 148, were carved by
Mexican-American craftsmen for use in *moradas* and at home altars.
Derived from the Mexican Cristo, the Christ is elongated, emaciated, and
sometimes wears a fabric loincloth or knee-length skirt; his wounds are

vivid and bloody and his suffering explicit. Because the Penitente Brotherhood did not include Indians, except when they were invited to walk in processions or to sing at wakes, Ufer's comment that "this painting has nothing to do with Indian life—it means the world at large" can be taken quite literally.

Indian, "mainstream" Catholic, and Penitente practices existed side by side in the Rio Grande Valley villages, notwithstanding continuous efforts by the clergy to achieve orthodoxy. The Franciscans, like most missionaries in New Spain, directed the Indians to build churches and to take part in Catholic ceremonies—even enforcing attendance at Mass by whipping. Over a long period of time, large numbers of "idolatrous" kachina masks were burned and attempts were made to suppress the dance itself. But the Pueblo Indian pantheon of supernatural beings was merely enlarged rather than superseded by the Catholic Trinity and the saints. In time, village patron saints were accepted, and cults developed around them that juxtaposed elements of native and Catholic rituals. Both Jesus and Mary occasionally were given minor roles, although the Hispanic Virgin of Guadalupe gained wide acceptance. They rejected much of the mythology of Christianity, along with the concepts of heaven and hell. Catholic churches became village ceremonial centers without displacing kivas.

Strictly Indian are the food-cycle rituals called animal dances observed by both Eastern and Western Puebloans and easily recognized by the dancers' costumes. Animal dancers assume the spirits of large game animals—buffalo, elk, antelope, deer, and mountain sheep—and often more than one species of animal appears in a given dance. All of these dances relate to the fertility and perpetuation of animals that supplement the agricultural diet of the Pueblo, and the dates on which the dance rituals are observed are very important for an understanding of Eastern Pueblo culture. Like the Deer Dance at Taos, the Buffalo Dance coincides with a Roman Catholic holiday. Both may be held on December 25 or on January 6, the latter Kings' Day in the Catholic liturgical calendar.

In historic times, stored, cultivated food had become scarce in the pueblos by early January, and supplementary, hunted food became increasingly important. With groups of Pueblo men away or about to leave for the Plains or the mountains to hunt buffalo, deer, or elk, rituals such as the Buffalo Dance gave villagers a religious occasion that focused both on the food that was being hunted and on redistributing what remained in the pueblo's larders. Communal feasting after the dance not only fed everyone in the village but also shared the provisions from more abundant households with those in need.

Gerald (Ira Diamond) Cassidy (1879–1934) painted the *Buffalo Dance* (plate 149) at Santo Domingo in 1922, a decade after he moved permanently from Cincinnati to Santa Fe to devote himself to painting. At twenty, as art director of a New York firm, Cassidy produced lithographs in the style of the then popular illustrator Howard Pyle. A careful observer of the Pueblo environment, Cassidy has caught much of the rich color and vitality of the dance with his facile brush. Typically, he placed the main figure on a foreground diagonal, yet his focus on a single dancer for a close-up of some of the dance's choreography is still reminiscent of Pyle. Cassidy may well have referred to photographs of Buffalo Dancers made by his wife,

149. Gerald Cassidy, *Buffalo Dance, Santo Domingo, New Mexico.* 1922

150. Buffalo Headdress. c. 1930s

Ina Sizer Cassidy (1869–1965), who was a prolific photographer of Pueblo subjects (see plate 153). Behind the figures in Cassidy's painting is the pueblo's large, cylindrical kiva. An exceedingly conservative pueblo, Santo Domingo even then was a difficult pueblo to photograph.

Although the Buffalo Dance shows strong Plains influence, the head-dress worn in this dance combines both Pueblo and Plains styles (see plate 150). Both headdresses were made from the heads of buffalo, but the one in Cassidy's picture, like the helmet masks of dancers in the Pueblo-wide kachina rituals, completely covers the head (compare the Plains buffalo headdress in plate 74). While Cassidy does not depict a specific phase of the dance cycle, the Buffalo Dance in every Eastern Pueblo village has an entrance song, a slow dance song, and a fast dance song. Between the songs, the "animals" often meander about the dance plaza mimicking the grazing, play, or mating behavior of game animals in the wild.

All Eastern Pueblo animal dances have significant ties to the food supply. The Buffalo Dance at Taos, for example, is associated with prayers for weather to facilitate hunting and is danced to bring snow or to moderate severe cold. Cassidy's portrayal, however, with its focus on a single dancer, does not suggest the larger issue of subsistence at the core of the dance. Like most pictures of Pueblo dance by Anglo artists, it does not reveal an understanding of the ritual's "concentration on the center."

When Joseph Henry Sharp painted the *Harvest Dance* in 1893 (plate 151), his exposure to Pueblo Indian culture had just begun. Like Cassidy, he gives no hint in his picture—or in his contemporary account of the dance—that he understood the full meaning of this fertility ritual or that he was aware of the centripetal thinking of the Puebloans. That year Sharp and another Cincinnati artist, John Hauser, rented a buckboard in Santa Fe and headed for the northern pueblos on a sketching tour. Their destination was Taos. After a few days at Tesuque Pueblo, they continued up the Rio Grande Valley, visiting the pueblos of Pojoaque, San Ildefonso, and Santa Clara en route to San Juan. There they spent a week making sketches as

151

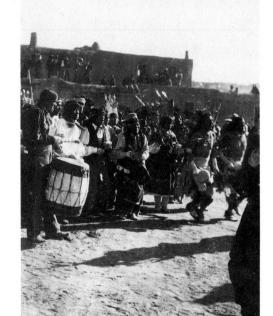

152

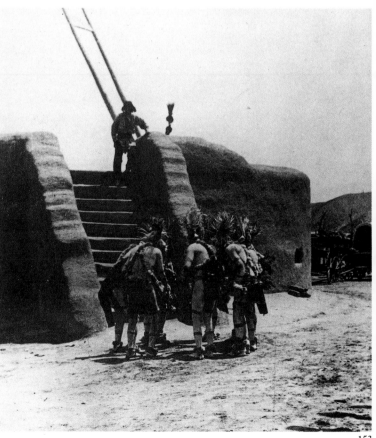

153

they waited for the annual feast of San Geronimo. In the course of the trip, Sharp made a number of studies of the Harvest Dance, which he developed into paintings later in his studio. In fall 1893, *Harvest Dance* was used to illustrate Sharp's detailed article on the dance for *Harper's Weekly*. The article, however, did not name a specific pueblo setting for the picture. Sharp's description reads in part:

> It is a striking scene of gorgeous color. The brilliant sunlight illumines the gaudy trappings of the dancers. Rows of gaily dressed Apaches, Navajos, and Pueblos on horseback encircle in quiet dignity the enthusiastic actors, while a little farther off the whole scene is framed in by the gleaming walls of the white and yellow houses, whose roofs are crowded with men, women, and children clad in their richest holiday garments in strong relief, and the distant mountains and deep blue sky.
>
> The men dancers have bunches of green and yellow parrot feathers fastened to the top of their waving raven hair, while around their necks are strings of beads made of shells, feldspar, and turquoise. Their bodies are nude to the waist, and are painted with a blue white clay sometimes merely in crude spots, while the legs and arms are frequently striped with the same or a different tone. Around the loins a Zuni or Moqui woven breechcloth embroidered in red and black is held in place by a white cotton girdle or sash, ending in balls and long strings, waving with every movement. Below the knee masses of brilliant colored wool are knotted, over various colored and beaded moccasins are anklets of white and black skunk or goat fur; and hanging from the belt behind, a fox skin with the tail downward. Under broad armlets of tinted buckskin are sprigs of cedar; a bunch of the same is held in the left hand, while the right shakes a gourd rattle at every change of posture.
>
> The dress of the women is a square of heavy dark blue wool, drawn over one shoulder and under the other, exposing part of the breast, while the sides are held together by ornamental silver pins. A long woven colored sash is wound around the waist. The legs are bare and notably fine; the feet small and beautifully formed. Their headdress is decidedly peculiar. It is made of an oblong piece of board or dried buffalo hide, notched at the top, with a T-shaped piece resembling the "Tau," the emblem of life of the ancient Egyptians, cut out of the centre. It is painted a light green, with red and yellow stripes and symbolic figures; on the sides and points are flecks of white eagle's down. The lower part is hollowed out to fit the head, and is held in place by thongs of buckskin fastened under the hair. Immense strings of shell and coral beads encircle the women's necks, and big Navajo silver rings or a crude turquoise hang as ear pendants. Many silver and copper bracelets dangle at their wrists as they wave the branches of evergreen from side to side in unison with the steps. Rich vermilion covers their cheeks and heightens their savage beauty. They are modest in demeanor, gracefully naive in movement, and rarely take their eyes off the ground during the dance.
>
> The dancing was kept up for seven long hours; but there was never any shirking; they stamped as energetically the last hour as the first. Any sign of fatigue would be met with renewed vigor of the chanting chorus, while the drummer would reverse his drum and thump harder on the head. The chorus huddled closer together, gesticulating seriously with their hands, as though to emphasize the meaning of their songs.
>
> At sundown they all filed solemnly into the church-yard, and kneeled down while the image of the saint was carried inside. A volley from the guns, then the Indian character asserted itself in a wild race of men and women to the estufa [kiva], where they indulged in their first refreshment of the day.

151. Joseph Sharp, *Harvest Dance, Pueblo Indians.* c. 1893–94

152. Norma Day, *Corn Dance, Tesuque Pueblo.* c. 1917

153. Ina Sizer Cassidy, *Koshare, Turquoise Kiva, Santo Domingo Pueblo.* 1921

225

Feasting was kept up far into the night, as were bonfires throughout the Pueblo and on the church towers and walls.[22]

Although Sharp did not identify the pueblo setting for *Harvest Dance,* comparison of the image with a photograph taken at Tesuque in 1917 (plate 152) makes identification with that pueblo seem likely. The distinctive Tesuque drum—its shape and light color—the male chorus in white shirts, and the T-shaped tablita (headdress) cutouts of the women dancers all reinforce this hypothesis. While the photograph encompasses only a small portion of the pueblo plaza, the distinctive shape of the chimneys, growing out of the architecture, parallels that in Sharp's painting. When the artists visited Tesuque, the pueblo buildings were in need of repair and only later refurbished, which makes it difficult to establish a definitive architectural link between the two images.

While Sharp suggests that the T-shaped cutout is the "Egyptian 'Tau'" (actually the tau is a Greek letter), it is in fact a designation of kiva affiliation—in this case the Turquoise Kiva. Every man and woman in the northern pueblos Sharp visited belongs to one of the two pueblo kivas, the Turquoise or the Squash (Pumpkin). Also referred to as the Winter and Summer kivas, both groups have ritual obligations to the pueblo to ensure bountiful crops and successful hunting.

The Harvest or Corn Dance is one of six dance types in the Rio Grande Pueblo villages. In addition, there are masked kachina dances, maskless kachina dances, animal dances, dances borrowed from other tribes, and nonreligious social dances. Although these dances fit differently into the ritual cycle of various Pueblo groups, each dance reinforces a sense of group solidarity and survival in the face of periodic food shortages.

Not only do all Pueblo groups have a number of ritual dance types, but all have secret societies as well. Members of two of the secret societies at Santo Domingo Pueblo, the Koshairi (Koshare) and the Quirana, are commonly called "clowns" by the general public and the popular press. But the function of the Koshairi and the Quirana is often misunderstood by non-Indians, and to label them clowns obscures their fuller role in Pueblo culture. Clowning by inverse speech or behavior is typical, and the Koshairi and the Quirana play important disciplinary roles in the community as jesters, pranksters, and masters of ceremonies. They also have key positions in the structures of several other communal activities. At Santo Domingo, for instance, the Rabbit Hunt is organized and policed by the Koshairi. Native tradition says that both societies originated in the pueblo's mythological past, along with the pueblo's kachinas. Each society is associated with one of the pueblo's two kiva groups, the Koshairi with the Turquoise Kiva and the Quirana with the Squash Kiva. In a 1921 photograph by Ina Sizer Cassidy, a group of Koshairi dancers performs in front of Santo Domingo's Turquoise Kiva (see plate 153).

Two years later, the noted Philadelphia and New York artist John Sloan (1871–1951) portrayed the Koshairi in almost the same location at Santo Domingo in the *Grotesques* (see plate 154). In the traditional manner of this pueblo, the dancers' bodies are painted in horizontal black stripes over a white background; eyes and mouths are ringed with black paint and heads are covered in white clay with cornhusks affixed to suggest horns. They

wear only old, black breechcloths, although sometimes a woolen or rabbit-skin blanket is worn at the shoulders. Here, braided rawhide bandoliers intertwined with evergreen boughs replace the blankets, and noisemakers are wrapped around the ankles.

Precisely which dance or ritual event Sloan has chosen to portray is difficult to ascertain, but the casual attire of the dancers and the light clothing of the spectators suggest a summer dance, quite possibly the August 4 Corn Dance honoring the pueblo's patron saint. Anthropologist Charles Lange, in 1959, described the Corn Dance as follows: "In size, careful costuming, and in conscientiously executed performance, this is a genuinely spectacular event that has long been an attraction to the Santo Domingo Indians, residents and absentees, Indians from neighboring villages, and non-Indians as well."[23] And an 1894 report by the United States government's Indian Agent H. R. Poorer states that the Corn Dance was considered "the finest to be seen among the pueblos."[24] Because of its size and flamboyance, the dance still attracts a large audience to Santo Domingo, just as it did in the 1880s (see plate 155). It is the one day of the year when all visitors—Indian, Hispanic, and Anglo—are welcome at an otherwise very conservative and restrictive pueblo, although photographs of religious rituals by Anglos are still prohibited.

When Sloan made his first visit to Santa Fe, in summer 1919, he was already a well-known artist in the East as well as a member of a group of painters called the Eight. Sloan went West on the recommendation of Robert Henri, formerly the group's leader, who had visited Santa Fe in 1916 and extolled the virtues of the picturesque land and its Indian and Hispanic inhabitants. Except in 1950, Sloan returned to Santa Fe each summer for the rest of his life. Stimulated by the magnificent landscape and the exotic Indian culture, he produced numerous paintings in Santa Fe. Many of them focus on Indian ceremonials, which he too believed would eventually disappear or become altered by the pressures of American society. At a time when these ceremonies were under attack by the government and religious groups as "immoral and degrading," Sloan wrote in defense of the Pueblo: "The American Indians, the few that are left, have a most closely knit religious and aesthetic culture. Their ceremonials and dances are practically one and the same thing. . . . The stopping of these dances . . . means the stopping of religious ceremonials of profound significance to the people performing them."[25]

Unlike many artists, Sloan has left diaries, notes, and correspondence that give insights into his thinking about the subjects of his paintings. He may have been referring to the *Grotesques* when he wrote: "A preliminary of the Corn Dance at Santo Domingo is the reenactment of an ancient ceremony in which the ancestral spirits consult on the coming dance, scouting the points of the compass for enemies. Assured on this point, the Koshare proceed slowly through the Plaza and return to the kiva and the dancers come forth for the ceremony."[26]

Although Sloan's scenes of New Mexico are very close in style to his New York cityscapes, his palette became brighter, his brushwork more fluent, and his compositions more solidly structured in the New Mexican paintings. These distinctions are apparent in the *Grotesques*: the immediate foreground is anchored by a row of tourists' heads that suggest theater

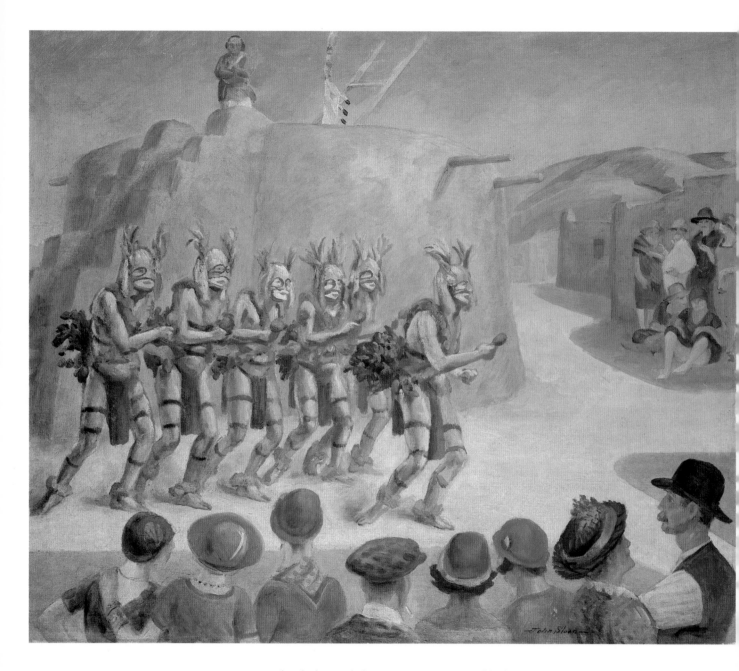

154. John Sloan, *Grotesques at Santo Domingo*. 1923

footlights, while strong contrasts of light and dark separate the dancers from the ogling spectators.

Sloan's title implies at least two interpretations. At first glance his *Grotesques* might seem to refer to the dancers, because bizarrely costumed Pueblo jesters like the Koshairi were called "grotesques"; but the term also might be applied to the tourists grouped on either side of the dance plaza near the Turquoise Kiva. Fortunately, the artist's own words interpret the title: "I think I am in a position to inform the reader that the grotesques in the picture are in the immediate foreground. The word could not be well applied to the Koshare [*sic*] whose actions and chant and dress make them more than humanly natural. They truly seem of the ancient world."[27]

Although most artists depicted American Indian subjects in their native environments, Robert Henri (1865–1929) encountered his model in San

155. Charles F. Lummis, *Crowd in Plaza at Santo Domingo.* c. 1888

Diego, in 1914, shortly before the opening of the Panama-California Exposition of 1915. Alfonsita Martínez Roybal, whose Tewa name, Povi Tamo (see plate 156), means Dawn Flower, had traveled to California in 1914 on the Santa Fe Railroad to demonstrate pottery-making in "The Painted Desert," an exhibit that featured a reconstruction of several Pueblo dwellings by Puebloans from New Mexico (see plate 157).[28] At the time, Henri was summering in La Jolla, and through his contact with Dr. Edgar L. Hewett, ethnologist-director of the School of American Research in Santa Fe, he was able to arrange for Indian models. Henri had always been attracted by exotic subjects, and this was the beginning of his long fascination with the American Indian. Later, he became a champion of their civil rights as well as a promoter of their art.

Povi Tamo's unaffected innocence is deftly conveyed by Henri's direct presentation—the figure placed at the picture plane, vivid flesh and costume colors against a strong but neutral background, and loose, bold brushwork. Her hair is arranged in a style typical of married Pueblo women, with some of it tied in a bun at the back of her head. She wears a white blouse and a large rectangle of red cloth that forms an overgarment covering one shoulder; a heavy silver necklace is draped over both garments (see plate 158). Similar necklaces are still made by Navajo silversmiths and sold or traded to the Puebloans, or sometimes to Anglo traders who in turn sell or trade them in the pueblos.

Although today most Navajo jewelry is worn by non-Indians, in the nineteenth century it was an important trade item in the native economy. Metallurgy and silversmithing were unknown in prehistoric times among the Indians of the American Southwest. The small amount of metal in the pueblos came from historic contact with the Spaniards and later with the Anglos in the form of finished metal tools, utensils, and firearms. Today, it is generally thought that silversmithing was introduced about 1850 by itinerant Mexican smiths, probably in the West, to the Zuni or the nearby

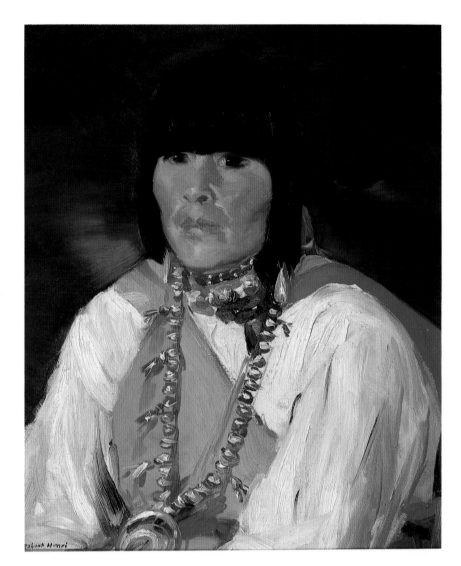

156. Robert Henri, *Povi Tamo (Dawn Flower)*. 1914

Navajo. From this area it spread west to the Hopi and east to the Rio Grande Pueblo villages.

Silver was worked by casting the molten metal in sandstone molds or by alternately heating and hammering the solid metal into desired forms. At first, the silver used by Navajo and Pueblo smiths was obtained from American and Mexican coins, and these early smiths produced only a few simple jewelry forms: silver beads for women and rounded or oval flatware for decorating leather goods for both people and horse gear. Some of these forms were distinctly Spanish, such as the crosses, flower blossoms, and crescents.

A half-century later, Povi Tamo is portrayed wearing some of the same jewelry types—a string of silver beads interspersed with pomegranate blossoms (commonly called squash blossoms), with a partially visible crescent form, or *naja*, as a central pendant. The *naja* form has a history of almost five hundred years on three continents. Brought to Spain from North Africa by the Moors, it was used there to decorate horses' headstalls; the Spaniards in turn brought it to the New World, where the Indians of

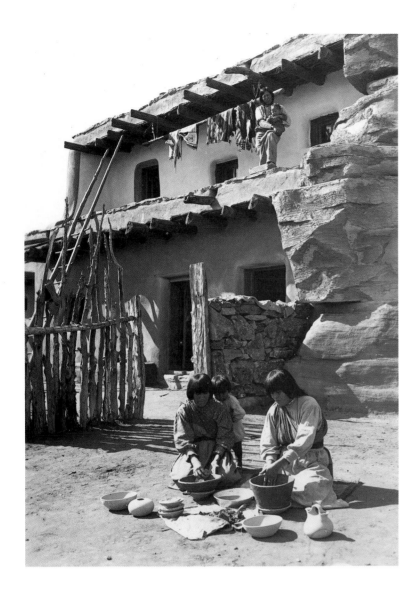

157. *Painted Desert Exhibit, Panama-California Exposition, San Diego, 1915*

the Southwest borrowed it for their horse gear and also for personal adornment, as a necklace pendant.

Beyond this history is the Navajo and Pueblo custom of holding wealth in silver jewelry. Povi Tamo's necklace not only adorns her person but also reveals her wealth and status. Quite likely she also wore several rings and bracelets to pose for her portrait or to appear in public.

In contrast to the Eastern Pueblo groups along the Rio Grande and its tributaries, the more isolated Western Pueblo villages of Hopi, Zuni, Acoma, and Laguna were sometimes less friendly to outsiders and less often subjects for artists. Consequently, it was with a sense of adventure that Warren Rollins (1861–1962), in 1905, began the first of many sketching trips to the Western Pueblo area, headquartering this time at the Hubbell Trading Post in Ganado, Arizona.

In Arizona again in 1909, Rollins met the archaeologist J. Walter Fewkes, who was doing exploratory investigations there for the Smithsonian Institution. Probably on Fewkes's recommendation, Rollins traveled to Santa Fe and Taos late the following year. In spring 1915 he made Zuni a

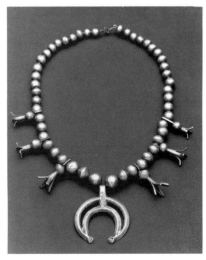

158. Navajo Necklace

231

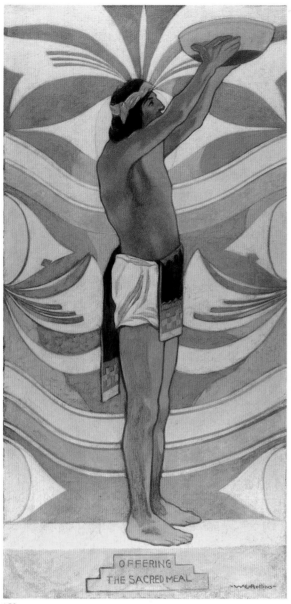

OFFERING
THE SACRED MEAL

~W.E.Rollins~

159

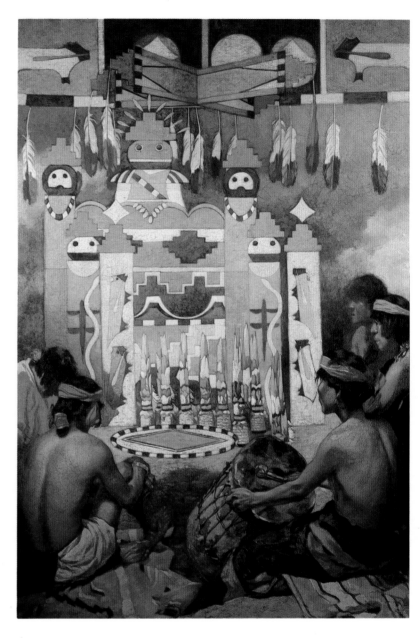

159. Warren Rollins, *The Altar of the Gods*. 1919

160. Altar of Ma'tke Tsannakive (Little Fire Fraternity)

161. Zuni Drum. c. 1900

base for the first of several sketching tours of that area; that fall he set up a studio in Santa Fe, where he remained until 1925.

At Zuni, in October 1918, Rollins began the ambitious triptych *The Altar of the Gods* (see plate 159), a scene that he reportedly witnessed in a kiva there.[29] In 1919, when the completed painting was first shown at the Museum of New Mexico in Santa Fe, Rollins explained the altar's symbolism in a letter:

The main structure of the altar represents the god of the heart of the sky capped by a cloud symbol. To the left and right of the sky god and capped by cloud symbols are the moon mother and sun father. The four leading slabs of the main structure represent the god of thunder and the dragon fly, symbols of rain. The two front slabs symbolize the cougar, badger, wolf, and bear who

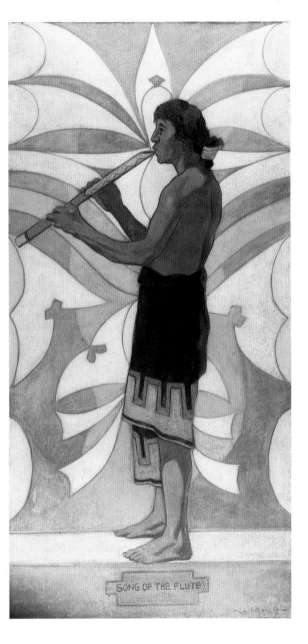

SONG OF THE FLUTE

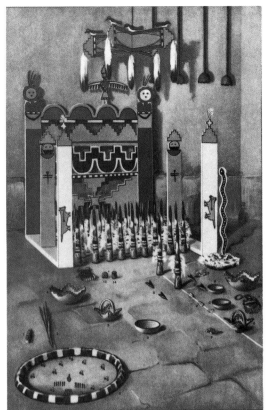

160

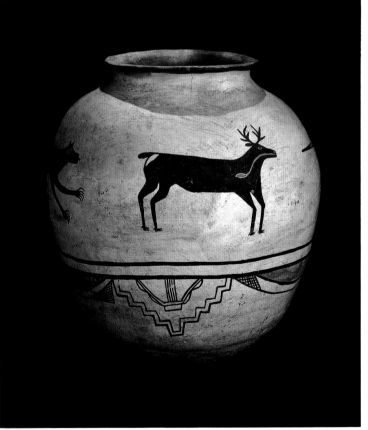

161

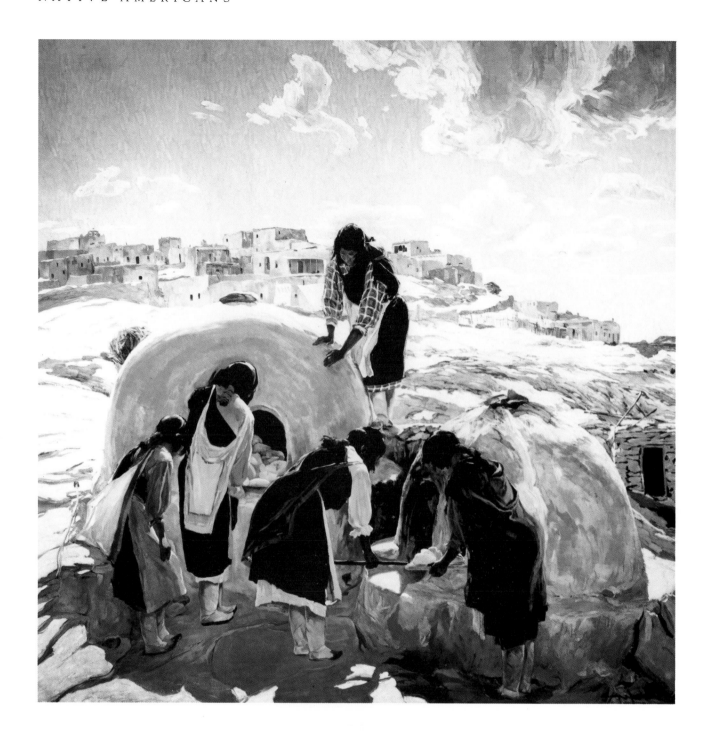

162. Walter Ufer, *The Bakers.* 1917

are especially designated to guard the four earth regions. Unlike the Hopi, the Zuni believe the serpent to be symbolic of wisdom and knowledge. "Milis" [fetishes] are placed in front of the altar and symbolize flame or life givers. The circular plaque in front of the altar indicates the center of the earth. Above the altar is the wind symbol pointing to the four cardinal points. The Zuni "akwimosi" [priest] prays for power to see disease and that sickness be carried off by the four winds. The thought of the Zuni in this ceremony and subsequent ceremonials is a prayer for rain. This is expressed in symbolism of the background of the painting. The background of the two panels is based upon the earliest Pueblo pottery designs.[30]

Rollins certainly had access to published documents, such as the annual reports of the Bureau of American Ethnology, which contained illustrations like the one in plate 160; but it is unlikely that at Zuni he ever saw the scene he represented in *The Altar of the Gods.* The artist may have seen an altar in a Zuni kiva—where the kivas are above ground—and he may have seen a group of men in a kiva. Yet certain aspects of both altar and paraphernalia suggest that he combined a variety of Zuni-like artifacts for this scene. An altar as elaborate as the one in Rollins's picture would not usually be accompanied by such a large number of foreground fetish figures. The textile is Navajo, and the drum almost surely is not a Zuni kiva ceremonial drum. Traditionally, a pottery drum, like a large *olla,* with a piece of animal skin stretched across the opening, was used in Zuni kiva ceremonies (see plate 161).

At Zuni so-called kiva drums were usually decorated with cougars, bears, or snakes, often depicted in combat on a white or cream-colored ground. The drum in the painting is more common to the Eastern Pueblos along the upper Rio Grande. While Rollins's altar resembles published illustrations of several Zuni altars, its details do not correspond to any single, known altar.[31]

A complete altar in a Zuni kiva includes a drypainting on the kiva floor, a carved and painted wooden screen that serves as an altar backdrop, and paintings on the wall. Among the ritual paraphernalia were wrapped ears of corn, carved or painted wooden slabs or sticks, feathers, and worked stone objects. We do not know the specific function of the altar Rollins has depicted, except that the cloud symbols indicate its relation to rain. At Zuni there are six kiva groups—of the sun, the Uwannami (rainmakers), the kachinas, the priests of the kachinas, the war gods, and the beast gods. Each kiva group has its special altar, and each holds ceremonies throughout the yearly cycle from one winter solstice to the next.

Zuni is now the common name for a Pueblo tribe that once occupied seven or more villages in northwestern New Mexico. Their fabled Seven Cities of Cibola led Coronado in search of the Zuni in 1540. The people he found called themselves *Ashiwi,* and their language has no known linguistic affiliation with other Pueblo languages. Today the Ashiwi live in a single village, Zuni, of about 5,000 people. Religious societies and clans formed the fabric of Zuni social and religious life. Puebloans, like their neighbors to the east along the Rio Grande and to the west at Hopi, the Zuni are farmers in an arid land and yet different from other Puebloans. Some of the twenty Zuni religious societies are exclusively male, such as the six kiva groups, while the medicine or curing societies and one of the two Zuni priesthoods accept both men and women. Throughout the year, these societies traditionally performed public and private rituals to ensure the well-being of the Zuni tribe. Given the secrecy of Zuni Pueblo about religious matters, it is not surprising that Rollins lacked complete information about the intricacies of kiva ritual.

The same secrecy about religion is characteristic of the Indians at Hopi, and the prohibition against white men witnessing most kiva rituals may have led some artists, such as Walter Ufer and William Leigh, to focus on more secular subjects and others, such as Irving Couse, to depict public rituals in village dance plazas.

163. Construction Method for a Pueblo *Horno* or Beehive Bread Oven.

Walter Ufer's *The Bakers* is an excellent example of the diffusion of cultural traits in the Southwest (plate 162). Broadly painted in the open air at Laguna Pueblo under a brilliant blue sky, a group of women works about an outdoor oven (see plate 163). Called an *horno* (Spanish for "oven") by Spanish-speakers and a beehive oven by Anglos, this oven type came to the Pueblo from New Mexico's early Spanish settlers, who also introduced wheat flour for bread. Later, tourists who came by train bought quantities of this bread, which like Indian crafts became a popular sales item.

An *horno* is made of adobe bricks covered with plaster. Usually built atop a base of bricks and flagstones, the oven proper has two openings, an arched doorway at the front and a small air vent in the back, near the top. Most often used for baking bread, these ovens sometimes serve for drying foods or cooking meat. The oven is always prepared first by burning a fire inside with the doorway covered; when the fire has burned down, the ashes are swept out; finally the bread or other food is placed inside with a long-handled paddle and the doorway recovered. The temperature can be lowered by swabbing the oven floor with a damp rag tied to a stick. The Pueblo bread baked in these ovens is creamy white, hard-crusted, and delicious! But cultural diffusion also has its limits: at Hopi Pueblo *hornos* were banished after the Pueblo Revolt of 1680, when Spanish influence was no longer tolerated.

Of all the Pueblo Indian groups in the Southwest, the Hopi remain the least acculturated. Their rejection of Spanish traits stemmed from special conditions of contact. Hopi was visited by most of the major exploratory parties but none stayed for more than a few days or weeks. Hopi country was more isolated and more arid than the land along the Rio Grande and thus less attractive to early European or Mexican colonists. After the Pueblo Revolt, the Franciscan missionaries, who had reached Hopi in 1629, were expelled for good. In the eighteenth century, the Navajo gained skill as horsemen and became a buffer between the Hopi and the Spanish settlements to the east. Contact, however, enriched the Hopi material culture—adding livestock and certain craft techniques along with metal knives, axes, hoes, and needles, acquired either directly from the Spaniards or by trade with the Navajo or other Puebloans. Yet, unlike the Rio Grande Pueblo accommodations to Spanish culture, the Hopi completely rejected changes in social, religious, and political spheres.

For more than 1,000 years the Hopi have lived in north central Arizona. Today their prehistoric ancestors are known by the Navajo term Anasazi, meaning "ancient ones." Most Hopi live atop First, Second, and Third Mesa, fingers of high ground jutting out to the south from a large landform called Black Mesa. On or near these three mesas are approximately 6,000 people in twelve Hopi communities; they speak four, mutually intelligible, Uto-Aztecan dialects: First Mesa, Mishongnovi, Shipaulovi, and Third Mesa. Like other Pueblo tribes to the east the Hopi are still agriculturalists. To grow traditional crops as well as fruit trees—especially peaches and apricots—in an arid environment, the Hopi have developed special techniques that include floodwater farming and irrigation agriculture. They plant deep-rooting crops, such as beans, corn, and fruit trees, in the sand dunes at the bases of the mesas, protecting the dunes with windbreaks made of rocks and brush. Livestock, which the Hopi began to tend after the

Spaniards arrived, are of much less importance to them today than to their Navajo neighbors.

Laborious traditional tasks of Indian women, and especially Pueblo women, often were idealized by non-Indian artists. In addition to caring for children, baking, cooking, making pottery and baskets, and carrying water, Hopi women built the houses they owned in a matrilineal society, while Hopi men hunted, worked the fields, tended livestock, wove textiles, and helped their female relatives build houses. Yet primitive man living harmoniously with nature was a favorite theme for William Leigh (1866–1955), who traveled as far as Africa to gather material for his highly charged genre and narrative paintings. Given Leigh's childhood in the post–Civil War South, a biographer wrote, he could hardly have "viewed the world other than romantically however real the turmoil that overwhelmed the South at the time of his birth."[32]

Leigh first visited the Southwest in 1906. His passion for the region deepened with subsequent visits, and he shifted from book and magazine illustration to painting Southwestern genre subjects. His earliest trip took him to the Indian pueblos of Laguna, Zuni, and Acoma. Leigh found Acoma "wildly picturesque and weirdly dramatic this 'Enchanted Mesa,'" a place "like a fantastic dream,"[33] and he recorded it in a series of oil studies and photographs. In 1912, after visiting Navajo country and the Hopi mesas, he moved with two companions to the base of First Mesa where he painted incessantly and filled his portfolios with detailed sketches of Hopi Indian life as well as desert plants and animals.

Among the finished paintings that Leigh developed in his New York studio from these sketches and photographs was *Pool at Oraibi* (plate 164), an inventive juxtaposition of images from two distinct pueblos. Although both figure and setting are ethnologically accurate, the Hopi Pueblo woman is drawing water from a reservoir at Acoma Pueblo (see plate 165). The woman's costume, hairstyle, and the canteen she is about to fill are all Hopi, but the water site is not. At the Hopi town of Oraibi there are three sources of water: the tank in the center of town, a few cisterns to the north, and two or three springs, or seeps, at the base of the Mesa. The pool of water in the painting resembles none of these, and indeed the sandstone cliffs and the ledge surrounding the small pool of water are similar to those in photographs made at Acoma by Leigh and several well-known turn-of-the-century photographers, including Adam Clark Vroman, George Wharton James, Edward S. Curtis, and Frederick Monsen.[34] Curtis's photograph shows an Acoma Pueblo woman taking water, appropriately, from the Acoma reservoir (see plate 166).

The traditional, pre-Spanish, Hopi woman's dress and sash, woven of native cotton and dyed dark brown or black, were gradually replaced by garments made of wool after the Spaniards introduced sheep to America. The dress in Leigh's painting is a single large piece of woolen cloth, and both dress and sash were woven by a Hopi man. (Although Hopi and Rio Grande Puebloans engaged in active trade with the Navajo to the west and taught them to weave, Navajo women do the weaving.) Often the only decoration on a Hopi woman's dress is the red and green piping, except for the red stitching that holds the garment over the right shoulder; the left side of the dress is fitted against the body under the arm. Before it came into use

164

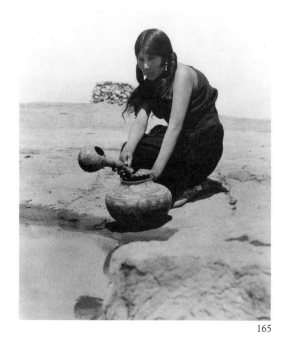

165

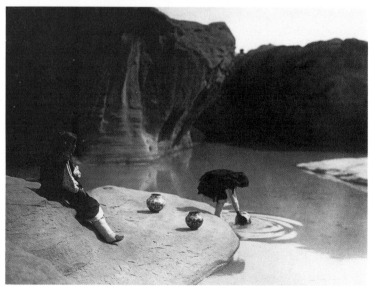

166

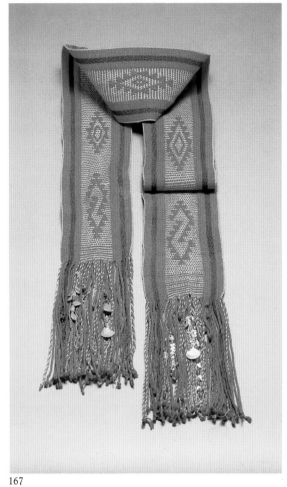

167

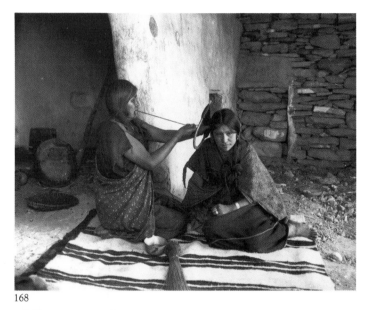

168

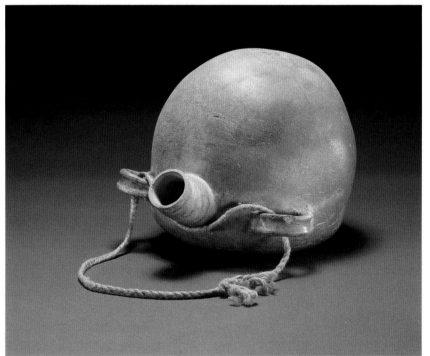

169

164. William Leigh, *Pool at Oraibi.* 1917

165. Frederick Monsen, *Hopi Woman Filling a Water Jar.* c. 1905

166. Edward S. Curtis, *Acoma Woman at a Pool*

167. Pueblo or Navajo Woven Sash

168. Adam Clark Vroman, *Creating a Hopi Maiden's Hair Whorl.* 1901

169. Hopi Canteen

as a dress, the woven rectangle was used by Hopi women as a cape or shawl. The cape had no piping, and its only design elaboration was a weaving pattern change at the ends. Wrapped around the woman's waist is a typical Pueblo wool sash (see plate 167). Leigh carefully particularized the woman's hairstyle: it is that of an unmarried Hopi woman who is old enough to marry. Arranged in a "butterfly whorl," the long hair is wrapped over a bent, U-shaped stick with the help of another woman (see plate 168). Married women at Hopi wear their hair hanging loose, as seen in the photograph by Frederick Monsen (see plate 165).

While the water dipper used by the woman could be of wood, gourd, or fired ceramic, canteens like the one in plate 169 are unquestionably ceramic. Similar canteens are used on all Hopi mesas. Potters gathered the clay from beds at the foot of each mesa, adding ground potsherds as temper. A large canteen like this holds several quarts of water and is carried on the back by means of a woven strap or tumpline fitted across the forehead and attached to the handles; it is further supported by a shawl, which releases some of the weight from the strap and the handles. Transporting heavy, filled canteens of water from the reservoir to the village was a long and arduous task.

For Leigh a single figure, such as this Hopi maiden kneeling beside a pool, embodied the qualities of dignity, self-sufficiency, and a sense of total harmony with nature. Individualism was not only Leigh's most revered character trait but a dominant theme that recurred throughout his writing—in novels, plays, poetry, and letters. "Great things," he wrote, "are done by single persons, never by mobs." To protect individuality, he believed, one must preserve self-respect. Although similar values prevail in the Hopi culture, emphasis is not on the individual but on his or her role within the group. Such ideals are often at odds with the realities of community life in small pueblos, where jealousies and feuds are common. An artist visiting a pueblo for a few weeks in the summer saw only a limited part of the community's social fabric, and often that part did not represent even a small segment of the entire culture. While artists frequently idealized everyday activities or invested them with excessive symbolism because of their own cultural biases, the same biases also led them at times to make less-frequent ceremonial observances seem too commonplace or prevented them from seeing these rituals in a larger context.

Despite the all-important Kachina Dances performed at Hopi over a period of seven months, a single, relatively minor Hopi ritual, the Snake Dance, has come to symbolize Hopi religion to much of the outer world, largely because of the work of Anglo painters and photographers. One of these painters was E. Irving Couse (1866–1936). Like many Taos Society members, he showed an early proclivity for drawing combined with an interest in Indian subjects. As a child in Saginaw, Michigan, he became acquainted with a small settlement of Chippewa who lived a few miles from the town, and Indian themes preoccupied him throughout his entire career.

A long love affair with the Southwest began in 1902, when Couse first visited Taos, on Ernest Blumenschein's recommendation. Couse returned to Taos the following summer, leaving on August 2 for the First Mesa town of Walpi. He spent six weeks in the area making oil studies and photographs

of the villages and the Hopi Snake Dance. His photographs indicate that he observed the Snake Dance at the Second Mesa town of Mishongnovi as well as at Walpi (see plates 170 and 171). In an interview later, Couse noted that the day after the dance at Walpi he "had the head snake priest, a fine looking Indian," pose for his picture. Working from these studies and photographs the following year in New York, Couse produced the elaborate studio painting *Moki Snake Dance* (plate 172; Moki [a Hopi word meaning "dead"], or Moqui, is an earlier name for the Hopi, apparently used by outsiders, with an undetermined meaning).

Couse's picture retains much of the immediacy of an eyewitness account, avoiding the sentimentality of his later work. The somber colors he uses in *Moki Snake Dance* are typical of his Klikitat painting style, developed during his stay in the Northwest between summer 1896 and fall 1898 and employed until about 1904.[35] From about 1902 to 1904 he used this style concurrently with the brighter palette he adopted in Taos, according to the dictates of his subjects. Couse combines several phases of the Snake Dance that actually occur sequentially. Indeed, the single term dance obscures the multiplicity of activities that takes place during a religious ritual that lasts for nine days. A paraphrase of Couse's description of this extended ceremony is as follows: for eight days snake priests from the village go to the surrounding countryside to gather snakes for the ceremony, returning each night to deposit them in a kiva where a private ritual is observed; on the ninth day the ceremonial dance is performed in the village plaza; [white-kilted] members of the Antelope Society provide drumbeats and flute accompaniment for the dancers; a priest carrying the snakes in a buckskin bag encloses himself in a kiva formed of branches in the center of the plaza; the snake dancers perform in threes, and as the first dancer passes the kiva, the priest hands him a snake, which the dancer grips in his mouth; this dancer is accompanied by another who carries a snake whip made of eagle feathers to tickle the snake's head and prevent it from biting; the third dancer [in the white hat] is the gatherer; after they have danced three times around the sacred rock in the center of the plaza, the gatherer picks up the snake dropped from the mouth of the first dancer; when all the snakes have been danced, they are heaped in a squirming mass on a drawing made of sacred cornmeal, a symbol of rain; finally, the snakes are rushed down the north, south, east, and west sides of the mesa and released to go underground and beseech rain of the Water God. Couse points out that most of the snakes used in the ceremony are poisonous rattlers that have not been defanged, adding that for the Hopi it is a grave offense to harm a snake.[36]

A Hopi snake dancer wears a kilt that is usually made of canvas painted dark red-brown, with black-and-white designs; hanging to one side are leather strips, a foxtail, and a row of rattles made of deer hooves—or, more recently, cone-shaped metal noisemakers (see plate 173). Snake dancers on all three Hopi mesas wear very similar costumes, which to non-Indian eyes often seem almost identical (plate 174). One turn-of-the-century illustrator, Joe Mora, observed that "the costuming and body painting of the Snake Dancers is practically the same throughout all the villages, the variations being so slight that they were not worthwhile recording."[37] Yet they do differ, and we can assume that to the Hopi these differences are important or they would not have been preserved.

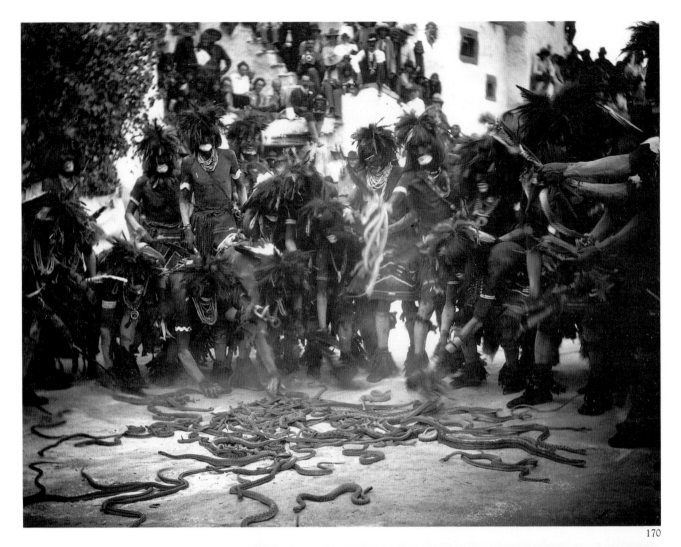

170

170. E. Irving Couse, *Snake Dance Sequence.* 1903

171. E. Irving Couse, *Snake Dance Sequence.* 1903

172. E. Irving Couse, *Moki Snake Dance.* 1904

173. Hopi Snake-Dance Kilt

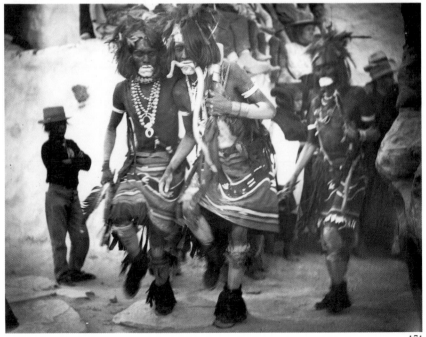

171

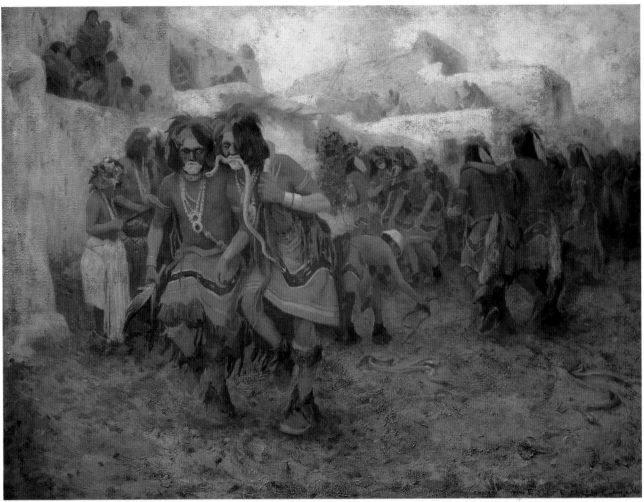

172

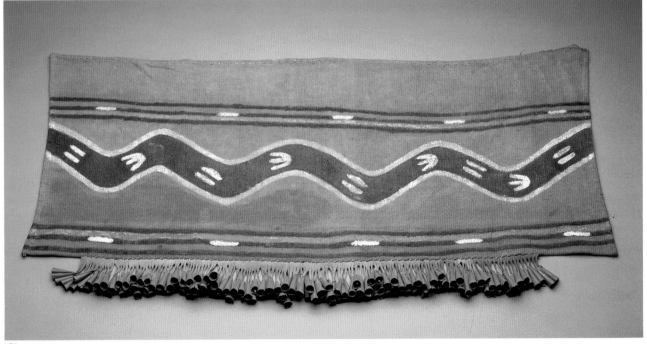

173

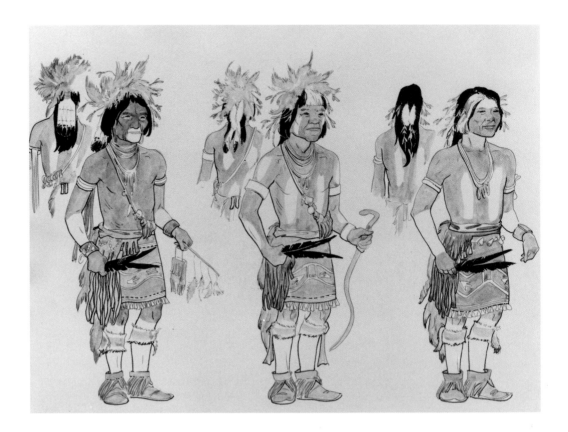

174. Barton Wright, *Snake Dancers from Three Hopi Mesas* (left to right: First Mesa, Second Mesa, Third Mesa)

The Hopi Snake Dance is performed in August, in alternate years with the Flute Dance. Although it falls outside the most important ritual cycle, that of the Hopi Kachina Cult, like the kachina rituals the Snake Dance is a petition for rain. Before the extensive United States Army presence in the Southwest, which effectively ended intertribal warfare in the mid-nineteenth century, male members of the Snake and Flute societies worked in concert to ensure success in war against the Ute, the Navajo, and the Apache. While members of the Snake Society were away from the village in combat, members of the Antelope Society made war medicines. Both society's rituals are intended to influence rain-controlling spiritual beings that live in the Underworld. As Couse indicated, the Snake Dance ritual culminates with the release of live snakes as Hopi messengers to those beings. Antelope Society rituals are performed outside the village, too, at springs or rainwater catchment basins and cisterns, sites that are believed to open directly into the Underworld and thus make the rituals visible to the supernatural beings.

Couse's *Moki Snake Dance* gives us an excellent picture of the lead snake dancers at the First Mesa town of Walpi, yet the pueblo backdrop he chose is probably the dance plaza of the Second Mesa town of Mishongnovi rather than the dance plaza at Walpi.[38] The figures in the right middle ground, the white-hatted snake gatherer and the two dancers seen from the back, are from the Mishongnovi dance. The Snake Dance, unfortunately, has disappeared at First Mesa, and we can only guess how long it will remain at Second and Third mesas. A photograph made by Lummis, in 1891, shows the site where the dance was presented at Walpi (plate 175). The disappearance of the dance from First Mesa emphasizes the importance of paintings

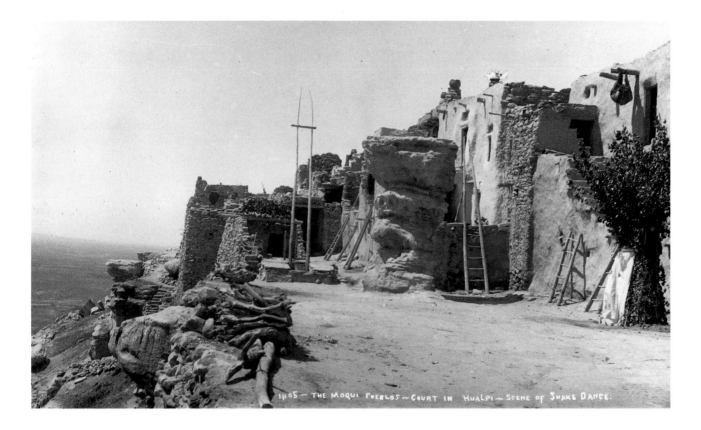

14 05 — THE MOQUI PUEBLOS — COURT IN HUALPI — SCENE OF SNAKE DANCE.

by artists such as Couse, as both documents and interpretations of history. At the same time, these pictures should be viewed analytically in relation to artifacts, photographs, and written records of the time.

Today Pueblo social organization is more complex than ever, interwoven with political as well as religious offices and functions. In each village, family households, kivas, clan groups, and ceremonial societies interlock the social, political, and religious affiliations of every resident. The Indian Reorganization Act of 1934 has augmented these traditional structures by creating village councils, each with representatives to a Hopi Tribal Council. And various pan-Pueblo organizations add another layer of complexity.

Tourist demand for traditional Pueblo basketry, jewelry, pottery, textiles, and wood sculpture—especially kachina dolls—has grown steadily since the late 1890s, and many Pueblo families support themselves from the proceeds of extensive craft sales. Affiliations of artists and craftsmen as well as craft-marketing groups further complicate an already dense political and social structure. And inevitably, outside tastes have impinged, modifying the traditional craft styles.

Although today some Pueblo villages are only a short drive from major population centers, such as Santa Fe and Albuquerque, they still remain quite separate culturally from the mainstream of Anglo culture. Even more distant from that mainstream are the Navajo and the Mojave, since fewer non-Indian travelers visit these tribal homelands. A popular Pueblo-dominated view of the area has emerged, based on the work of numerous Anglo artists who have visited the Southwest. As a result of this unbalanced picture of the culture area and its inhabitants, many tribes throughout the region are barely visible in popular literature.

175. Charles F. Lummis, *The Moqui Pueblos—Court in Hualpi [Walpi]—Scene of Snake Dance, August 22, 1891*

245

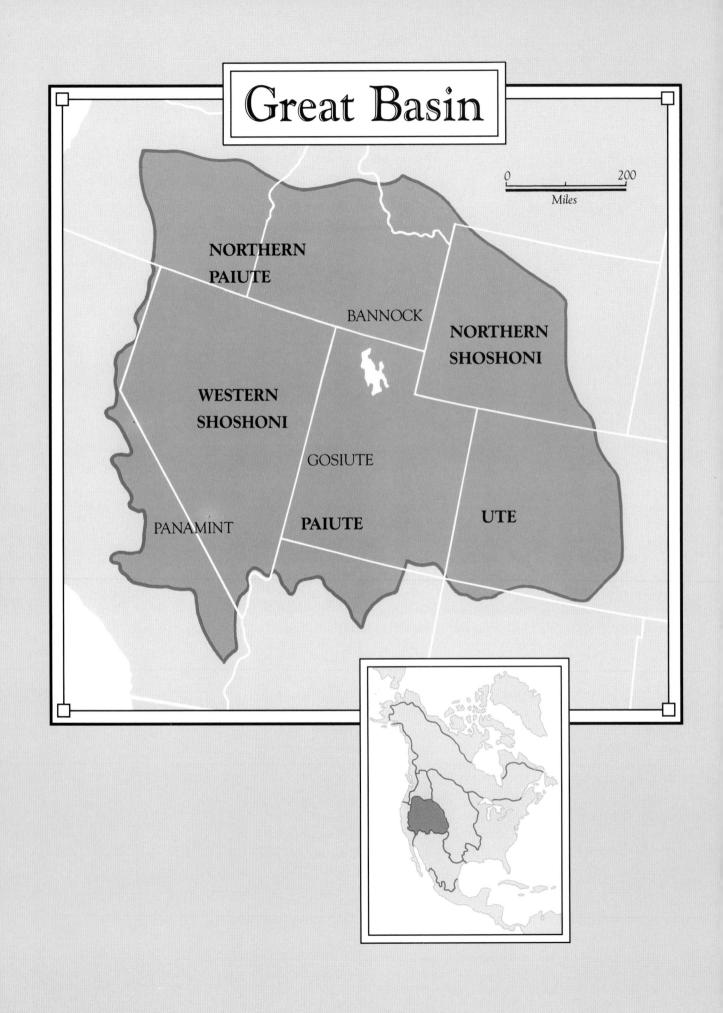

Great Basin

NORTHERN
PAIUTE

BANNOCK

NORTHERN
SHOSHONI

WESTERN
SHOSHONI

GOSIUTE

PANAMINT

PAIUTE

UTE

0 200
Miles

In the literature of anthropology and geography, the Great Basin usually has close cultural and ecological ties to the Plateau, the Southwest, and the California culture areas, but a combination of environmental, historical, and cultural factors makes the Great Basin culture area unique.

In the bowl of the Great Basin, rivers and streams drain into Pleistocene lakes and playas (lake bottoms). More than half of the bowl consists of parallel mountain ranges that screen rains from adjacent desert basins. (The same physiographic features are also present in portions of eastern California and parts of the adjacent Southwest, which make up the continent's Intermontane region.) Within the boundaries of the Great Basin there is a great diversity of plants and animals.

The Great Basin includes a huge natural desert area, most of Utah and Nevada, parts of Colorado, Wyoming, Idaho, Oregon, and California, and fringes of New Mexico and Arizona. Except for the open desert country in the southwest corner, most of the Great Basin is surrounded by uplands: to the east stand the Wasatch and the Rocky mountains; to the west, the Sierra Nevada; to the southwest, the Colorado Plateau; and to the north, the Columbia Plateau. The aridity of the basin makes vegetation sparse, and only sagebrush, piñon trees, and junipers grow with any profusion. Because of the harsh environment, at the time of white contact the Great Basin Indians were essentially gatherers, who foraged and dug for anything edible—seeds, berries, nuts, roots, snakes, lizards, insects, rodents; and thus during the Mexican period (1821–47) this group received the derisive term "diggers."

The Great Basin has been inhabited for more than eleven thousand years. From approximately 11,000 to 7,000 B.C., the region was populated by hunters of large game, whose culture archaeologists call Pre-Archaic or Paleo-Indian. The existence of these people is known from assemblages of stone tools characteristic of hunters of large game in the Southwest and the Great Plains.

More recent is the Desert culture, which began about 8,000 B.C., and is believed to have lasted until the coming of the Anasazi, about 100 B.C. From then on the people of the Desert culture shared the Great Basin with these early Puebloans and other later migrants to the region. The archaeological and ethnographic record indicates that the Desert culture supported a hunting and gathering people with low population densities, a simple technology, and kin-based lineage units. In late prehistoric and historic times, this culture coexisted with the northern extension of the Pueblo culture, and the Desert culture disappeared after A.D. 1200.

Since the sixteenth and seventeenth centuries, the Great Basin has been inhabited almost exclusively by Numic-speakers. Numic, a branch of the Uto-Aztecan language family, is generally subdivided into seven distinct languages: Mono, Northern Paiute, Shoshone, Comanche, Kawaiisu, Panamint, and Ute. The only non-Numic language spoken in the historic period in the Great Basin is Washoe, a language whose users some scholars consider Californian. This linguistic uniformity is mirrored to a great extent in other cultural patterns, including housing, clothing—especially of rabbit skins—and basketry (see plates 176 and 177). Warm rabbit-skin coverings, made by twining twisted strips of the animal's fur, served both as robes and bedding.

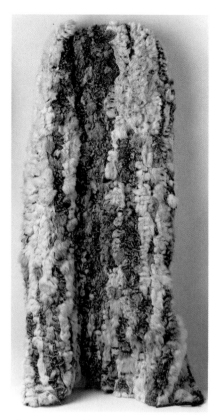

176. Paiute Rabbit-skin Blanket

Euro-American interaction with the Indians of the Great Basin falls into three periods of contact: the Spanish, from the seventeenth century through 1821; the Mexican, from 1821 to 1847; and the American, from 1848 to the present. Throughout these periods the Indian population adapted to Western culture, but at the same time it retained significant features of its aboriginal cultures.

The period of Spanish contact saw the smallest incursion by Euro-Americans in the region. Two significant features of cultural contact in this period are the adoption of the horse and the beginning of trade relations with Europeans and Americans. It is generally agreed that Ute warriors, who were raiding in New Mexico, brought the horse to the Great Basin, and it is likely that former Indian slaves in the Spanish households of New Mexico facilitated the dispersal of the horse to the Great Basin. With the horse came an entirely new inventory of equipment for riding, decorating, and maintaining them. The horse also brought changes in settlement patterns—some of them necessary for feeding the horses. Because of the horse, trade and travel increased, and new techniques of warfare developed along with a changed role for warfare in the Indian society of the region.

Much of the Spanish-Indian commerce was carried on in the Southwest, particularly in the Hispanic communities of Santa Fe and Taos. From the Spanish, the Indians received metal tools and containers, rifles, beads, and cloth. Perhaps the most important "item" exchanged for these Spanish products, however, was Indian slaves, captured by Great Basin Indians. The most desirable slaves were Indian women and children, who were more docile and useful in subsistence activities than men. Slaves were frequently placed with ranchers, but they also were used in Spanish mines and in town households.

During the period of Mexican rule slaving and other trading continued, but the Great Basin Indians also came in contact with British and American fur trappers, United States government exploration parties, and the first overland travelers to Oregon and the Pacific Northwest. The competition for the fur resources of the Great Basin had led to a widespread depletion of fur-bearing game, especially beaver, by the 1840s, with a consequent depletion in the supply of important foods in the Indian diet.

Among the American explorers searching for safe overland routes to California via the Great Basin during the Mexican period was one of the best-known army officers, John C. Frémont, who later figured prominently in the American annexation of California. In addition to government-sponsored exploration surveys, the Great Basin was traversed by private citizens migrating to California and Oregon. All of these travelers caused extensive disruption as they made their way west, foraging, hunting, and carrying new diseases against which the native populations had no natural defenses.

In 1847, a new group of settlers—the Mormons—arrived in the Great Basin, and they dramatically transformed the region with their settlements. Shortly afterward, the Treaty of Guadalupe Hidalgo (1848) ended the Mexican-American War, and the discovery of gold in California (1849) further fueled migration into the Basin. Although the Mormons were first attracted to a remote part of northern Mexico as a refuge from religious oppression, these members of the Church of Jesus Christ of Latter Day

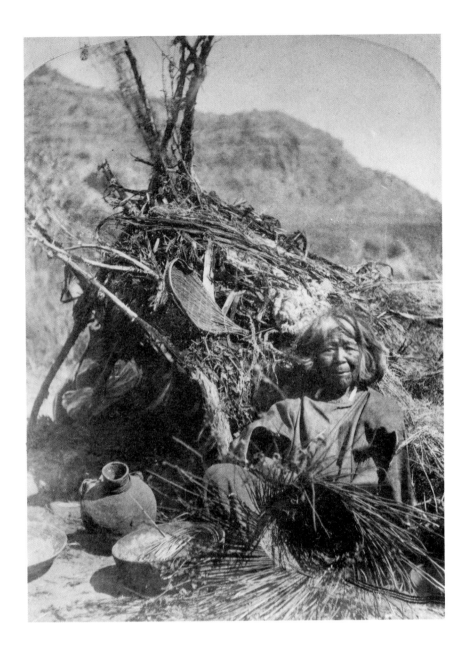

177. John K. Hillers, *"The Basket Maker"—KAI-VAV-ITS (A Tribe of Pai Utes)*. 1872

Saints quickly established themselves as the preeminent American presence in the area around the Great Salt Lake. At first they established peaceful relations with the more powerful tribes—the Ute and Shoshone—and then tried to maintain them through diplomacy and gifts of food and clothing. Although there were episodes of warfare between the Mormons and Indians of the Great Basin, the Mormons successfully ended the slave trade. It is generally agreed that their treatment of Indians during this period was superior to the treatment of Indians by other whites. Yet they failed in their attempt to convert the Indians.

During the 1850s and '60s, western Nevada experienced a new wave of migration—this time of prospectors in search of silver. The Comstock Lode was discovered in this area, an attraction that lured numerous whites to the region—not only miners but farmers, ranchers, storekeepers, and

many others—to serve the miners' needs. To protect the white settlers from Indian raids, the United States Army was used to police the area.

In the late 1850s, a number of reservations were established for the Great Basin tribes, but in many instances these lands were later usurped for whites, often with the connivance of government officials who were employed to protect Indian rights. In general, Great Basin Indian reservations diminished in size as the white population increased, as mineral discoveries made Indian land more valuable to whites, and as government policy toward Indians changed.

One of the native groups that lived in the Great Basin along with the Ute, Paiute, and Bannock was the Gosiute. The Gosiute Indians are far less known than the Ute, the Paiute, or their more distant neighbors the Bannock. The traditional Gosiute homeland, west of the Great Salt Lake and east and southwest of the Great Salt Lake Desert, along the contemporary borders of Utah and Nevada, is one of the most uninhabitable regions of the Basin. It was both remote and difficult to traverse, because of the rugged terrain and the scarcity of water. This is why little is known of the traditional Gosiute culture—including the language, which linguists classify as Western Shoshone.

The Gosiute population was estimated by various nineteenth-century travelers at between two hundred and four hundred persons, and there is general agreement that the basic cultural patterns of the Gosiute were essentially the same as those of other Shoshonean-speakers in the Great Basin. Because of the limited resources in their environment as well as a minimal artifact inventory, early white travelers unaware of the intangible values of the culture saw Gosiute lifeways as poverty-stricken. The American army officer Captain James Hervey Simpson, observing the Gosiute in 1859, described them as "very low and dirty, eating rabbits, rats, lizzards, snakes, insects, rushes, grass seeds, roots," and other forms of low life.[1] An even more vehement description of Gosiute deprivation is the statement of a year earlier by Jacob Forney, Utah's superintendent of Indian Affairs. Forney describes a small Indian tribe then about forty miles west of Salt Lake City as "without exception the most miserable looking set of human beings I ever beheld. I gave them some clothing and provisions. They have heretofore subsisted principally on snakes, lizards, roots, etc."[2] These descriptions clearly reflect the bias of the Euro-American agricultural society.

Today, scholars recognize several Gosiute locations, including Deep Creek, Skull Valley, Trout Creek, Tovela Valley, Rush Valley, Cedar Valley, and Tintic Valley. In spite of these differences in locale there are no appreciable differences in language or culture among these Gosiute groups, yet it is generally assumed that there was no extended political organization uniting them in these different locations. One feature that distinguished Gosiute culture from that of their Ute neighbors (as well as from those of other Shoshonean groups) was the absence of the horse. The Gosiute did not acquire the horse until relatively late in historic times, and then only in limited numbers. To an extent, the limited food supply available to them made the horse a liability.

Supplemented only by rabbit and an occasional deer or antelope, the radically limited diet of the region forced a widely dispersed settlement

pattern. During fall and winter, however, the Gosiute usually congregated in pine-nut camps and then in winter villages, where political authority often rested with a single individual or "chief," who directed religious festivals and communal rabbit and/or deer hunts. By contrast, antelope hunts were directed by a religious leader—a shaman. Except for these communal occasions, however, the male head of a household made decisions for his domicile. Frequently, the household included more than one wife and her children. The preferred wife was the cross-cousin, a paternal aunt's daughter.

Because of the region's limited resources for building, housing and brush shelters were not elaborate. Equipment for collecting and processing seeds and pine nuts—baskets and stone mortars and pestles—was also simple. The common weapon was the bow and arrow; and clothing prior to extensive white contact was limited to rabbit-fur robes and blankets, and rudimentary garments made of animal skin and vegetal fiber. The Paiute blanket illustrated here is very much like those used by the Gosiute (see plate 176).

The paucity of material artifacts among the Gosiute, their isolation and seasonal movements, and the limited color in their costume and landscape undoubtedly deterred many artists from seeking them out as subjects. The thousands of adventurers attracted by the aureate call of California after 1849 felt acutely the awesome size of the American continent. The "forty-niners" were not the first to traverse the vast distances, but they far outnumbered their predecessors. As the era of road building and exploration extended through mid-century, many government-sponsored and independent artists fanned out across the West, crossing and recrossing the Rockies, recording again and again the image of the Oregon Trail. By 1858, and especially after the Civil War, the federal government supported numerous scientific expeditions to find suitable routes to California. These expeditions sought shorter and more practical routes than the Oregon Trail, which was too far north to be useful beyond Fort Hall, Idaho. In 1858 and 1859, Captain James Hervey Simpson, a western veteran of the Topographical Corps of Engineers, was among the explorers assigned to finding serviceable routes for wagon roads across the Great Basin of Utah to California. The artist H. V. A. Von Beckh was a member of Simpson's second expedition to this region, in 1859.

In the letter of transmittal accompanying his official report, Simpson stated, "I have now the honor to submit a report and map of my explorations and opening, in 1859, of two new wagon-routes across the Great Basin of Utah, from Camp Floyd to Carson Valley, by means of which the traveling distance from Camp Floyd to San Francisco, when compared with the old Humboldt River route, has been shortened, in the case of my more northern, 283 miles, and in the case of my more southern route, 254 miles."[3] Simpson proffered grateful thanks to his many assistants, singling out Von Beckh for his "original sketches of scenery" and the expedition's topographical draftsman John J. Young, of Washington, D.C., who redrew and developed the sketches into watercolors for the official report. Because of Young's skill, the Von Beckh views are much grander in their presentation of western scenery and genre than the standard topographical work of the day. In the *Beautiful Cascade, Timpanogos [Utah]*, for example, Young

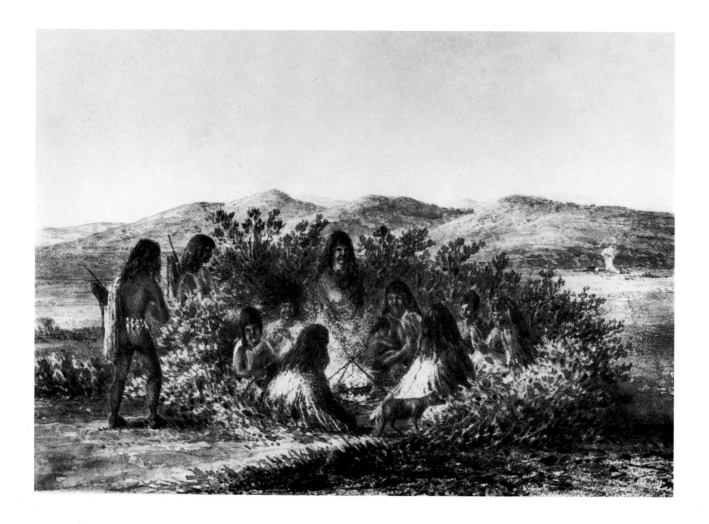

178. John J. Young, after H. V. A. Von Beckh, *Go-Shoot Habitation, Pleasant Valley, Utah.* 1859

has exaggerated and dramatized the verticality of the towering cliffs and precipitous falls.

In contrast, Von Beckh's *Gosiute Indians* focuses more on the foreground activity than on the barren rolling hills in the distance (plate 178). Summarily treated by both Von Beckh and Young, the Gosiute are described in detail by Simpson in his report of the group's travels through Pleasant Valley, Utah, on May 9, 1859:

> Both men and women wear a cape made of strips of rabbit-skins, twisted and dried, and then tied together with strings, and drawn around the neck by a cord. This cape extends to just below the hip, and is but a scant protection to the body. They seldom wear leggins or moccasins, and the women appear not to be conscious of any impropriety in exposing their persons down to the waist. Children at the breast are perfectly naked, and this at a time when overcoats were required by us. The men wear their hair cut square in front, just above the eyes, and it is allowed to extend in streamers at the temples. The women let their hair grow at random. They live on rats, lizards, snakes, insects, grass-seed, and roots, and their largest game is the rabbit, it being seldom that they kill an antelope.

Simpson then carefully described the precise scene that Von Beckh recorded in pencil and Young translated later into watercolor: "Just at sunset

. . . [we] walked out to see some of these Goshoots at home. We found, about 1.5 miles from camp, one of their habitations, which consisted only of some cedar branches disposed around in the periphery of a circle, about 10 feet in diameter. . . . In this enclosure were a number of men, women, and children. . . . In the center was a camp-kettle suspended to a three-legged crotch or tripod. In it they were boiling the meat we had given them."[4] This is precisely the view that Von Beckh presents on paper.

Although nothing is known about Von Beckh's life and career apart from his affiliation with Simpson's survey, Young is often identified as a draftsman with the War Department, a topographical engineer, and an engraver. After his return from one further expedition, he spent his remaining years in Washington, according to listings in that city's directory from 1860 until 1879, the year of his death.[5]

Simpson's reconnaissance of the Wasatch Mountains and the Great Basin was of pivotal importance. In time the routes west to California and north to Fort Bridger, Wyoming Territory, became well-traveled avenues across the vast domains of the Great Basin. The Civil War postponed the publication of Simpson's final report until 1876, when Von Beckh's sketches, redrawn by Young, opened the eyes of many travelers to the beauties of the Great Basin and the expansive terrain between it and the Pacific. Among these illustrations is the single view of a Gosiute family or group gathered around a cooking fire.

In 1868, after the government began to establish reservations for many of the Great Basin tribes, a Utah Indian agent reported that the industrious Gosiute were earning their living by herding stock and doing other kinds of labor for the settlers in the region. But in parts of Nevada and southern Utah, other Gosiute bands still exist on reservations, in inaccessible areas of the Great Basin.

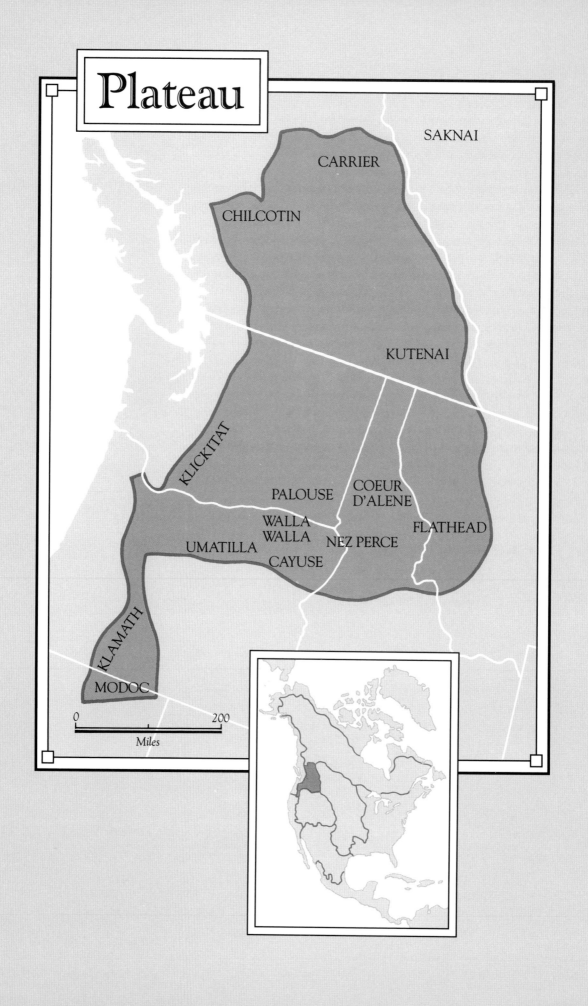

Plateau

SAKNAI

CARRIER

CHILCOTIN

KUTENAI

KLICKITAT

PALOUSE

COEUR
D'ALENE

WALLA
WALLA

FLATHEAD

NEZ PERCE

UMATILLA

CAYUSE

KLAMATH

MODOC

0 200

Miles

The Plateau culture area lies between the Rocky Mountains to the east and the Cascades to the west, and in many studies it is called the Intermontane region. A high, rather arid region, its northern and southern boundaries are the great bend of the Fraser River and the Columbia Plateau, respectively. In terms of more contemporary political boundaries, the Plateau includes Idaho and portions of Montana, Oregon, Washington, interior British Columbia, and Saskatchewan. Two major river systems dominate the region, the Columbia and the Fraser. In aboriginal times these rivers, together with their tributaries—the Thompson, Okanagan, Dischutes, Umatilla, Snake, and Willamette—provided both food and avenues of travel and trade.

From the rivers, Plateau Indians took salmon, their principal staple, as well as sturgeon and trout, and their basic plant foods were roots and berries. Before extensive contact with non-Indians there were two major language families in the Plateau area, Penutian and Salish. Among the Penutian-speaking tribes are the Klamath, Modoc, Nez Perce, Klikitat, Cayuse, Palouse, and Chinook. These tribes or their cultural ancestors have inhabited the middle Columbia River since at least 6,000 B.C. North of the Columbia River and into the interior drainage of the Fraser River are Salishan-speaking tribes, including the Carrier, the Chilcotin, and the Sakani. A third language family, the Athabaskan, is represented by one tribe, the Kutenai.

Although the Plateau is commonly considered a single geographic or physiographic phenomenon, the area in fact is cut by several rivers and mountain ranges that create numerous "plateaus" rather than a single high mesa. A second common confusion about this culture area is the assumption that its location between the Northwest Coast and the Great Plains results in cultures that are little more than a synthesis of elements drawn from these two culture areas.

Although the Indians of the Plateau were never in direct contact with the Spaniards, they were significantly influenced by the diffusion of the horse brought by Spanish colonists in the Southwest. The horse probably reached the Plateau in the early eighteenth century, most likely via Shoshonean-speakers from the Great Basin. As it did in the Great Basin, the arrival of the horse had a significant impact on the tribal cultures of the Plateau. In addition to the trappings required of horse riders, the presence of the horse changed settlement, warfare, trading, and hunting patterns as well as the perception of wealth. Perhaps the most telling of these changes was the ability to traverse longer distances to locate settlements, wage war, trade, and hunt. With the horse came increased contact with the tribes of the western Great Plains, which brought elements of Plains culture to the Plateau. One cultural borrowing from the Plains was probably the Sun Dance ritual, adopted by the Plateau after the eighteenth century.

In 1805–6, when Lewis and Clark crossed the Plateau, they saw numerous examples of Spanish trade goods among the Plateau tribes, including trade guns, metal implements, and cooking vessels. Early explorers also observed the enormous horse herds kept by some of the Plateau tribes, especially the Nez Perce, Cayuse, and Flathead. These large herds were more than effective transportation, they were central to a concept of wealth based on horse ownership.

By the start of the nineteenth century, traders from eastern Canada began to penetrate the Plateau in search of furs. Not only did these traders bring European manufactured goods to exchange for furs but they often were accompanied by Iroquois employees with their own cultural traditions from the Woodlands. As in other parts of the continent, several fur trading companies, among them the North West, Hudson's Bay, and the American Fur Company, competed for trade with the Plateau tribes. By the 1820s several trading posts were operating in the Plateau area.

As elsewhere, Christian missionary activity followed closely on the heels of the fur traders. Among the earliest missionaries were the Rev. Henry H. Spalding, who established a Presbyterian mission among the Nez Perce in 1836, and the Rev. Pierre de Smet, the French Jesuit, who was especially active in the 1840s among the Flathead and Coeur d'Alene. Protestant and Catholic missionaries were equally active, especially among the tribes along the Oregon Trail.

Ultimately, white American immigrants traveling via the Oregon Trail brought the greatest cultural changes to the Plateau. These changes came in the form of foreign diseases spread by land-hungry farmers and ranchers and by the United States Army, which protected the white immigrants. In addition, with the discovery of gold in 1860 on land occupied by the Nez Perce, came hordes of fortune seekers to Indian lands in Oregon and Idaho. Although the first regular United States Army troops reached Fort Vancouver, at the mouth of the Columbia River, in 1849, much of the military action against Plateau Indians in the 1840s and '50s was conducted by volunteer forces. Volunteers responded to the Cayuse War (see p. 260), following the Whitman massacre, in 1847, but thirty years later, in 1877, the Nez Perce War was conducted by the regular army.

The Nez Perce War was made famous by Chief Joseph's campaign across the Bitterroot Mountains, and it illustrates the interlocking of white forces arrayed against the Plateau Indians. The roots of this war are buried in the conflict surrounding the settlement of the Oregon Territory by whites after the opening of the Oregon Trail in 1843. In 1855 the Walla Walla Treaty granted the Nez Perce a reservation of approximately eleven million acres in Idaho and Oregon. Following the discovery of gold in the 1860s, a large portion of this reservation north of the Snake and Clearwater rivers was opened by United States government decree to American mining. To ensure the safety of the miners, troops were stationed on the reservation. In 1863 the reservation boundaries were redefined to reduce Nez Perce holdings to just over one million acres—a loss of ninety per cent of the original reservation. At the time, the Nez Perce were divided in religious affiliation (Presbyterian vs. Catholic), in political loyalties (pro- vs. anti-American), and by administrative issues (Presbyterian ministers became the Indian agency managers in 1870). By 1875 these problems, along with reservation land disputes, aggravated the situation and led to the Nez Perce War of 1877. The two chiefs of the Nez Perce, Joseph and Ollokot, provided the leadership and direction that outmaneuvered the United States Cavalry during that war. In a final action just south of the Canadian border, seeking sanctuary in Canada, Chief Joseph and his war-weary Nez Perce tribe finally surrendered to General Nelson A. Miles and his superior forces on October 5, 1877.

This last battle of the Nez Perce War, fought in the Bear Paw Mountains of northern Montana, ended a 1,300-mile retreat by the Nez Perce from northeastern Oregon. Their circuitous flight toward the Canadian border is universally regarded as one of the great military strategies, one in which civilian, noncombatant casualties were kept to a minimum, at least by the Nez Perce. It is probably not accurate, however, to call the defensive actions along this forced march a war or to portray Chief Joseph as the single, great strategist of this march.

The Battle of Bear Paw took place thirty miles from the safety of the Canadian border. Here, Chief Joseph delivered his surrender speech, which ended with the now-famous phrase: "I will fight no more forever." Numerous illustrations depict him handing over his rifle to General Miles amid a driving snowstorm. At the battlefield, the Indian prisoners numbered 418: 87 men, 184 women, and 147 children. Thirteen additional prisoners were subsequently captured on their way to exile in Oklahoma, because at Bismarck, North Dakota, their number had increased to 431. At Bismarck, General Miles, who had been overruled by his commanding officers in Washington, reneged on his promise to allow Joseph and his followers to return to a Nez Perce reservation in Idaho. Instead, they were transported south, first to Kansas and then to Oklahoma, where Joseph remained until 1885. Some of the Oklahoma Nez Perce ("Non-treaty Nez Perce," who refused to sign the 1861 treaty that exchanged their Oregon land for a reservation in Idaho), however, were allowed to return to Idaho. In time, government officials resettled Joseph and a small following on the Colville Reservation in northern Washington, both to punish him and to prevent him from acquiring a larger following among other Nez Perce bands. Chief Joseph died there in 1904.

Although the lives of Charles Russell (1864–1926) and Chief Joseph (1839–1904) coincided for forty years, there is no evidence that the two men ever met. Russell probably painted *Chief Joseph* (plate 179) from a photograph, because the portrait closely resembles Charles M. Bell's photograph of the chief, taken in Washington, D.C., in 1879. Bell photographed Joseph when the leader presented himself to President Hayes to plead the case of his people during their exile. The Indian chief's pose, his physiognomy, costume, and hairdress, are similar in both images (see plate 180). Like the photographer, Russell saw his subject as a proud and noble warrior, despite his defeat and surrender to the United States government. Both painting and photograph confirm his resolute nature. Russell painted Chief Joseph several times, and one of the other pictures is based on a photograph by Frank J. Haynes, taken of Joseph in Bismarck, North Dakota, in 1877, as the Nez Perce went into exile in Oklahoma.

Russell did not leave a legacy of Indian portraits like his fellow Montanan artist Edgar S. Paxson (see p. 265). Russell was impelled to paint Chief Joseph in 1900, because of the growing myth about his leadership of the Nez Perce in the war of 1877. The war began seventy-two years after the Nez Perce met and fed the starving Lewis and Clark expeditionary party, in 1805. This was sixty-five years after John Jacob Astor's American Fur Company founded an outpost at Astoria, in Oregon, in 1812, and forty-one years after the first Protestant mission was established, in 1836, among the Nez Perce in Idaho. Yet none of these previous contacts prepared the

179. Charles Russell, *Chief Joseph*. 1900

180. Charles M. Bell, *Thunder Coming from the Water Up over the Land (Chief Joseph)*. 1879

Nez Perce or neighboring tribes for their displacement from their ancestral homelands. Chief Joseph and his father both sought to protect the Wallowa Valley, their ancestral homeland. Historian Alvin Josephy explains Chief Joseph's reputation as a great strategist in the War of 1877:

> The truth was that the Nez Perces' military successes resulted from a combination of overconfidence and serious mistakes on the part of the army and volunteer leaders, the vast and rugged terrain that gave the Indians great freedom of movement and made pursuit difficult, the democratic and group aspects of Indian culture that nurtured individual initiative and self-reliance—though always in behalf of the group—and, to a very great extent, the Nez Perces' intense courage and patriotic determination to fight for their rights and protect their people. Indian strategy and tactics had played a strong role, but at each step of the way these were discussed and agreed upon in councils of all the chiefs and experienced war leaders and were carried out on the field by the fighters. Joseph sat in the councils, but since he had never been a war chief, his advice carried less weight than that of men like Five

Wounds, Rainbow, and Toohoolhoolzote. On the march and in battle Joseph
. . . took charge of the old men, women, and children, an assignment of vital
importance and sacred trust, while Ollokot and the experienced warriors led
the young men on guard duty or in combat. The whites had no way of
knowing this, and, as events continued to unfold, the legend that Nez Perce
strategy was planned and executed by one man, Joseph, was spread far and
wide by the hapless forces opposing him and was accepted without question
by newspaper writers and the American public.[1]

Russell's painting of Chief Joseph helps perpetuate the myth about the
man.

The loss of reservation land is a pattern repeated throughout the Plateau
in the nineteenth century. In the early twentieth century, the Allotment
Act, giving title to reservation land to individual families, led to even more
significant losses of Indian land when Indian families sold their land to
whites. Despite the payment of land claims in the 1950s by the United
States government, the loss of Indian land brought with it a decline in
Indian identity, employment opportunities, and traditional cultural prac-
tices. Today numerous Plateau reservations are consolidated areas on which
two or more tribes reside, further blurring traditional tribal identity.

One of the most inflammatory incidents in Plateau history, which
helped to fuel the Cayuse War of 1848, is portrayed by Irving Couse in *The
Captive* (plate 181; see also p. 263)—an episode from the story of the
Whitman massacre of 1847 that precipitated that war. Violence between
whites and the Cayuse Indians disturbed a peace that had prevailed since
the time of the Lewis and Clark expedition. The incident began at the
Presbyterian mission at Waiilatpu in Oregon Territory, founded by Marcus
Whitman, a minister and physician, and his devout followers in 1836.

Nearly a half century later this shocking incident was still vivid in the
minds of settlers in the region. In December 1889, Virginia Walker Couse,
the recent bride of Irving Couse, wrote to her sister Fanny from Paris,
asking her to suggest a historic Indian subject for a large painting that would
have enough drama to dazzle a Paris Salon jury: "Mr. Couse wants to paint a
big Indian picture for the Exhibition of '92. He wants to do something
historical and Fan do you know of any history that tells much about the
Indians & their wars? . . . He wants to do some thing that is well known in
history if possible so it will take. If you will pick up all the Indian informa-
tion you run across & remember it for him you will be doing him a great
favor. It is so hard to find any thing American here. It is quite impossible
you know for the libraries are all French."[2]

The Whitman massacre was a likely theme, because Virginia Couse's
family lived in Klikitat country, on the Washington side of the Columbia
River, about seventy-five miles west of the site of the historic massacre. Like
the Whitmans, the Walkers were devout Presbyterians and had helped to
found and build a small church at Zena, later known as Spring Valley,
Oregon, where they first settled in 1845. The idea that disputed Oregon
Territory was settled by American expansionists and their followers proba-
bly also appealed to Couse. John Cawelti wrote that "the myth of the West
as progressive pioneers cultivating a desolate wilderness and thereby ac-
complishing the manifest destiny of the American people was very likely
the most widely accepted public vision of the frontier in the nineteenth

181

182

181. E. Irving Couse, *The Captive*. 1891

182. E. Irving Couse, *Model in Couse's Studio, Walker Ranch, Washington (Columbia River)*. 1891

century because it seemed to correspond with the actuality of the westward movement and with the central moral ideologies of Christianity and progress."[3] Couse's picture is clearly many-layered, and it is one of his major accomplishments.

In early summer 1891, the Couses returned to the United States and settled for a time on the Walker ranch. Near the main ranch house Virginia's father built a studio of Couse's design in the style of a French farmhouse. Here, the artist developed his concept for *The Captive*, using his wife as the model for the captive, Lorinda Bewley. Typically, Couse referred to his many photographs and sketches, and his pencil sketch on grid paper shows how he transferred the image directly to canvas. Like his mentor Bouguereau, Couse rendered the smooth, opalescent flesh tones, tense muscles, and fine bone structure of his model. The idealized beauty of the seventeen-year-old mission aide is characteristic of his painting style at this time.

The Whitman massacre began on Monday, November 29, 1847. That day the Whitmans and eleven other whites were killed by Cayuse warriors led by Chief Tilokaikt. These killings culminated years of Indian frustration with white theft and settlement of their land, Protestant-Catholic missionary conflicts, dishonorable government policy toward Indians, conflict between mountain men and missionaries, the Whitmans' own insensitivities toward the Indian people they came to minister, and, most immediately, with white diseases that were decimating the Indians. Indeed, another kind of deceit played a part in the Whitman massacre: the Cayuse had been told by white mountain men that the medicine the Whitmans had been administering to the Indians was poison. By murdering the Whitmans and any diseased whites hospitalized at their mission, Tilokaikt believed that he was protecting his own people. On November 29 and over the next few days fourteen lives and fifty-one captives were taken, most of the latter women and children. Lorinda Bewley was one of the captives.

Although reports vary widely, it seems that for eleven days Lorinda and her companions were held nearby at the emigrant house and a number of other women were taken as wives by Cayuse warriors. South of the mission, across the Walla Walla River, the converted Umatilla chief Five Crows (renamed Hezekiah by his Presbyterian mentor) learned of the plight of the captives from nearby Catholic missionaries, who asked him to intercede on behalf of those who were being held.

Five Crows, captivated by the beauty of Lorinda Bewley, prevailed upon the Cayuse at Waiilatpu to bring the young woman to his lodge on the Umatilla River. Lorinda's experience was described by the historian Hubert Bancroft.

> Having no one to protect her, she was torn from the arms of sympathizing women, placed on a horse, and in the midst of a high fever of both mind and body, was carried through a November snow-storm to the arms of this brawny savage. Five Crows behaved in a manner becoming a gentlemanly and Christian savage. He made his captive as comfortable as possible, and observing her opposition to his wishes, gave her a few days in which to think of it, besides allowing her to spend a portion of her time at the house of the

Catholic bishop. But this generous mood was not of long duration, and nightly she was dragged from Blanchet's presence to the lodge of her lord, the priests powerless to interfere.[4]

Later, during a deposition taken by the priest Brouillet, Lorinda charged that the priests not only failed to protect her but ordered her "to go [with Five Crows] . . . 'as he might do us all an injury.' . . . [And, even] one of the young priests asked me, in a good deal of glee, 'how I like my companion.'"[5] Whether these statements were accurate or the product of an emotionally charged episode, the deposition was powerful propaganda (see the discussion of the Captivity narrative, p. 30).

In *The Captive*, Couse no doubt chose to paint Lorinda in white to heighten the effect of her defilement, placing her on the floor of Five Crow's tipi to accentuate her sense of despair and degradation. The viewer's emotional response to the obvious struggle and resistance of the captive is reinforced by the graphic depiction of her bloodied wrist bonds. Couse chose a Klikitat model named Catsunut from a nearby reservation to pose as Five Crows (plate 182). The Klikitat were in the habit of pitching a temporary camp not far from the Walker ranch, where they stopped to pick berries and trade baskets. Members of the Penutian language family, like the Nez Perce, they lived formerly on the Cowlitz, Lewis, White, Salmon, and Klikitat rivers in central Washington State north of the Columbia River. After ceding their lands to the United States, on June 9, 1855, the Klikitat were relocated to the Yakima Reservation in the central part of the state. One of the artifacts Couse has chosen to include for pictorial effect, however, does not belong to any of the Plateau people. The shield next to Five Crows, on the viewer's right, strongly resembles one of two painted Comanche shields captured by the army in an engagement with the Comanche at Paint Creek, Texas, on March 7, 1868. Saddles of the type shown in the background were used throughout the Woodlands as well as in the West. This one suggests a pad saddle made of leather stuffed with straw, with a bow and pommel of antler rather than wood.[6]

In early January 1848, Peter Ogden, head of the Hudson's Bay Company at Fort Vancouver, succeeded in rescuing all of the captives by paying the Cayuse a ransom: "Sixty-two three-point blankets, sixty-three cotton shirts, twelve guns, six hundred loads of ammunition, thirty-seven pounds of tobacco, and twelve flints as well as seven oxen and sixteen bags of coarse flour."[7] Many years later, Lorinda Bewley told her story to her granddaughter, Myra Sager Helm, who in turn published it in *Lorinda Bewley and the Whitman Massacre*.[8]

While anthropological and art historical analysis of pictures of the Plateau Indians by non-Indian artists adds dimension to both cultures, in their own time these paintings had still another dimension as instruments of propaganda. In today's climate, however, such an analysis must avoid the cavalier attitudes of the past toward the Indian.

Changing Views

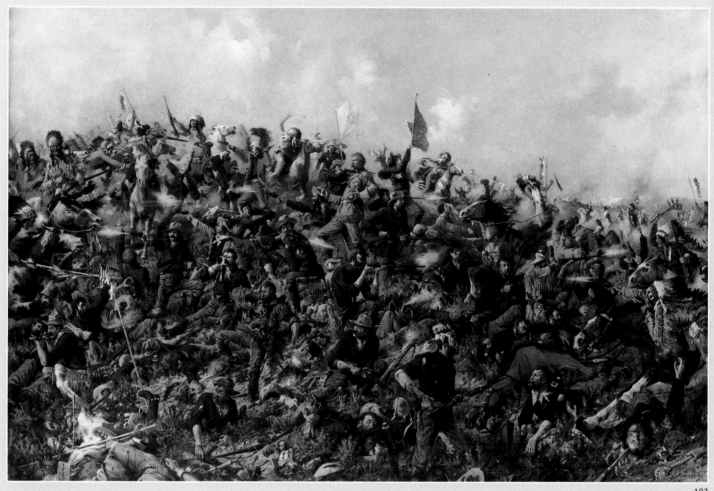

American Indian power to make war came to an end in the late nineteenth century, but Indian resistance to white domination and exploitation has continued. Exchanging tomahawks and rifles for legal and political weapons, native Americans have adopted political action as a primary means for asserting their rights. Until World War Two, there were isolated instances of Indian activism, highlighted by collective tribal action in 1911 and by the granting of citizenship to Indians in 1924. Many Indians served in the armed forces during both world wars, and several won the Congressional Medal of Honor. After World War Two, the need to settle land claims forced the federal government to redress past wrongs.

In the 1960s, '70s, and '80s, Indian resistance took on a new dimension. The newer leaders were college educated, and some of them participated in the civil rights and counter-culture movements as well as in radicalized political-action groups. While the struggle for "Red Power" during this period is too complex to document here, artists working in modernist and contemporary idioms have responded to this struggle primarily by focusing on the values of the American Indian tradition or on the ironies and stereotypes inherent in the way our society has treated the native American.

On July 4, 1876, the country celebrated a century of progress and innovation at the Philadelphia Centennial Exposition. On July 5, Eastern newspapers chronicled the Battle of the Little Big Horn. Custer and his command of five companies, totaling more than 260 men, were annihilated—the elite 7th Cavalry organized specifically to contain the Plains Indians had been ambushed and destroyed to the last man. Custer's defeat was a national disgrace for a populace of forty million Americans. Overnight, Congress was galvanized into action and the nation's military received marching orders to subdue all of the hostile tribes in the West.

Despite the determined drive by the United States Army, the last of the warring Plains bands were not subdued until 1881. But the continuing frustration of the army manifested itself in December 1890, when a unit of the 7th Cavalry massacred several hundred Sioux Indians at Wounded Knee Creek in South Dakota. Most of the casualties were women and children and few escaped the action (see plate 89). The massacre prompted one of the country's leading poets, Stephen Vincent Benét, to write: "I shall not rest quiet in Montparnasse/I shall not be there—I shall rise and pass./Bury my heart in Wounded Knee." Ironically, by winning the Battle of the Little Big Horn, in 1876, the nation's Plains Indians lost the war and their dreams vanished into obscurity.

Documentation of Custer's "last stand" has accumulated for over one hundred years, and many historians have advanced differing versions of the battle. So too have many artists, and three interpretations of the battle are of particular interest here. The first, by Edgar S. Paxson (1852–1919), was completed in December 1899 (see plate 183). Paxson's qualifications for this task are impressive. He had lived with both Indians and soldiers in the West and had achieved the respect of both groups. In addition to his abilities as an artist and his detailed research into the battlefield itself, Paxson interviewed countless Indian warriors and army soldiers who participated in the Sioux campaign of 1876–77. His spectacular version of the

183. Edgar S. Paxson, *Custer's Last Stand.* 1899

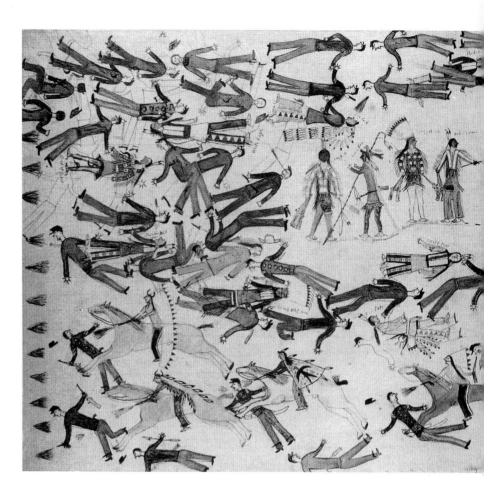

battle was painted on a six-by-nine-foot canvas that weighed over one thousand pounds when framed.

Custer's Last Stand evokes a potent response from the viewer, and the poignant, emotional commentary by General E. S. Godfrey, who led the rescue force, underscores the despair and tragedy of war:

> I can never forget that sight! The early morning was bright, as we ascended to the top of the highest point whence the whole field came into view, with the sun to our backs. "What are those?" exclaimed several as they looked at what appeared to be white boulders. Nervously I took the field glasses and glanced at the objects; then almost dropped them, and laconically said: "The dead!" Col. Weir, who was near, sitting on his horse, exclaimed: "Oh how white they look! How white!" No there were no accessories; everything of value was taken away: arms, ammunition, equipment and clothing. Occasionally, there was a body with a bloody undershirt, drawers or socks, but the name was invariably cut off. The naked mutilated bodies, with their bloody fatal wounds, were nearly all unrecognizable, and presented a scene of sickening, ghastly horror! There were perhaps a half dozen spades and shovels, as many axes, a couple of picks and a few hatchets in the whole command; with these and knives and tin cups we went over the field and gave the bodies, where they lay, a scant covering of mother earth and left them, in the vast wilderness, hundreds of miles from civilization, friends and homes—to the wolves![1]

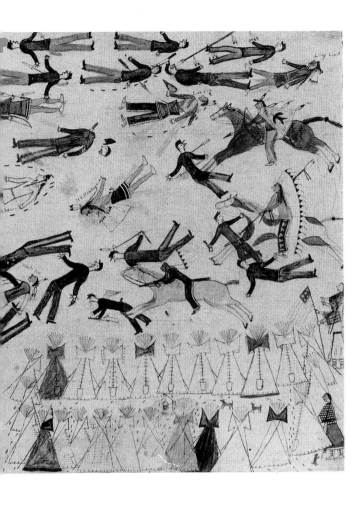

184. Kicking Bear (Sioux), *Battle of the Little Big Horn.* 1898

About the same time Paxson made his painting, another version of the Battle of the Little Big Horn, a pictograph painted on muslin, was done by the Sioux Indian artist Kicking Bear, at Pine Ridge Agency in South Dakota (plate 184). The noted warrior, who fought in the battle, has been described by the United States government as a "chronic troublemaker," by his own people as a "patriot and gallant warrior," and by the soldiers who fought against him as "courageous and shrewd."[2] "Indian bashing" at the national level was prevalent during the late years of the nineteenth century, and undoubtedly it influenced the recording of historical events from the Indian viewpoint. Indeed, some historians felt that Kicking Bear, who was cautious and conservative, harbored a fear of retaliation or punishment by the whites and, therefore, refrained from giving his version of the battle for over twenty years.

Kicking Bear's pictograph was eventually sold to the local Indian agent, and at the artist's request the agent added the names of the Indian leaders and the Sioux warriors who fell in the battle. Kicking Bear identified the participants:

> The Sioux chiefs—including Sitting Bull, Rain-in-the-Face, Crazy Horse, and Kicking Bear—stand in the center [respectively numbered]. Kicking Bear omitted Gall, who was one of the leaders in the battle, from this central group because Gall had not remained hostile to Whites later in his life, as had

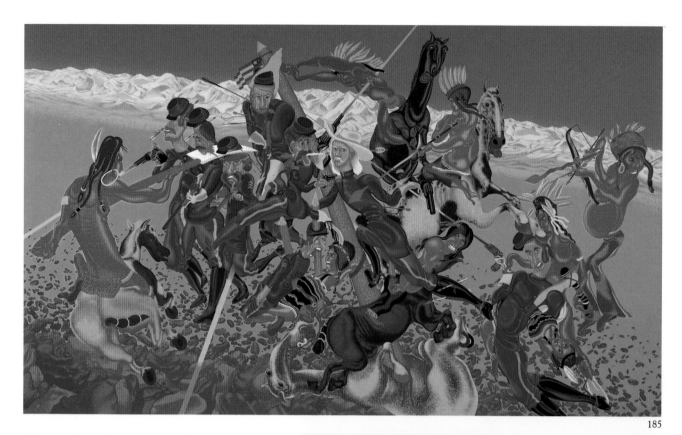

185

185. Peter Saul, *Custer's Last Stand.*
1972–73

186. Andy Warhol, *Russell Means, Chief
of the Sioux.* 1976

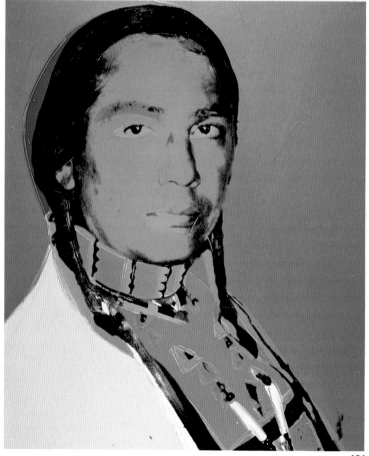

186

Kicking Bear. An empty space is left among the leaders where Gall should have been.

Custer, in buckskins and with long hair, is depicted below and to the left of the chiefs. Fallen Indians have been named. The triangles along the left margin are bursts of gunfire representing the last of the fighting. Uncolored figures are the spirits of the fallen. At the lower right women prepare to celebrate the victory in the camp.[3]

Significantly, the artist does not show the mutilation of the soldiers, but he pictures himself lifting a scalp from one of Custer's Indian scouts. The slain Custer is shown in his favorite buckskin costume and wearing his hair long (he was called "Long Hair" by the Indians).

Modern recognition of the unjust, stereotypical assessments of the Indian has produced a satirical imagery enhanced at times by a fresh artistic vocabulary. An example of this tendency is seen in the work of Peter Saul (b. 1926). Saul, Robert Colescott, Andy Warhol, and others, have cleverly taken familiar icons and exploded their meaning by mockingly readjusting these images. Saul's riotous, absurd pictures of bucking broncos attack the mythical-heroic figure of the American cowboy, making him a modern rodeo star.

Born in San Francisco, Saul studied at Stanford University, California School of Fine Arts, and finally at Washington University, where he earned a B.F.A. in 1956. His irreverent art has reflected a number of styles, and his tough rhetoric has resulted in an intentional abandonment of traditional notions of beauty and aesthetics. Saul constructs a frenetic, cartoon-land vision of cowboys and Indians.

Peter Saul's large-scale canvas, *Custer's Last Stand,* is a contemporary view of the Battle of the Little Big Horn (plate 185), and it is best explained by the artist in a letter:

> *Custer's Last Stand* was my first "western" picture. It came about because I was driving back to Mill Valley, Cal, after a visiting artist job somewhere in the midwest and stopped at Cody, Wyoming where they have this huge western museum. There was "Custer's Last Stand" (Paxton's [sic] ? I forget). It appealed to me, socially. A lot of people were looking at it + enjoying figuring out who was dead, who was dying + who shot who ('this Indian must have already scalped that guy because look, and so forth'). I've had a lot of trouble getting people involved with my pictures (art-types always find holes in the ground + laser beams more "thought provoking" than bullet holes—my bad luck), so I figured, quite wrongly, that this national fable would help me out, gather a crowd in N.Y.
>
> I got the likeness for "Custer" himself from seeing the movie "Little Big Man." The drawing style—those peculiar distortions + anatomical mistakes I got (to a certain extent, it's also in keeping with my overall work) from the Time-Life series on Cowboys + Indians. Eye witness drawings of people getting scalped etc. were made by non-artists making certain kinds of "mistakes" that help the picture to look authentic to me, so I just exaggerated those mistakes for my modern version.[4]

Asked whether the "violence and gore" in his work came from personal predilection or were intended as a comment about American society, Saul replied that both were true: "An actual bullet striking flesh inflicts terrible

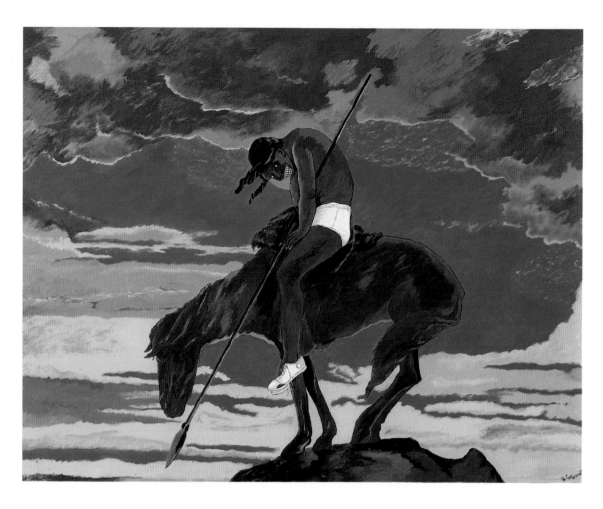

187. Robert Colescott, *End of the Trail.*
1976

pain; the painted version inflicts nothing but paint on canvas, and is therefore somewhat funny. I can't paint such a thing without bursting out laughing, and yet I'm completely serious. That jumble of thinking is the solution to the problem of depicting 'violence and gore.' It's funny, but it's not so funny. . . . It's the intellectual dignity of modern art that upsets me, excites me to paint as I do."[5]

In 1968, the American Indian Movement (AIM) was founded by Dennis Banks, George Mitchell, Clyde Bellecourt, and Russell Means. This group was responsible for the upsurge in militant political action. Worldwide publicity on the protest occupation of Alcatraz, in 1969, gained support for the movement. In 1973, AIM members and supporters occupied the Sioux Pine Ridge Reservation in South Dakota—site of the 1890 Wounded Knee massacre. The occupation was called off several months later, after the shooting of two Indians and a federal marshal. AIM leaders were indicted, but the case was dismissed on grounds of prosecution misconduct.

As a result of the seventy-one-day standoff during the Wounded Knee occupation in 1973, Russell Means, an Indian leader and chief of the Sioux, became one of the most famous Indians since Sitting Bull and Crazy Horse annihilated the 7th Cavalry detachment of General Custer in 1876. Spokesman for AIM and a champion of the rights of other minorities around the globe, Means is a hero to many and a dangerous subversive to others.

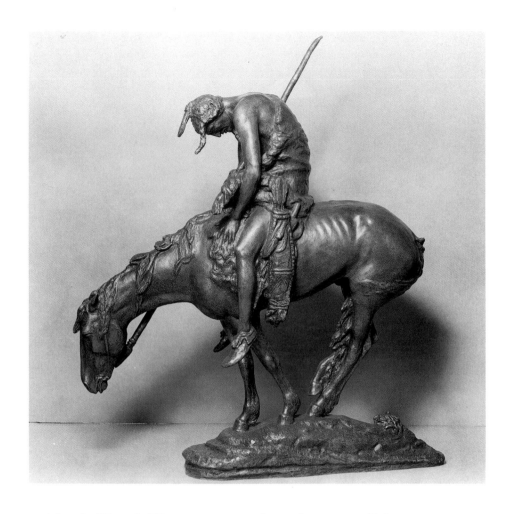

After the Wounded Knee occupation, the media converted Means into a Hollywood version of the resplendent Indian. Soon after, he also became one of the icons mass-produced by artist Andy Warhol (1928–1987; plate 186). A central figure in Pop Art and a counter-culture figure in the art of the 1970s and '80s, Warhol received national recognition with his multi-image paintings of celebrities made from documentary photogaphs, in which the subjects, like Means, are shown against flat, unarticulated backgrounds, highlighted with splashes of high-keyed colors. With a minimum of facial detail Warhol has accurately conveyed this stubbornly resolved, supremely dignified Sioux. Irving Couse and Joseph Sharp's idealized Indians with all the storytelling props, illuminated and somewhat depersonalized, seemingly transformed into matinee idols, are not too far from the stereotyped icons mass-produced by Warhol. And, like these earlier painters, Warhol avidly collected Indian artifacts.

In their reaction to the seriousness of Abstract Expressionism, Pop artists, such as Saul and Warhol, spared neither the Indian as subject matter nor the Indian mystique. Another artist who has adapted the idiom of Pop Art to Indian themes is Robert Colescott (b. 1925). After receiving both a B.F.A. and an M.F.A. from the University of California, Colescott studied with Fernand Léger in Paris, in 1949–50. Adapting the work of earlier American masters as points of departure for his parodies, he creates paintings that are intentionally wry and mocking.

End of the Trail by Colescott (plate 187) is a true reflection of the artist's irreverence, and its visual imagery is filled with wit and humor. Colescott's point of departure here is the familiar image of the noble, heroic warrior, who grudgingly but philosophically accepts his fate, in this case a sculpture by James Earle Fraser (1876–1953; see plate 188). In South Dakota the young Fraser had witnessed the futile and tragic territorial conflicts between the Indians and government soldiers. From his experience, Fraser developed a deep sympathy for native Americans. Fraser's *End of the Trail* expresses the Indian's absolute despair at the loss of his native land, although his tender, lyrical style blunts the literary content. It is a symbol of the total defeat of the Indian by the white man. Parodying Fraser, Colescott has garbed his forlorn Indian chief, whose skin and features are those of a black man, with incongruous tennis shoes and jockey shorts and has given him a malevolent, wide-mouthed grin. Yet, the visual effect is serious—the linkage of black Americans with native Americans, both of them subjugated by white America.

Another artist whose irreverent wit extends into his use of Indian motifs is Roy Lichtenstein (b. 1923). Lichtenstein studied under Reginald Marsh at the Art Students League in 1939. After two years at the School of Fine Arts at Ohio State University, he was drafted into the army; returning to the university in 1946, he earned both a B.F.A. and an M.F.A. Lichtenstein's work of the early 1950s included imagery of the nineteenth-century Far West, but from 1957 to 1960 he worked in an Abstract Expressionist style. By 1961 he had joined the Pop Art ranks along with Claes Oldenburg, James Rosenquist, and Andy Warhol.

A decade later, living in Southampton near the Shinnecock reservation, Lichtenstein painted a series of pictures of the American Indian, creating visual analogues of Indian motifs from different tribal cultures and geographic locations. Lichtenstein's motivation for the series may have been prompted by a reflection on the so-called romantic past of the preindustrial Indian in harmony with nature; or, like Colescott, he may have observed that Indian forms establish a historical base for American art, mindful of the relationship of primitive African art to Cubism in modern European art. Jack Cowart writes that these paintings of Indians "come out of the Surrealist background: there is still an anthropomorphic, imagined narrative, with a shrewd mix of differing scales of objects and reuse of eye and lip (eyes being also characteristic elements in Northwest Coast Indian art, and lips being a Pop fascination in works by Andy Warhol and Wesselmann as well as in de Kooning's Abstract Expressionist paintings)."[6]

Lichtenstein's large Indian paintings have been compared to prehistoric murals on the walls of kivas as well as to modern Indian and Hispanic murals. "Working within the conventions developed for his Surrealist works Lichtenstein overlaps forms," Cowart continues, "manipulates negatives to produce simultaneous conflicting readings, and injects a residue of humor into the high-colored paintings."[7] *Indian Composition* (plate 189) shows two standing Indian figures in profile, bisected by a center line, their forms comprised of the geometric design elements found on Southwest Indian pottery. Lichtenstein makes use of wood grain patterning and diagonal shading lines here as he does in his other works of this period. Like some of the earlier artists discussed in this book, he has combined artifacts from

more than one Indian culture: Plains Indian beadwork and painted hide containers (parfleches) with Southwest Indian painted pottery designs. Lichtenstein's paintings "are provocative on several levels, ranging from an appreciation of cultural qualities and the political minority issues of today's American Indian movement, to the debased Indian motifs in such stereotyped vehicles as cowboy-and-Indian movies and the tourist trading-post totem pole which . . . [the artist] had in his studio in the early 1960s."[8]

Several later twentieth-century artists responded with great intensity to the predicament of the native American, as did Robert Henri early in the century. Henri believed that each of his [Indian] subjects was imbued with "something of the dignity of life, the humor, the humanity, the kindness, something of the order" that would someday "rescue the race and the nation" (see pp. 228–29).[9] The true nature of America's native, recognized by Henri and a number of more avant-garde artists, is poignantly felt in a portrait of a Pomo Indian by Joseph Raffael (b. 1933). In Raffael's *Pomo* (plate 190), the strength of his feelings is expressed with "flicks and twists of color swirl[ing] across the drawn structure; a web of lines serves . . . to emphasize the anatomical features of the face."[10] The overpowering *Pomo* seems to mirror all of man's vicissitudes.

After attending Cooper Union School of Art and Architecture, Brooklyn-born Raffael studied under Josef Albers and James Brooks at Yale

189. Roy Lichtenstein, *Indian Composition.* 1979

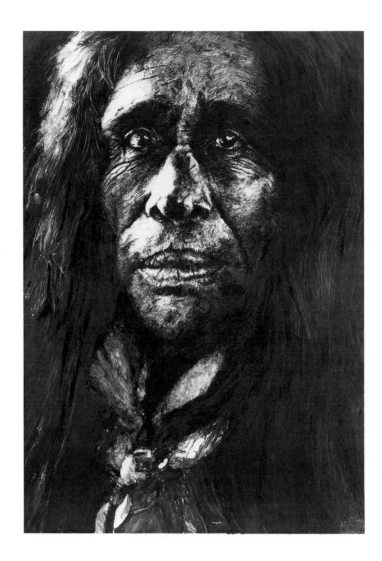

190. Joseph Raffael, *Pomo.* 1970

University, where he received a B.F.A. in 1956. After a year in Florence and Rome on a Fulbright fellowship, in 1958–59, Raffael worked in New York until 1966, taught at the University of California at Davis for several years, and then returned to the East. In 1968, he began to search for images that extended their meaning beyond the concerns of formal style, because he did not want his "work as an artist [to] become separate from his identity as a man." He looked for "objects which had heroic or noble qualities, which possessed 'a higher glow to them.'"[11] Inspired by the powerful visual material he found in books and magazine articles on the native American, Raffael began working on the first of a series of large Indian portraits. Moved by the aged yet ageless Indian faces he had seen, he wrote, "I saw a depth of feeling and experience, which moved me profoundly. My being resonated without shared brotherhood and human-hood. In their faces I saw my being. 'Pomo,' in particular, felt this way for me. That being's eyes and expression brought me to a greater sense of myself."[12] Working from black-and-white photographs, Raffael used his color with a painterly freedom that allowed him to identify more closely with his subject. His Indian images became the vehicle through which he was able to unify his art and his personal concerns.

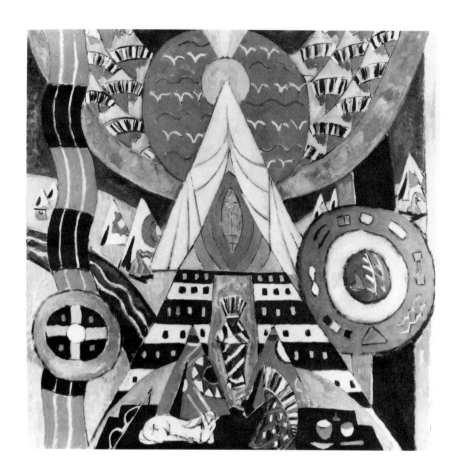

191. Marsden Hartley, *Indian Composition*. 1914

For Marsden Hartley (1877–1943), the American Indian offered the Euro-American a hope for salvation. In Berlin, just before the outbreak of World War One, Hartley had painted four large canvases on the theme of Franz Kafka's novel *Amerika*, inspired by American Indian culture. As the prospect of war increased, Hartley's excitement at being in Berlin waned, and nostalgic for his native land, he turned to American themes for his work. In America, Hartley had been exposed to collections of native American art at New York's Museum of Natural History, and his interest in American native culture was renewed in Europe with the popularity of Indian subject matter. Berlin's Ethnological Museum and the Trocadéro Museum in Paris had large holdings of Indian material, and as late as 1914 there had been Indian road shows touring Europe. In addition, Giorgio de Chirico and August Macke had incorporated American Indian motifs into their work, and in several still lifes of 1912 Hartley, too, introduced Indian artifacts. With the war impending, Hartley seems to have turned to Indian themes with the thought that "by painting symbols of what he perceived as a gentle race, he could affirm the idea of human nobility," believing that the Indian, "like other primitive people, held fast to a holistic, harmonious view of life that included rituals to nourish the spirit."[13] Several months after the war began, Hartley wrote to Alfred Stieglitz "that he wanted to be an Indian, that the true expression of human dignity would be to paint his face with the symbols of the race he adored, go to the West, and face the sun forever."[14]

Hartley's Indian paintings, such as *Indian Composition,* of 1914 (plate 191), are vivid in color, emblematic, and abundant in overlapping Indian motifs. In this one, he has combined tipis, beaded rosettes with crosses, beaded strips for decorating blankets and robes, a round silver ornament, baskets, and small Indian figures next to a horse with a cross on his flank. Cross-inscribed rondels that appear here as Indian beaded rosettes are seen later in his paintings as symbols suggesting a religious or transcendental meaning. Symbolic motifs that may be personal to the artist are the small Indians and the white horse in the foreground.

An artist profoundly affected by the Southwest, Georgia O'Keeffe (1887–1987) first discovered New Mexico in 1917 but did not return there until summer 1929, as a guest of the ebullient socialite and arts patron Mabel Dodge Luhan. O'Keeffe became reacquainted with New Mexico's space and endless horizons, and its bold desert colors stimulated new ideas for her work. From 1929, the artist spent summers in New Mexico and winters in New York with her husband, the photographer Alfred Stieglitz, until she settled permanently in Abiquiu in 1949.

After studying at the Art Institute of Chicago and then at the Art Students League, in 1907, under William Merritt Chase, she experimented for several years with different jobs, returning to New York, in 1914, to study under Arthur Wesley Dow at Columbia University's Teachers College. Dow's dictum, "to fill a space in a beautiful way," led to the development of her unique visual vocabulary.

Although O'Keeffe is known for her mystical interpretations of the New Mexican landscape, she also found inspiration in the region's native American cultures. She attended Pueblo dances and rituals and visited the sacred ruins at Puye and other prehistoric sites. Impressed with the ceremonial use of bones, feathers, and sacred peaks, she made these elemental, timeless forms part of her art.

Between 1931 and 1946, O'Keeffe painted seven pictures of Pueblo Indian kachina dolls. Her interest in the art and religious customs of the native American places her in the direct tradition of earlier artists, who documented Indian rituals or incorporated religious paraphernalia into their work. O'Keeffe, however, was especially drawn to the spiritual implications of Pueblo culture, and her depictions of the kachina dolls stand for the ritual itself. In a letter to Henry McBride from Alcalde, New Mexico, in July 1931, she wrote: "And then I wonder what painting is all about What will I do with those bones and sticks and stones—and the big pink sea shell that I got from an indian—it looks like a rose—and the small kachina—indian doll—with the funny flat feather on its head and its eyes popping out—it has a curious kind of live stillness.[15]

The Ho-te (Hopi) kachina doll O'Keeffe depicts in *Kachina* (plate 192) was once in her collection, a gift from her friend the photographer Paul Strand, and the doll may well have been the one she mentioned to McBride. Jan Garden Castro observes that "Strand's use of textural definition and unsentimental objectivity, recognized as a significant photographic innovation by Adams and by Stieglitz, can be compared to the immediacy and sharp, close focus that soon became O'Keeffe's signature."[16] O'Keeffe has emphasized the distinctive characteristics of the Ho-te kachina's yellow case mask with pop eyes, snout, stars, and bold feather

192. Georgia O'Keeffe, *Kachina.* 1931

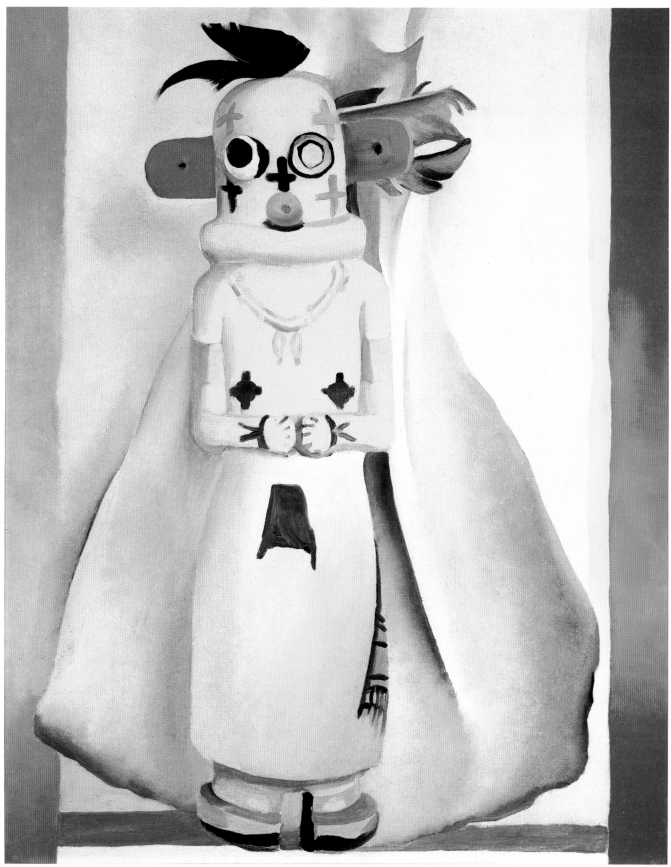

192

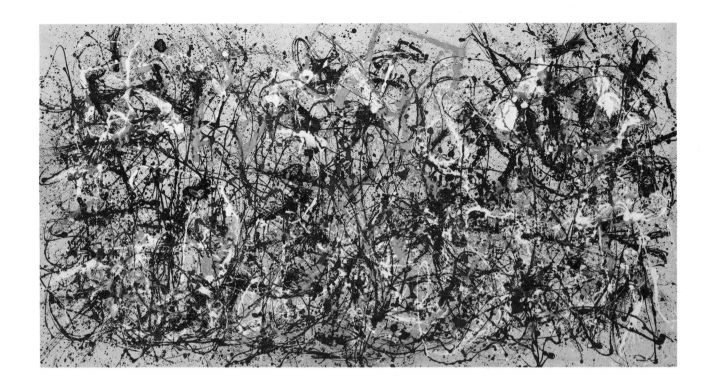

193. Jackson Pollock, *Autumn Rhythm.*
1950

headdress. Framing her composition on two sides with bands of vivid color, the artist has simplified and monumentalized the figure to increase its dynamism.

Another artist whose life and work were touched by a native American culture was Wyoming-born Jackson Pollock (1912–1956). By the time he was ten, Pollock and his family had lived in six different locations in three states, and more moves were to come. In 1923, the family moved to Arizona, where Jackson visited Indian ruins and observed the sand painting and ceremonial dances of the state's Navajo and Hopi tribes—an experience that left a deep impression on him and was imprinted on his work later.

Although he was recognized by a small number of other artists during the 1930s, Pollock's career did not flourish until the late 1940s. Questioned about his work in 1947, Pollock remarked: "My painting does not come from the easel. I hardly ever stretch my canvas before painting. I prefer to tack the unstretched canvas to the hard wall or floor. I need the resistance of a hard surface. On the floor I feel nearer, more a part of the painting, since this way I can walk around it, work from the four sides and literally be in the painting. This is akin to the method of the Indian sand painters of the West."[17] Pollock may well have felt like the Navajo patient who sits on the sand painting at the focal point of the curing ceremony. Pollock believed that he worked from the inside out, as nature does. This kinship is also stated by W. Jackson Rushing:

The Indian artist squeezes the colored sands tightly between thumb and forefinger and releases them in a controlled stream, resulting in a "drawn" painting. Pollock, too, achieved "amazing control" in a seemingly freewheeling process by using a basting syringe "like a giant fountain pen." The other

similarities between the sand painter's process and that used by Pollock are at once obvious. Just as the sand painter works strictly from memory, Pollock also worked without preliminary drawings characterizing his paintings as "more immediate—more direct."[18]

Like the Indian patient seeking a cure, Pollock struggled to rid himself of bouts of alcoholism and depression. Rushing adds that *Autumn Rhythm* (plate 193) may be interpreted as a ritual act in which "Pollock stands for the shaman who is his own patient. . . . The Navajo believe that contact with the numinous power of the image unifies the patient with nature by putting him in touch with mythic progenitors."[19]

An artist whose life has fully integrated art and the Indian is Paul Dyck (b. 1917). A descendant of the Flemish painter Sir Anthony van Dyck, Dyck's father was an early pioneer in western Canada, where the family lived among the Blackfeet Indians, near Calgary, for a number of years beginning in the late 1880s. The family's long tradition in art led to his early training under his uncle, Johann von Skramlik, a European portrait painter, and to further studies in Prague, Florence, Paris, and Rome.

Dyck has lived among the Cheyenne, Blackfeet, Crow, Oto, Pawnee, Kiowa, Comanche, Zuni, Navajo, Apache, and Hopi. As an initiate of the peyote ceremonial rites, he has observed and painted the Indian as a living entity rather than from an ethnological viewpoint. Like his idol George Catlin, he has devoted his life to the study of Plains Indians and to the preservation of their historical contribution to America. Catlin had a profound influence on Dyck's early years, inspiring him to continue the work Catlin began in the nineteenth century. A prominent authority on Plains Indian culture, Dyck has assembled a major collection of Indian ethnological material, housed on his ranch in the Verde Valley in Arizona, where he has lived as a rancher for more than fifty years.

Dyck's own art moves from realism to abstraction, reflecting the breadth of his artistic ability. In the semiabstract impressionistic representation *Dear Mr. Catlin, I Love You . . .* (plate 194), Catlin and Catlin-like figures emerge from the amorphous background. Dyck has condensed Catlin's history, background, and interests, casting them in a panorama that pays homage to "a unique life and unique man, George Catlin, American." Paul Dyck's letter "Dear Mr. Catlin," expresses his innermost feelings about his predecessor:

Was it that day so very long ago when the rustle of buckskins and the whisper of feathers made your heart dance with excitement or was it just the smoke smell of the faraway fires of the West still clinging to the ones gliding by? How was your day when your rendezvous with destiny beckoned to the West, to the Red People of your heart—that day of decision to devote your life to freedom, dignity, and beauty?

Remember the hustle of the early St. Louis town, the handshake of William Clark, the soft Spring breeze from the prairies of the West, the first visit with the People of your dreams. You did find color enough there to paint a rainbow, stopped like a deer, just for the sight of you alone. Yellow prairies, flowers white and blue, buffalo, elk, antelope against a sky so very new. Red sentinels watching you wander over the land. Red paint faces staring at you in wonderment. You, with your open heart, must have looked very strange to

194. Paul Dyck, *Dear Mr. Catlin, I Love You. . . .* 1964

the ones whose tomorrow was to end because of no room left for them in the souls bent on conquest of the land.

What did you think of the first regal robes and the lodges blending in the earth so sweet in your path so very long? You did find time to capture the marvels, only your eyes and heart could see so clear. The Sun and Spirit must have been with you, for you could see the life of the Forever Time, a time plowed under like the sod, with only an echo of the moccasins on the wind.

The land of the West was always a part of you; the same as the People who captured your heart. No journey in the world nor any effort too great for you; you sang to the Sun; you gave notice to the World—the Red Indian, his unmatchable world indeed did exist. Handshakes, praises, laurels, and hon-

ors must have soothed your aching soul; did the hate and laughter tear you apart?

Your dream world did change like the falling leaves, blowing away feather after feather, lodge after lodge. Faraway lands across the ocean could not replace the whisper of the prairies in your heart nor still the distant echoes of the drumbeat of freedom. Oh, just to fly again, Shining Mountains, where are you?

Your heart is there, I know, high over the mountains and the prairies, high over the lodges that warmed you in friendship so long ago—the treasures of beauty you gave to the world shall shine forever—

Dear Mr. Catlin, I love you. . . .[20]

Notes

Full information about the shortened references here may be found in the Select Bibliography.

INTRODUCTION

1. Savage, *Indian Life*, 6.

WOODLANDS

1. Hulton, *America 1585*, 3.
2. Engravings after White's watercolor drawings were published by Theodore de Bry in 1590, in part 1 of *America*, which includes Harriot's *Briefe and true report*; all subsequent comments by Harriot are from this source.
3. All information on the dugout canoe is from Stephen R. Claggett, Chief Archaeologist, Office of State Archaeology, State Historic Preservation Office, Raleigh, North Carolina; the authors are grateful for his expertise.
4. See Harriot's text to plate 12, "The manner of making their boates," in Theodore de Bry, *America*.
5. See Harriot's text to plate 13, "Their manner of Fishynge in Virginia."
6. Hulton and Quinn, *American Drawings of John White*, 1: 103; White's biography is from this source.
7. Rowe, "Ethnography and Ethnology," 5.
8. Feest, "Powhatan's Mantle," 133; all other information on the mantle is from this source.
9. Smith, *Generall Historie of Virginia*, 4: 122.
10. Nielsen, "Paintings and Politics," 91.
11. *Picture of the Baptism of Pocahontas*, 4.
12. Cosentino, *Paintings of Charles Bird King*, figs. 46 and 58.
13. This was the title recorded in the Royal Academy exhibition catalogue of 1772.
14. Quoted from a letter written in 1681 by Penn, "for his agents to read to the Indians in anticipation of his coming to Pennsylvania," in *Ambiguous Iroquois Empire*, ed. by Francis Jennings, 242.
15. West is quoted in *Paintings of Benjamin West* by Von Erffa and Staley, 207.
16. Ibid.
17. Abrams, *Valiant Hero*, 72.
18. Southerland, ed., *William Penn*, 155ff. A transaction that took place between Penn and the Delaware Indians on July 15, 1682, describes the kind of trade item used in negotiations for land purchases. This type of agreement may have symbolized a mythical peace treaty, as did the wampum belt. Alternatively, the real document for the treaty may be lost.
19. Jennings, *Ambiguous Iroquois Empire*, 245.
20. Weslager, *The Delaware Indians*, 167.
21. Von Erffa and Staley, *The Paintings of Benjamin West*, 207.
22. According to John Filson, Boone related his story to him first; for the account, see Filson's *The Discovery, Settlement and Present State of Kentucke: . . . To Which is Added . . . /The Adventures of Col. Daniel Boone . . .* (Wilmington, Del., 1784). The Boone story was subsequently elaborated in literature and in art.
23. In 1851, Bodmer and Millet collaborated on an assignment Bodmer received from an American publisher to provide illustrations for stories of "early pioneer life in America and the perils of Indian attacks." Bodmer composed the landscape while Millet drew the figures. Learning of the Frenchman's involvement, the American publisher angrily withdrew from the contract. Although the project was never completed, a few of the drawings were published later as lithographs in the *Annals of the United States Illustrated— The Pioneers* (see William J. Orr, "Karl Bodmer: The Artist's Life," in *Karl Bodmer's America*, 370).
24. Information courtesy of Herbert C. Houze, Curator, Winchester Arms Museum, Buffalo Bill Historical Center, Cody, Wyoming.
25. Glanz, *How the West Was Drawn*, 69.
26. Ibid., 68.
27. Among the best-known collections of these biographical works were Samuel G. Drake's *Indian Biography Containing the Lives of More Than Two Hundred Indian Chiefs . . .* (1832), B. B. Thatcher's *Indian Biography: Or, An Historical Account of Those Individuals Who Have Been Distinguished Among the North American Natives as Orators, Warriors, Statesmen and Other Remarkable Characters*, and McKenney and Hall's *History of the Indian Tribes of North America, with Biographical Sketches and Anecdotes of the Principal Chiefs* (1849–54). Among the individual biographies, William L. Stone contributed three, on the lives of Joseph Brant (1838), Red Jacket (1841), and Uncas and Miamtonomi (1842). Benjamin Drake, in turn, immortalized Black Hawk (1839) and Tecumseh (1841). And, in 1855, Black Hawk's autobiography was published.
28. Rev. John Breckenridge, "Red Jacket," in McKenney and Hall, *History of the Indian Tribes of North America*, 1: 124.
29. Quoted in Dunlap, *Rise and Progress of the Arts of Design*, vol. 2, pt. 2; 395–96.
30. Bryant, "Weir As Illustrator," 2.
31. Nunes, "Red Jacket," 7.
32. Albert G. Overton changes the date of Bartoli's portrait of Cornplanter to 1786, based on information in government records in the National Archives, Washington, D.C. These records pertain to Cornplanter's trip to New York to speak before the United States Congress, in April 1786; they also list the gifts that Cornplanter received from General Richard Butler, who accompanied the chief and his men to Philadelphia and New York that year. Two of these gifts—the two silver armbands and the silver medal—are depicted in the Bartoli portrait. According to Overton, a lithograph made in about 1788 and reproduced in McKenney and Hall's *The Indian Tribes . . .* seems to be based on the portrait. Overton believes that the 1796 date assigned to this portrait was probably inscribed later by the owner of the picture. Overton's comments were obtained from the registrar's files, New-York Historical Society, September 4, 1979, photocopy.
33. Donaldson quoted in Truettner, *The Natural Man Observed*, 143.
34. Information courtesy of Edward Maeder, Curator, Textiles and Costumes, Los Angeles County Museum of Art.
35. Jarvis's biographer, H. E. Dickson, was shown this portrait attributed to Jarvis by Mrs. Lanier, the registrar of M. Knoedler & Company, New York City, who asked him to comment on it. In a letter to Mrs. Lanier, of December 29, 1948, Dickson states that "if this could be established as of 1833 it would be the very last Jarvis painting to which a date can now be affixed. Jarvis was still in full production in 1833, overwhelmed with commissions at Savannah in the early spring, and then presumably returned to New York. I don't know the details concerning Black Hawk's eastern sojourn but presume that Jarvis may well have sought him out as a celebrity of the day. Jarvis did know Gen. E. P. Gaines who had been sent to oppose Blackhawk; he painted Gaines and there is a letter written to him by Gaines in Cincinnati in 1828." Although Dickson had requested pertinent data from Lanier on the portrait and presumably received it, no mention of the work appears in his biography of the artist.

 Professor William Gerdts, City University of New York, December 17, 1986, remarked to the authors that it is difficult to determine the authorship of this portrait because of the absence of Jarvis's late work.
36. Published on March 11, 1865, 242.
37. Costume information courtesy of Edward Maeder (see note 34).
38. Coen, *The Indian as the Noble Savage*, 65.
39. Information courtesy of Herman J. Viola, Director, Quincentenary Programs, National Museum of Natural History, Smithsonian Institution, Washington, D.C.
40. Quoted in McDermott, "Another Coriolanus," 98.
41. Hodge, *Handbook of American Indians*, 142ff.
42. Kane, *Wanderings of an Artist*, 59.
43. Ourada, *The Menominee Indians*, 82.
44. Ibid.
45. Ely, "Art and Artists of Milwaukee," 72.
46. Section two of the constitution of the State Historical Society of Wisconsin states that "the objects of the Society shall be to preserve

the . . . history of the Indian tribes [in Wisconsin]"; quoted in *Wisconsin Historical Collections,* 1855–56, 2: xxxvi.

47. Lanman, *Summer in the Wilderness,* 59.
48. Mary H. Eastman, *Dahcotah,* illustrated by Seth Eastman, xiv.
49. *Bureau of American Ethnology* 30, 378.
50. Mary Eastman quoted in McDermott, *Seth Eastman,* 56.
51. Brush, "An Artist Among the Indians," 55.
52. Brush quoted in Bowditch, *George de Forest Brush,* 23–24.
53. Paul Kane, "Wanderings of an Artist . . ." in Harper, *Paul Kane's Frontier,* 62.
54. In 1845, Joshua Clark recorded an account of the founding of the Iroquois Confederacy from two Onondaga leaders, published four years later as *Onondaga; or reminiscences of Earlier and Later Times; Being a Series of Historical Sketches Relative to Onondaga; with notes on the Several Towns in the Country, and Oswego.* Clark, however, confused Hiawatha (hayehwatha?) with the culture hero Tharonhiawagon (thaehyawa'?ki). Two years earlier, in 1847, Henry Rowe Schoolcraft published this Onondaga version in his *Notes on the Iroquois* without acknowledging Clark as his source. Then, Schoolcraft repeated the error in his six-volume work, *Historical and Statistical Information Respecting the History, Condition and Prospects of the Indian Tribes of the United States* (1851–57). Longfellow, in turn, consulted Schoolcraft, in 1854, as the poet looked for material for a poem modeled after the Finnish epic *Kalevala.* Perhaps because of the immediate success of Longfellow's poem, Schoolcraft published *The Myth of Hiawatha, and Other Oral Legends, Mythologic and Allegoric, of the North American Indians* (1856). The first selection in this volume was "Hiawatha; or Nanabozho," giving authority to Longfellow's error.
55. Longfellow, *Song of Hiawatha,* 45.
56. William Brandon in Josephy, ed., *Heritage Book of Indians,* 249.
57. Tuckerman, *Book of the Artists,* 470–71.

SUBARCTIC

1. Costume information courtesy of Edward Maeder, Curator, Textiles and Costumes, Los Angeles County Museum of Art.
2. See Nute, "New Discoveries," 34.
3. Cooper, *Homer Watercolors,* 200.

GREAT PLAINS

1. Thwaites, ed., *Journals of the Lewis and Clark Expedition,* 1: 270.
2. Jackson, ed., *Letters of the Lewis and Clark Expedition,* 539.
3. See Ewers et al., *Vanishing Frontier,* 67, fig. 48.

4. Ginger Renner to Trenton, November 11, 1985.
5. Ewers, *Artists of the Old West,* 232.
6. Reuben G. Thwaites, ed., "S. H. Long's Expedition," in *Early Western Travels, 1748–1846* . . . (Cleveland: Arthur H. Clark, 1905), 14: 9.
7. James, comp., *Account of an Expedition,* 1: 135.
8. Perhaps members of the Long party differed in their interpretations of the dance, some calling it a dog dance and others a war dance.
9. Quoted in Unrau, *Kansa Indians,* 45–46.
10. Edwin James, comp., *Account of an Expedition from Pittsburgh to the Rocky Mountains . . .* (Barrie, Mass.: Imprint Society 1972), 75–76.
11. In 1851, Frederick Scott Archer of London invented a photographic process that employed a glass plate coated with a binding material called collodion, a solution of guncotton in alcohol and ether. To this solution ammonium bromide and ammonium iodide were added. This mixture was then coated on a glass plate and allowed to stand until it set to a jellylike consistency. In a dark area, the plate was immersed in a bath of silver nitrate, which caused the sensitive silver iodobromide to form in the pores of the collodion. While wet, the glass plate was transferred to a light-tight holder and then to the camera where exposure had to be made at once. Because the plate had to be developed and exposed before it became dry, the process was applicable mainly to studio work; however, energetic and ambitious photographers built portable darkrooms on wagons or in tents to make use of this cumbersome equipment. The technique is referred to as the wet-collodion process.

 The wet-plate process, although used into the twentieth century for certain types of photography, was inconvenient for most photography, and particularly for candid shots. It was replaced by the dry-plate process in the 1880s, and the plates were manufactured commercially in England, Germany, Belgium, and the United States. Within a few years, it supplanted the wet collodion plates.
12. Biographical information on the artist comes from Ellen Miles's paper, "Saint-Mémin, Valdenuit, Lemet," 1–28; Miles's information is based on Philippe Guignard's biography of the artist, *Notice Historique sur la Vie et les Travaux de M. Févret de Saint-Mémin* (Dijon, France, 1853).
13. Miles, "Saint-Mémin," 6–8.
14. According to E. McSherry Fowble, Curator of Graphics and Paintings, Winterthur Museum, the first owner of this watercolor was Sir Augustus John Foster.
15. Jackson, ed., *Letters of the Lewis and Clark Expedition,* 2: 411, n. 1.
16. Viola, *Indian Legacy of Charles Bird King,* 13.
17. One of King's biographers believes that the artist's sources of inspiration for his composition were Van Dyck's triple portrait of *Charles*

I and Hogarth's study of his servants (see Cosentino, *Paintings of Charles Bird King,* 63). King was certainly acquainted with the old masters through his art education and European travels, and in his own gallery were prints and numerous plaster casts, such as life-size busts of Washington, Adams, and Hamilton, anatomical figures, and full-length figures of Pluto, Cerberus, and the Apollo Belvedere (Cosentino and Glassie, *The Capitol Image,* 40).
18. See Cosentino, *Paintings of Charles Bird King,* 65, fig. 48.
19. Quoted in Cosentino, 66.
20. See Catlin, *Letters and Notes,* 1: opp. 148, fig. 65.
21. The robe is discussed by Judy Thompson, *The North American Indian Collection: A Catalogue* (Berne, Switzerland: Historical Museum, 1977), 152, fig. 78; and by Ewers, *Plains Indian Painting,* 30.
22. Catlin, *Letters and Notes,* 1: 145–46.
23. Ibid., 1: 3.
24. Ibid., 1: 157.
25. Ibid., 1: 164ff.
26. Col. David D. Mitchell quoted in Schoolcraft, *Historical and Statistical Information,* 253–54.
27. Roehm, *Letters of George Catlin,* 344–45.
28. Catlin, *Letters and Notes,* 1: 54.
29. Information on the Assiniboin is from the *Bureau of American Ethnology Bulletin* 30, 103.
30. Catlin, *Letters and Notes,* 1: 56.
31. Ibid., 2: 194–200.
32. Ibid., 2: 196.
33. Ibid., 2: 196–97.
34. Denig is quoted in DeSmet, *Western Missions and Missionaries,* 117–18. Denig related his version of the warrior's story in a letter to Father Pierre DeSmet, who in turn incorporated the information in his "letters" to religious colleagues in Brussels, Belgium.
35. Maximilian, *Travels in the Interior of North America,* 22: 318, 321.
36. John Ewers believes that "the name of this young woman implies a kinship with the Crow tribe"; and that "since the Teton and the Crow were bitter enemies, it may be that she was taken as a captive in a raid, or was the daughter of a captive, raised as a Sioux" (see Ewers, "An Appreciation of Karl Bodmer's Pictures of Indians," in *Views of a Vanishing Frontier,* 87).
37. *Catalogue of the Free Exhibition of Indian Photographs Taken by Walter McClintock* (Los Angeles: Southwest Museum, n.d.), no. 33, "Woman Tanning a Green Hide." For information on women and industry, see McClintock, *Old Indian Trails,* 167.
38. Maximilian, *Travels in the Interior of North America,* 23: 160.
39. See Ewers, *Plains Indian Painting,* 16.
40. See Tyler, ed., *Alfred Jacob Miller,* 117 A and 120 A.

41. Miller quoted in Ross, ed., *The West of Alfred Jacob Miller*, opp. 85.
42. See Alfred Jacob Miller "Notebook" and Macgill James File, Bernard DeVoto Papers, Stanford University Research Library, Palo Alto.
43. Rathbone, *Charles Wimar*, 17.
44. Seven prints from Wimar's ambrotypes remain today in the City Art Museum of St. Louis. Wimar's extant letters, deposited in the Missouri Historical Society, Saint Louis, reveal the artist's difficulties in photographing the Indians. Many of Wimar's sketches and drawings from his travels are held in the collections of the City Art Museum and the Missouri Historical Society.
45. Dr. Lincoln B. Spiess, who has translated most of Wimar's letters into English, finds no evidence to document the artist's observation of a Mandan buffalo dance; information courtesy of Ms. Goering, Curator, Missouri Historical Society.
46. Quoted in Ms. Goering's letter to the authors, January 19, 1986. The same article was reprinted in English by W. T. Helmuth in *Arts in St. Louis* (Saint Louis, 1864), 41ff.
47. Biographical information on Stanley is from Schimmel, "John Mix Stanley."
48. Schoolcraft is quoted in McDermott, *Seth Eastman*, 83.
49. Ibid., 81.
50. The painting is in the collection of the United States Capitol Building, Architect of the Capitol, Washington, D.C.
51. Eastman, *American Aboriginal Portfolio*, 83–84.
52. Brackenridge, 219.
53. Information provided by Herbert G. Houze, Curator, Winchester Arms Museum, Buffalo Bill Historical Center, Cody, Wyoming. "Kentucky" was a popular term, adopted in the mid-1850s, perhaps because of Daniel Boone's prowess with long rifles.
54. Bingham quoted in Bloch, *George Caleb Bingham*, 75.
55. Department of the Interior, Census Office, *Report on Indians Taxed and Indians Not Taxed in the United States at the Eleventh Census: 1890*, 52d Cong., 1st sess., Mis. Doc. no. 340, pt. 15 (Washington, D.C.: Government Printing Office, 1894).
56. Ibid., 57.
57. The eyewitness account was written originally in Teton Dakota dialect by George Sword, an Oglala Sioux Indian, formerly captain of the Indian police at Pine Ridge agency and translated by an Indian for Miss Emma C. Sickels. A copy of the original Sioux manuscript is in the archives of the Bureau of Ethnology (see Mooney, *Ghost-Dance Religion*, 798). Gaul's actors follow rather closely this lengthy description of the dance.
58. Wildman, "Frederic Remington," 715–16.
59. Remington to his wife, Missie [Eva], November 18, 1908, Taft Papers, Kansas State Historical Society, Topeka.
60. Quoted in Hassrick, *Remington*, 34.
61. Ibid.

NORTHWEST COAST

1. Josephy, ed., *Heritage Book of Indians*, 279.
2. Cook, "Voyage of the Resolution," 319.
3. The hat, however, is not described in the Society of Antiquaries of Scotland Accessions List for 1781, according to Dale Idiens, Keeper, History and Applied Art Department, Royal Museum of Scotland, Edinburgh.
4. Webber to Canon Douglas, December 31, 1783, quoted in Cook, "Voyage of the Resolution," 319–20.
5. Kane, *Artist Among the Indians*, 1.
6. Ibid., 208.
7. Ibid., 217.
8. George F. MacDonald, *Haida Monumental Art . . .* (Vancouver: University of British Columbia Press, 1983), 62.
9. Shadbolt, *Emily Carr*, 30.
10. Ibid., 192.
11. Ibid., Carr quoted by Shadbolt.
12. Krause, *Tlingit Indians*, 85–87, 106–7.

CALIFORNIA

1. Choris quoted in Dinnean, "Choris"; 4–6.
2. Choris quoted in *San Francisco One Hundred Years Ago*, transl. by Porter Garnett (San Francisco: A. M. Robertson, 1913), 2–3.
3. Information courtesy of Professor Emeritus Norman Neuerburg, specialist in Spanish mission architecture.
4. The watercolor sketch of the two dancers is also in the Honeyman Collection, Bancroft Library.
5. Extract from Kotzebue's report translated in Mahr, *Visit of the "Rurik,"* 61.
6. Translation from the French by Porter Garnett in *San Francisco One Hundred Years Ago*, 9–10; see n. 2.
7. Ibid., 8–9.
8. Von Humboldt quoted in Trenton and Hassrick, *Rocky Mountains*, 16.
9. This account was published in London by Henry Colburn, in two volumes, in 1813 and 1814.
10. Von Langsdorff in *Voyages and Travels*, 2: 190–94. Other statements by the artist-naturalist come from the same source.
11. Ibid., 194.
12. Ibid., 92.
13. Ibid., 195.
14. Quoted in Bernstein, "Alfred Kroeber," 4.
15. Mary Jane Aerni to authors, August 30, 1986.
16. John Garzoli Collection.
17. Barrett, "Pomo Indian Basketry," 135.
18. Ethnographic information from David Wayne Peri, Professor of Anthropology, Sonoma State University, California.
19. Peri, "Games of Staves," 5–6. See also Barrett, "Material Aspects of Pomo Culture," 343–46.
20. Raschen quoted in the *Morning Call (San Francisco)*, January 21, 1894.
21. Ibid.
22. Baird, *Hudson*.
23. Searles R. Boynton, *The Painter Lady: Grace Carpenter Hudson* (Eureka: Interface California Corp., 1978), 39–40.
24. Some of these photographs can be found in the Sun House, a repository for the artist's papers at Ukiah, California.
25. Boynton to Trenton, March 2, 1984. According to a native Pomoan, *Ka-ma* means "near the water," while the alternate title for the painting, *Found in the Brush*, is identified as a metaphor: "Father is unknown." Whether or not these sayings relate to biblical references, such as Moses in the bulrushes, is unclear. Grace Hudson's purpose in adopting this metaphor also is a mystery. In fact, we are told that many of Hudson's titles have a tendency to lean toward the bizarre when translated. We wish to express our gratitude to Suzanne Abel-Vidor, former curator of the Sun House, Ukiah, California, who related this information to us.
26. Bierstadt quoted in Trenton and Hassrick, 122.
27. Photograph and ethnographic information courtesy of Craig D. Bates, Curator of Ethnography, United States Department of the Interior, National Park Service, Yosemite National Park, California. Bates believes that this is the missing Vance view no. 62, "View of Indian Commissioners—Dr. Wozencrast, Col. Johnson—Indian Agent and Clerks in Treaty with the Indians."
28. Heizer, *Eighteen Unratified Treaties;* brought to our attention by Craig Bates.
29. Stevens, *Nahl*, 136.

SOUTHWEST

1. See Barba, *Möllhausen*.
2. A. W. Whipple Journals, April 15, 1853–March 22, 1854, (Oklahoma Historical Society). Information courtesy of Dr. Robert Nespor, Archivist.
3. Möllhausen, *Diary of a Journey*, 2: 10–12.
4. U.S. Army Corps of Engineers, *Report upon the Colorado River*, 66.
5. Photographs of the Victorian era traditionally portrayed whites clothed. Conversely, Indians were photographed in costume or seminude, a nudity that was deemed allowable for white titillation.
6. Diaries of John Gregory Bourke, Manuscript Division, United States Military Academy, West Point, N.Y. Information courtesy of Marie T. Capps, Map and Manuscript Librarian. For mention of Moran, see Bourke,

Snake-Dance of the Moquis of Arizona, 5. For a biographical sketch of the artist, see Philadelphia *Public Ledger* (obituary), November 11, 1914.

7. *El Palacio* 13, 67.
8. Sharp, "An Artist Among the Indians," 7.
9. Quoted in Fenn, *Beat of the Drum,* 115.
10. See Fenn, *J. H. Sharp,* 318. Crucita's daughters Matilda Hadley and Nettie (Natividad) Lujan confirm that their mother stopped modeling when she married Jim Lucero in 1924.
11. *Victor Higgins, 1884–1949,* retrospective exhibition catalogue, Museum of New Mexico, Fine Arts Museum, 1971.
12. *Victor Higgins: An Indiana-Born Artist Working in Taos, New Mexico,* exhibition catalogue, Art Gallery of the University of Notre Dame and Indianapolis Museum of Art, 1975, 12.
13. Bickerstaff, *Pioneer Artists of Taos,* 8–9.
14. Berninghaus to Dr. Carey B. Elliott, January 14, 1945. Courtesy of Forrest Fenn, Fenn Galleries, Ltd., Archives; and Berninghaus to R. L. Jameson, Fort Worth, March 5, 1940, Archives of American Art, Smithsonian Institution, Shuler-Berninghaus Collection, roll SW1, frame 314.
15. Cook, "Blumenschein," 20.
16. Ernest L. Blumenschein, "The Story of Painting Moon, Morning Star and Evening Star," Archives of American Art, Smithsonian Institution, roll 269, frame 159. All other quotations from Blumenschein on the dance are from this source.
17. Trenton and Houlihan, *Native Faces,* 63.
18. Ufer quoted in "Art in the Southwest," *El Palacio* 24, 403.
19. Ibid., 404.
20. Walter Ufer to Mrs. Alexander P. Gest, March 8, 1920, Ufer Collection, Rosenstock Arts, Denver, Colorado; courtesy of Stephen L. Good.
21. For further information on the early Penitente ritual, see Weigle, *Penitentes* and *Brothers of Light, Brothers of Blood.*
22. Sharp, "Pueblo Indian Dance," 982.
23. Lange, *Cochiti,* 385.
24. H. R. Poorer quoted in *Report on Indians Taxed and Indians Not Taxed in the United States* (Washington, D.C.: United States Department of the Interior, Census Bureau, 1894), 437.
25. Sloan, "Indian Dance," 17.
26. Sloan, *Gist of Art,* 260.
27. Ibid., 270.
28. Information from Henri's Record Book of 1914, courtesy of Janet J. LeClair, New York.
29. See *El Palacio* 5, 204.
30. Rollins's letter is reproduced in *El Palacio* 7, 94–95.
31. Several of the altars illustrated in Stevenson's "The Zuni Indians: Their Mythology, Esoteric Fraternities and Ceremonies," 3–634, reveal a number of elements Rollins incorporated into his painting. Since Coxe's field research was published in 1904, Rollins could easily have referred to it. A set of Bureau of American Ethnology reports remains today in the Couse archives, suggesting that other artists whose subject matter was the American Indian also used these volumes.
32. See DuBois, *W. R. Leigh.*
33. Leigh, "My Life."
34. Leigh's photograph *Pool of Water on Acoma Rock, New Mexico* is deposited in the Photography Files of William R. Leigh, Gilcrease Institute of American History and Art, Tulsa, Oklahoma. We are grateful to curator of art Anne Morand, who brought the photograph to our attention.
35. Biographical details of Couse's travels provided by Virginia Couse Leavitt, Tucson, Arizona.
36. Quoted from Couse's interview with DeWitt Lockman in 1927, "a trip to Hopi in 1903," courtesy of Virginia Couse Leavitt.
37. Joe Mora quoted in Stewart, Dockstader, and Wright, *The Year of the Hopi,* 72.
38. Virginia Couse Leavitt, to Trenton, December 18, 1985. There is some disagreement on the location depicted in Couse's painting. Scholar Barton Wright believes that it represents the dance plaza of Mishongnovi, and Emory Sekaquaptewa, a Hopi on the museum staff of the University of Arizona, Tucson, does not recognize it as any pueblo in particular.

GREAT BASIN

1. Steward, "Basin-Plateau Aboriginal Sociopolitical Groups," 134.
2. Hodge, *Handbook of American Indians,* 496–97.
3. Simpson, *Report of Explorations,* 7.
4. Ibid., 52–53.
5. Taft, *Artists and Illustrators,* 268.

PLATEAU

1. Josephy, *Patriot Chiefs,* 260.
2. Virginia Couse to her sister Fanny, L122: 9, December 24, 1889, courtesy of Virginia Couse Leavitt, Tucson, Arizona. We appreciate all the Couse information that Virginia Couse Leavitt has generously shared with us.
3. Cawelti, "The Frontier and the Native American," 146.
4. Bancroft, *Works of Hubert Howe Bancroft,* 29: 663.
5. Quoted in Gray, *History of Oregon,* 498.
6. Ethnologist John Ewers states that "the shield looks very much like the one deposited in the United States National Museum, which was illustrated by Colonel Richard Irving Dodge in *Our Wild Indians* and described as a 'Comanche War Shield.'" We thank him for his assistance in identifying the shield and describing the saddle in Couse's painting.
7. Cline, *Peter Skene Ogden,* 192.
8. Published by Metropolitan Press, Portland, Oregon, 1951.

CHANGING VIEWS

1. E. S. Godfrey, Capt. 7th Cavalry, Brevet Major U.S. Army, is quoted in William Edgar Paxson, Jr., *E. S. Paxson,* 45. W. E. Paxson adds, "The soldier who helped Edgar most to get a clear idea of the battle was Gen. E. S. Godfrey. He had been first lieutenant of 'K' Troop in Captain Benteen's contingent of the 7th Cavalry at the Little Bighorn" (ibid., 44). In spite of the quality of it and its historical significance, it did not find a permanent location until 1963, when the family sold it to the Whitney Gallery of Western Art at the Buffalo Bill Historical Center in Cody, Wyoming, for $50,000.
2. All information on Kicking Bear and his pictograph is from the Southwest Museum archives.
3. Quoted information from the Southwest Museum archives.
4. Saul to Trenton, November 1985.
5. Saul in "Saul on Saul," *Peter Saul* (Dekalb: Northern Illinois University, 1980), 7–8.
6. Jack Cowart, *Lichtenstein,* 127–28.
7. Ibid., 128.
8. Ibid.
9. Quoted in Trenton, *Picturesque Images,* 113.
10. Garver, *Joseph Raffael,* 17.
11. Ibid.
12. Raffael made his statement on the portrait to Trenton in 1981.
13. Udall, *Modernist Painting in New Mexico,* 44.
14. Hartley quoted in Barbara Haskell, *Marsden Hartley,* 42.
15. Punctuation and spelling are O'Keeffe's. *Georgia O'Keeffe: Art and Letters,* with essays by Jack Cowart, Juan Hamilton, Sarah Greenough (Washington, D.C.: National Gallery of Art, 1987), 203.
16. Castro, *O'Keeffe,* 158.
17. Pollock quoted by Rushing in "Ritual and Myth," 291.
18. Ibid.
19. Ibid.
20. Printed by the Tucson Arts Festival, Tucson, Arizona, 1970.

List of Illustrations

Select Bibliography

BOOKS

Abrams, Ann Uhry. *The Valiant Hero: Benjamin West and Grand-Style History Painting*. Washington, D.C.: Smithsonian Institution Press, 1985.

Adair, John. *The Navajo and Pueblo Silversmiths*. Norman: University of Oklahoma Press, 1944.

Alloway, Lawrence. *Roy Lichtenstein*. New York: Abbeville Press, 1983.

The American Frontier from the Atlantic to the Pacific. . . . Vol. 2. From Lewis and Clark through the Mexican War. Newton, Mass.: The Rendells, Inc., 1981.

Baird, Joseph Armstrong, Jr. *Grace Carpenter Hudson (1865–1937)*. Exhibition catalogue. San Francisco: California Historical Society, 1962.

Bancroft, Hubert Howe. *The Works of Hubert Howe Bancroft*. Vol. 29. *History of Oregon*. San Francisco: History Company Publishers, 1886.

Barba, Preston Albert. *Balduin Möllhausen: The German Cooper*. Philadelphia: University of Pennsylvania, 1914.

Beaglehole, J. C. *The Life of Captain James Cook*. Palo Alto: Stanford University Press, 1974.

Berkhofer, Robert F., Jr. *The White Man's Indian: Images of the American Indian from Columbus to the Present*. New York: Alfred A. Knopf, 1978.

Bickerstaff, Laura M. *Pioneer Artists of Taos*. Denver: Sage Books, 1955.

Bloch, E. Maurice. *George Caleb Bingham: The Evolution of an Artist*. Berkeley and Los Angeles: University of California Press, 1967.

Bourke, John G. *The Snake-Dance of the Moquis of Arizona: Being a Narrative of a Journey from Santa Fe, New Mexico, to the Villages of the Moqui Indians of Arizona*. 1884. Reprint: Tucson: University of Arizona Press, 1984.

Bowditch, Nancy Douglas. *George de Forest Brush: Recollections of a Joyous Painter*. Peterborough, N.H.: Noone House, 1970.

Boynton, Searles R. *The Painter Lady: Grace Carpenter Hudson*. Eureka, Calif.: Interface California Corp., 1978.

Brackenridge, H. M. *Views of Louisiana together with a Journal of a Voyage up the Missouri in 1811*. Pittsburgh: Cramer, Spear, and Eichbaum, 1814.

Breckenridge, John. "Red Jacket." In vol. 1, *History of the Indian Tribes of North America, with Biographical Sketches and Anecdotes of the Principal Chiefs*, by Thomas L. McKenney and James Hall. Philadelphia: D. Rice and A. N. Hart, 1849–54.

Bryant, William Cullen, II. "Robert Weir As Illustrator." In *Robert W. Weir of West Point: Illustrator, Teacher and Poet*. Exhibition catalogue by Michael E. Moss. West Point, N.Y.: United States Military Academy, 1976.

Burbank, E.A., and Ernest Royce. *Burbank Among the Indians*. Caldwell, Idaho: The Caxton Printers, 1944.

Castro, Jan Garden. *The Art and Life of Georgia O'Keeffe*. New York: Crown Publishers, 1985.

Catlin, George. *Letters and Notes on the Manners, Customs, and Conditions of North American Indians*. 2 vols. New York: Dover Publications, 1973.

———. *O-kee-pa, A Religious Ceremony and Other Customs of the Mandans*. Edited by John C. Ewers. New Haven: Yale University Press, 1967.

Cawelti, John G. "The Frontier and the Native American." In *America as Art*, by Joshua C. Taylor. Washington, D.C.: National Collection of Fine Arts, Smithsonian Institution Press, 1976.

Choris, Louis. *Voyage pittoresque autour du Monde. . . .* Paris: Firmin Didot, 1822.

Clark, Joshua. *Onondaga; or, Remembrances of Earlier and Later Times; Being a Series of Historical Sketches Relative to Onondaga; With Notes on the Several Towns in the Country and Oswego*. 2 vols. Syracuse, N.Y.: Stoddard and Babcock, 1849.

Cline, Gloria Griffen. *Peter Skene Ogden and the Hudson Bay Company*. Norman: University of Oklahoma Press, 1974.

Coen, Rena Neumann. *The Indian as the Noble Savage in Nineteenth Century American Art*. Ann Arbor: UMI Research Press, 1978.

Cook, Captain James. "The Voyage of the Resolution and Discovery, 1776–1780." In *The Journals of Captain James Cook on His Voyages of Discovery*, edited by J. C. Beaglehole. Cambridge: University Press and the Hakluyt Society, 1967.

Cooper, Helen A. *Winslow Homer Watercolors*. New Haven and London: National Gallery of Art, Washington, D.C., and Yale University Press, 1986.

Cosentino, Andrew J. *The Paintings of Charles Bird King, 1785–1862*. Washington, D.C.: National Collection of Fine Arts, Smithsonian Institution Press, 1977.

———, Andrew J., and Henry H. Glassie. *The Capitol Image: Painters in Washington, 1800–1915*. Washington, D.C.: Smithsonian Institution Press, 1983.

Cowart, Jack. *Roy Lichtenstein: 1970–1980*. Saint Louis: Saint Louis Art Museum, 1981.

Cummins, D. Duane. *William Robinson Leigh, Western Artist*. Norman and Tulsa: University of Oklahoma Press and Thomas Gilcrease Institute of American History and Art, 1980.

Densmore, Frances. *The Collection of Water-Color Drawings of the North American Indian by Seth Eastman in the James Jerome Hill Reference Library, Saint Paul*. Saint Paul: James Jerome Hill Reference Library, 1954.

Department of the Interior, Census Office. *Report on Indians Taxed and Indians Not Taxed in the United States at the Eleventh Census: 1890*. 52d Cong., 1st sess., mis. doc. no. 340., pt. 15. Washington, D.C.: Government Printing Office, 1894.

DeSmet, P. J. *Western Missions and Missionaries: A Series of Letters by Rev. P. J. DeSmet*. New York: P. J. Kenedy [copyright, 1859].

Dockstader, Frederick J. *Great North American Indians: Profiles in Life and Leadership*. New York: Van Nostrand Reinhold, 1977.

Dodge, Richard Irving. *Our Wild Indians: Thirty-Three Years' Personal Experience among the Red Men of the Great West*. Hartford: A.D. Worthington, 1890.

Drucker, Philip. *Cultures of the North Pacific Coast*. San Francisco: Chandler Publishing Co., 1965.

———. *Indians of the Northwest Coast*. New York: American Museum of Natural History, 1955.

Dubois, June. *W. R. Leigh: The Definitive Biography*. Kansas City: Lowell Press, 1977.

Dunlap, William. *History of the Rise and Progress of the Arts of Design in the United States*. Vol. 2, pt. 2. 1834. Reprint: New York: Dover Publications, Inc., 1969.

Eastman, Mary H. *The American Aboriginal Portfolio*. Philadelphia: Lippincott, Grambo, 1853.

———. *Dahcotah; or, Life and Legends of the Sioux around Fort Snelling*. New York: Wiley, 1849.

Ely, Lydia. "Art and Artists of Milwaukee." In *History of Milwaukee County*, edited by H. L. Conrad. Chicago: 1898.

Ewers, John C. *Artists of the Old West*. Garden City, N.Y.: Doubleday, 1973.

———. "Fact and Fiction in the Documentary Art of the American West." In *The Frontier Reexamined*, edited by John Francis McDermott. Chicago: University of Illinois Press, 1967.

———. *Indian Life on the Upper Missouri*. Norman: University of Oklahoma Press, 1968.

———. *Plains Indian Painting: A Description of an Aboriginal American Art*. Palo Alto: Stanford University Press, 1939.

———, Marsha V. Gallagher, and David C. Hunt. *Views of a Vanishing Frontier*. Omaha: Center for Western Studies, Joslyn Art Museum, 1984.

Feest, C. F. "Powhatan's Mantle." In *Tradescant's Rarities . . .* , edited by Arthur MacGregor. Oxford: Clarendon Press, 1983.

Fenn, Forrest. *J. H. Sharp: The Beat of the Drum and the Whoop of the Dance*. Santa Fe: Fenn Publishing, 1983.

Fleming, Paula Richardson, and Judith Luskey. *The North American Indians in Early Photographs*. New York: Harper and Row, 1986.

Galt, John. *Life, Studies, and Works of Benjamin*

West, Esq. London: T. Cadell and W. Davies, 1820.

Garver, Thomas H. *Joseph Raffael: The California Years, 1969–1978.* San Francisco: San Francisco Museum of Modern Art, 1978.

Gidley, M. *A Documentary Narrative of Chief Joseph's Last Years.* Seattle: University of Washington Press, 1981.

Glanz, Dawn. *How the West was Drawn: American Art and the Settling of the Frontier.* 2d ed. Ann Arbor: UMI Research Press, 1982.

Goetzmann, William H. *Karl Bodmer's America.* Lincoln: University of Nebraska Press, 1984.

Gray, W. H. *A History of Oregon, 1792–1849, Drawn from Personal Observation and Authentic Information.* San Francisco: H. H. Bancroft, 1870.

Hail, Barbara A. *Hau, Kóla!: The Plains Indian Collection of the Haffenreffer Museum of Anthropology.* Providence, R.I.: The Haffenreffer Museum of Anthropology, 1980.

Harper, J. Russell. *Paul Kane's Frontier.* Austin: University of Texas Press, the Amon Carter Museum, and the National Gallery of Canada, 1971.

Harriot, Thomas. *A briefe and true report of the new found land of Virginia.* Frankfurt, Germany: Wechel, 1590.

Haskell, Barbara. *Marsden Hartley.* New York and London: Whitney Museum of American Art and New York University Press, 1980.

Hassrick, Peter. *Frederic Remington. . . .* New York and Fort Worth: Harry N. Abrams, Inc., and the Amon Carter Museum of Western Art, 1973.

Heizer, Robert F. *The Eighteen Unratified Treaties of 1851–1852 between the California Indians and the United States Government.* Berkeley: Archaeological Research Facility, Department of Anthropology, University of California, 1972.

Hills, Patricia. *The Genre Painting of Eastman Johnson. . . .* New York and London: Garland Publishing Co., 1977.

Hodge, Frederick Webb. *Handbook of American Indians, North of Mexico. Bureau of American Ethnology. Bulletin 30.* Washington, D.C.: Government Printing Office, 1910.

Hofstadter, Richard, and Seymour Martin Lipset, eds. *Turner and the Sociology of the Frontier.* New York and London: Basic Books, 1968.

Holm, Bill. *Northwest Coast Indian Art.* Seattle: University of Washington Press, 1965.

Hulton, Paul, and David Beers Quinn. *The American Drawings of John White, 1577–1590. . . .* Vol. 1. London and Chapel Hill: Trustees of the British Museum and the University of North Carolina Press, 1964.

Hulton, Paul. *America 1585: The Complete Drawings, John White.* Chapel Hill: University of North Carolina, 1984.

Jackson, Donald D., ed. *Letters of the Lewis and Clark Expedition with Related Documents, 1783–1854.* Vol. 2. 2d ed. Urbana: University of Illinois Press, 1978.

————, ed. *Black Hawk (Ma-ka-tai-me-she-kia-kiak) An Autobiography.* Urbana: University of Illinois Press, 1955.

James, Edwin, comp. *Account of an Expedition from Pittsburgh to the Rocky Mountains, Performed in the Years 1819 and '20, by Order of the Hon. J. C. Calhoun, Sec'y of War: Under the Command of Major Stephen H. Long. . . .* 3 vols. London: Longman, Hurst, Rees, Orme & Brown, 1823.

Jennings, Francis, ed. *The History and Culture of Iroquois Diplomacy: An Interdisciplinary Guide to the Treaties of the Six Nations and Their League.* New York: Syracuse University Press, 1985.

————. *The Ambiguous Iroquois Empire. . . .* New York: W. W. Norton, 1984.

Johnston, Patricia Condon. *Eastman Johnson's Lake Superior Indians.* Afton, Minn.: Johnston Publishing, 1983.

Josephy, Alvin M., Jr., ed. *The American Heritage Book of Indians.* Narrative by William Brandon. New York: Bonanza Books, 1961.

————. *The Artist was a Young Man: the Life Story of Peter Rindisbacher.* Fort Worth: Amon Carter Museum of Western Art, 1970.

————. *The Patriot Chiefs: A Chronicle of American Indian Leadership.* New York: Viking Press, 1961.

Kane, Paul. *Wanderings of an Artist Among the Indians of North America. . . .* London: Longman, Brown, Green, Longmans, and Roberts, 1859.

Kinietz, W. Vernon. *John Mix Stanley and His Indian Paintings.* Ann Arbor: University of Michigan Press, 1942.

Krause, Aurel. *Die Tlinkit Indianer.* Jena: H. Costenoble, 1885. English translation: *The Tlingit Indians.* Seattle: University of Washington Press, 1956.

Lange, Charles. *Cochiti: A New Mexico Pueblo Past and Present.* Austin: University of Texas Press, 1959.

Langsdorff, Georg Heinrich. *Langsdorff's Narrative of the Rezanov Voyage to Nueva California in 1806. An English Translation Revised and Corrected, with Notes, etc., by Thomas C. Russell.* San Francisco: Private Press of Thos. C. Russell, 1926.

————. *Bemerkungen auf einer Reise um die Welt in den Jahren 1803 bis 1807 von G. H. Langsdorff.* 2 vols. Frankfurt-am-Main: Friedrich Wilmans, 1812.

————. *Voyages and Travels in Various Parts of the World, During the Years 1803, 1804, 1805, 1806, and 1807.* 2 vols. London: H. Colburn, 1813–14.

Lanman, Charles. *A Summer in the Wilderness.* New York: D. Appleton, 1847.

Leitch, Barbara A. *A Concise Dictionary of Indian Tribes of North America.* Algonac, Mich.: Reference Publications, 1979.

Lindsay, Kenneth C. *The Works of John Vanderlyn.* Binghamton: University Art Gallery, State University of New York, 1970.

Longfellow, Henry Wadsworth. *The Song of Hiawatha.* Boston and New York: Houghton Mifflin, 1890.

Lowie, Robert H. *The Crow Indians.* New York: Holt, Rinehart, Winston, 1956.

McClintock, Walter. *Old Indian Trails.* Boston and New York: Houghton Mifflin, 1923.

McDermott, John Francis. *Seth Eastman: Pictorial Historian of the Indian.* Norman: University of Oklahoma Press, 1961.

McKenney, Thomas L., and James Hall. *History of the Indian Tribes of North America, with Biographical Sketches and Anecdotes of the Principal Chiefs.* 3 vols. Philadelphia: D. Rice and A. N. Hart, 1849–54.

Mahr, August C. *The Visit of the "Rurik" to San Francisco in 1816.* Palo Alto: Stanford University Press, 1932.

Malone, Henry Thompson. *Cherokees of the Old South: A People in Transition.* Athens: University of Georgia Press, 1956.

Meyers, Albert Cook, ed. *William Penn's Own Account of the Lenni Lenape or Delaware Indians.* Somerset, N.J.: Middle Atlantic Press, 1970.

Miles, Ellen. "Saint-Mémin, Valdenuit, Lemet: Federal Profiles." In *American Portrait Prints: Proceedings of the Tenth Annual American Print Conferences,* edited by Wendy Wick Reaves. Charlottesville: University Press of Virginia and the National Portrait Gallery, Smithsonian Institution, 1984.

Miller, David Humphreys. *Custer's Fall: The Indian Side of the Story.* New York: Duell, Sloan, and Pearce, 1957.

Mitchell, Lucy M. *A History of Ancient Sculpture.* Vol. 2. New York: Dodd, Mead and Co., 1888.

Möllhausen, Balduin. *Diary of a Journey from the Mississippi to the Coasts of the Pacific with a United States Government Expedition.* Vol. 2. London: Longman, Brown, Green, Longmans & Roberts, 1858.

Mooney, James. *The Ghost-Dance Religion and Wounded Knee.* New York: Dover Publications, 1973.

Morgan, Joan B. *George de Forest Brush (1855–1941), Master of the American Renaissance.* New York: Berry-Hill Galleries, 1985.

Ortiz, Alfonso. *The Tewa World: Space, Time, Being and Becoming in a Pueblo Society.* Chicago: University of Chicago Press, 1969.

————. *New Perspectives on the Pueblos.* Albuquerque: University of New Mexico Press, 1972.

Ourada, Patricia K. *The Menominee Indians: A History.* Norman: University of Oklahoma Press, 1979.

Paxson, William Edgar, Jr. *E. S. Paxson: Frontier Artist.* Boulder, Colo.: Pruett Publishing, 1984.

Pearce, Roy Harvey. *Savagism and Civilization: A Study of the Indian and the American Mind.* Revised edition. Baltimore: The Johns Hopkins Press, 1967.

Pennsylvania University Museum. *The Noble Savage: The American Indian in Art.* Philadelphia: University of Pennsylvania Publications, 1958.

The Picture of the Baptism of Pocahontas, Painted by Order of Congress. . . . Washington, D.C.: Peter Force, 1840.

Prucha, Francis Paul. *The Great Father: The United States Government and the American Indians.* 2 vols. Lincoln: University of Nebraska Press, 1984.

Rathbone, Perry. *Charles Wimar, 1828–1862: Painter of the Indian Frontier.* St. Louis: City Art Museum, 1946.

———, ed. *Westward the Way.* Saint Louis: City Art Museum, 1954.

Ray, Verne F. *Cultural Relations in the Plateau of Northwestern America.* Los Angeles: Southwest Museum, 1939.

Renner, Frederic G. *Charles M. Russell: Paintings, Drawings, and Sculpture in the Amon Carter Museum.* New York: Harry N. Abrams, Inc., and the Amon Carter Museum of Western Art, 1974.

Ritzenthaler, Robert E., and Frederick A. Peterson. *The Mexican Kickapoo Indians.* Milwaukee: Milwaukee Public Museum, 1956.

Roehm, Marjorie Catlin. *The Letters of George Catlin and His Family: A Chronicle of the American West.* Berkeley: University of California Press, 1966.

Rosenblum, Robert. *Andy Warhol: Portrait of the Seventies.* Edited by David Whitney. New York: Whitney Museum of American Art, 1979.

Ross, Marvin, ed. *The West of Alfred Jacob Miller (1837): From Notes and Water Colors in the Walters Art Gallery. . . .* Norman: University of Oklahoma Press, 1951.

Rushing, W. Jackson. "Ritual and Myth: Native American Culture and Abstract Expressionism." In *The Spiritual in Art: Abstract Painting, 1890–1985*, by Maurice Tuchman et al. New York: Los Angeles County Museum of Art and Abbeville Press, 1986.

Ruby, Robert H., and John A. Brown. *A Guide to the Indian Tribes of the Pacific Northwest.* Norman: University of Oklahoma Press, 1986.

———. *Negia Eells and the Puget Sound Indians.* Seattle: Superior Publishing, 1976.

Russell, Carl P. *Firearms, Traps, and Tools of the Mountain Men.* New York: Alfred A. Knopf, 1967.

Sanders, Gordon E. *Oscar E. Berninghaus, Taos, New Mexico: Master Painter of American Indians and the Frontier West.* New Mexico: Taos Heritage Publishing, 1985.

Satz, Ronald N. *Tennessee's Indian Peoples: From White Contact to Removal, 1540–1840.*

Knoxville: University of Tennessee Press, 1979.

Saul, Peter. "Saul on Saul." In *Peter Saul,* edited by Dennis Adrian. DeKalb: Northern Illinois University Press, 1980.

Savage, William W., Jr., ed. *Indian Life Transforming an American Myth.* Norman: University of Oklahoma Press, 1977.

Schoolcraft, Henry R. *Historical and Statistical Information Respecting the History, Condition, and Prospects of the Indian Tribes of the United States.* 6 vols. Philadelphia: Lippincott, Grambo, 1851–57.

———. *The Myth of Hiawatha, and Other Oral Legends, Mythologic and Allegoric of the North American Indians.* Philadelphia: J. B. Lippincott, 1856.

———. *Notes on the Iroquois; or Contributions to the Statistics, Aboriginal History, Antiquities and General Ethnology of Western New York.* Albany, N.Y.: Erastus H. Pease, 1847.

———. *Personal Memoirs of a Residence of Thirty Years with the Indian Tribes on the American Frontiers: With Brief Notices of Passing Events, Facts and Opinions, A.D. 1812 to A.D. 1842.* Philadelphia: Lippincott, Grambo, 1851.

Schwartz, Seymour I., and Ralph E. Ehrenberg. *The Mapping of America.* New York: Harry N. Abrams, Inc., 1980.

Shadbolt, Doris. *The Art of Emily Carr.* Seattle: University of Washington Press, 1979.

Simpson, James H. *Report of Explorations Across the Great Basin of the Territory of Utah for a direct Wagon-Route from Camp Floyd to Genoa, in Carson Valley, in 1859. . . .* Washington, D.C.: United States Government Printing Office, 1876.

Sloan, John. *Gist of Art.* New York: American Artists Group, 1939.

Smith, John. *The Generall Historie of Virginia, New-England, and the Summer Isles. . . .* Vol. 4. London: printed by J. Dawson and J. Haviland for Michael Sparks, 1624.

Southerland, Jean R., ed. *William Penn and the Founding of Pennsylvania, 1680–1684.* Philadelphia: University of Pennsylvania Press, 1983.

Spier, Leslie. *Yuman Tribes of the Gila River.* Chicago: University of Chicago Press, 1933.

———. *Cultural Relations of the Gila River and Lower Colorado Tribes.* New Haven: Yale University Publications in Anthropology 3, 1936.

Stevens, Moreland L. *Charles Christian Nahl: Artist of the Gold Rush, 1818–1878.* Sacramento: E. B. Crocker Art Gallery, 1976.

Stewart, Tyrone, Frederick Dockstader, and Barton Wright. *The Year of the Hopi: Paintings and Photographs by Joseph Mora, 1904–6.* Washington, D.C.: Smithsonian Institution, 1979.

Stone, William L. *Life of Joseph Brant-Thayendanegea: Including the Border Wars of the American Revolution and Sketches of the*

Indian Campaigns of Generals Harmer, St. Clair and Wayne; and Other Matters Connected with the Indian Relations of the United States and Great Britain from the Peace of 1783 to the Indian Peace of 1795. 2 vols. New York: A. V. Blake, G. Dearborn, 1836.

———. *The Life and Times of Red Jacket or Sago-ye-wat-ha; Being the Sequel to the History of the Six Nations.* New York and London: Wiley and Putnam, 1841.

———. *Unicas and Miantonamoh.* New York: Dayton and Newman, 1842.

Strong, Eugenia Sellers. *Roman Sculpture from Augustus to Constantine.* New York: Charles Scribner's Sons, 1907.

Sturdevant, William C., gen. ed. *Handbook of North American Indians. California.* Vol. 8. Washington, D.C.: Smithsonian Institution, 1978.

———. *Handbook of North American Indians. Northeast.* Vol. 15. Washington, D.C.: Smithsonian Institution, 1978.

———. *Handbook of North American Indians. Southwest.* Vols. 9 and 10. Washington, D.C.: Smithsonian Institution, 1979 and 1983.

———. *Handbook of North American Indians. Subarctic.* Vol. 6. Washington, D.C.: Smithsonian Institution, 1981.

Surtees, Robert J. *Canadian Indian Policy.* Bloomington: Indiana University Press, 1982.

Taft, Robert. *Artists and Illustrators of the Old West, 1850–1900.* New York: Charles Scribner's Sons, 1953.

Thatcher, B. B. *Indian Biography: Or an Historical Account of Those Individuals Who Have Been Distinguished among the North American Native as Orators, Warriors, Statesmen and Other Remarkable Characters.* New York: J. & J. Harper, 1832.

Thomas, Davis, and Karin Ronnefeldt, eds. *People of the First Man.* New York: E. P. Dutton, 1976.

Thompson, Judy. *The North American Indian Collection: A Catalogue.* Palo Alto and London: Stanford University Press and Oxford University Press, 1939.

Thwaites, Reuben Gold, ed. *Original Journals of the Lewis and Clark Expedition, 1804–1806.* Vols. 1–7 and atlas. New York: Dodd, Mead, 1904.

Trenton, Patricia. *Picturesque Images from Taos and Santa Fe.* Denver: Denver Art Museum, 1974.

———, and Patrick T. Houlihan. *Native Faces: Indian Cultures in American Art. . . .* Los Angeles: LAACO Incoporated and the Southwest Museum, 1984.

———, and Peter Hassrick. *The Rocky Mountains: A Vision for Artists in the Nineteenth Century.* Norman: University of Oklahoma Press, 1983.

Truettner, William H. *The Natural Man Ob-*

served: A Study of Catlin's Indian Gallery. Washington, D.C.: Amon Carter Museum of Western Art, Fort Worth, and the National Collection of Fine Arts, Smithsonian Institution, 1979.

Tuckerman, Henry T. *Book of the Artists.* . . . 1867. Reprint. New York: James F. Carr, 1966.

Tyler, Ron, ed. *Alfred Jacob Miller: Artist on the Oregon Trail.* Fort Worth: Amon Carter Museum, 1982.

Udall, Sharyn Rohlfsen. *Modernist Painting in New Mexico, 1913–1935.* Albuquerque: University of New Mexico Press, 1984.

Unrau, William E. *The Kansa Indians.* . . . Norman: University of Oklahoma Press, 1971.

U.S. Army Corps of Topographical Engineers. *Report Upon the Colorado River of the West Explored in 1857 and 1858 by Lt. Joseph C. Ives.* 36th Cong., 1st sess., S. Ex. Doc. 90 (Serial 1058). Washington, D.C.: Government Printing Office, 1861.

Vaughan, Thomas. *Captain Cook, R.N.: Resolute Mariner.* Portland: Oregon Historical Society, 1974.

Victor Higgins, 1884–1949. Santa Fe: Museum of New Mexico, Fine Arts Museum, Retrospective exhibition catalogue, 1971.

Victor Higgins: An Indiana-born Artist Working in Taos, New Mexico. Exhibition catalogue, Art Gallery of the University of Notre Dame and the Indianapolis Museum of Art, 1975.

Viola, Herman J. *Diplomats in Buckskins: A History of Indian Delegations in Washington City.* Washington, D.C.: Smithsonian Institution Press, 1981.

————. *The Indian Legacy of Charles Bird King.* New York and Washington: Doubleday Press and Smithsonian Institution Press Publication, 1976.

Von Erffa, Helmut, and Allen Staley. *The Paintings of Benjamin West.* New Haven and London: Yale University Press, 1983.

Walker, James R. *Lakota Belief and Ritual.* Lincoln: University of Nebraska, 1980.

Weigle, Marta. *Brothers of Light, Brothers of Blood: The Penitentes of the Southwest.* Albuquerque: University of New Mexico Press, 1976.

————. *The Penitentes of the Southwest.* Santa Fe: Ancient City Press, 1970.

Weir, Irene. *Robert W. Weir, Artist.* New York: House of Field-Doubleday, 1947.

Weslager, Clinton A. *The Delaware Indians: A History.* New Brunswick, N.J.: Rutgers University Press, 1972.

Wied-Neuwied, Maximilian Alexander Philip, Prinz von. *Travels in the Interior of North America. Early Western Travels, 1748–1846.* Vol. 22. Edited by Reuben Gold Thwaites. Cleveland, Ohio: Arthur H. Clark, 1905.

UNPUBLISHED MATERIAL

Berninghaus, Oscar. Papers. Archives of American Art, Smithsonian Institution, Washington, D.C., Shuler-Berninghaus Collection. Microfilm roll SW1, frame 314.

Bernstein, Bruce. "Alfred Kroeber and the Study of Pomoan Basketry." Paper presented at the fifth annual meeting of the Native American Art Studies Association at Ann Arbor, Michigan, October 1985. Photocopy.

Blumenschein, Ernest. Papers. Archives of American Art, Smithsonian Institution, Washington, D.C. Microfilm roll 269, frame 159.

Bourke, John Gregory. Diaries (1881). Manuscript Division, United States Military Academy, West Point, New York.

Couse, Eanger Irving. Papers and photographs. Couse Family Archives, Tucson, Arizona.

Grant, John, Jr. "An Analysis of the Paintings and Drawings by Eastman Johnson at the St. Louis County Historical Society." Master's thesis, Graduate School of the University of Minnesota, 1960.

Griffin, Warren. "A Circle of Light." Unpublished biography of Warren Rollins, 1974. New Mexico State Records Center and Archives, Santa Fe.

Leigh, William. "My Life." 2 vols. Unpublished autobiography, n.d., Leigh Collection, Gilcrease Institute of American History and Art, Tulsa, Oklahoma.

Miller, Alfred Jacob. "Notebook" and Macgill James File, Bernard DeVoto Papers, Stanford University Research Library, Palo Alto, California.

Neilson, Reka. "Charles F. Wimar." Master's thesis, Washington University, Saint Louis, 1943.

Raschen, Henry. Biographical information. State Library, Sacramento, California.

Santa Fe Railroad Archives. "The Art Collection of the Santa Fe [Railroad]." Prepared by Santa Fe Advertising Department, Chicago, June 5, 1985. Photocopy.

————. "Titles of Santa Fe Calendar Pictures." List prepared by Santa Fe Railroad, Chicago.

Schimmel, Julie. "John Mix Stanley and Imagery of the West in Nineteenth-Century American Art." Ph.D. diss., Institute of Fine Arts, New York University, 1983.

Taft, Robert. Papers. Kansas State Historical Society, Topeka.

Ufer, Walter. Papers. Ufer Collection, Rosenstock Arts, Denver, Colorado.

Whipple, A. W. Journals (April 15, 1853–March 22, 1854). Manuscript Collection, Oklahoma Historical Society, Oklahoma City.

PERIODICALS

Barrett, S. A. "Material Aspects of Pomo Culture." *Bulletin, Public Museum, Milwaukee* 20, pt. 2 (August 1952): 343–46.

————. "Pomo Indian Basketry." *University of California Publication in American Archaeology and Ethnology* 7, no. 3 (1908): 133–309.

Benisovich, Michael. "Peter Rindisbacher, Swiss Artist." *Minnesota History* 32 (September 1951): 155–62.

Brush, George de Forest. "An Artist Among the Indians." *Century Magazine* 8 (May 1885): 54–57.

Bushnell, David I. "John Mix Stanley, Artist-Explorer." *Annual Report of the Smithsonian Institution for the Year Ending June 30, 1924* (1925): 507–12.

————. "Sketches by Paul Kane in the Indian Country, 1845–1848." *Smithsonian Miscellaneous Collections* 99, no. 1 (January 9, 1940): 1–25.

————. "Villages of the Algonquian, Siouan, and Caddoan Tribes West of the Mississippi." *Smithsonian Institution, Bureau of American Ethnology, Bulletin* 77 (1922): 1–211.

Coen, Rena. "David's Sabine Women in the Wild West." *Great Plains Quarterly* 2, no. 2 (Spring 1982): 67–76.

Cook, Howard. "Ernest L. Blumenschein." *New Mexico Quarterly Review* (Spring 1949): 20.

Dinnean, Lawrence. "Ludovik Andrevitch Choris: Artist and Naturalist." *Bancroftiana* (August 1985), no. 89: 4–6.

Edgerton, Samuel Y., Jr. "The Murder of Jane McCrea: The Tragedy of an American *Tableau d'Histoire.*" *Art Bulletin* 57, no. 4 (December 1965): 481–92.

El Palacio 5, no. 12 (October 12, 1918): 204.

———— 7, no. 4 (July 15, 1919): 94–95.

———— 13 (September 1, 1922): 67.

———— 24 (May 19–26, 1928): 403–4.

Ewers, John C. "Charles Bird King, Painter of Indian Visitors to the Nation's Capital." *Annual Report of the Board of Regents of the Smithsonian Institution Publication* 4149 . . . *for the Year ending June 30, 1953* (1954): 463–73.

Goodrich, Lloyd. "The Painting of American History." *American Quarterly* 3 (1951): 283–94.

Hodge, Frederick W. "Handbook of American Indians North of Mexico." *Smithsonian Institution Bureau of American Ethnology Bulletin* 30 (1910): 496–97.

The Kennedy Quarterly 16, no. 2 (June 1978): 92.

Lockwood, Luke Vincent. "The St. Memin Indian Portraits." *The New-York Historical Society Quarterly.* Bulletin 12, no. 1 (1928): 3–26.

McDermott, John Francis. "Another Coriolanus: Portraits of Keokuk, Chief of the Sac and Fox." *Antiques* 54, no. 2 (August 1948): 98–99.

———. "Peter Rindisbacher, Frontier Reporter." *Art Quarterly* 12, no. 1 (Spring 1949): 129–44.

Mitchell, Charles. "Benjamin West's Death of Wolfe." *Journal of the Warburg and Courtauld Institutes* 7 (1944): 21–23.

Nielsen, George R. "Paintings and Politics in Jacksonian America." *Capitol Studies, U.S. Capitol Historical Society* 1, no. 1 (Spring 1972): 87–92.

Nunes, Jadviga de Costa. "Red Jacket: The Man and His Portraits." *The American Art Journal* 12, no. 3 (Summer 1980): 4–20.

Nute, Grace Lee. "New Discoveries." *Beaver* (December 1945): 34.

———. "Peter Rindisbacher, Artist." *Minnesota History* 14 (September 1933): 283–87.

———. "Rindisbacher's Minnesota Water Colors." *Minnesota History* 20 (March 1939): 54–57.

Pearce, Roy H. "The Significance of the Captivity Narrative." *American Literature* 19 (1978): 1–20.

Peri, David Wayne. "The Game of Staves." *News from Native California* 1, no. 3 (July/August 1987): 5–6.

Pritchard, Kathleen Moss. "John Vanderlyn and the Death of Jane McCrea." *Art Quarterly* 12 (1969): 361–65.

Rowe, John Howland. "Ethnography and Ethnology in the Sixteenth Century." *The Kroeber Anthropological Society Papers* no. 30 (1964): 1–19.

Sharp, Joseph. "An Artist Among the Indians." *Brush and Pencil* 4 (April 1899): 7.

———. "The Pueblo Indian Dance." *Harper's Weekly* (October 14, 1893): 982.

Skinner, Alanson. "A Sketch of Eastern Dakota Ethnology." *American Anthropologist* n.s. 21, no. 2 (1919): 164–74.

Sloan, John. "The Indian Dance from an Artist's Point of View." *Arts and Decoration* 20 (January 1924): 17, 56.

Stevenson, Matilda Coxe. "The Zuni Indians: Their Mythology, Esoteric Fraternities and Ceremonies." *23rd Annual Report of the Bureau of American Ethnology for the Years 1901–1902* (1904): 3–634.

Steward, Julian H. "Basin-Plateau Aboriginal Sociopolitical Groups." *Smithsonian Institution Bureau of American Ethnology.* Bulletin 120 (1938): 1–346.

Thompson, J. R. Fawcett. "Thayendanegea, the Mohawk and His Several Portraits." *The Connoisseur* 170, no. 683 (January 1969): 49–54.

Walch, Peter S. "Charles Rollin and Early Neoclassicism." *Art Bulletin* 19, no. 2 (June 1967): 123–210.

Wildman, Edwin. "Frederic Remington, the Man." *Outing* 41 (March 1903): 715–16.

Wind, Edgar. "The Revolution of History Painting." *Journal of the Warburg and Courtauld Institutes* 2 (1938): 116–27.

Wollon, Dorothy, and Mary Kinard. "Sir Augustus F. Foster and 'The Wild Natives of the Woods,' 1805–07." *William and Mary Quarterly* 3d series, 9 (1952): 191–214.

Acknowledgments

The idea for this publication had its origins in 1984, when the authors were organizing an exhibition of paintings of Indian subjects from the Los Angeles Athletic Club's Collection of American Art and of artifacts from the Southwest Museum Collection. During their planning, the authors became aware that art about the American Indian had seldom had the benefit of authoritative cultural analysis.

Their exhibition and catalogue—*Native Faces: Indian Cultures in American Art*—opened at the Southwest Museum in September 1984. The exhibition later traveled to the Joslyn Museum in Omaha and the Tucson Museum of Art. The authors wish to acknowledge their appreciation to the Board of Trustees of the Southwest Museum and to Mr. Frank Hathaway, Senior Managing Partner of LAACO Limited, managing company of the Los Angeles Athletic Club. Without the initial exhibition and its catalogue, the present volume might not have been conceived.

From the start the authors recognized that the focus of the Los Angeles Athletic Club's collection on the Indians of the Southwest, the Great Plains, and California was restrictive. A larger plan encompassing all the Indian culture groups of the United States, and drawing on painting and artifact collections throughout North America and Europe, was needed for a more extensive treatment of the subject. Phyllis Freeman, of Harry N. Abrams, Inc., strongly supported the concept of a collaboration between an anthropologist and art historian to undertake a cultural analysis and critique of paintings about American Indian subjects. With her encouragement and enthusiasm the research for this book was launched, and for her support the authors will forever be grateful.

Throughout the course of this research many individuals have generously supported this project. A special expression of gratitude for their fine assistance in providing us with valuable information and materials is extended to the following: Suzanne Abel-Vidor, The Sun House, Ukiah, California; Al Abrams, Phoenix, Arizona; Mary Jane Aerni, Berkeley; John Aubrey, Newberry Library, Chicago, Illinois; Pam Bass and Neil Ryder Hoos, Harry N. Abrams, Inc., New York; Craig Bates, National Park Service, Yosemite, California; E. Maurice Bloch, Los Angeles, California; Helen Greene Blumenschein, Taos; Searles R. Boynton, D.D.S., Ukiah; Anna Jean Caffey, Stark Museum of Art, Orange, Texas; Lee A. Callander, Museum of the American Indian, Heye Foundation, New York; Marie T. Capps, United States Military Academy, West Point, New York; Edwin H. Carpenter, The Huntington Library, San Marino, California; Denny Carter, Cincinnati, Ohio; Stephen R. Claggett, Office of State Archaeology, North Carolina Department of Cultural Resources, Raleigh; Richard Conn, Denver Art Museum, Colorado; Sue Critchfield, Museum of New Mexico, Santa Fe; Géza Csorba and Zsuzsanna Bakó, Hungarian National Gallery, Budapest; Elizabeth Cunningham, Anschutz Corporation, Denver, Colorado; Susan Danly, Pennsylvania Academy of Fine Arts, Philadelphia; Larry Dawson, Lowie Museum, University of California, Berkeley; Lawrence Dinnean, Bancroft Library, University of California, Berkeley; Christine Doran, The Oakland Museum, Art Department, Oakland, California; Paul Dyck, Rimrock, Arizona; Rowland Elzea, Delaware

Art Museum, Wilmington; John C. Ewers, Arlington, Virginia; Stuart Feld, Hirschl and Adler Galleries, New York; Jay R. Ferguson, The Filson Club, Louisville, Kentucky; Martha Fleischman, Kennedy Galleries, New York; Paula Fleming, National Anthropological Archives, Washington, D.C.; E. McSherry Fowble, Winterthur Museum, Delaware; Elizabeth J. Foster, Los Angeles; Michael Frost, Bartfield Gallery, New York; Marsha Gallagher and David Hunt, Joslyn Museum, Omaha, Nebraska; William H. Gerdts, The Graduate School, City University of New York, New York; Karen M. Goering, Missouri Historical Society, Saint Louis; Stephen L. Good, Rosenstock Arts, Denver, Colorado; George R. Hamell, New York State Museum, Albany; James Hanson, Nebraska State Historical Society, Lincoln; Bonnie Hardwick, Bancroft Library, University of California, Berkeley; Peter Hassrick, Buffalo Bill Historical Center, Cody, Wyoming; Jim Berry Hill, Berry-Hill Galleries, New York; Mark Hoffman, Maxwell Galleries, San Francisco, California; Kay House, San Francisco State University, California; Dale Idiens, Royal Museum of Scotland, Edinburgh; Barbara Isaac, Peabody Museum of Archaeology and Ethnology, Harvard University, Cambridge, Massachusetts; Harvey Jones, Oakland Museum, Art Division, California; Virginia and Ernie Leavitt, Tucson, Arizona; Janet LeClair, New York; Kenneth R. Lister, Royal Ontario Museum, Toronto, Ontario, Canada; Nancy C. Little, M. Knoedler & Co., Inc., New York; Pat Lynagh, Library of the National Museum of American Art and the National Portrait Gallery, Smithsonian Institution, Washington, D.C.; Mary Alice Mackay, The New-York Historical Society, New York; Arthur MacGregor, Department of Antiquities, Ashmolean Museum, Oxford, England; Peter MacNair, British Columbia Provincial Museum, Victoria, B.C.; Brita F. Mack, Huntington Library, San Marino, California; Edward Maeder, Los Angeles County Museum of Art; Marlene Mann, San Francisco, California; Fred Meyer and Anne Morand, Thomas Gilcrease Institute of American History and Art, Tulsa, Oklahoma; Ellen G. Miles, The National Portrait Gallery, Washington, D.C.; Shelley Mills, Fine Arts Museum of San Francisco, California; Leslie Mobbs and Sylvie Gervais, Public Archives, Ottawa, Ontario, Canada; Robert Nespor, Oklahoma Historical Society, Oklahoma City; Norman Neuerburg, Los Angeles; Frank Norick, Lowie Museum, University of California, Berkeley; Arthur L. Olivas, Photo Archives, Museum of New Mexico, Santa Fe; Eli Paul, Nebraska State Historical Society, Lincoln; Marilyn K. Parr, Silver Spring, Maryland; David Wayne Peri, Sonoma State University, California; Peter Palmquist, Arcata, California; Mary Edgar-Patton, Saint Louis Art Museum, Missouri; Stella Paul, Archives of American Art, Huntington Library, San Marino, California; Gerald P. Peters, Peters Corporation, Santa Fe, New Mexico; Ginger Renner, Paradise Valley, Arizona; Lawrence Reynolds, Los Angeles; Richard Rudisill, Photo Archives, Museum of New Mexico, Santa Fe; Stefani Salkeld, San Diego Museum of Man, California; Victoria Schmitt, Gallery of Sporting Art, Genesee County Museum, Mumford, New York; David E. Schoonover, Beinecke Rare Book and Manuscript Library, Yale University, New Haven, Connecticut; Jim Sefcik and Anne Woodhouse, The State Historical Society of Wisconsin, Madison; Robert L. Shalkop, Anchorage Historical and Fine Arts Museum, Alaska; Douglas Sharon, San Diego Museum of Man,

California; Sherry Smith-Gonzales, State Records Center and Archives, Santa Fe, New Mexico; Lawrence Sommer, Saint Louis County Historical Society, Duluth, Minnesota; James Sperry, State Historical Society, Bismarck, North Dakota; Lincoln B. Spiess, Saint Louis, Missouri; Ray W. Steele, C.M. Russell Museum, Great Falls, Montana; Herman J. Viola, Director, Quincentenary Programs, National Museum of Natural History, Washington, D.C.; Edwin L. Wade, Philbrook Museum of Art, Tulsa, Oklahoma; Malin Wilson, Santa Fe, New Mexico; Barbara A. Wolanin, Office of the Architect of the Capitol, Washington, D.C.

During the course of our research we found a number of institutions to be of special value both for their materials and their staff. Thus we should like to express a special debt of gratitude to the Southwest Museum staff for its able assistance, above all to Daniela Moneta, Craig Klyver, Richard Buchen, Michael Wagner, Jeannette Leeper, Cheri Falkenstien-Doyle, Claudine Scoville, Steven LeBlanc, and Yolanda Galvan. We also extend our sincere thanks to the University of California, Los Angeles, Art Library staff, including Joyce Ludmer, Patricia Moore, Ray Reece, and Max Marmor.

The amalgamation of the book's content required the special talents of an editor who could blend the texts of the historian and anthropologist. Jeanne D'Andrea's skills and dedication have been vital in realizing this complex publication. To her we should like to express our warmest gratitude.

We are also indebted to the many private collectors, museums, and institutions for their cooperation and assistance in allowing to us to reproduce their fine works; they are acknowledged individually, in the picture captions.

And, finally, for the support of our loving spouses whose patience and endurance during the course of this project sustained us through all the trials and tribulations of producing a book of this magnitude, we thank you!

Index

Numerals in italics refer to illustrations.

298

Photograph Credits

Abrams Photo/Graphics: 14, 27, 31, 43, 51, 59, 61, 64, 65, 71, 74, 81, 83, 94, 140
Hillel Burger: 47
James L. Conzo: 12
John Danicic, Jr.: 156
Warren Hanford: 142
Jim Jardine: 99
James O. Milmoe: 60, 87, 139, 149, 172
Bruce Ojard: 37
Lawrence Reynolds Photography: 23, 39, 42, 53, 88, 97, 103, 111, 117, 126, 130, 161, 164
Malcolm Varon: 69
White Line Photography: 116, 120